PARIS

Life & Luxury in the Eighteenth Century

PARIS

Life & Luxury in the Eighteenth Century

Edited by Charissa Bremer-David

with essays by Charissa Bremer-David, Kimberly Chrisman-Campbell, Joan DeJean, Mimi Hellman, and Peter Björn Kerber

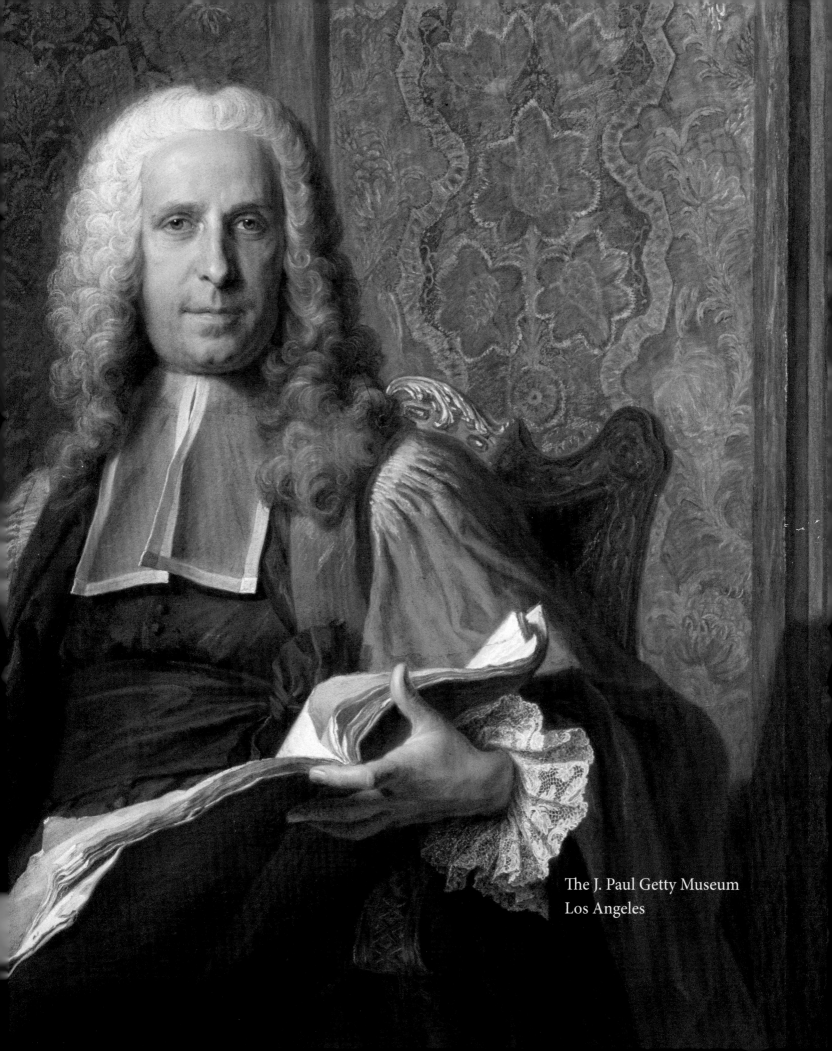

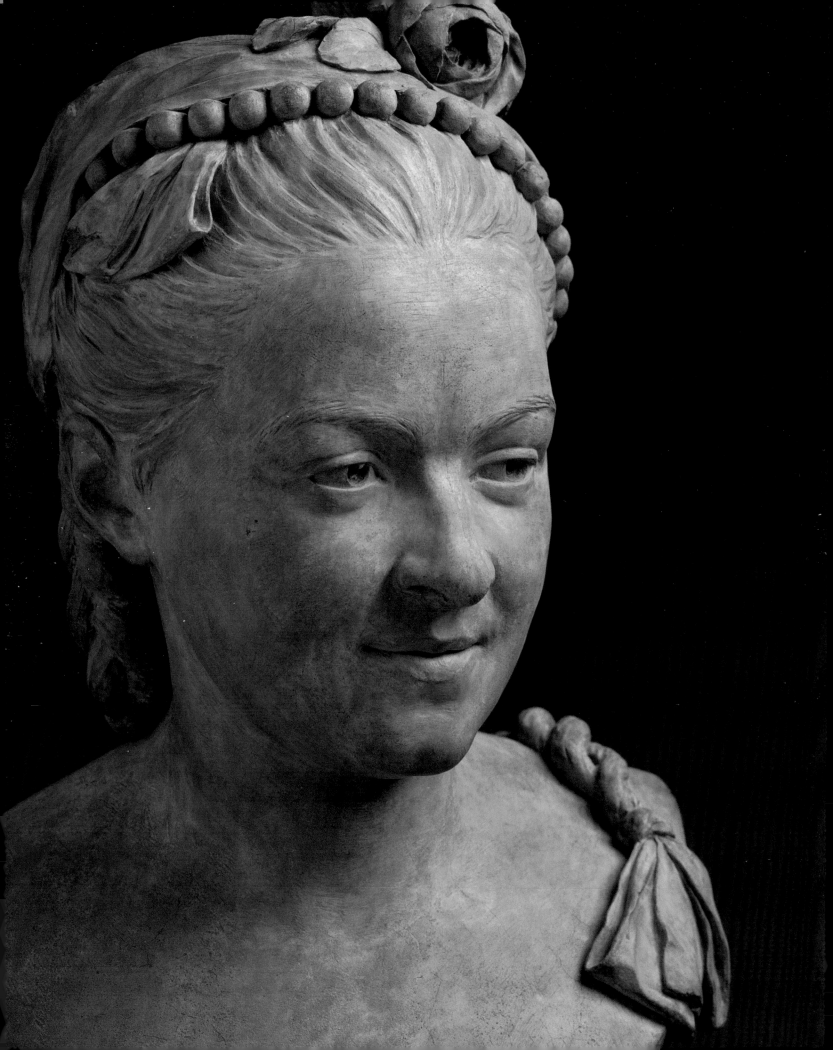

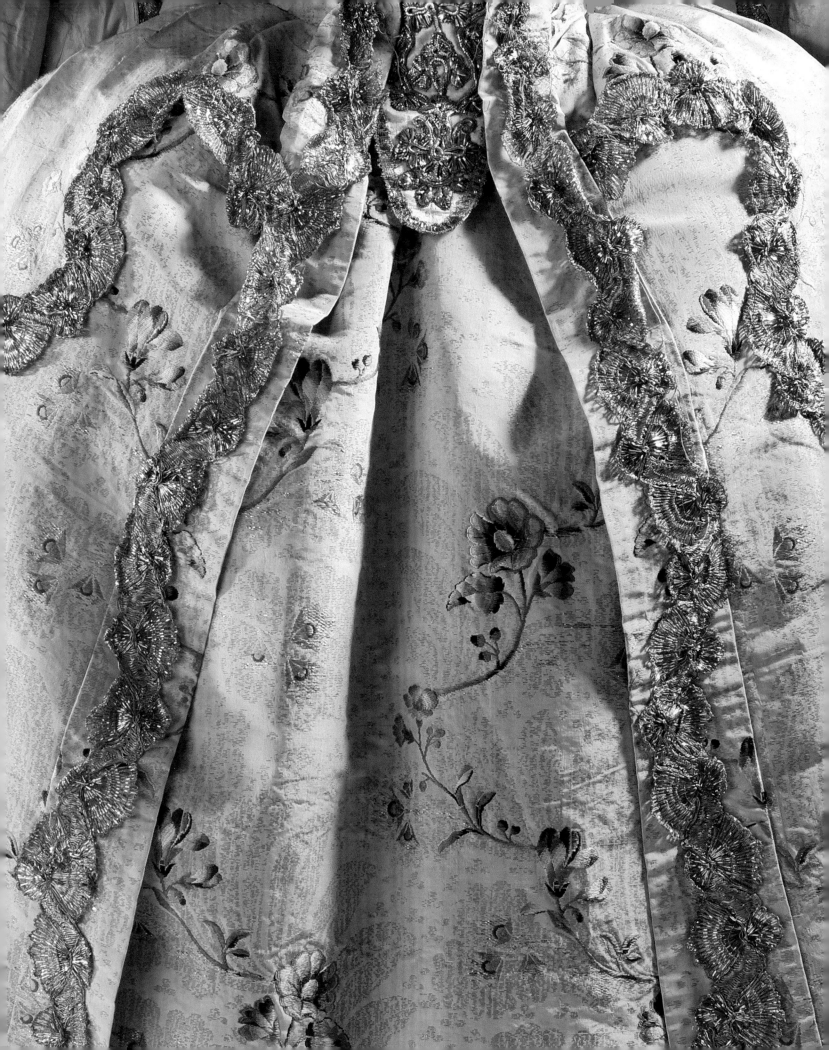

This volume accompanies the exhibition *Paris: Life & Luxury*, on view at
the J. Paul Getty Museum at the Getty Center, Los Angeles, April 26–August 7, 2011,
and the Museum of Fine Arts, Houston, September 18–December 10, 2011.

© 2011 The J. Paul Getty Trust
Second printing
Published by the J. Paul Getty Museum, Los Angeles
Getty Publications
1200 Getty Center Drive, Suite 500
Los Angeles, California 90049-1682
www.getty.edu/publications

Gregory M. Britton, *Publisher*

John C. Harris and Beatrice Hohenegger, *Editors*
Cynthia Newman Bohn, *Manuscript Editor*
Kurt Hauser, *Designer*
Amita Molloy, *Production Coordinator*
Pam Moffat, *Photo Researcher*

Photography and digital imaging supplied by Jack Ross, Lead Photographer;
Rebecca Vera-Martinez, Photographer; Gary Hughes, Imaging Technician; Michael Smith,
Imaging Technician/Project Manager

Typography by Diane Franco
Color separations by ProGraphics, Rockford, Illinois
Printed in Malaysia by CS Graphics

Library of Congress Cataloging-in-Publication Data
Paris : life and luxury in the eighteenth century / edited by Charissa Bremer-David ;
with essays by Charissa Bremer-David…[et al.].
 p. cm.
 Published to accompany an exhibition on view at the J. Paul Getty Museum, Los Angeles,
 Apr. 26–Aug. 7, 2011, and at the Museum of Fine Arts, Houston, Sept. 18–Dec. 10, 2011.
 Includes bibliographical references and index.
 ISBN 978-1-60606-052-0 (hardcover)
1. Paris (France)—Social life and customs—18th century—
Exhibitions. 2. Luxury—Exhibitions. 3. Art objects, Rococo—France—Paris—Exhibitions.
4. Art objects, French—France—Paris—Exhibitions. I. Bremer-David, Charissa.
II. J. Paul Getty Museum. III. Museum of Fine Arts, Houston.
 DC715.P2546 2011
 944'.361034—dc22
 2010037003

Front Jacket: *Mantel Clock* (see fig. 13).
Page i: *Illuminated Lottery Number* (Game Piece from a Cavagnole Game Bag),
 French, ca. 1750. Watercolor on vellum, 4.3 × 3.8 cm (1¹¹⁄₁₆ × 1½ in.).
 Component of Exhibition Object List no. 55.
Pages ii–iii: Detail of fig. 48.
Page iv: Exhibition Object List no. 69 (detail).
Page v: Exhibition Object List no. 63a and b (detail).
Page vi: Exhibition Object List no. 65 (detail).
Page viii: Exhibition Object List no. 54 (detail).
Page ix: Exhibition Object List no. 96.
Page x: Exhibition Object List no. 26 (detail).
Page xiv: Exhibition Object List no. 59 (detail).
Page 9: Exhibition Object List no. 6.
Page 10: Exhibition Object List no. 17 (detail).
Page 32: Detail of fig. 10; front view.
Page 52: Exhibition Object List no. 21 (detail).
Page 74: Detail of fig. 29; front view.
Page 90: Detail of fig. 13.
Page 114: Exhibition Object List no. 64 (detail).
End-sheets: Reproduction of the end-sheets of volume 3 of Exhibition Object List
 no. 112.
Back Jacket: Detail of fig. 59; front view (Exhibition Object List no. 64).

Contents

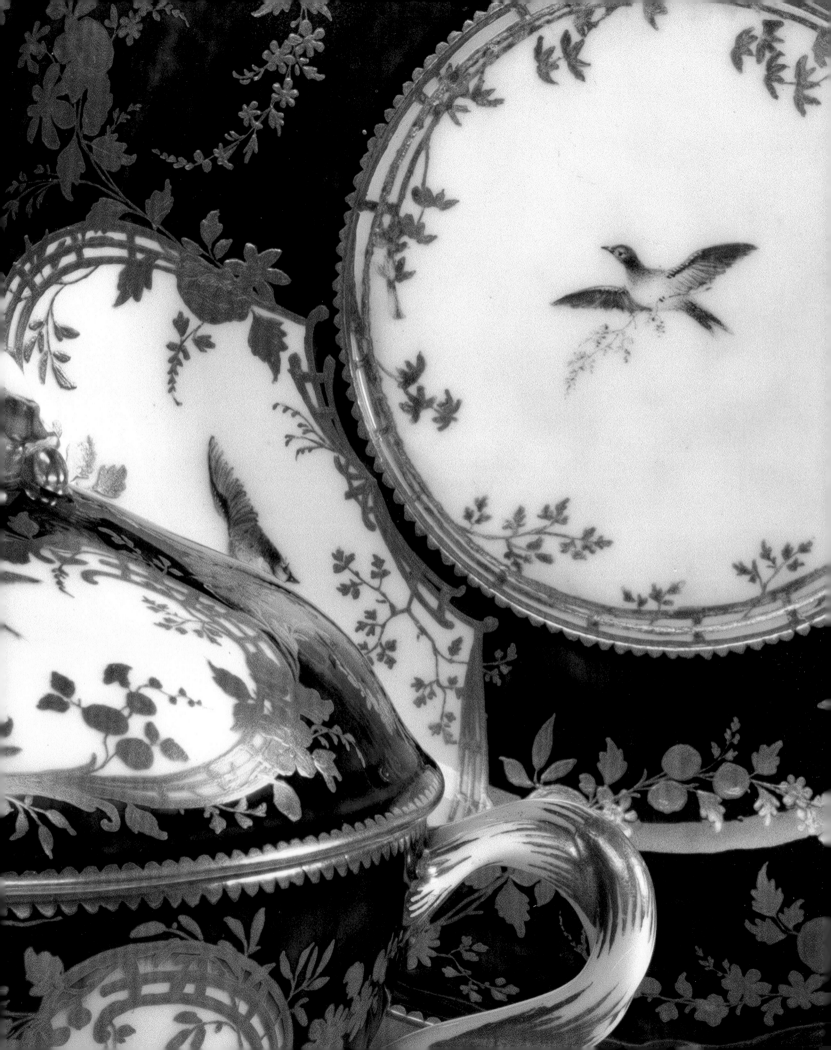

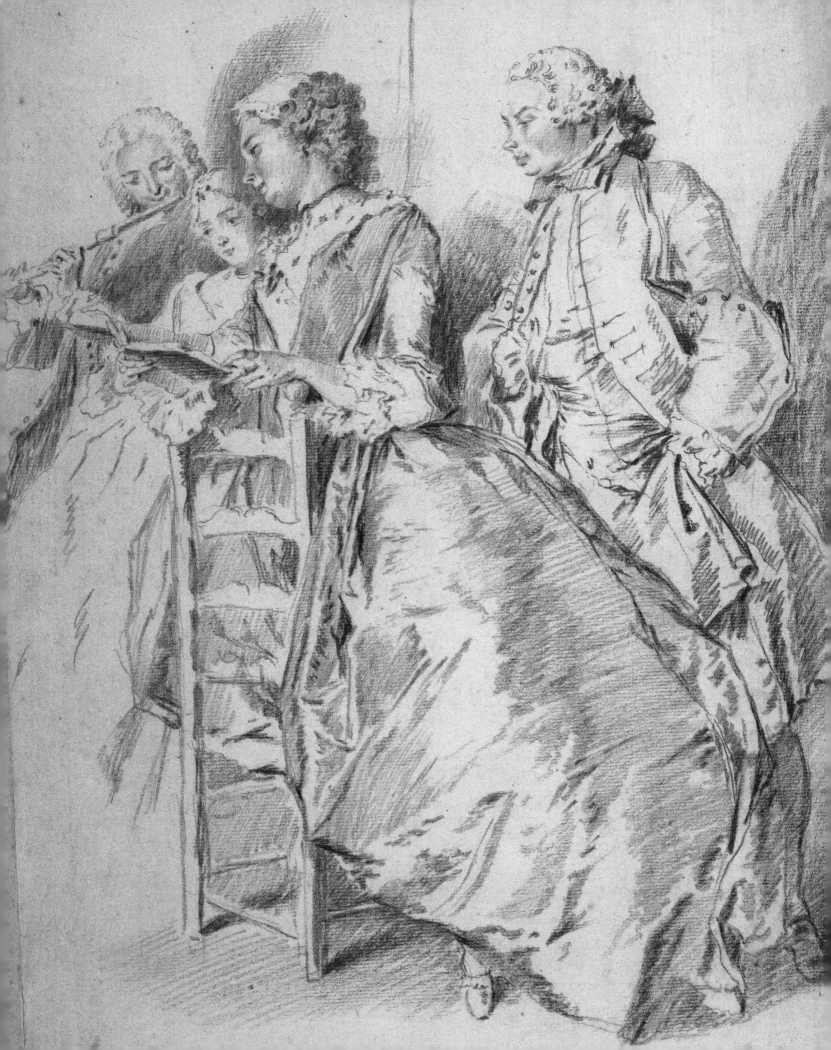

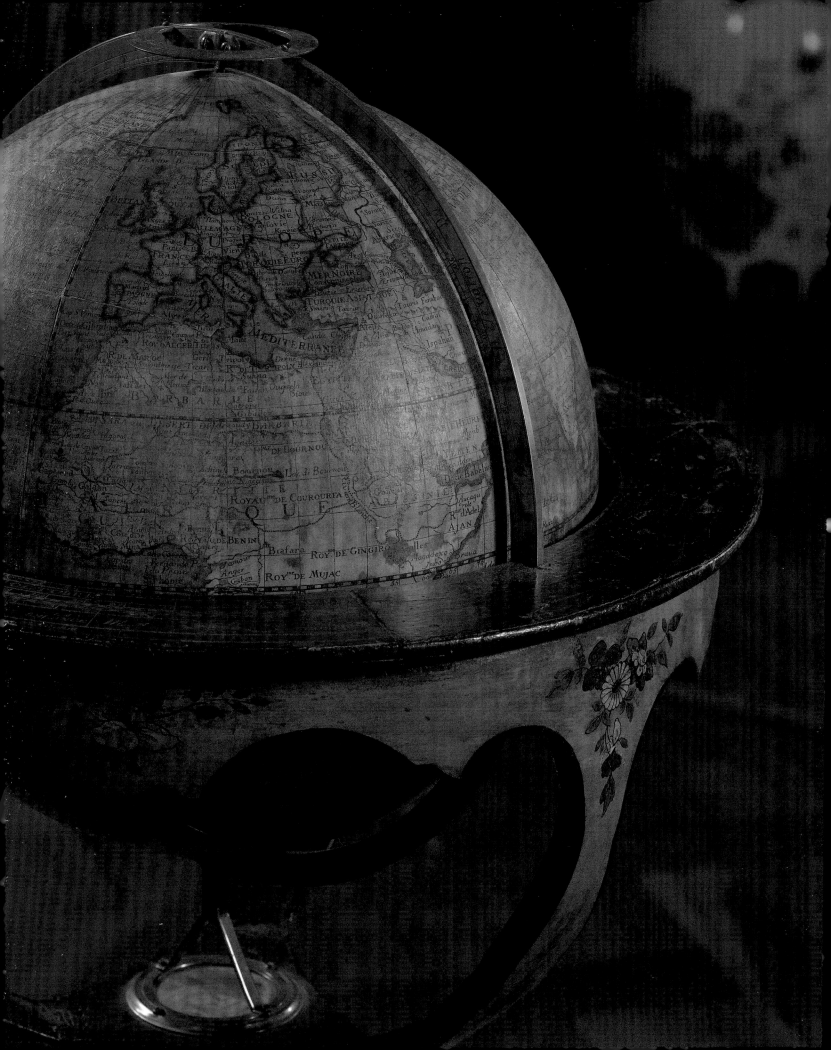

Foreword

In word and image, *Paris: Life & Luxury in the Eighteenth Century* reimagines a wide and diverse range of works of art within their original material context of a mid-eighteenth-century elite Parisian lifestyle. That elusive context—so difficult to reconstruct since the extant objects are dispersed geographically across collections and intellectually across modern academic disciplines—is brought to life within these pages by the accompanying studies of polite behavior, sociability, customs, and practices. Taking inspiration from the traditional visual allegories of the Four Times of Day (Morning, Midday, Afternoon, and Evening), the chapters in this book describe and examine the activities of a day in a prosperous Parisian household, arranged chronologically from morning to night as visualized through surviving paintings, sculpture, metalwork, furniture, applied arts, scientific and timekeeping instruments, textiles and dress, engravings, and architectural plans.

The first two chapters set the scene in terms of time and place: Charissa Bremer-David, curator of sculpture and decorative arts at the J. Paul Getty Museum, begins with an exploration of time consciousness and time-keeping in eighteenth-century Paris, while Joan DeJean, trustee professor of French at the University of Pennsylvania, describes the evolution in architectural design toward more intimately sized interior spaces that provided greater privacy. Three following chapters investigate the deeper meanings of routine pastimes: fashion and self-identity in the morning toilette, by independent scholar Kimberly Chrisman-Campbell; the role and influence of reading and erudition on art collecting by Peter Björn Kerber, assistant curator of paintings at the J. Paul Getty Museum; and nocturnal visuality and sociability by Mimi Hellman, associate professor of art history at Skidmore College. To each of these authors we extend our profound thanks for their thoughtful and thought-provoking contributions. Additionally, we thank the volume editor, Charissa Bremer-David, for her vision, oversight, and wonderful commitment to the entire project.

The publication of this book coincides with a major temporary exhibition, *Paris: Life & Luxury*, at the J. Paul Getty Museum at the Getty Center, Los Angeles, and at the Museum of Fine Arts, Houston, curated by Charissa Bremer-David with assistance from Peter Björn Kerber. The exhibition grew directly from the Getty Museum's magnificent French decorative arts collection and the correspondingly strong holdings of eighteenth-century illustrated French books in the Research Library and Special Collections of the Getty Research Institute, another program of the J. Paul Getty Trust. The breadth and strength of these collections naturally focused the parameters of the exhibition on the reign of Louis XV (reigned 1723–74). The illustrations here draw heavily on these "home collections" and on the dozens of other objects lent to the exhibition by gracious and generous lenders in the United States and abroad. The closing appendices, which provide essential information on, and a critical bibliography for, all of the objects in the exhibition, were compiled with great thoroughness and skill by graduate students Kira d'Alburquerque, Emily Beeny, and Grace Chuang.

We are enormously grateful to several other key individuals at the J. Paul Getty Museum and at Getty Publications who are responsible for this beautiful and elegant book: to Antonia Boström, senior curator of sculpture and decorative arts, for her support and guidance; to photographers Jack Ross and Michael Smith for the series of new and evocative photographs of decorative arts objects and gallery interiors in the Getty Museum; to editors John C. Harris and Beatrice Hohenegger and to manuscript editor Cynthia Newman Bohn for their patience and diligence; to photo researcher Pam Moffat for her unflagging detective efforts; and to book designer Kurt Hauser for his artistic vision and creative talent.

It has been a genuine pleasure to bring the exhibition and this book to fruition. We hope that audiences at the Los Angeles and Houston venues of *Paris: Life & Luxury* and readers of the present volume will enjoy them as much as we have enjoyed creating them.

DAVID BOMFORD PETER C. MARZIO
Acting Director Director
J. Paul Getty Museum Museum of Fine Arts, Houston

Acknowledgments

Many specialists and colleagues have contributed generously to the research and writing of this book. First and foremost, well-deserved acknowledgments go to the contributing authors who delivered insightful, cross-disciplinary chapter essays: Joan DeJean, Kimberly Chrisman-Campbell, Peter Björn Kerber, and Mimi Hellman. The content of this book has benefited enormously from their diverse perspectives, fresh intellectual approaches, breadth of expertise, and generosity of spirit. An equal measure of thanks goes to three graduate art history students who worked diligently and tirelessly to compile and cross-check the appendices: Kira d'Alburquerque, Emily Beeny, and Grace Chuang. It has been an unforgettable privilege to work with this team.

Members of the Department of Sculpture and Decorative Arts at the J. Paul Getty Museum read the manuscript analytically, offered helpful advice, and extended much-needed support at critical moments: Antonia Boström, senior curator, Jeffrey Weaver, associate curator, Anne-Lise Desmas, associate curator, and Ellen South, senior staff assistant. Former interns in the department Suleena Bibra, Marie Faye Barrera, and Kelly Turner, and current intern Elizabeth Buhe dedicated their time and talent at various stages. Other curatorial colleagues contributed essential guidance as well, including Scott Schaefer, senior curator of paintings, and Peter Björn Kerber, assistant curator of paintings, Elizabeth Morrison, curator of manuscripts, and Christine Sciacca, assistant curator of manuscripts; as well as Édouard Kopp, assistant curator of drawings. Due to their efforts, the manuscript is much improved. Members of the Decorative Arts and Sculpture Conservation Department at the same institution, especially Brian Considine, Katrina Posner, Arlen Heginbotham, Mark Mitton, and Adrienne Pamp, confirmed information concerning the physical characteristics of some of the materials and also extended much practical assistance, as did Sue Ann Chui of the Paintings Conservation Department and Nancy Turner and Nancy Yocco of the Paper Conservation Department.

Under the steadfast oversight of the former director of the J. Paul Getty Museum, Michael Brand, and current acting director David Bomford, staff in other departments of the museum contributed to the development of this book and to the associated exhibition *Paris: Life & Luxury*. Without their vision and perseverance, these dual projects would not have come so successfully to fruition: Quincy Houghton, associate director of exhibitions and public programs; Amber Keller, Kirsten Shaefer, and Sophia Allison in the Exhibitions Department; Merritt Price, Robert Checchi, Christina Webb, and Elie Glynn in the Design Department; Paco Link, Anne Martens, and Catherine Comeau in Collections Information and Access; Toby Tannenbaum and Clare Kunny in Education; Michael Smith, Jack Ross, Gary Hughes, Brenda Smith, and Leigh Grissom in Museum Imaging Services; Sally Hibbard, Betsy Severance, Carole Campbell, and Cherie Chen in the Registrar's Office; and Bruce Metro and his incomparable Preparations team. Thomas Gaehtgens, director of the Getty Research Institute (GRI), contributed advice and guidance to the authors while David Brafman, associate curator of collection development at the GRI, kindly shared his expertise, and Stephan Welch and Kevin Young their time, in preparing the special collection materials and rare books for photography and display. Publisher Gregory Britton led a wonderful team at Getty Publications, including editors John C. Harris and Beatrice Hohenegger, manuscript editor Cynthia Newman Bohn, photo researcher Pam Moffat, production coordinator Amita Molloy, and designer Kurt Hauser.

We are delighted that the exhibition travels to Houston, Texas, and we are especially appreciative of the collaboration warmly extended by Peter C. Marzio, director at the Museum of Fine Arts, and by Edgar Peters Bowron, Audrey Jones Beck Curator of European Art. The latter enthusiastically embraced, at an early stage, the underlying concepts of *Paris: Life & Luxury*.

We are most grateful to those colleagues across the United States and abroad who responded to our calls for information and to the institutions and private collectors who graciously supported this book with illustrations and the exhibition with critical loans. Their generous contributions have, individually and collectively, enriched the depth and breadth of the contents of both: at the Musées d'Amiens Métropole,

Musée de Picardie, Sabine Cazenave; at the Art Institute of Chicago, James Cuno, Christopher Monkhouse, and Ghenete Zelleke; at the Musée des Arts décoratifs, Paris, Beatrice Salmon and Anne Forray-Carlier; at Bernheimer Fine Old Masters, Munich, Konrad O. Bernheimer; at Caring for Textiles, Los Angeles, Sharon Shore; at Carnevale and Lohr, Bell Gardens, California, David Carnevale; at the Cleveland Museum of Art, Deborah Gribbon and Jon Seydl; at the Detroit Institute of Arts, Graham W. J. Beal, Alan Phipps Darr, and Yao-Fen You; at Gurr Johns, London, Harry Smith; at the Musée Fabre, Montpellier, Michel Hilaire; at the Museum of Fine Arts, Houston, Peter C. Marzio and Edgar Peters Bowron; at the Museum of Fine Arts, Saint Petersburg, Florida, John E. Schloder; at the Huntington Library, Art Collections, and Botanical Gardens, San Marino, California, John Murdoch and Catherine Hess; at the Los Angeles County Museum of Art, Michael Govan, Patrice Marandel, Sharon Sadako Takeda, Fionn Lemon, Clarissa Esguerra, and Nicole LaBouff; at the Musée du Louvre, Paris, Henri Loyrette, Marie-Catherine Sahut, Geneviève Bresc-Bautier, Guilhem Scherf, Marc Bascou, and Frédéric Dassas; at the Metropolitan Museum of Art, New York, Thomas P. Campbell, Keith Christiansen, Katharine Baetjer, J. Kenneth Moore, Jayson Kerr Dobney, Ian Wardropper, Jeffrey Munger, James D. Draper, and Daniëlle Kisluk-Grosheide; at the Museums and Galleries of Leeds City Council, Leeds, Ian Fraser; at the National Gallery, London, Nicholas Penny, David Jaffé, and Humphrey Wine; at the National Gallery, Washington, D.C., Earl A. Powell III, Mary Levkoff, and Mary Morton; at the Nationalmuseum, Stockholm, Solfrid Söderlind, Torsten Gunnarsson, Mikael Ahlund, Linda Hinners, and Jan Norrman; at the Resnick Collection, Beverly Hills, Bernard Jazzar; at Stiebel, Ltd., New York, Gerald G. Stiebel; at the Museo Thyssen-Bornemisza, Madrid, Carlos Fernández de Henestrosa y Argüelles; at Trinity College, Hartford, Alden R. Gordon; at the Victoria and Albert Museum, London, Mark Jones, Paul Williamson, Hilary Young, Richard Edgcumbe, Judith Crouch, Sonia Solicari, Christopher Maxwell, and Sarah Medlam; independent scholars Mary Tavener Holmes, New York, and Carolyn Sargentson, London; clock conservators John Hegeman, Altadena, California, and James Cipra, Long Beach, California; as well as MaryLou Boone, Pasadena, California; Lynda and Stewart Resnick, Beverly Hills, California; and those private collectors who wish to remain anonymous.

To each and every one who contributed to this book and to the exhibition, thank you.

CHARISSA BREMER-DAVID
Curator of Sculpture and Decorative Arts
J. Paul Getty Museum

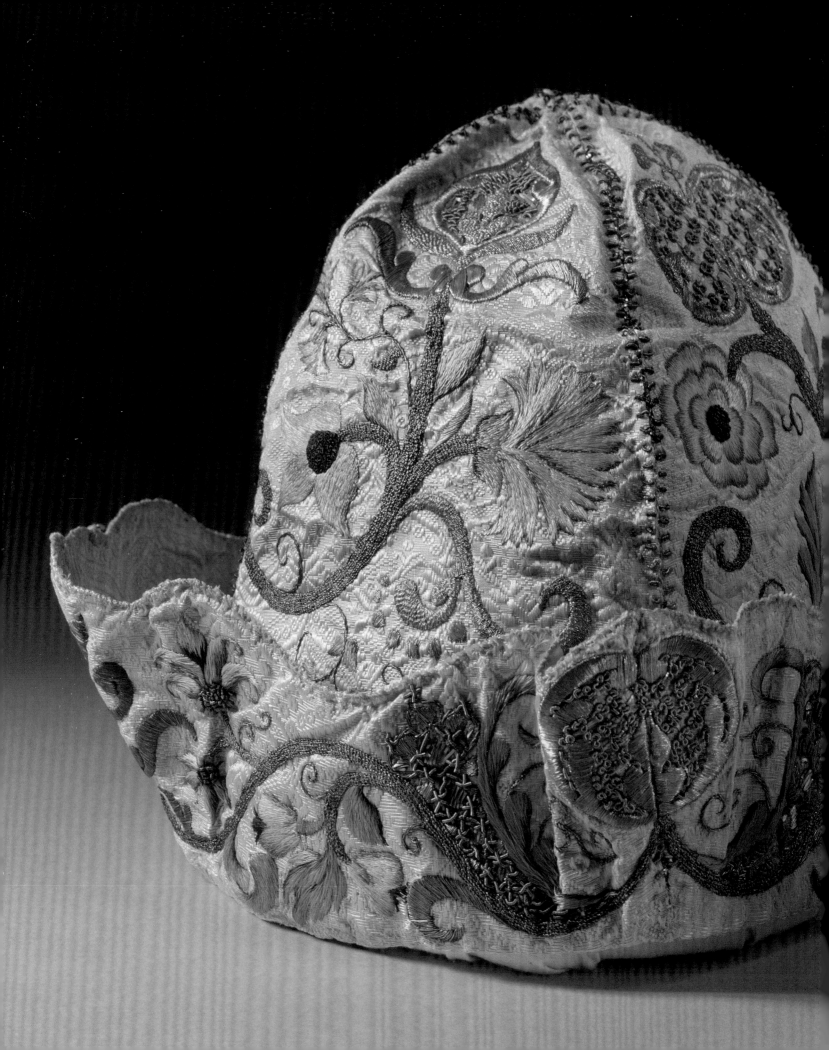

Introduction:

In Defense of Luxury[1]

Charissa Bremer-David

In today's world of marketing and name branding, the term *luxury* is a potent catchword signifying quality, prestige, and costliness. The modern "luxury goods market" encompasses a broad class of finely designed commodities, made with superlative craftsmanship and exceptional materials, that exceed the needs and means of average consumers. Within this category are found private jets and sports cars, haute couture and jewelry, gold or platinum watches incorporating the latest technology, exquisite leather shoes and accessories, cosmetics and perfumes, rare food stuffs and vintage wines. When used to describe services or surroundings, the adjective *luxurious* promises abundant attention, impeccable detailing, and exclusive accommodation. Tellingly, the term also refers to a specific levy, the "luxury tax," excised on nonessential products and services. The word is especially potent in contemporary marketing because it conveys and confers an older notion of a refined taste—one that recognized, understood, and appreciated not only excellence, elegant design, and style but also the time, effort, and skilled handicraft required to achieve these qualities. This older sensibility, so wittily expressed by Voltaire (1694–1778) in *Le Mondain* (*The Worldling*), his poem of 1736, would have been second nature to the most elite members of society in eighteenth-century Paris and it is that sensibility, the now-elusive lifestyle which accompanied it, and the extant objects which still manifest its essence that captivate our attention here.

For all its physical manifestations, past and present, luxury is a rather flexible concept that shifts in response to individual self-identity and to collective experiences of prosperity or austerity. English dictionaries define *luxury* as "the habitual use of, or indulgence in what is choice or costly, whether food, dress, furniture, or appliances of any kind; something

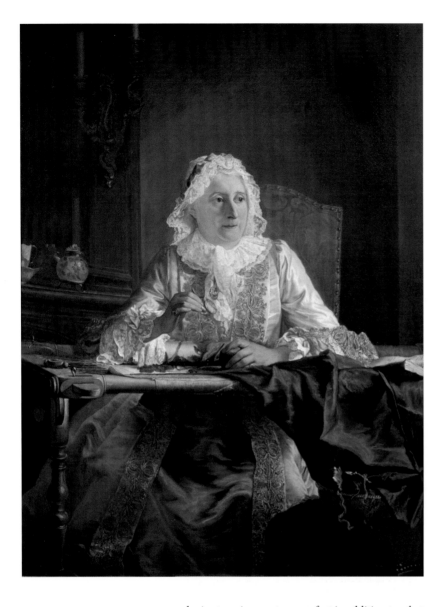

Figure 1
JACQUES-ANDRÉ-JOSEPH
AVED (French, 1702–1766),
*Portrait of Madame Antoine
Crozat, marquise du Châtel
(born Marguerite Legendre
d'Armeny)*, 1741. Oil on
canvas, 138.5 × 105 cm
(54½ × 41⁵⁄₁₆ in.). Montpellier,
Musée Fabre, 839.2.1. Photo:
Scala / White Images / Art
Resource, N.Y.

which, through a linguistic association, became conflated in the commentaries circulating within the early Christian church with *luxuria* (extravagance) and with the carnal passion of lust (*luxure* in French), one of the seven deadly sins or capital vices. This duality influenced the evolution of the word so that in common use *luxury* (or *luxe*) had inversely positive and negative connotations in seventeenth- and early-eighteenth-century France. It was considered both appropriate and desirable for the wellborn to maintain an appearance of luxury according to their social rank, but it was considered presumptive and false to dress sumptuously or to live in a manner above one's station. The representation of status through costly attire, through the pomp of ceremony or ritual, and through etiquette in speech and manners was legitimate if it confirmed and reinforced the social hierarchy; conversely, the assumption of these traits by those not entitled to them was perceived as a misuse and usurpation of resources and customs that threatened the traditional distinctions of the social order and, thereby, authority.

The significance of these outward signs was more than symbolic, for they were transformative forces in the creation and perpetuation of identity. As the historian John Shovlin explained, "Signs, such as fine clothing, were not merely indications that the possessor was a man of quality, they contributed to making him such."[4] It was in the self-interest of the first and second estates of France, the clergy and the nobility, to uphold these visual representations and differentiations of rank. An anonymous Paris publication of 1680, purportedly written by the theologian Jacques Boileau (1635–1716), maintained that, "It is true that the Christian religion permits girls and women to attire and adorn themselves according to their quality and their condition; but it must be without affectation and without excess, for propriety's sake and not for luxury."[5] Excessive or unsuitable extravagance and luxury were considered potentially corruptive forces to be discouraged and avoided. The 1701 edition of the *Dictionnaire Universel* unequivocally defined *luxe* in this critical light, as "superfluous expenditure; excessive sumptuousness, whether in dress, in furniture, or at table, etc."[6]

Improvements to Parisian urban life beginning in the 1660s, under the initiative of Louis XIV (1638–1715, reigned from 1643), contributed to an environment in which the city's inhabitants enjoyed an ambience of greater safety (with the foundation of the police force and of a system of street lighting), increased intellectual discourse (with the establishment of new acade-

conducive to enjoyment or comfort in addition to what are accounted the necessities of life…something desirable but not indispensable" and "anything pleasing to the senses, and also…difficult to obtain; an expensive rarity."[2] In French, the equivalent word *luxe* has a corresponding, yet deeper meaning, since it connotes more than just the enjoyment of expensive things, referring instead to a "way of life characterized by large expenditures devoted to the acquisition of superfluous goods, by a taste for ostentation and the greatest comfort."[3] The English adjective *deluxe* directly reflects this French idea of a surfeit of well-being.

For centuries, however, luxury did not convey this meaning. The etymology of the word *luxury* goes back to the Latin root *luxus* (excess and abundance),

mies for science, music, and architecture), and leisure entertainments (with the opening of the Comédie Française theater and of cafés), all factors that fostered a lively communal and cultural life, as well as commerce.[7] The simultaneous expansion of banking and fiscal speculation created immense new fortunes that funded elite lifestyles. It is no coincidence that once the center of royal government moved from Versailles to Paris with the regent Philip II, duc d'Orléans (1674–1723, *régent* from 1715), new sensibilities blossomed among those Parisians who had the means to acquire material possessions and luxuries traditionally reserved for the nobility. Granted, a majority of the wage-earning urban population remained disadvantaged, but mobility did exist for an increasing number of aspiring, prosperous families, like the Crozat dynasty, whose sons found economic opportunities and social advancement as crown administrators, judicial officers, and financiers (fig. 1).[8]

As the century progressed during the reign of Louis XV (1710–1774, reigned from 1723), those who could afford superfluous expenditure responded more and more to the forces of fashion and consumption, as structured and manipulated by the guilds and the merchants, that rendered clothes and objects rapidly obsolete.[9] Parisian notarial inventories spanning the eighteenth century chart the increasing appearance of nonessential goods among the more well-to-do and many of these items, especially furniture and table wares, were created for ever more specific functions.[10] The varying types of furniture, particularly chairs designed for comfort and conversation, and their arrangement in domestic spaces and the presence of specialized vessels for dining and drinking, such as teasets, indicated that the new forms of civility and socializing were spreading. Many contemporary social commentators perceived these modern luxuries of convenience and comfort as a generally improving influence rather than a debilitating vice.[11]

Moreover, in the contemporary intellectual discourse concerning luxury, it was argued that the commerce in nonessential goods resulted in public benefit because the increasing demand for such items provided employment for craftsmen and tradesmen, shopkeepers and merchants.[12] In 1714 Bernard Mandeville (1670–1733) posited in his *Fable of the Bees, or Private Vices, Public Benefits* that the private vice of luxury actually contributed to the communal good, "The root of evil, avarice, That damn'd ill-natur'd baneful vice, Was slave to prodigality, That noble sin; whilst luxury

Employ'd a million of the poor, And odious pride a million more."[13] And, furthermore, if society should reform and become virtuous, then production, arts, and crafts would lapse, "As pride and luxury decrease, So by degrees they leave the seas, Not merchants now, but companies Remove whole manufactories. All arts and crafts neglected lie."[14] Leaving aside Mandeville's controversial paradox of private/public morality, many French observers nonetheless concurred that the business of luxury created work, especially since shopping and spending were not limited to the prosperous, and purveyors of nonessential goods of varying quality catered to purchasers at all levels.[15] Ultimately, luxury was relative for, according to Claude-Charles de Peyssonnel (1727–1790), "It is fortunate that *les petits* should appropriate the luxuries.... Industry loses nothing thereby—it simply changes purchaser: I even venture to believe that it gains, for *les petits* are infinitely more numerous than *les grands*."[16] It is not surprising, therefore, that just exactly what constituted a luxury shifted according to the author and the period. This very ambiguity was raised in the philosophes' greatest publication, the *Encyclopédie*, "But what is this luxury that we so infallibly attribute to so many objects?"[17]

Parisian elites were not deaf to this discourse. They were participants in it, and Voltaire was their champion, meeting those who stood on the moral high ground of the luxury debate with satire and a shameless, epicurean joie de vivre in *The Worldling*. With searing wit, he questioned the motives and reasoning of those contemporaries—those "Religionists"—who called for pious abstinence and frugality by mythologizing the ancient virtues of the classical Golden Age. But Voltaire paid a price and was persecuted, ostensibly for the poem's irreverent mockery of Adam, the "fruit-eating first father," who failed to pare his nails even if he did enjoy a state of grace in the Garden of Eden.[18] The author consequently left France for the Low Countries in December 1736, some months after the publication of his poem, and did not return until March 1737, when he composed *Défense du Mondain, ou l'Apologie du luxe* (*Defense of the Worldling, or An Apology for Luxury*), which accused his opponents of hypocrisy, while praising the mercantile policies of Jean-Baptiste Colbert (1619–1683), controller of finance under Louis XIV. Voltaire's polemic prompted a correspondence between two principals of the Parisian elites which is revealing and salient here. Responding to a letter from the vastly wealthy and famous art collector, bibliophile, and *salonnière* Jeanne Baptiste d'Albert de

Figure 2 (following page)
EDME BOUCHARDON (French 1698–1762), *Cupid*, before 1757. Marble, 73.9 × 34.5 (diam. at base) cm (29⅛ × 13⁹⁄₁₆ in.). Washington, D.C., National Gallery of Art, Samuel H. Kress Collection, 1952.5.93. Photo: courtesy of the Board of Trustees, National Gallery of Art, Washington, D.C.

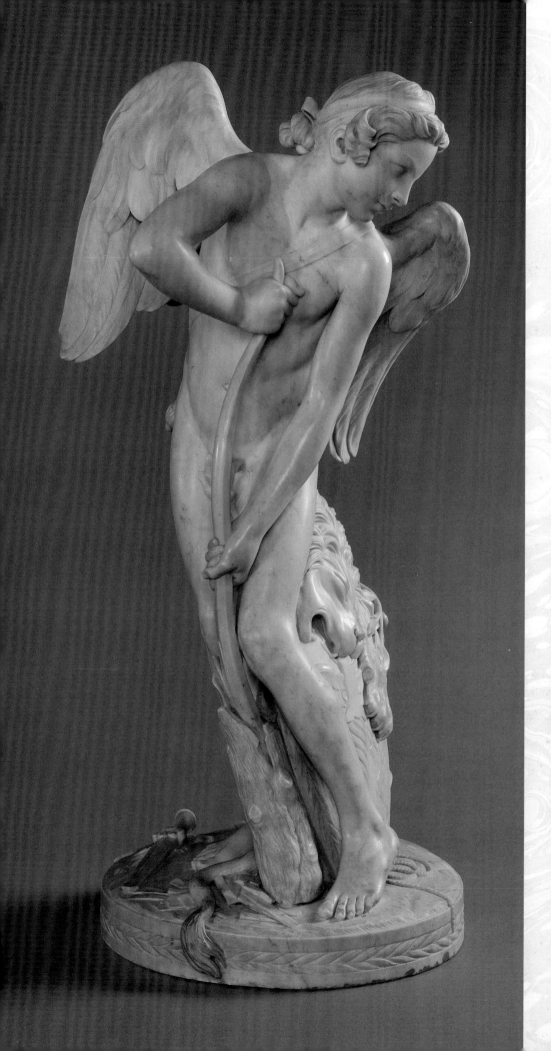

The Worldling

VOLTAIRE, 1736

Others may with regret complain
That 'tis not fair Astrea's reign,
That the famed golden age is o'er
That Saturn, Rhea rule no more:
Or, to speak in another style,
That Eden's groves no longer smile.
For my part, I thank Nature sage,
That she has placed me in this age:
Religionists may rail in vain;
I own, I like this age profane;
I love the pleasures of a court;
I love the arts of every sort;
Magnificence, fine buildings, strike me;
In this, each man of sense is like me.
I have, I own, a worldly mind,
That's pleased abundance here to find;
Abundance, mother of all arts,
Which with new wants new joys imparts
The treasures of the earth and main,
With all the creatures they contain:
These, luxury and pleasures raise;
This iron age brings happy days.
Needful superfluous things appear;
They have joined together either sphere.
See how that fleet, with canvas wings,
From Textel, Bordeaux, London brings,
By happy commerce to our shores,
All Indus, and all Ganges stores;
Whilst France, that pierced the Turkish lines,
Sultans make drunk with rich French wines.
Just at the time of Nature's birth,
Dark ignorance o'erspread the earth;
None then in wealth surpassed the rest,
For naught the human race possessed.
Of clothes, their bodies then were bare,

They nothing had, and could not share:
Then too they sober were and sage,
Martialo lived not in that age.
Eve, first formed by the hand divine,
Never so much as tasted wine.
Do you our ancestors admire,
Because they wore no rich attire?
Ease was like wealth to them unknown,
Wasn't virtue? Ignorance alone.
Would any fool, had he a bed,
On the bare ground have laid his head?
My fruit-eating first father, say,
In Eden how rolled time away?
Did you work for the human race,
And clasp dame Eve with close embrace!
Own that your nails you could not pare,
And that you wore disordered hair,
That you were [weathered] in complexion,
And that your amorous affection
Had very little better in't
Than downright animal instinct.
Both weary of the marriage yoke
You supped each night beneath an oak
On millet, water, and on mast,
And having finished your repast,
On the ground you were forced to lie,
Exposed to the inclement sky:
Such in the state of simple nature
Is man, a helpless, wretched creature.
Would you know in this cursed age,
Against which zealots so much rage,
To what men blessed with taste attend
In cities, how their time they spend?
The arts that charm the human mind
All at his house a welcome find;

In building it, the architect
No grace passed over with neglect.
To adorn the rooms, at once combine
Poussin, Correggio the divine,
Their works on every panel placed
Are in rich golden frames incased.
His statues show Bouchardon's skill,
Plate of Germain, his sideboards fill.
The Gobelins tapestry, whose dye
Can with the painter's pencil vie,
With gayest coloring appear
As ornaments on every pier.
From the superb salon are seen
Gardens with Cyprian myrtle green.
I see the sporting waters ride
By jets d'eau almost to the skies.
But see the master's self approach
And mount into his gilded coach,
A house in motion, to the eyes
It seems as through the streets it flies.
I see him through transparent glass[es]
Loll at his ease as on he passes.
Two pliant and elastic springs
Carry him like a pair of wings.
At Bath, his polished skin inhales
Perfumes, sweet as Arabian gales.
Camargot at the approach of night
Julia, Gossin by turns invite.
Love kind and bounteous on him pours
Of choicest favors plenteous showers.
To the opera house he must repair,
Dance, song, and music charm him there.
The painter's art to strike the sight,
Does there with that blest art unite;
The yet more soft, persuasive skill,

Which can the soul with pleasure thrill.
He may to damn an opera go,
And yet perforce admire Rameau.
The cheerful supper next invites
To luxury's less refined delights.
How exquisite those sauces flavor!
Of those ragouts I like the savor.
The man who can in cookery shine,
May well be deemed a man divine.
Chloris and Ægle at each course
Serve me with wine, whose mighty force
Makes the cork from the bottle fly
Like lightning darting from the sky.
Bounce! To the ceiling it ascends,
And laughter the apartment rends.
In this froth, just observers see
The emblem of French vivacity.
The following day new joys inspires,
It brings new pleasures and desires.
Mentor, Telemachus descant
Upon frugality, and vaunt
Your Ithaca and your Salentum
To ancient Greeks, since they content them:
Since Greeks in abstinence could find
Ample supplies of every kind.
The work, though not replete with fire,
I for its elegance admire:
But I'll be whipped Salentum through
If thither I my bliss pursue.
Garden of Eden, much renowned,
Since there the devil and fruit were found,
Huetius, Calmet, learned and bold,
Inquired where Eden lay of old:
I am not so critically nice,
Paris to me's a paradise.[19]

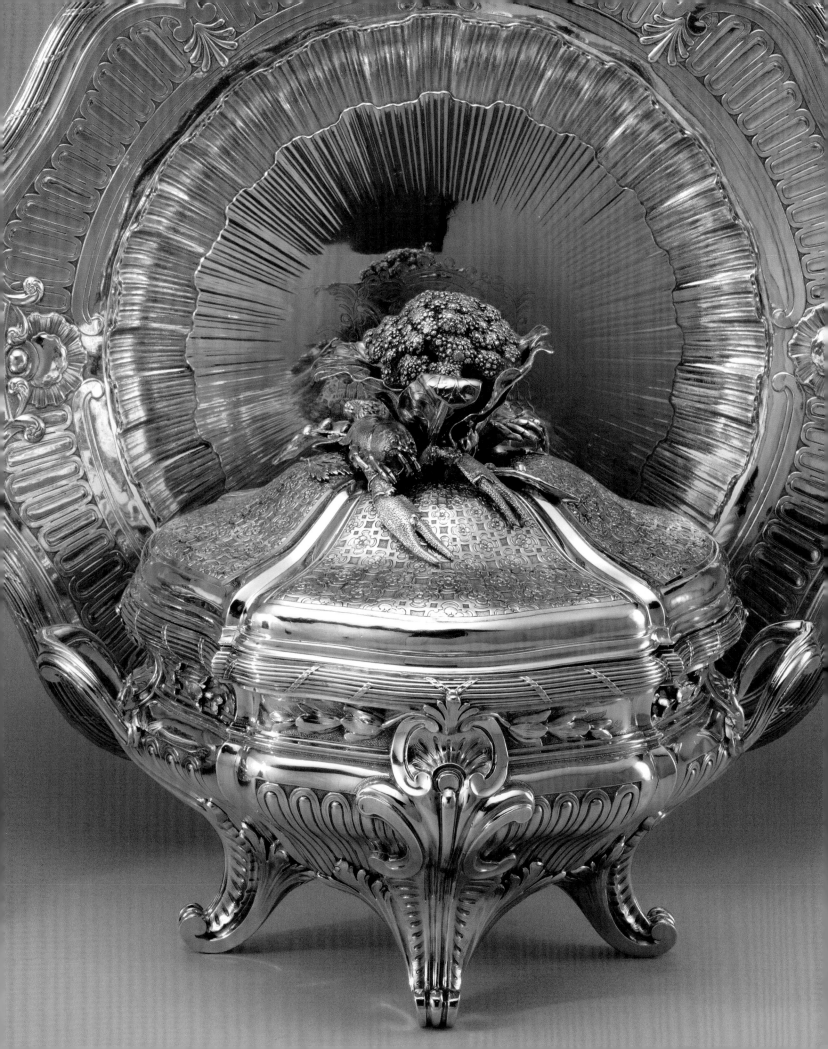

Luynes, la comtesse de Verrue (1670–1736), Jean-François Melon (1675–1738), former secretary to the regent, the duc d'Orléans, wrote:

> I read, Madame, the ingenious *Apologie du luxe*; I consider this small work as an excellent political lesson, disguised as pleasant banter. I am flattered to have demonstrated in my *Political Essay on Commerce*, how this taste for the fine arts and this employment of riches, this spirit of a great State that one calls luxury, are necessary for the circulation of coin and for the maintenance of industry; I consider you, Madame, as one of the great examples of this truth. How many Parisian families subsist solely by the patronage you give to the arts?[20]

The Worldling is particularly informative for the modern reader because Voltaire itemized those pleasures and arts that he considered luxuries, going so far as to identify their makers by name: the chef and cookbook author François Martialo (also called Massialot or Massialo [1660–1733]), the artists Nicolas Poussin (1594–1665) and Correggio (1489–1534), the sculptor Edme Bouchardon (1698–1762) (fig. 2), the silversmith Thomas Germain (1673–1748) (fig. 3), the royal manufactory of tapestries at the Gobelins, and the composer Jean Philippe Rameau (1683–1764).

The poem is a veritable short list of who's who and a long list of what's what. The longer list is comprehensive, covering everything from housing and gardens, equipages, furnishings and art to clothes, table wares, perishables, and even ephemeral entertainment. Among the luxuries mentioned are magnificent buildings, gardens with jetting water fountains, spring-suspension carriages with glazed windows, beds and tapestries, paintings in gilt-wood frames and marble sculpture, rich attire, silver plate, savory stews and flavorful sauces, wine and champagne, perfume, operas and concerts. Voltaire describes, in essence, a lifestyle in which the protagonist was fully immersed. One can readily imagine the well-read and discerning patron, who purchased paintings on the basis of their subject matter and execution, also exercising comparable aesthetic judgment and taste in selecting the pattern of a waistcoat and in choosing from among an offering of expensive lace cuffs and shoe buckles. The subject of the poem, was, in short, a connoisseur who recognized, understood, appreciated, and took pleasure in excellence, design, and style in all its forms, down to the minutest detail. Whether large or small, serious or seemingly frivolous, all these matters constituted and visualized identity.

The title of the poem, *The Worldling*, is also revealing for it referred to an ancient yet persistent notion, which was both a creation and a consequence of trade, that equated luxury with the importation of foreign customs from exotic places and with materials from around the globe. While the origins of this concept are as old as long-distance trade, its currency in seventeenth- and eighteenth-century France was revived and encouraged by the crown's involvement, and by individual investment, in overseas colonization and maritime companies. Jacques Savary (1622–1690), a lawyer and the state's expert on international trade, reasoned that commerce in, and exposure to, foreign goods brought a refining *douceur* (sweetness) to life.[21] *The Worldling* gives voice to this notion with its mention of Dutch, French, and English fleets transporting precious cargoes from the Indus and Ganges river regions. Voltaire even argued the point one step further with the statement that indigenous luxury goods reached, in their turn, foreign shores, "Sultans make drunk with rich French wines."[22] Voltaire's worldly connoisseur displayed an intellectual curiosity and a wide-ranging taste for luxury from across broad horizons.

Taking its cue from Voltaire, this book sheds light on the luxurious lifestyle enjoyed by a growing elite population in mid-eighteenth-century Paris. The Latin word *lux* (light, especially daylight) gives logic to the order of the following chapters, which carry the reader through a notional day in the life of a prosperous Parisian household. Essays on temporal literacy and domestic interiors describe the shifting settings of time and space and are followed by a sequence of studies inspired by contemporary visual renderings of the allegorical theme of the Hours of the Day. These focus on specific activities, arranged in order from morning to night, such as dressing, reading, and nocturnal socializing. The essays not only reimagine a range of values and practices within their material contexts, they also show how attitudes and behaviors defined their holders' identities in a world of ideas and things that was challenging to navigate. For a life of comfort and pleasure structured upon the archetypal ideals of elegance and erudition could only be achieved by a mastery of sophisticated practical skills, knowledge, wit, and eloquent comportment in choreography with a pleasing sociability and politesse.

Rather than merely celebrating mid-eighteenth-century Paris or perpetuating the mythology of its charm and gallantry, if not its perceived decadence, the contributors to this book reveal the subtlety and

Figure 3
THOMAS GERMAIN (French, 1673–1748), *One of a Pair of Lidded Tureens, Liners, and Stands* (detail), ca. 1744–50. Silver, tureen: 30 × 34.9 × 28.2 (11³⁄₁₆ × 13¾ × 11⅛ in.); stand: 4.2 × 46.2 × 47.2 cm (1⅝ × 18³⁄₁₆ × 18⁹⁄₁₆ in.). Los Angeles, J. Paul Getty Museum, 82.DG.13.1–2.

7

complexity of the lifestyle of its elites by considering a paper trail of contemporary publications, floor plans, guidebooks, etiquette manuals, inventories, and letters, together with a broad array of surviving works of art—paintings, sculpture, furniture, clocks and watches, lighting fixtures, table wares, toilette and writing accessories, and articles of dress. Objects that are today dispersed physically across collections and intellectually across disciplines are united visually and thematically in order to critically examine the activities of a day in a time and place that Voltaire understood, and we can appreciate, as a luxurious, worldly paradise.

Notes

My coauthors and valued colleagues Joan DeJean, Kimberly Chrisman-Campbell, Peter Björn Kerber, and Mimi Hellman are all gratefully acknowledged for their contributions to this volume and for their stimulating discourse, nuanced perspectives, and insightful scholarship. Sincere thanks are also extended to Christian Michel for introducing the present writer to Voltaire's poem *Le Mondain (The Worldling)*.

1. *L'Apologie du luxe (An Apology for Luxury)* was the subtitle given by Voltaire (born François Marie Arouet) to his *Défense du Mondain (Defense of the Worldling)*, composed in response to the polemical reception of his previous poem *Le Mondain (The Worldling)* of 1736. See Morley 1872, vol. 36, pp. 170–74.

2. http://dictionary.oed.com/cgientry/50137208?single=1&query_type=word&queryword=luxury and http://www.websters-online-dictionary.org/definitions/luxury (accessed June 22, 2010).

3. *Petit Robert*, p. 1120: "mode de vie caractérisé par de grandes dépenses consacrées à l'acquisition de biens superflus, par goût de l'ostentation et du plus grand bien-être."

4. Shovlin 2000, p. 583.

5. Boileau 1680, pp. 106–7: "Il est vray que la Religion Chrétienne permet aux filles & aux femmes de se parer & de s'orner suivant leur qualité & leur condition; mais elle veut que ce soit sans affeterie & sans excés, pour la bien-seance, & non pour le luxe."

6. Furetière 1701, vol. 2 (E-N): "LUXE, f. m. Dépense superfluë; sumptuosité excessive, soit dans les habits, soit dans les meubles, soit dans la table, &tc."

7. DeJean 2005.

8. On the daily life of eighteenth-century Parisian wage earners and servants, see Roche 1987. On the social mobility of Parisian-based financiers, see Ziskin 1999.

9. Roche 1987, pp. 127–29, 145. For elite patronage at the French court during this time, see the seminal exhibitions Paris 1974 and Versailles–Munich–London 2002–3.

10. Pardailhé-Galabrun 1991.

11. Maxine Berg and Elizabeth Eger, "Introduction," and "The Rise and Fall of the Luxury Debates" in Berg and Eger 2003, pp. 5, 7.

12. On the constituents involved in the Parisian marketplace for luxury goods in pre-Revolutionary France, see Sargentson 1996.

13. Mandeville 1714, vol. 1, p. 13, lines I–M.

14. Mandeville 1714, vol. 1, p. 18, line U.

15. Fairchilds 1993.

16. As quoted by Roche 1987, p. 129.

17. As quoted in Maxine Berg and Elizabeth Eger, "The Rise and Fall of the Luxury Debates" in Berg and Eger 2003, p. 11. See also DeJean 2009, p. 15. Jean-François de Saint-Lambert (1716–1803) posed and rebutted all these arguments in his entry for *Luxe* in the *Encyclopédie*, which summarized the moral, religious, social, economic, and political sides of the issue and compared, as well, the historical and contemporary perspectives from local, state, and global levels; see Diderot and Le Rond d'Alembert 1751–65, vol. 9 (Ju-Mam), pp. 763–71.

18. Contemporaries believed that the 1736 persecution of Voltaire was at the behest of Cardinal de Fleury, chief minister of Louis XV. See http://www.voltaire-integral.com/Html/10/23_Mondain.html (accessed May 4, 2009).

19. Translated in Morley 1872, vol. 36, pp. 84–88. For an annotated version in the original French, see l'Association Voltaire Intégral: http://www.voltaire-integral.com/Html/10/23_Mondain.html (accessed May 4, 2009).

20. http://www.voltaire-integral.com/Html/10/23_Mondain.html (accessed May 4, 2009): "J'ai lu, madame, l'ingénieuse *Apologie du luxe*; je regarde ce petit ouvrage comme une excellente leçon de politique, cachée sous un badinage agréable. Je me flatte d'avoir démontré, dans mon *Essai politique sur le commerce*, combien ce goût des beaux-arts et cet emploi des richesses, cette âme d'un grand État qu'on nomme luxe, sont nécessaires pour la circulation de l'espèce et pour le maintien de l'industrie; je vous regarde, madame, comme un des grands exemples de cette vérité. Combien de familles de Paris subsistent uniquement par la protection que vous donnez aux arts?"

21. Excerpt from Jacques Savary, *Le parfait négociant ou Instruction générale pour ce qui regarde le commerce des marchandises de France et de pays étrangers* (Paris, 1675), as quoted and translated in Berg and Eger 2003, p. 9. On the extent and influence of long-distance trade, particularly from the Far East, in the Parisian luxury goods market, see Sargentson 1996, pp. 62–96; and Maxine Berg, "Asian Luxuries and the Making of the European Consumer Revolution," in Berg and Eger 2003, pp. 228–44.

22. This nationalistic view of commerce, which privileged the French, has been critically studied in recent scholarship. For East to West cross-cultural consumption, see, for instance, Scott 2003 and Hellman 2010.

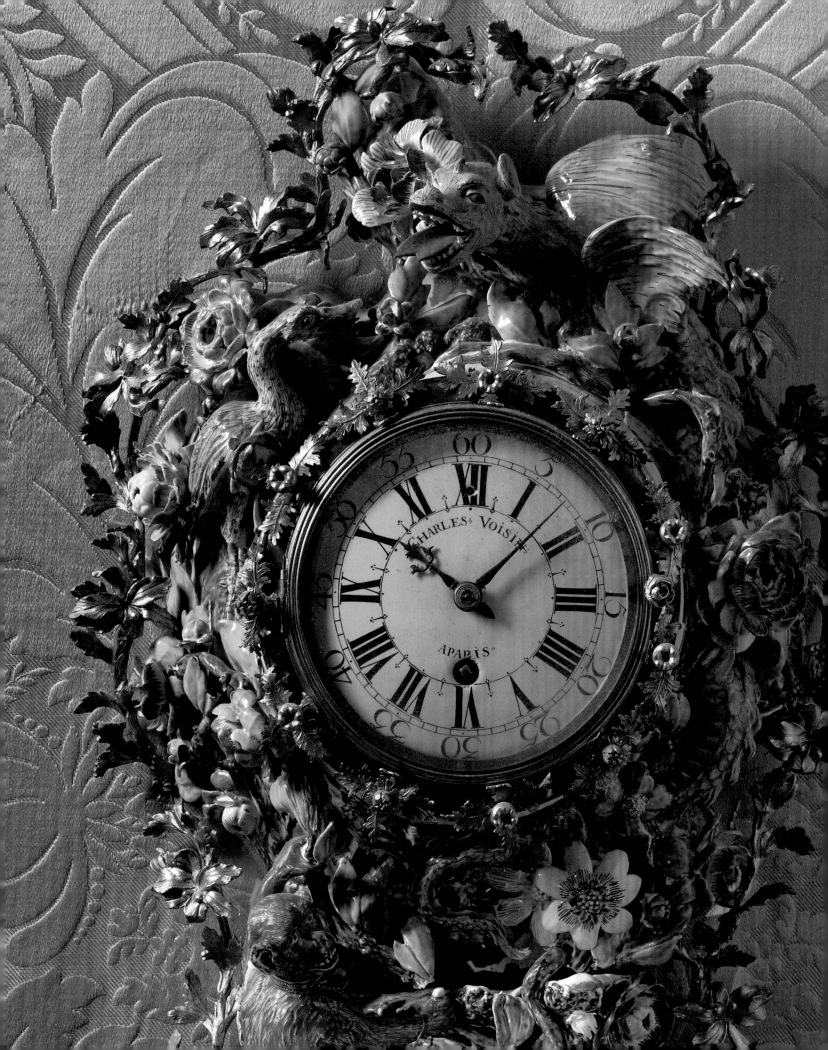

About Time:

The Hours of the Day in Eighteenth-Century Paris

I

Charissa Bremer-David

Daily life is filled with repetitive activities—seemingly mundane motions and actions that are nevertheless weighted with meaning because of their cumulative effect in structuring time and defining experience. Whether they arise from business, busyness, or leisure, these rituals, occupations, and pastimes are significant. Not only do they express the contemporary habits and values of individuals and of society but, on a more profound level, they reveal a collective consciousness of order and discipline. From the minute to the hour, to the day, to the week, to the month, to the season, to the year, any single activity incorporates both immediacy, existing in the moment, and endurance, reflected in its continuing practice. This paradox, in which the insignificance of the quotidian burgeons into a potency of cyclical recurrence, is expressed in artistic traditions by the allegory known as the Hours of the Day or the Times of Day.

A series of oil paintings on copper known as *The Four Times of Day* by Nicolas Lancret (1690–1743) explores this allegorical theme within the context of an elite, fashionable Parisian lifestyle at the end of the 1730s (figs. 4–7). The protagonists engage in sociable activities with an effortless grace that belies an underlying consciousness of time in all its senses: natural, horological, and metaphorical. In *Morning*, a young woman receives the visit of a close acquaintance, an abbé who comes for tea while she prepares for the day at her toilette (fig. 4). A *cartel* clock, fixed to the wall behind the sofa, indicates the time as eight minutes after nine o'clock.[1] Will attendance to fleeting beauty and the responsibilities of polite hospitality take precedence over the ostensibly spiritual purpose of the encounter?[2] *Midday* shows a foursome in a parklike setting (fig. 5). Three of the figures, two women and a gentleman, gaze intently at a sundial carved into the vertical stone wall of a fountain. The shadow of the gnomon points straight to the Roman numeral XII,

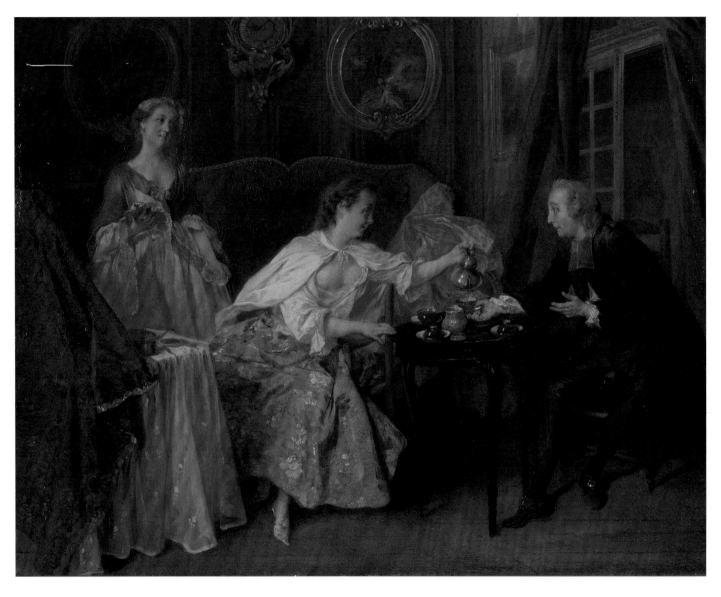

Figure 4
Nicolas Lancret (French,
1690–1743), *The Four Times
of Day: Morning*, 1739.
Oil on copper, 28.6 × 36.5 cm
(11¼ × 14⅜ in.). London,
National Gallery, Bequeathed
by Sir Bernard Eckstein 1948,
5867.

thus allowing the three to reset their irregular pocket watches to local solar time, which was known as "true time" (or *temps vrai*).[3] The fourth companion, a woman wearing a yellow dress, stands stiffly, as if frozen in time while contemplating the beauty of the cut roses in her hand, symbols of the brevity of life. Likewise, *Afternoon* is set outdoors, where a seated couple enjoy a game of trictrac in the cool shade, in the company of two other women (fig. 6). The game requires both skill and luck, as chance rules the roll of the dice and thus favors one player over the other.[4] Do the words of the figure standing at the left, whose lips are parted in speech, interrupt the match to offer advice, announce a visitor, or remind the companions of another obligation? *Evening* presents an unlikely nocturnal scene of

five women, wearing white shifts, who bathe in a pond under the light of a full moon (fig. 7). Resembling the chaste nymphs of Diana, the ancient Roman goddess of the moon and of the hunt, the women seem at ease within the darkness of the wooded glade. But the presence of the moon here has a meaning that is more secular and sacred than mythological. By the 1730s, anyone who could lay hands on a common almanac knew the precise rising and setting times of the moon for each day, down to the hour and the minute, along with the phases of its complete cycle of 29½ days.[5] Dependent on the illumination of moonlight at night, most individuals would have been aware of the night sky, with its celestial bodies, the planets and their satellites, whose movements and eclipses aided navigation, cartography,

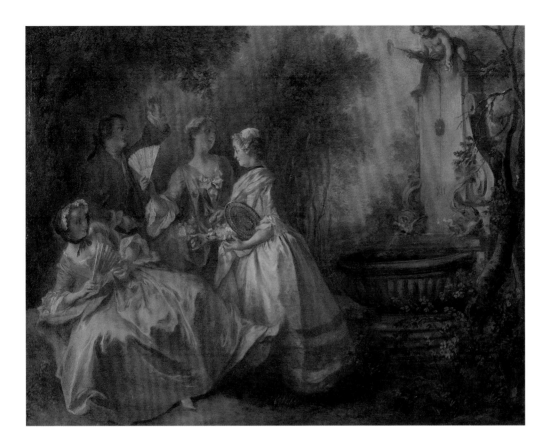

Figure 5
NICOLAS LANCRET (French,
1690–1743), *The Four Times
of Day: Midday*, 1739–41.
Oil on copper, 28.9 × 36.8 cm
(11⅜ × 14½ in.). London,
National Gallery, Bequeathed
by Sir Bernard Eckstein 1948,
5868.

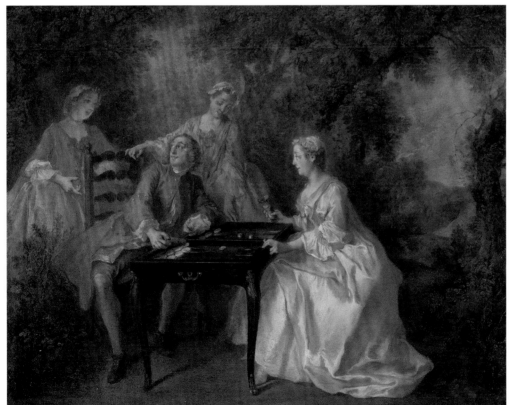

Figure 6
NICOLAS LANCRET (French,
1690–1743), *The Four Times
of Day: Afternoon*, 1739–41.
Oil on copper, 28.6 × 36.8 cm
(11¼ × 14½ in.). London,
National Gallery, Bequeathed
by Sir Bernard Eckstein 1948,
5869.

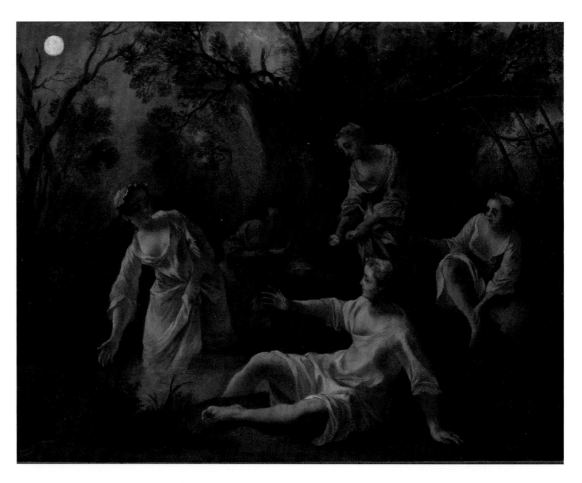

Figure 7
NICOLAS LANCRET (French, 1690–1743), *The Four Times of Day: Evening*, 1739–41. Oil on copper, 28.9 × 36.8 cm (11⅜ × 14½ in.). London, National Gallery, Bequeathed by Sir Bernard Eckstein 1948, 5870.

and astronomical research. The lunar cycle was also important because it played a role in establishing the liturgical calendar, by determining the major moveable religious feast day of Easter and, by calculation from that date, Ash Wednesday, Ascension, and Pentecost.

The scenes of Lancret's *Four Times of Day* exhibit several layers of personal and communal awareness of time that, taken together, reveal the complexity of knowledge and practices of eighteenth-century French society. Various conceptions and understandings of time coexisted along with individual and shared social mentalities about time discipline and punctuality. Seventeenth-century advancements in the fields of astronomy and time-keeping technology informed eighteenth-century urban life, with the result that discoveries about the impact of remote planets and their moons on Earth's natural time had become common knowledge, and mechanical innovations had made more accurate clocks and diminutive watches available to a broader group of consumers. Clocks and watches gradually grew more affordable during the 1700s as production methods improved. While the prevalence

of the devices helped to order civic and domestic life, their presence also raised moralizing concerns about using time well, productively or virtuously, and accounting for one's time. The pace of the minute hand around the clock dial came to symbolize the passage of time—time spent, time lost, time wasted.[6] Pictorial metaphors about time as fleeting, or as eternal, found expression as allegorical subjects in the visual arts, from painted works, such as these, to sculptural ornament on clock cases.

Eighteenth-century Parisians were temporally literate. Civic clocks situated throughout the city provided numerous visual and aural cues for the benefit of all inhabitants and visitors, regardless of rank, wealth, or education. Historically, urban clocks characterized a well-regulated city or town; they signaled not only the hours of the day but also the sessions of legislative bodies and public holidays. Customarily situated high in turrets, above the level of most roof lines, the large clock faces could be seen from many distant vantage points, while the ringing bells could be heard indoors as well as out. In 1370, when King Charles V of France

(1337–1380, reigned from 1364) had the first public clock installed in Paris, it was placed in a corner tower of the royal palace, close by the busy Pont au Change over the Seine River, where it rang the hours "to promote the orderly running of the bureaucracy and the orderly life of the citizens."[7] Charles decreed, furthermore, that the church bells of Paris be synchronized to the royal clock.[8] Hundreds of years later, eighteenth-century guidebooks describe how the descendant of this clock, known as the Horloge du Palais, still called the Paris Parlement into session with its chimes.

Many other communal clocks served the people of Paris within their local neighborhoods, but two may be singled out for the primacy of their locations and their sounding at times of public rejoicing. The first, dating from 1603–8, actually had dual faces. Situated at the western end of the Île de la Cité, on the Pont Neuf, in the water-pumping station and public fountain known as La Samaritaine, the twin clock dials were set into the building's east and west facades. The principal dial, above the fountain on the bridge, was incorpo-

rated into a sculptural relief representing the New Testament story of Christ at the well with the Samaritan woman (John 4:5–15). The second dial was positioned on the opposite side of the building and was visible for a great distance along the river embankment stretching west. A gilded dome at the top of the structure enclosed a set of carillon bells that rang out melodies every hour and every quarter hour (fig. 8). The chimes, which were quite pleasing to hear, sounded even at night and during periods of public rejoicing. Farther to the east, in the Place de Grève, another clock could be seen at the top of the Hôtel de Ville. Besides signaling the hours, it, too, rang continuously during the three-day periods of official public celebration.[9]

Aside from the events regulated by the horological time of communal clocks, everyday life in Paris teemed with routine business activities, the scheduling of which was as much the cause as the consequence of time discipline and civic orderliness. Daylight, if not solar time, continued to play a significant and very practical part in governing some kinds of work,

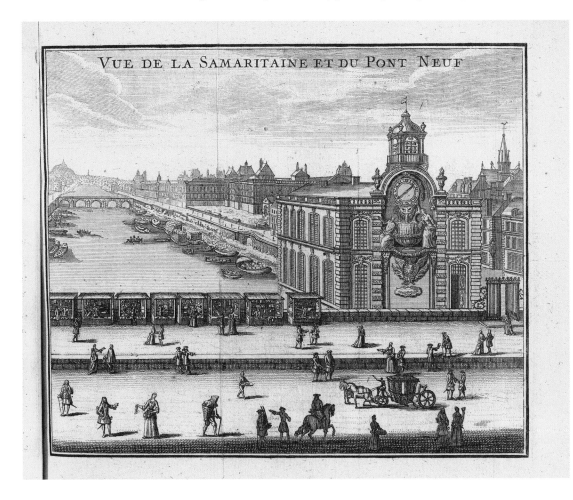

VUE DE LA SAMARITAINE ET DU PONT NEUF

Figure 8
GEORGE-LOUIS LE ROUGE
(French, d. 1790), *Vue de la Samaritaine et du Pont Neuf* from *Les curiositez de Paris, de Versailles, de Marly, de Vincennes, de S. Cloud, et des environs* (Paris, 1723). Engraving, 16.3 × 17.9 cm (6⅜ × 7 in.). Los Angeles, Getty Research Institute, Research Library, 89-B14047.

commerce, and even transportation. For example, members of the goldsmiths' guild and those who melted precious metals, such as watchcase makers, were required to practice their craft in sight of the public and on the street. Guild regulations accordingly stipulated that they work only during daylight hours, which fluctuated seasonally. From April to October, they were permitted to operate from six o'clock in the morning until eight o'clock in the evening but were allowed only shortened hours during the remaining months of the year, from eight in the morning until six in the evening.[10]

The duration of daylight also affected transportation. The departure locations, days, and times of passenger coaches and mail couriers from Paris to points north, east, and south were well established as were the corresponding arrivals. Carriages destined for Dunkirk and Calais, for instance, left every Monday and Friday morning from the Grand Cerf on the rue Saint-Denis at eight o'clock in the morning. Those bound for Brussels and Holland also departed from the same stable yard on Wednesdays and Saturdays at six o'clock in the summer and seven o'clock in the winter. While passenger carriages typically traveled during daylight, mail couriers often rode through the night. The post for La Rochelle left from the rue Contrescarpe every Monday, Wednesday, and Friday at midnight; during peace time, messengers with letters directed to Madrid also departed from there at midnight every Friday (and took fifteen days to arrive at their destination).[11] The orderly adherence to these business hours and transportation schedules depended upon the temporal literacy of eighteenth-century Parisians as well as their sense of time discipline and punctuality.

Nocturnal traffic, whether pedestrian or equestrian, in eighteenth-century Paris was illuminated by a sophisticated system of candlelight, glowing from within glass-sided lanterns that were strategically positioned in public squares, at intersections, at uniform intervals along streets, and within public gardens.[12] For eight months of the year, the city was lit up at twilight "as bright as day, in every street, be it short or long, by the many lights that shine forth from the beautiful and equally numerous lamps."[13] By 1740, there were a total of 6,408 lanterns within the city center and along the streets of the faubourgs, so that business and social activities consequently extended late into the night.[14] Illumination efforts complemented the rhythms of natural lighting, from both sun and moon, in order to conserve resources, limit expenditures, and maximize benefits. The time at which the lanterns were lit and the

duration of their illumination were adjusted according to seasonal and lunar fluctuations. Beginning in 1708, lanterns were in use from the first of September to the end of April, and they were lit at seven o'clock in the evening during the first month, at half past six during the month of October, at six starting on November 15, and at five in December and January, and in reverse order from February to the end April, by which point the lanterns were lit at half past eight in the evening.[15] During winter twilight Parisian pedestrians could discern the hour by the lighting of these lanterns. Those overseeing the system were so pragmatic as to stipulate the quality, weight, and size of the candles—and thereby the rate and length of time they burned—in order to facilitate traditional civic and religious nocturnal events. In December 1719, in consideration of the celebration of Noël, when so many of the faithful would be walking in the dark to attend midnight mass, the commissioner in charge of scheduling provided detailed instructions to the lantern lighters that no nocturnal illumination would be needed on the nights leading up to, during, and just after the full moon (December 22, 23, 25, 26, and 27), but that large, slow-burning candles were to be lit on the night of the Feast of the Nativity (December 24).[16]

Temporality and seasonality were reinforced, moreover, through the medium of print. Almanacs and calendars included such standard information as the times of the rising and setting of the sun and moon, the hour and minute of the start of a new season (marked by an equinox or solstice), and even the timing of solar and lunar eclipses (fig. 9). The concepts of temporal continuity, chronology, and history were imbedded in these publications as well, in sections devoted to correspondences between biblical origins and classical antiquity (which contained calculations on the age of the Earth), the unbroken succession of French kings from the year A.D. 420, and notices of the birthdays of contemporary European princes. In effect, these materials codified the past, present, and future.[17] Editions of almanacs and calendars intended specifically for Parisians called out a variety of other important dates in urban life, from legal matters (court sessions and vacations) to financial deadlines (due dates of taxes and *rentes*) to leisure activities (local fairs and theater seasons) to spiritual observances (religious holy days, saints' days, and periods of fasting or abstinence). Printed in anticipation of each New Year, these aids were widely available in a variety of sizes and formats that catered to every need,

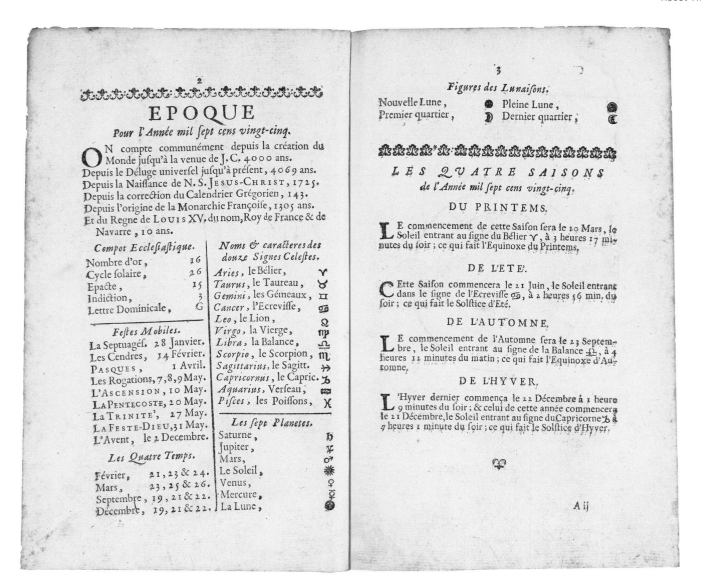

Figure 9
LAURENT D'HOURY (French, 1683–1725), *Époque Pour l'Année mil Sept cens vingt-cinq* and *Les Quatre Saisons* from *Almanach Royal pour l'Année MDCCXXV* (Paris, 1725). Bound volume, 19.8 × 24 cm (7⅝ × 9⅜ in.). Los Angeles, Getty Research Institute, Research Library, 2709-539.

preference, and budget, from single broadsheet to softbound, pocket-size volume to luxurious, leather-bound folio. Editors even devised calendars with a system of symbols and simple notations that could be comprehended by the nonliterate.[18] At the other end of the spectrum, artists and artisans created expensive and precious examples that were highly decorative, conversation pieces, such as the freestanding enameled plaque described in the 1762 *L'Avantcoureur* as an almanac "that could make a rich appearance on a chimney mantel, to the side of porcelain and bronzes. It is an enameled almanac in banner format, supported and framed by gilt-brass flowers. The twelve signs of the zodiac are dispersed among the flowers of the border; the whole ensemble makes a very pleasing impression."[19]

Human interaction, customs, traditions, and habits also served to set and re-affirm collective concepts of time and time discipline within quotidian life. The most vivid summary of a typical day in this bustling city was published in 1782 by the essayist, caustic social commentator, and keen observer of his fellow Parisians, Louis-Sébastien Mercier (1740–1814). Encompassing a period of twenty-four hours, Mercier's chapter "Les Heurs du Jour" (The Hours of the Day) in his book *Tableau de Paris* recounts the sights, sounds, smells, and experiences of a wide range of the population, from magistrate to vegetable seller.[20] The city apparently slept little.

Buried within Mercier's sequence are several salient clues about eighteenth-century clock time in Paris. By this date, it was commonly understood

The Hours of the Day

The different hours of the day offer by turns the image of perpetual motion and stagnating tranquility, the scene shifts from one to the other in a constant succession, and nearly within the same space of time.

VII AT SEVEN O'CLOCK *all the gardeners, who have been to market, return to their marshes, bestriding their hacks, or asses, with empty baskets. One is not troubled then by the rattling of coaches, nor meet with anybody in the streets but clerks going to their respective offices, with their heads dressed and profusely powdered, at this unfashionable time of the day.*

IX AT NINE, *the streets are crowded with a swarm of barbers and hair-dressers, holding in one hand their curling-irons, in the other a ready dressed periwig, their cloaths [sic] bepowdered from top to bottom; this is the livery of their profession, on which account they are by the populace nicknamed* Merlans *(Whitings). At the same time the coffee-house waiters carry breakfasts to the inhabitants of ready furnished apartments, whilst our unexperienced* centaurs *[horsemen], followed by their footmen, gallop away towards the* Boulevards, *to the great terror of the harmless passenger, who is often the victim of their bad horsemanship.*

X AS THE CLOCK STRIKES TEN, *a sable cloud of lawyers, and other limbs of the law, in two dread-inspiring divisions march on towards the* Palais *and the* Châtelet, *the judges to sleep, the pleaders to waste their lungs, and the clients to lose the best or win the worst cause, according to the humor in which the judge awakes from his slumber. Nothing to be met with, but men dressed in bands and black gowns, laden with bags full of briefs, rejoinders, &c. plaintiffs and defendants in full cry after them.*

XII AT TWELVE, *money and change brokers hasten in crowds to the* Bourse, *or Exchange, whilst idlers lounge away towards the* Palais Royal, *to see, but much more to be seen. The* Faubourg *and street of* St. Honoré, *where dwell the Financiers and other men in place are, at this hour, filled with humble suitors, who come to solicit for pensions or places.*

Those who make their heads and wits pay for the relief of their hungry stomachs, prepare themselves to resort under some of those hospitable roofs, where genius in distress is always sure to find a good table; you may see them set off for so commendable an expedition in the best dress they could hire or purchase, walking on tiptoe for fear of splashing their white stockings, and treading as light as possible from one end of Paris to the other; avoiding, with the greatest care, though not always with the desired success, the unmerciful approach of carriages, especially the hackney ones; as this is one of the most busy hours of the day for those uncomfortable vehicles; such is indeed the great demand for them, that the first caller gets in at one door, and a second, scaling on the other side, sits himself down by the former, and then a formal appeal lies before the Commissaire, *who determines the priority of right between the contending parties.*

An hour after the streets are cleared. It is dinner time—A perfect calm succeeds to the rattling storm of coaches, vinaigrettes, cabrioles, *but this tranquility is soon disturbed again.*

V **At a quarter past five**, *Hell is in a manner broke loose. Woe to him who is obliged to walk the streets at that time, as they are blocked up by carriages crossing each other, and racing towards the play-houses and public walks.*

Peace and quiet return again; and at seven in the evening all is silent, as if the whole city and its inhabitants were laid under the powerful spell of some enchanter. It is the most dangerous part of the evening in autumn, because the Guet, or watch, is not yet set, and many outrages are committed about that time.

IX **At nine o'clock** *the charm is destroyed, and the noise of carriages stuns once more your ears, threatens the lives of the foot passengers: it proclaims the return of the idle opulence from a tragedy, which they did not feel; or a comedy, which they* would not *understand, because it held up too faithful a mirror to their vices and folly.*

XI **At eleven o'clock** *suppers are nearly ended, the coffee-house politicians, indigent scribblers, starving garreteers, shut out from their places of resort, are now on their way to their ready furnished apartments, if such a name can be given to a small room, or rather hole on the fifth or sixth story, where all the movables* [corresponding to the French word *mobilier*, meaning movable furniture] *consist in a couple of broken chairs, a most wretched bed, and worse bedding. The forlorn daughters of prostitution give up their chace* [sic]*, or stand close to the walls and in dark corners, lest they should be taken up by the Guet, or watch, who now beat their rounds; for the supreme legislator of the Canaille,*

the formidable Lieutenant de Police *has said, "Till eleven at night thou mayest revel in all manner of excess, insult the passengers, shew thyself the disgrace of thy sex and humanity, but after that hour, thou shalt only be permitted to sin in private;" and in these matters that magistrate is the law and prophets....*

XII **Between twelve and one**, *the snoring tradesman is roused by the rattling noise of the coaches. Such is the contempt of the great for everything that might in any respect bring them to the standard of other men, that what is night for these, is by the former turned into day, for none but the plebeian can be mean enough to set with the sun and rise with that brilliant luminary, whose first chearing [sic] rays never were meant to irradiate any other being than the brutes, or what is still less in the eyes of the great, the laboring part of mankind.*

Long before the break of day, ten thousand countrymen and women arrive at the gates of Paris, with the provisions of fruit, pulse, and flowers, and after having undergone a thorough search from the officers, are permitted to enter the city, and carry their useful loads to the Halles, a place which is the mart for all the markets in Paris....

VI **At six in the morning**, *and until seven in the depth of winter; but by three hours earlier in the fine season, the laborers and artificers quit their hard pillows, and return to their toils and fatigues—alas!*[21]

that the regularity of these mechanical devices was abstracted from the rhythms observed in the natural world. Horological time measured the length of one full day uniformly, regardless of the seasonal duration of sunlight. Although time measurement in Europe was not yet consistent, the French adhered to a diurnal pattern that divided a day of twenty-four equal units into two rounds of twelve hours each, the first twelve stretched from midnight to noon (known as the morning hours), and the second round of twelve hours from noon to midnight (known as the evening hours). Mercier's sequence of clock hours reflects this imbedded practice.

As noted above, the environment of Paris contained numerous public clocks that fostered a shared sense of time and helped to structure communal life. Their presence, furthermore, implied a well-governed and orderly city. Within the domestic sphere, clocks likewise represented a well-run and orderly household, just as watches evinced a disciplined and regulated private life. This growing market for personal timepieces was fueled by parallel advancements in production and technology. The production of, and trade in, clocks and watches developed over the course of the late-seventeenth and early-eighteenth centuries. Makers specialized, as reflected in three principle divisions: *horlogers grossiers,* who made the great clocks of public buildings, *horlogers en moyen volume,* who made pendulum clocks, and *horlogers* or *ouvriers en petit,* who made watches. The labor of assembly was broken down into a process that could involve as many as thirteen distinct artisans, collaborators, and subcontractors, but usually only the name of the expert craftsman responsible for the mechanism appeared on the enameled dial of the clock face or was engraved into the movement.

The most skilled practitioners considered their efforts to be as much intellectual as manual. The son of clockmaker Jacques Gudin (1706–1743) defined the profession as belonging "at one and the same time, to the sciences by the knowledge it demands, and to the arts by the knowledge it employs,"[22] and the famous fabricator of marine chronometers and contributor of several articles on clocks and timekeeping to the *Encyclopédie,* Ferdinand Berthoud (1727–1807; clockmaker-mechanician to the king and to the Ministry of the Marine[23] from 1764), called the truly innovative clockmaker an *architecte-mécanicien,* meaning one who was both a theorist and a capable mechanician.[24]

In France, during this period, horological innovations came from three areas of expertise: from men

of science, working within the Académie Royale des Sciences and the Observatoire de Paris; from members of the Parisian guild of master clockmakers; and from independent amateurs, who assembled and used their own personal collections of scientific instruments and machine tools. Despite fierce rivalries and the rigid boundaries that separated their respective academic and corporate memberships, a variety of individuals devised technological advancements that spurred the field and, in turn, benefitted the public as the improvements were incorporated into standard production. Abstract ideas took physical form through collaborations of mind and skill. A notable example of such a partnership was the one that existed between Christiaan Huygens (1629–1695; one of the six founding members of the Académie Royale des Sciences and inventor of the clock pendulum and spring balance) and the master clockmaker Isaac II Thuret (1630–1706; clockmaker ordinary to the king and to the Académie Royale des Sciences[25] before 1672). Thuret executed, according to Huygens's designs, exceptionally accurate clocks, in the 1660s, and watches, in the 1670s, whose time-keeping precision varied only seconds per day for the former and within minutes per day for the latter.[26]

So-called amateur mechanicians, working on the periphery of these official institutions and societies, made significant contributions as well. Among these was the attorney and notary Alexandre Fortier (1700–1770), a very well-informed student of astronomy and inventor who was highly regarded among the circle of educated elites that included the provincial treasurer and renowned physicist Joseph Bonnier de la Mosson (1702–1744). Having published a treatise on the diurnal movement of the Earth in the Copernican solar system (1745), Fortier designed an elaborate and complex instrument, the *pendule à planisphère* (planisphere clock), which charted and timed the motions of celestial bodies (fig. 10). The case and dials of the instrument survive, although the movement, unfortunately, does not. Its central dial represents the sphere of the Earth as a plane in the form of a circular disk inscribed with the names of oceans, countries, and cities (with prominence given to the Paris meridian) in an order corresponding to their longitudinal positions around the globe. The hands on the face of this and surrounding dials indicate both horological time and solar time at the designated degree of longitude. Chapter rings surrounding the disk show the days of the lunar cycle; the signs of the zodiac and their related constellations; months of the year; and the diurnal hours of a full day

Figure 10
Case: attributed to JEAN-PIERRE LATZ (French, ca. 1691–1754); movement: ALEXANDRE FORTIER (French, ca. 1700–1770), *Planisphere Clock,* ca. 1745–49. Oak veneered with kingwood; silvered brass; gilt-bronze mounts; glass; gilt paper, 281.9 × 94 × 38.1 cm (111 × 37 × 15 in.). Los Angeles, J. Paul Getty Museum, 74.DB.2.

than just an admirably complex instrument, since its mechanisms could indicate time in cities across Europe as well as tidal flows in northern French ports and, thereby, help to estimate the arrival of messengers serving him in his capacity as director of the king's secret diplomacy.[27]

As the eighteenth century progressed, timepieces appeared increasingly among the possessions of a wider spectrum of the population. Once the quality of the mechanisms achieved a standard of reliability and accuracy, consumers appreciated them both as useful objects of interior decoration and as personal accessories to elegant attire.[28] A survey of Parisian after-death inventories tracks this development. From the 1750s, 40 percent of the household inventories listed different sorts of clocks ranging in value from twenty-five to more than two hundred livres.[29] Often, there were several clocks and watches within a single household. They were available from multiple sources throughout the city. Although master clockmakers did sell the products of their own workshops, they could and did also act as retailers for others. But the makers did not hold a monopoly on sales. Dealers in luxury goods (*marchands-merciers*), upholsterers, mirror makers, and other agents traditionally involved in household furnishing controlled the major share of the market.[30]

The variety of clock cases responded to the ever-changing fashions of architectural and interior décor. They were typically placed in visually and spatially prominent positions within symmetrically furnished rooms, where their axial position structured space and attracted attention.[31] Clocks with short pendulums (*pendules*) were designed to rest freestanding on horizontal surfaces, such as mantelpieces or table tops, or to hang vertically, suspended against the wall (*cartels d'applique*) or anchored to a wall bracket. They were also inserted into furniture, particularly cabinets and filing cupboards (*cartonniers*). Clocks with longer pendulums (*régulateurs*) became pieces of furniture in their own right.

The ticking of clocks and the chiming of their bells sounded the very heartbeat of eighteenth-century Paris as timepieces were dispersed throughout the city, situated within private households, and worn on the body. Their ubiquity strongly implies that communities, families, and individuals found them useful for ascertaining the hour and helpful in regulating time spent. Beyond punctuality, there was the need to account well for one's time, since bourgeois society, even the wealthy *grande bourgeoisie*, still adhered to ancient

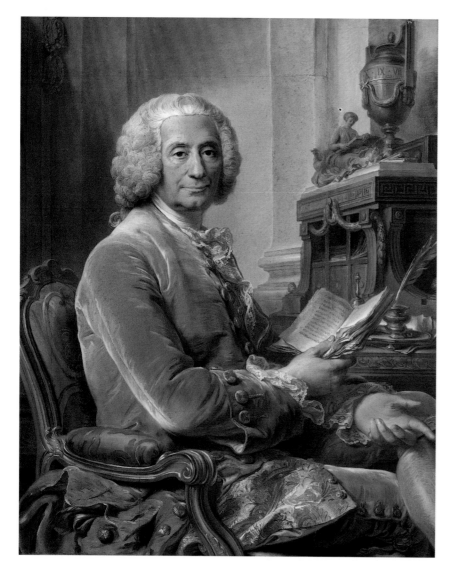

Figure 11
JEAN VALADE (French, 1710–1787), *Portrait of Monsieur Faventines*, 1768. Pastel on paper, 107 × 88 cm (42⅛ × 34⅝ in.). Private Collection.

indicated by two sequences of Roman numerals from I to XII, with quarter-hour divisions, and six-minute increments counted in Arabic numerals. Subsidiary dials track the phases of the moon; the regular eclipses of Io, the first satellite of the planet Jupiter (which served to calculate longitude on Earth); the tides in ports of northern France; and the days of the week. The instrument is surmounted by an orrery, a three-dimensional model of the solar system.

The original owner, Louis-François de Bourbon, prince de Conti (1717–1776), a notable collector of extraordinary clocks and instruments, attracted many talented clockmakers to his residence at the Palais du Temple, which happened to be a privileged enclave in Paris exempt from guild jurisdiction. But, perhaps, this sophisticated *pendule à planisphère* was, for him, more

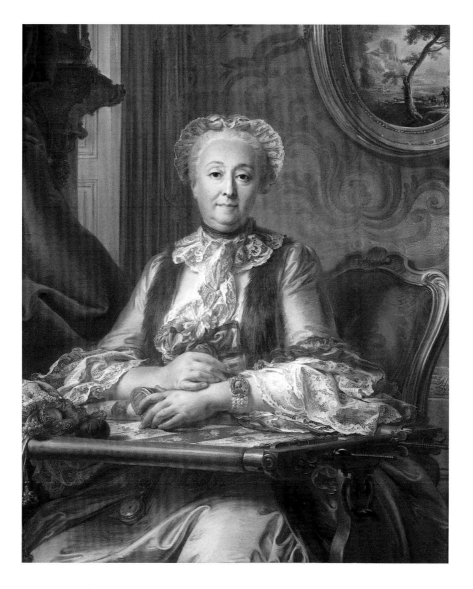

admonitions against wasting time and to moralizing precepts concerning the productive use of time. As the 1768 portraits by Jean Valade (1710–1787) of Monsieur and Madame Faventines illustrate, the rich tax farmer (*fermier général*) and minor hereditary noble (from the ranks of *noblesse de robe*) and his wife desired to see themselves, and to be seen by others, as conscientious and industrious in their daily occupations (figs. 11 and 12).[32] Pierre Faventines (1695–1776) is shown seated at his paper-strewn desk, reading a bound copy of the *Contes Moraux* (*Moral Tales*) by Jean-François Marmontel (1723–1799).[33] His clock, ingeniously disguised as an antique-style urn sitting atop the file cabinet, indicates the hour, with the point of a gilt star, as ten o'clock. At its base there is small sculptural group, made seemingly of gilt bronze, which presents a seated

female figure reading under the vigilance of a rooster, whose cry at dawn was nature's first alarm. For her part, Madame Faventines is portrayed industriously working at her needlework frame at the precise hour of noon, according to the watch pinned by a chatelaine to her robe and just visible within the shadow of her lap. For the *very* highest ranks of society, however, costly and luxurious clocks and watches alluded to a leisured status, as represented in both Lancret's *Four Times of Day* and Mercier's *Hours of the Day*, wherein time was noted but not constrained by bourgeois conventions concerning the demands of quotidian business nor by expectations of productivity.

For Mercier, the prevalence of clocks represented a sobering reminder of misspent time and mortality: "People put a pendulum clock on every mantelpiece;

Figure 12
JEAN VALADE (French, 1710–1787), *Portrait of Madame Faventines*, 1768. Pastel on paper, 107 × 88 cm (42⅛ × 34⅝ in.). Private Collection.

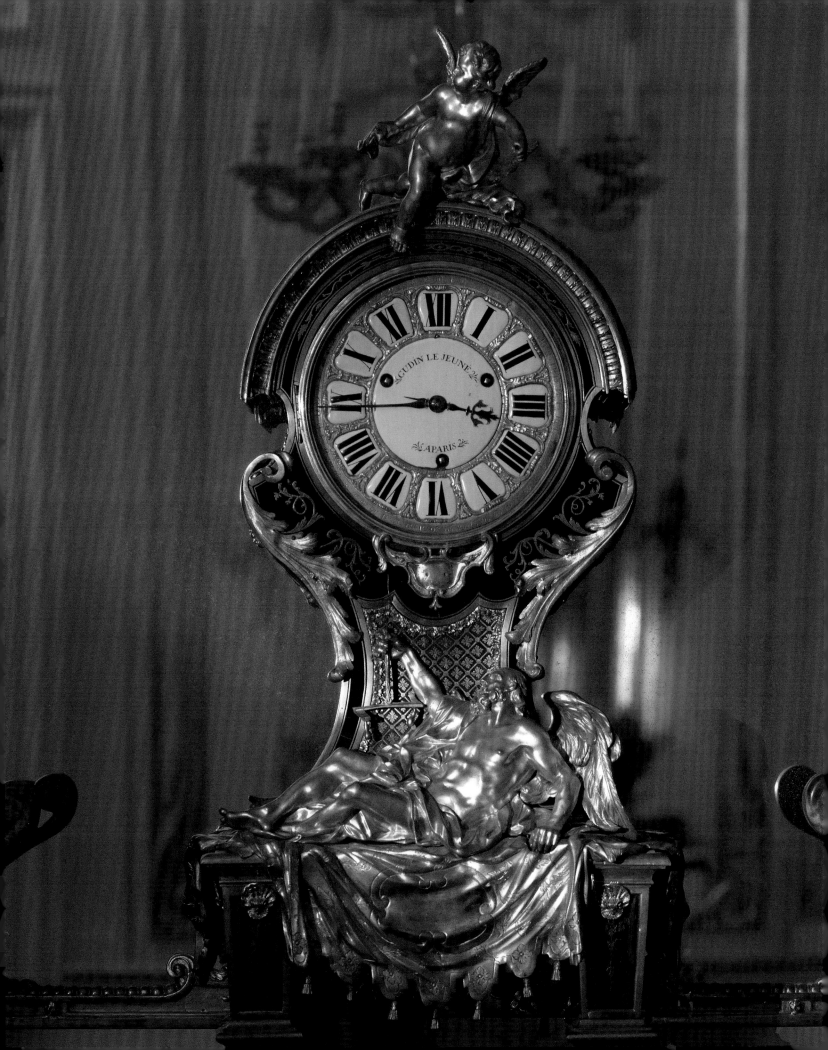

they are wrong; what a lugubrious fashion. There is nothing so sad as to contemplate a pendulum: you see your life slipping away, so to speak, and the movement warns you of all the moments that are being taken away and which will never return."[34] The concept of time as being simultaneously finite and fleeting yet ever-repeating and eternal was deeply imbedded in European thought. This duality ultimately derived from a conflation of two ancient Greek words, *kairos*, meaning opportunity, and *aion* (or aeon), meaning forever or eternity. The Greeks personified *kairos* as a winged young man with a set of balance scales, while *aion* was connected with a winged figure enveloped by a coiling snake or with Phanes, the winged youth encircled by a snake, symbolic of the seasons, and accompanied by signs of the zodiac.[35] The snake was considered an appropriate representative of time because a serpent's body "is long, swift in movement and silent in its progress."[36] When rendered in a coil, with its mouth biting the tail, like a circle without beginning or end, the serpent symbolized eternity. The concept of time as a deadly, destructive force originated with the linguistic association between the Greek word for time, *chronos,* and the Greek name for the oldest and most formidable deity Kronos (in Latin Saturnus, Roman god of agriculture), who overthrew his father and devoured his own children (see Exhibition Object no. 71). His attribute was the sickle. The long distillation of these meanings, associations, and symbols created the early modern figure of Father Time, an aged, winged, and bearded male customarily identified by one or more related attributes: a sickle or scythe, a serpent biting its tail, and a sandglass.[37] Although the allegory of time carried negative connotations of decay and death, as Mercier bitterly observed, time's eternal force could withstand and endure. Time defeated vice to vindicate virtue, justify innocence, or reveal truth.[38]

It should come as no surprise that such moralizing themes were deemed particularly suitable for the ornamentation of clock cases. The most sculptural examples frequently include a miniature figure of Father Time with outstretched arms gesturing toward the dial and its ever-moving hands, prompting the viewer to be conscious of the passage of time. Happily, though, Father Time was more often trumped by Cupid in the form a winged child, Eros, who carries the dangerous scythe out of reach, literally expressing the adage "Love conquers Time" (*Amor vincit Tempus*).[39] This theme was given form in the metal mounts on a popular model of pendulum clock designed by

André-Charles Boulle (1642–1732) and produced in his Parisian workshop from around 1690 to about 1726 (fig. 13).[40] The painter Jean-François de Troy (1769–1752) incorporated variants of this clock, and perpetuated its currency into the 1730s, in at least four of his works: *Gabriel Bernard de Rieux,* a portrait of about 1720–25, *The Detached Garter* of 1724, *Reading in a Salon* of about 1728–30 (see fig. 23), and *A Lady Fastening a Ribbon on a Sword* of 1734.[41] The sculptor François Girardon (1628–1715) created the model of Father Time for Boulle, from which the *ébéniste* (cabinetmaker) cast the mount that he positioned on the plinth below the clock dial.[42] The recumbent figure looks aloft to the flying form of Cupid, fixed to the summit of the clock case, whose outstretched left hand originally grasped a long-staffed scythe (now lost) which he has stolen from his allegorical elder. A surviving drawing by Boulle shows this missing implement.[43]

But a clue to the clock's subliminal message is the curious instrument that Father Time holds up in his right hand. Almost always identified as a pair of balance scales, the device is actually a foliot escapement, a regulating component that controlled the speed of some clock mechanisms.[44] The innovation of the verge and foliot escapement dates back to the fourteenth century and its use continued into the nineteenth century. The device comprised a suspended horizontal bar, sometimes extended by two short arms, which were fitted with a pair of pear-shaped weights. The heaviness and position of the weights affected the oscillations of the bar, which regulated the speed of the gears and the precision of the time-keeping mechanism. The clever creation of a new attribute—a foliot escapement—for Father Time can be credited to the Italian artist Giovanni Antonio Sacchiense, called Pordenone (1484–1539), who portrayed this technological advancement in his fresco of about 1533 on the facade of the Palazzo d'Anna in Venice. That fresco is now obliterated but the detail of Father Time is known from an extant drawing by Pordenone and from a derivative woodcut print attributed to Giuseppe Nicola Rossigliani, called Vicentino (active 1510–1550), which was probably the intermediary visual source for Girardon and Boulle. Eros appears in these versions, standing rather than flying because he is without wings. Significantly, the child does not disarm Father Time but rather interferes with the suspension cord of the foliot, thereby disrupting the continuity of Time. Boulle's inclusion of the device in the decoration of his clock cases was self-referential, for the movements supplied by his circle

of clockmakers actually incorporated a later variant called the crown verge escapement.

The ancient Greeks and Romans perceived time in terms of the eternally recurring cycles of nature and man: the Four Seasons, the Four Times of Day, and the Four Ages of Man.[45] Groupings of the Four Winds, the Four Continents, the Four Elements, and the Four Humors, or Temperaments, were thought to reveal the notion of universal order in the heavens, in the physical world, and in human nature. The movements of the stars, planets, and moon influenced not only the annual cycle of seasons on Earth but also, through astrology, the life cycle of men. Nature and human activity were coefficient measures of time. The Greeks, moreover, conceptualized the day into four segments, dividing the span of sunlight into periods denoted by a reference to the position of the sun, such as "early afternoon," or to an associated activity or meal.[46] From the second century A.D., Roman authorities publicly called out these quarterly intervals at three hours after day break, at noon, and at three hours after midday. These concepts

persisted for centuries and were given renewed literary and visual expression through the rich repertoires of later Renaissance and Baroque emblemata.

The enormously influential *Iconologia* by Cesare Ripa (fl. ca. 1600) surveyed, defined, and codified these ancient themes of time and seasonality and related them to the divine gods and mortals from classical mythology; the Seasons and the Times of Day were complemented by the Twelve Months of the Year as well as the Twelve Hours of Day (sunrise to sunset) and the Twelve Hours of Night (evening twilight to morning twilight).[47] The resonance of Ripa's publication is evidenced by its numerous reprintings and translations over nearly three hundred years. In the 1644 French edition, the Four Times of Day were personified by Aurora, Venus, Diana, and Proserpine, deities whose mythological histories or powers linked them to the natural phenomena of light and darkness corresponding to morning, midday, evening, and night, respectively.[48] Artists particularly took inspiration from these themes, drawing upon Ripa's well-known canon of iconography,

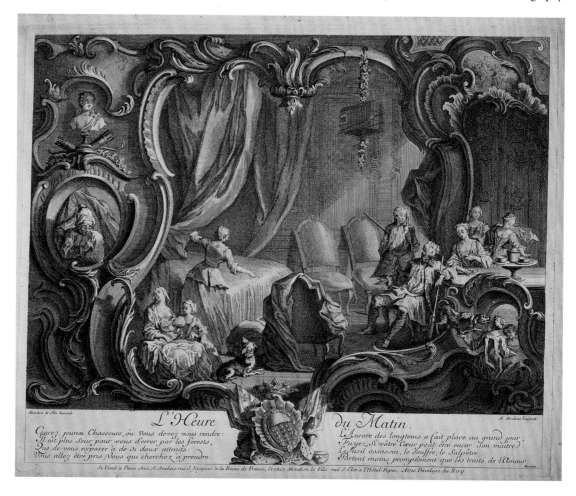

Figure 14
JEAN MONDON *le fils*, designer (French, fl. 1736–45) and Antoine Aveline, engraver (French, 1691–1743), *L'Heure du Matin*, ca. 1738. Engraving, 35.5 × 43 cm (14 × 17 in.). New York, Columbia University, Avery Architectural and Fine Arts Library, AK 1355 M74 FF.

using them to instill symbolism and structure within their allegories of time and portrayals of nature.

By the mid-eighteenth century, the prevalence of these cycles of time and nature occurring *eternally* in artistic programs had tried the patience of at least one Parisian critic, Étienne La Font de Saint-Yenne (1688–1771), who encountered them in abundance within interior decorative schemes, where their perfunctory appearance rendered them commonplace and unimaginative. "In this way, restricted by lack of space to paltry little subjects which are in any case far above eye level [as over doors and over mantels], painting is reduced in these large rooms to cold, insipid, totally uninteresting representations: the Four Elements, the Seasons, the Senses, the Arts, the Muses and other commonplaces which are the triumph of the plagiarist journeyman painter, requiring neither genius nor imagination, pitifully worked and re-worked for more than twenty years in a hundred thousand ways."[49]

The Four Times of Day, however, were not so ubiquitous in mid-eighteenth-century Paris and the cycle was omitted from La Font's list. Indeed, until the four separate cycles painted as harbors and river scenes in the 1750s and 1760s by Claude-Joseph Vernet (1714–1789), the subject had a slower development than the others and was more frequently expressed in print form.[50] A set of prints, for instance, designed around 1738 by Jean Mondon le fils (fl. 1736–1745) and engraved by Antoine Aveline (1691–1743) and François-Antoine Aveline (1718/27?–1780?) shows the transition of the genre away from traditional allegorical emblems, since it owes more to the influence of *gravures de mode* (prints devoted to popular fashions and models of deportment; figs. 14–17). Mondon's set portrays members of an elite urban household, along with their servants, pursuing activities appropriate to the Four Times of Day: *L'Heure du Matin* (*Morning*), receiving visitors; *L'Heure du Midi* (*Midday*), dining; *Le Tems de L'Aprés-dinée* (*After Dinner*), promenading and reading; and *Le Tems de La Soirée* (*Evening*), dancing.[51] Poetic captions below alluded to the gallantry of the protagonists on each occasion. Fittingly, Mondon

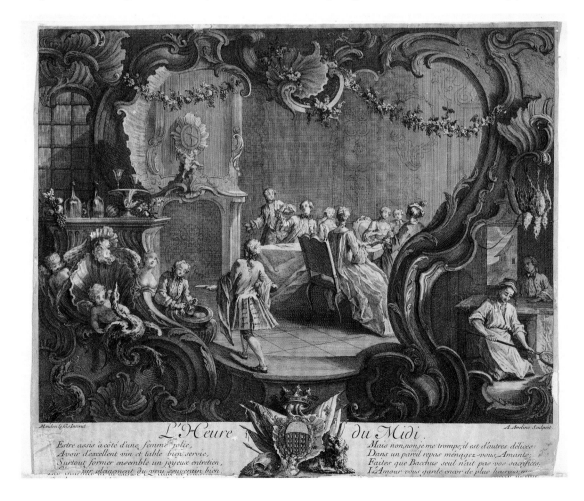

Figure 15
Jean Mondon *le fils*, designer (French, fl. 1736–45) and Antoine Aveline, engraver (French 1691–1743), *L'Heure du Midi*, ca. 1738. Engraving, 35.5 × 43 cm (14 × 17 in.). New York, Columbia University, Avery Architectural and Fine Arts Library, AK 1355 M74 FF.

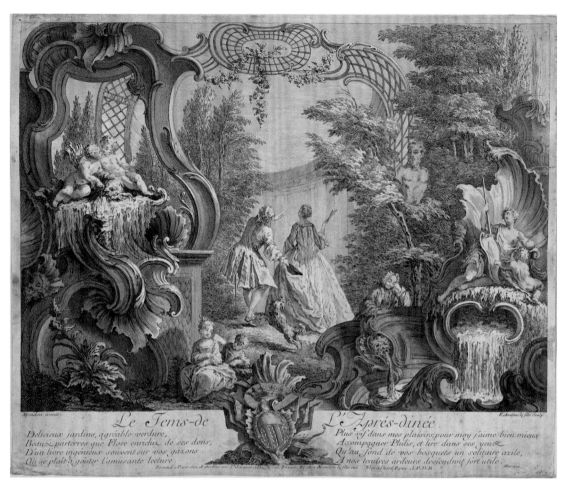

Le Tems-de L'Aprés-dinée.

Delicieux jardins, agréable verdure, Plus vif dans mes plaisirs, pour moy j'aime bien mieux
Beaux parterres que Flore enrichit de ses dons, Accompagner Philis, et lire dans ses yeux
D'un livre ingenieux souvent sur vos gazons Qu'au fond de vos bosquets un solitaire azile,
On se plaît à goûter l'amusante lecture. A nos tendres ardeurs deviendroit fort utile.

Figure 16

JEAN MONDON *le fils*, designer
(French, fl. 1736–45) and
FRANÇOIS-ANTOINE AVELINE,
engraver (French, 1718/27?–
1780?), *Le Tems-de
L'Aprés-dinée*, ca. 1738.
Engraving, 35.5 × 43 cm (14 ×
17 in.). New York, Columbia
University, Avery Architectural
and Fine Arts Library,
AK 1355 M74 FF.

subtly suggested natural or ambient lighting: *Matin* shows a streak of sunlight, presumably coming through a window hidden behind the curtain; flames from the kitchen hearth reveal a kneeling cook in the margin of *Midi*; the foreshortened shadows of the leaping dog and the gentleman fall along the garden path in *Aprés-dinée*; and brightly lit candles illuminate the salon in *La Soi-rée*. *Midi* is the only scene to feature a clock, which is incorporated into the mantel of the chimney piece. Its face is marked at the top with the Roman numeral XII and the time is indicated as half past twelve.

Returning to the series of *The Four Times of Day* by Nicolas Lancret, we see that the artist rejected the tired traditional personifications and mythological allegories and chose instead to render the individual subjects of his cycle as contemporary genre scenes of fashionable, elite life. In the spirit of *Seria ludo* (serious matters in a playful vein), the compositions were visually intended to first delight the eye and the senses of viewer before engaging his intellect and his conscious-ness on the nature of time and time measurement.

In the case of *Morning*, the only interior scene of the four, Lancret certainly succeeded in his first goal—one observer at the 1739 Salon in the Palais du Louvre, where the painting was displayed, was taken with the coquetry of the beautiful young woman whose bodice was in revealing disarray, "This young person, with her bodice nonchalantly open and her dressing gown thrown back…pours tea in a cup that M. l'Abbé holds out to her with a distracted air; because he is attentive only to this beauty's disarray. A maid takes it all in, smiling slyly."[52] The remaining three paintings were not displayed then, nor at subsequent Salons, so the com-mentator did not have the chance to perceive Lancret's entire program with all its multilayered meanings.

As neither the circumstances surrounding the creation of this cycle nor its eighteenth-century history are known, one must turn to the derivative engravings, printed in mirror-image to the originals, for insight into the reception of the paintings and their subjects. Nicolas de Larmessin III (1684–1755) engraved the four scenes and presented them at the 1741 Salon, where

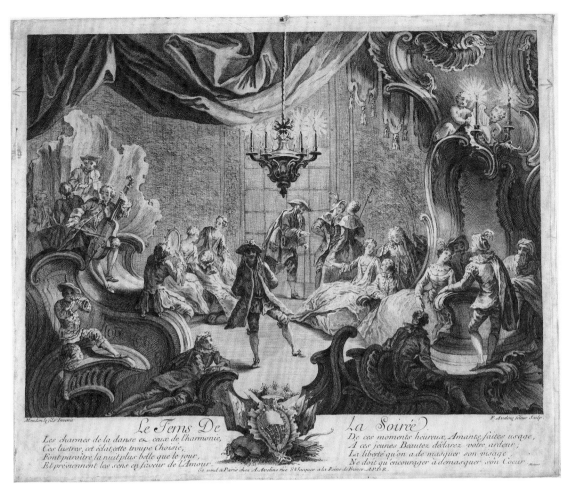

Le Tems De La Soirée

Les charmes de la danse et ceux de l'harmonie,
Ces lustres, cet éclat, cette troupe Choisie,
Font paroitre la nuit plus belle que le jour,
Et préviennent les sens en faveur de l'Amour.

De ces moments heureux, Amants, faites usage,
A ces jeunes Beautez déclarez votre ardeur;
La liberté qu'on a de masquer son visage
Ne doit qu'encourager à demasquer son Coeur.

they bore the titles *Les Quatre Heures du Jour: Le Matin* (*Morning*), *Le Midi* (*Midday*), *L'Après-Dinée* (*After Dinner*), and *La Soirée* (*Evening*).[53] Each was accompanied by a poetic caption (by an anonymous author), that lightheartedly pondered the questions of gallantry, love, and beauty. The verse composed for *Le Midi* goes one step more and appropriately incorporates an element of time: "This moment [noon] makes the measure and law of the day, The hours on this point will regulate themselves: Love sees this, indicates it, and seems to say to the Beauties, All your hours belong to me."[54]

While the captions to the engravings offer one way to interpret Nicolas Lancret's *Four Times of Day*, the cycle of paintings itself offers a visual multivalence of both time-keeping devices and pictorial motifs in eighteenth-century art. Certainly, the scenes are pleasing aesthetically in terms of execution, with their luminous colors glistening on top of copper sheets, and they are entertaining in terms of subject, presenting captivating and charming portrayals of polite society, but it is their exploration of temporal

life that gives them substance. Lancret's concern with time—in its natural, horological, metaphorical, and social senses—sprang from a perceptive awareness of ancient yet still prevailing traditions, more recent seventeenth- and eighteenth-century advancements in technology, contemporary sociability, and everyday practices. His visualization of a day adroitly combined elements of taste and fashion, etiquette and comportment, classical erudition and scientific enquiry, in order to refresh the allegory and to contextualize it within the world of elite, mid-eighteenth-century Paris.

Figure 17
Jean Mondon *le fils*, designer (French, fl. 1736–45) and François-Antoine Aveline, engraver (French 1718/27?–1780?), *Le Tems De La Soirée*, ca. 1738. Engraving, 35.5 × 43 cm (14 × 17 in.). New York, Columbia University, Avery Architectural and Fine Arts Library, AK 1355 M74 FF.

NOTES

The author gratefully acknowledges the kind and generous support of Kira d'Alburquerque, Suleena Bibra, Antonia Boström, Anne-Lise Desmas, Ian Fraser, Mary Tavener Holmes, Édouard Kopp, and Jeffrey Weaver as well as the helpful comments and valuable insights of co-contributors to this volume, especially Kimberly Chrisman-Campbell, Joan DeJean, and Mimi Hellman.

1. Baker and Henry 1995, pp. 367–68. On the novelty of French consumption of tea in the 1730s, see London–Glasgow 2008.

2. For more on the subject of the toilette, see Kimberly Chrisman-Campbell's chapter in this volume.

3. In an age of inexactitude and even after the time-keeping precision of clocks improved with the introduction of the pendulum around 1656–57, the balance spring in the 1660s, and the anchor escapement around 1666–71, it remained common practice to set or to check the accuracy of a clock or watch against solar noon. Although the identities of the inventors and earliest dates of these innovations were disputed then (and are still debated now), these three technological advancements are considered key to the horological revolution, which brought the accuracy of pendulum clocks to within ten to fifteen seconds per day of "true time" and that of balance spring watches to within five to ten minutes per day. See Landes 1983, pp. 88, 116–22, 124–26, 421 n. 17; and Glennie and Thrift 2009, p. 35.

4. The game is sometimes identified as backgammon, but since the players have score pegs as well as dice, it is more likely trictrac, an "honest" and popular board game in seventeenth- and eighteenth-century France. See Belmas 2006, pp. 136–39.

5. The most respected eighteenth-century Parisian almanac was the *Almanach Royal* printed by the d'Houry and Le Breton families, *avec approbation & privilege du Roy*, for it reported the metrological determinations based on the Parisian meridian and the astrological ephemerides as verified by a member of the Académie Royale des Sciences. See Sarrazin-Cani 1999, p. 420.

6. Minute hands were introduced to clock faces in the 1580s and second hands to pendulum clocks by 1690. See Landes 1983, pp. 89, 114, 121, 129–30. Following the invention of the balance spring, minute hands appeared on watches in France around 1700 and second hands in the 1740s.

7. Dohrn-van Rossum 1996, pp. 141–42, 156.

8. Barnet 1998, pp. 87–88.

9. Le Rouge 1723, vol. 1, pp. 45, 60, 244–45.

10. Augarde 1996a, p. 95.

11. Saugrain 1771, pp. 236–37, 317, 410–11, 426.

12. DeJean 2005, pp. 206–7. On interior lighting during this period, see Mimi Hellman's chapter in this volume.

13. Anonymous, *Gazette de Robinet*, October 29, 1667, as quoted and translated by Schivelbusch 1988, p. 90 n. 20: "Il fera comme en plein midi, Clair la nuit dedans chaque rue, De longue ou de courte étendue, Par le grand nombre de clartés Qu'il fait mettre de tous costés En autant de belles lanternes!"

14. Herlaut 1916, p. 163.

15. Herlaut 1916, p. 188.

16. Herlaut 1916, p. 167; Schivelbusch 1988, pp. 90–91.

17. On the calendrical correspondences between biblical history and classical antiquity, see the chapter by Peter Björn Kerber in this volume.

18. Sarrazin-Cani 1991.

19. *L'Avantcoureur* (January 11, 1762), p. 20: "…qui peut figurer richement sur une tablette de cheminée à côté des porcelaines et des bronzes. C'est un almanach en bannière, émaillé, soutenu et bordé de fleurs en cuivre doré d'or moulu. Les douze signes du zodiaque sont jettés parmi ces fleurs autour de la bordure; le tout fait un effet très-agréable." The almanac was available at the price of three to six louis. It may have resembled the enameled perpetual almanac, ca. 1741–42, now in the Wallace Collection, London (Hughes 1996, vol. 3, pp. 1171–78).

20. Mercier 1782–88: "Chapter CCCXXX. Les Heures du Jour," in *Tableau de Paris*, vol. 4 (1782), pp. 146–59.

21. Mercier 1782, pp. 149–55, 157–58.

22. As quoted by Augarde 1996a, p. 51.

23. *Horloger Mécanicien de Sa Majesté et de la Marine*.

24. Augarde 1996a, pp. 72, 280–82.

25. *Horloger Ordinaire du Roi et de l'Académie des Sciences*.

26. Landes 1983, p. 125; and Augarde 1996a, pp. 72–73, 401–2.

27. The entire movement, pendulum, and bells of this instrument were removed at an unknown date and are not known to survive, although another planisphere by Fortier is preserved intact in the Wallace Collection in London. See Wilson et al. 1996, pp. 92–101; Augarde 1996a, pp. 46, 227–29; and Hughes 1996, vol. 1, p. 415.

28. Fairchilds 1993.

29. As a point of reference, the cost of compiling a notarized inventory in eighteenth-century Paris ranged from fifteen to forty livres and represented more than twenty-days work. See Pardailhé-Galabrun 1991, pp. 4, 169.

30. Augarde 1996a, pp. 85–105, 171, 179.

31. On the evolving arrangement of rooms within fashionable Parisian residences at this time, see Joan DeJean's chapter in this volume.

32. Poitiers 1993, pp. 76, 81–82, 84.

33. Concerning the serial publication history of the *Contes Moraux* and their contemporary reception, see Rechniewski 2007.

34. Mercier 1782–88: "Pendules," in *Tableau de Paris*, vol. 12 (1788), pp. 279–80, as translated by Pardailhé-Galabrun 1991, p. 169.

35. Battistini 2004, pp. 23–25.

36. According to Cyril, bishop of Alexandria in the early fifth century, as quoted by Hurt 1971, p. 26 n. 11.

37. Panofsky 1972.

38. The most famous composition of this theme in Paris was *Time Rescues Truth from the Attacks of Envy and Discord*, painted in 1641 by Nicolas Poussin (1594–1665) and installed in 1648 in the ceiling of the Grand Cabinet in the Palais du Louvre (now in the Musée du Louvre).

39. Leeds–Los Angeles 2008–9, pp. 72–73; and Wilson et al. 1996, pp. 58–64.

40. Wilson et al. 1996, pp. 20–27; and Hughes 1996, vol. 1, pp. 349–53, 375–82.

41. Leribault 2002, pp. 268–69, 271, 322–23, 335.

42. Frankfurt 2009–10, pp. 340–41; and Wilson et al. 1996, p. 23.

43. Reproduced in Hughes 1996, vol. 1, p. 380.

44. Hurt 1971, pp. 17–18.

45. Battistini 2004, pp. 126–29.

46. The unit of an hour was in use by the time of Herodotus (ca. 480–430 B.C.). See Dohrn-van Rossum 1996, pp. 18–19.

47. The work was first published 1593 without illustrations and then in 1603 with illustrations: Cesare Ripa, *Iconologia, ouero Descrittione di Diverse Imagini cauate dall'antichità & de propria inuentione* (Rome, 1603). It was followed by *Iconologia ouero Descrittione d'Imagini delle Virtu, Vitij, Affetti, Passioni Humane, Corpi Celesti, Mondo e Sue Parti* (Padua, 1611). The latter is reprinted in *Garland Series* 1976, pp. 88–89, 109–11, 131–37, 220–30, 337–50, 500–508.

48. Baudoin 1644, pp. 176–78. The illustrations were engraved by Jacques de Bie (ca. 1581–1643). This edition excludes the twelve hours of day and the twelve hours of night. On the developing association of the Four Times of Day with deities, see Shesgreen [1982], pp. 74–88. For a summary of the various editions of Ripa's *Iconologia*, see Maser 1971, pp. vii–xxi.

49. Originally published anonymously as *Réflexions sur quelques causes de l'état présent de la peinture en France. Avec un examen des principaux Ouvrages exposés au Louvre le mois d'Août 1746* (The Hague, 1747). English translation by Belinda Thomson and Christopher Miller, as quoted in "Étienne La Font de Saint-Yenne (1688–1771) from *Reflections on some Causes of the Present State of Painting in France*," in Harrison, Wood, and Gaiger 2000, p. 558.

50. Holmes 1991, pp. 90–93; and Holmes 1985, chapter 2 (unpaginated). On the development of the genre, see Shesgreen [1982]. Regarding the Vernet cycles, see Paris 1976–77, pp. 64–67, 91–92, 117–18.

51. When the set was announced in the April 1738 volume of the serial *Mercure de France*, the scenes were said to represent ordinary activities of civilian life. See *Mercure de France* (April 1738), p. 202; Roux 1930, vol. 1, pp. 288–89; and *Les Heures du Jour* in Mondon (n.d.).

52. Chevalier de Neufville de Brunabois Montador, *Description raisonnée des tableaux exposés au Louvre, 1739, Lettre à Mme la Marquise de S.P.R.*, as quoted in Holmes 1991, p. 90.

53. Nevill 1908, p. 157.

54. "Cet instant fait du Jour la mesure et la Loy, Les Heures sur de point se regler entre ells: L'Amour le voit, l'indique, ce semble dire aux Belles Tout les vois heures sont a moy." Translation courtesy of Kira d'Alburquerque. See http://www.britishmuseum.org/research/search_the_collection_database/search_object_image.aspx?objectId=3098612&partId=1&searchText=Lancret+Larmessin&fromADBC=ad&toADBC=ad&orig=%2fresearch%2fsearch_the_collection_database.aspx&numPages=10¤tPage=3&asset_id=456186 (accessed April 1, 2010).

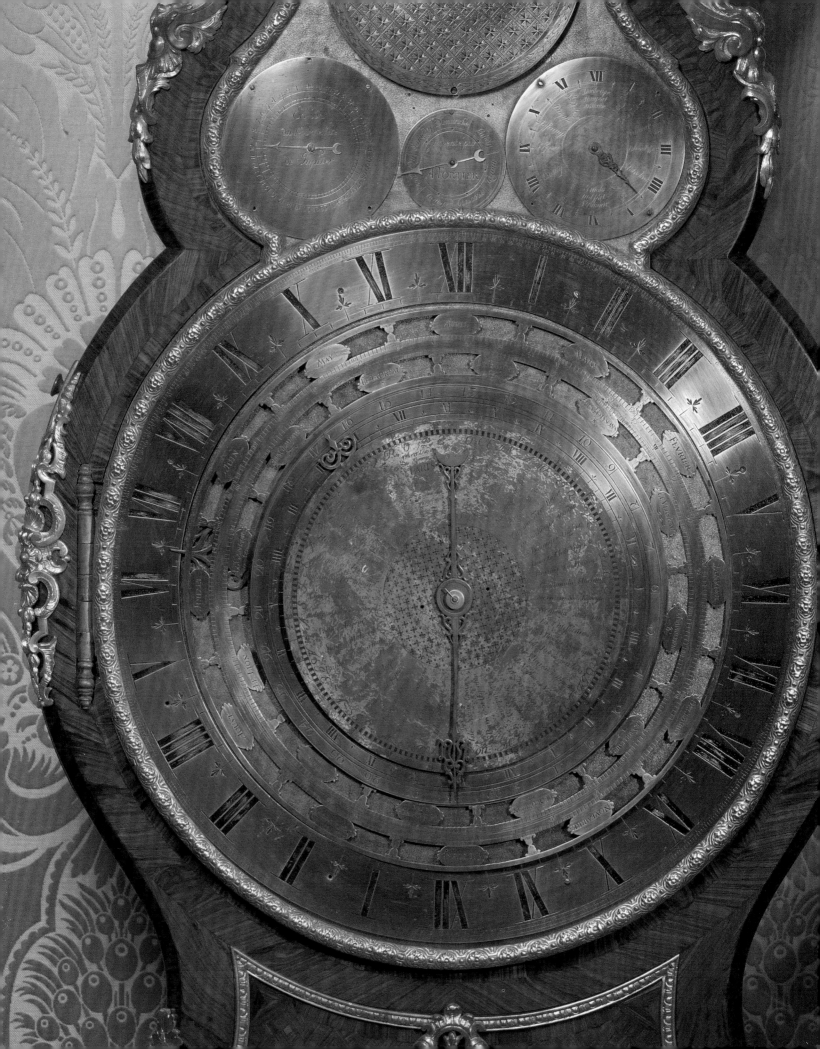

A New Interiority:

The Architecture of Privacy in Eighteenth-Century Paris

II

Joan DeJean

At the turn of the eighteenth century, one of the most radical transformations in the history of the city of Paris was just beginning.[1] The metamorphosis started during the final years of the seventeenth century on and around the Place de Nos Conquêtes, one of the last great monuments of the reign of Louis XIV (1638–1715, reigned from 1643), today known as the Place Vendôme. The adjacent area soon became the city's financial hub because so many of those who took up residence there were members of a group that was fast becoming ever more wealthy and ever more prominent in Parisian life: financiers. By the time the transformation was winding down, shortly before the middle of the century, two vast new neighborhoods had been added to the cityscape, the Faubourg Saint-Honoré on the Right Bank and the Faubourg Saint-Germain on the Left Bank.

All this development took place so quickly that the map of Paris was constantly being redrawn, as cartographers tried to keep up with the pace of the city's expansion. On the map produced by engraver François de L'Épine for cartographer Albert Jouvin de Rochefort in 1672–74, for example, the Faubourg Saint-Germain is a vast wilderness, a tree-covered expanse. By 1710, however, a second version of this map by two of the architects most deeply implicated in all the new construction, Pierre Bullet (d. 1716) and François Blondel (1618–1686), depicts the first new buildings in the Faubourg. Finally, on the map commissioned by city official Michel-Étienne Turgot (1690–1751) from Louis Bretez (d. 1736) in 1734, the area has been almost completely built up.[2]

The architectural projects undertaken in the new neighborhoods of turn-of-the-century Paris were in various ways unlike anything previously done in the city. To begin with, a great

many of them were commissioned by a new kind of client—non-aristocrats. Beginning with the Place Vendôme, the Parisian building boom was fueled largely by the very new wealth of individuals from the financial sector. And even those aristocrats who built residences in the Faubourgs for the most part bank-rolled them in the manner of the financiers, using profits generated just prior to 1720 from the speculation that arose when the Banque Royale (organized by Scotsman John Law [1671–1729]) took over France's public debt and the administration of the country's revenue.[3] In addition, the new neighborhoods featured a kind of habitation never before dominant in Paris: freestanding dwellings. The new constructions on the Place Vendôme were the last to share party walls; from then on, Paris began to be covered with stand-alone residences surrounded by large gardens, a truly sub-urban urban architecture. For the first time, French architects were planning domestic architecture that spread horizontally rather than vertically.[4]

The homes built in the new neighborhoods that opened up in eighteenth-century Paris were the first residences ever intended primarily to accommodate, and even to encourage, activities and needs to which architects had never before accorded priority. Whatever the client's concerns, eighteenth-century French architects were ready with a solution, most often in the form of a new kind of room designated for a specific activity.[5] The variety of rooms that appeared for the first time in these residences—everything from reading rooms and writing rooms to children's rooms to tiny spaces in which to drink coffee—have a great deal to tell us about the kinds of activities that were beginning to be seen as playing an essential role in the daily life of an ever larger number of people.

Because of the variety of new spaces, homes for the first time could be gendered, with certain rooms and even entire zones set aside for the mistress of the house (a dressing room, spaces for clothes storage, a boudoir) and others for its master (a room for filing papers, one in which to receive business associates in an intimate setting). Parisian dwellings were also designed to function differently at different times of the day. All these innovations—new rooms, the gendering of the home, its new functionality—were at the service of a desire that had almost never before been articulated and one to which architects had therefore paid little attention prior to the eighteenth century: the desire for privacy and for a private life.

The architects active in eighteenth-century Paris were innovative in still another way: they systematically recorded their accomplishments in print. Before this time, a small number of celebrated architectural treatises, often republished, and a few isolated floor plans, almost always of great public monuments, constituted the architectural record. The turn of the eighteenth century in France inaugurated a new era in the print culture of architecture. The most noted architects instinctively used print to preserve the era's architectural accomplishments and its innovations—in treatises, building manuals, collections of floor plans of the contemporary homes considered noteworthy. They thereby suggested that the brand of domestic architecture they were helping to define should stand on an equal footing with the public architectural projects that had previously been commemorated in print. In addition, since modern interior decoration was born in eighteenth-century Paris and since the original interior decorators were always architects, they also edited compilations of striking examples of contemporary interior decoration, from the best ways to use mirrors to the most interesting new wall treatments. Finally, since many of the age's greatest furniture designers were also architects, they naturally recorded their accomplishments in print as well.

All in all, eighteenth-century French architects and designers produced a veritable flood of publications. The simple mass of publications advertised to the significant French-speaking audience all over Europe, and even farther afield, the news that a new kind of interior architecture and a new kind of interior space were taking shape in Paris. Never before had the architecture and design of an era been so thoroughly documented, and never had they been documented at the moment of their creation. Never before had architects proclaimed themselves to be modern and declared that great architecture should be liberated from the influence of antiquity. During the first half of the eighteenth century, French architectural theoreticians—Jean Courtonne (d. 1739) in 1725, Pierre-Jean Mariette (1694–1774) in 1727, and Jacques-François Blondel (1705–1774) in 1737 and 1752—announced that "modern" French architecture had invented "an art completely unknown to the ancients," the art of making homes comfortable.[6] Their publications also announced to the world that Italian architecture's moment was on the wane and that in its place French architecture had become the model to follow. The fact that so many architecture-related works were published

and republished also indicates that a new readership had come into existence: a general audience interested in contemporary architecture and the way it was changing the home.[7]

These various publications made it possible for clients far from Paris to copy the design of Parisian residences. (A number of prominent French architects helped encourage this development when they took up residence in foreign capitals—from Geneva to Saint Petersburg—to build homes in the French style for clients there.) The publications also made it possible for an audience that could not have afforded an architect-designed residence to incorporate some of the innovations associated with the new French school of architecture into their more modest homes. These less affluent followers of the contemporary architectural scene then completed the cycle by recording their own accomplishments in print. In memoirs, journals, and correspondences, numerous inhabitants of eighteenth-century Paris left eloquent testimony to their fascination with architecture and interior decoration. All these publications together paint an image of the eighteenth century in Paris as the first design- and decoration-obsessed age.

* * *

Prior to the eighteenth century, architect-designed residences played an essential role in a culture of display. In the seventeenth century, all French palaces and grand residences had a single goal: to make the daily life of the home's inhabitants into a perpetual demonstration of wealth and power. Their floor plans thus follow the same model, long sequences of rooms, known as *enfilades,* in which each room featured a door leading directly into the next space. The doors in each *enfilade* were perfectly aligned so that, when all of them were open, a visitor could look directly from the first room into the final space and thereby tally up with a single glance the sum total of all the evidence of the owner's affluence and rank. Access to the final rooms in the sequence was reserved for the most important visitors. To get there, however, it was necessary to go through each and every room. This meant that the home's inhabitants were on constant, public display. In the seventeenth century, when the sequential or *enfilade*-based system of domestic architecture reigned supreme, the concept of a private life could have no meaning.

Indeed, that was literally the case. It was only in 1690, in the first edition of the brilliant *Dictionnaire universel* by Antoine Furetière (1619–1688), that the expression *vie privée* (private life) made its inaugural appearance in a dictionary as "the opposite of a public life." The following year, Augustin-Charles d'Aviler (d. 1700) published his *Cours d'architecture*, which was immediately translated into English as *Lessons in Architecture*, often republished and expanded, and destined to become the eighteenth century's most influential building manual. D'Aviler formulated the first major critique of domestic architecture centered on display. It was in *Lessons in Architecture* that the distinction that came to define most clearly eighteenth-century French architecture as a school first appeared in print: between spaces known as *appartements de parade*—public, reception, or display space—and what d'Aviler termed *appartements de commodité*—the new kinds of rooms in which individuals actually lived. D'Aviler described the new space as "that which is less grand and more used" and said that it was to be devoted to what he called simply "living."[8] From both his definition and Furetière's, it is clear that, at the turn of the eighteenth century, no one was sure exactly what "the opposite of a public life" could mean or how to describe the life that would be carried out in rooms set aside for "living."

D'Aviler's description marked the beginning of eighteenth-century French architecture's devotion to the values of the era's buzzword—*commodité* (comfort or convenience). It also marked the beginning of the new French architecture's embrace of a new ideal: the use of architecture to serve the values of an individual's and a family's private life. *Cours d'architecture* inaugurated nearly a century during which French architects became the first of their profession to reject what had been until then the dominant goals of domestic architecture, the creation of imposing facades and grand exteriors and the design of reception spaces that were literally larger-than-life. Beginning in the late seventeenth century, the proceedings of the French Académie Royale d'Architecture and the most prominent architectural treatises all contain scornful dismissals of previous models for architecture, such as that based on the work of the sixteenth-century Italian architect Andrea Palladio. French architects complained that their predecessors had produced residences that were "virtually uninhabitable," that they had not paid attention to such basic concerns as natural light, and that they had not even thought of including a good spot for a bed.[9]

In eighteenth-century Paris, architects focused their attention on interior architecture, on developing rooms in which individuals could carry out their daily lives outside the public eye. To do so, they invented the

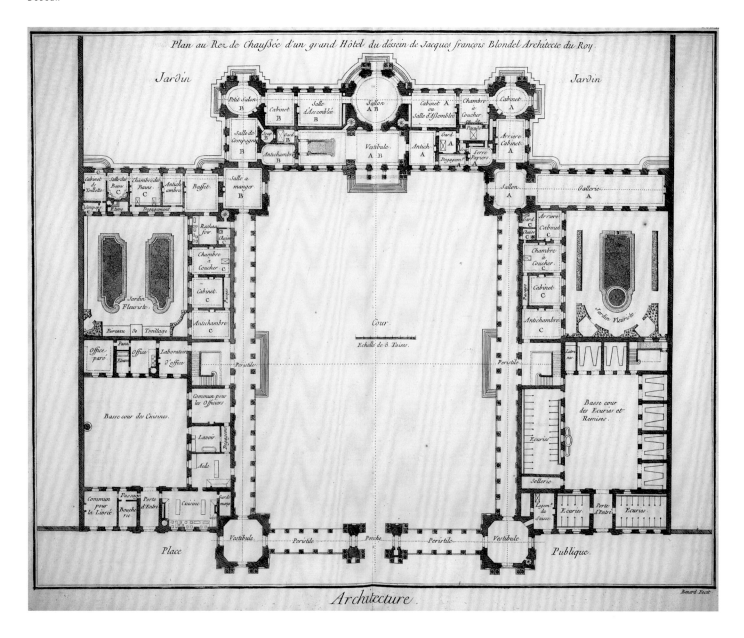

concept of rooms intended *not* to be seen by all. They redesigned what they named, in a phrase eloquent in its simplicity, *les dedans* (the insides), the home's private interior spaces. In the process, they made the creation of floor plans into what they themselves came to think of as an art form, which they referred to as *distribution*. Thanks to their efforts, distribution—the design of a home's layout—came to be seen as the essence of domestic architecture. Distribution also became a complicated process, and this explains why published floor plans of noted Parisian dwellings became so popular: they were the visible record of the new art of distribution.

Jacques-François Blondel belonged to an ancien régime architectural dynasty. In 1740, he created the first true school of architecture, the École des Arts, a key moment for the profession of architecture. Many of the most influential architects of the next generation, French and foreign alike, trained there, as did craftsmen. (Blondel even taught laypeople to appreciate the new architecture and its monuments.) Blondel was also a remarkably eloquent theoretician and a noted architectural engraver. It was thus logical that he became a much-published architect as well. Because of his teaching and his publications, Blondel was seen as the most influential architect in Europe in the eighteenth cen-

tury. Today, he is probably best known as the architect who did more than anyone else to preserve for posterity the great residences of eighteenth-century Paris. The four volumes of his *Architecture française* (1752–56) accomplish something never before attempted: they provide a record, neighborhood by neighborhood, of a great city's architectural monuments, ancient and, above all, modern.

All this made it logical that Denis Diderot (1713–1784) and Jean Le Rond d'Alembert (1717–1783), the editors of that defining monument to the Enlightenment, the *Encyclopédie, ou Dictionnaire raisonné des sciences, des arts et des métiers*, would have chosen Blondel to write the entries related to architecture and to engrave the explanatory plates. The most impressive of those plates is, like many of Blondel's floor plans, the design for an imaginary residence (fig. 18). It gives us the vision that the foremost architect of his generation chose to present to the international audience targeted by the *Encyclopédie* as the perfect Parisian residence, the model "hôtel." (The term *hôtel* originally referred to the town houses built for aristocrats; as soon as non-aristocrats began constructing residences every bit as fine as those of aristocrats, they were also known as *hôtels*.)

Blondel's plate is a comprehensive illustration of the nuances of distribution. By mid-century—the *Encyclopédie*'s seventeen volumes of text were published between 1751 and 1765; the first of eleven volumes of plates appeared in 1762 under the title *Recueil des planches sur les sciences, les arts libéraux et les arts méchaniques, avec leurs explications*—the opposition, first timidly articulated by d'Aviler in 1691, between an architecture of display and an architecture of comfort had become perfectly clear, and Blondel's layout immediately calls attention to this opposition. The *appartement de parade* is situated at the very top of his plan. We see a series of rooms with perfectly aligned doors. Visitors coming into the home from the garden on the upper left entered the *petit salon*; from there, they had a clear view to the other end of the suite, straight through the large salon and two *salles d'assemblée* to the *cabinet* on the upper right. These rooms were reserved for formal entertaining and receiving important guests, those the home's owners wished to impress most and with whom they were generally not on terms of particular intimacy. Such entertaining took place primarily in the morning.[10]

Even the ceremonial suite, however, had been refashioned in a very visible way by the style of the new interior architecture. Eighteenth-century architects also found fault with the sequential model because of what they saw as the monotony of the *enfilade*'s succession of virtually identical, square, essentially boxlike spaces. In Blondel's model ceremonial suite, square and rectangular rooms thus alternate with round and oval shapes. Other rooms, for example, the salon adjacent to the gallery, featured rounded corners. Blondel explained that these various curving shapes eliminated the corners that cut into a room's decorative scheme and provided decorators instead with an ideal, continuously flowing, surface.

By the mid-eighteenth century, this one zone at the very top of Blondel's plan represents all that remained of the formal, public space that had dominated seventeenth-century domestic architecture. In the suite that occupies the parallel zone just below the display suite, the rooms no longer follow the enfilade pattern. The floor plan is laid out on a less direct line, and the rooms are more numerous. Many are quite small, and they are interconnected in more complex ways. We are already in a semiprivate realm, that of the *appartements de compagnie*.[11]

There is, to begin with, the *salle de compagnie* immediately below the *petit salon* on the upper left. This space was designed to be less formal than the *grands salons* and other reception spaces in the *appartement de parade*. It was there that the family would receive closer friends, perhaps in the afternoon before or after they had enjoyed a meal together in a room that the French had only very recently begun to ask their architects to include in their homes: the *salle à manger* (dining room). (In 1735 Louis XV [1710–1774, reigned from 1723], decided it was time Versailles had a room reserved for dining; this was among the earliest such rooms in France. Prior to the mid-eighteenth century, meals were eaten in a variety of rooms on tables moved about as needed.)

Clustered around the *salle de compagnie* and the *salle à manger* are a number of rooms designed to enhance the convenience and comfort of the guests received there. There is, for example, a *buffet* adjacent to the dining room: food was prepared there for serving. Next to the *buffet* is a *réchauffoir*: food was brought there from the kitchen, located at the opposite end of the home's left side, and kept warm until it was to be served. Finally, an extremely small octagonal room is accessible from the dining room and the *salle de compagnie*: it was designed to showcase one of the most significant technological innovations of modern French architecture, one of which Blondel was

Figure 18
JACQUES-FRANÇOIS BLONDEL (French, 1705–1774), *Plan du rez-de-chaussée d'un grand hôtel du dessein de Jacques-François Blondel, architecte du roy* from *Recueil de planches, sur les sciences, les arts liberaux, et les arts méchaniques, avec leur explication*, edited by Denis Diderot and Jean Le Rond d'Alembert, vol. 1 (Paris, 1762). Engraving, H: 40 cm (15⅞ in.). Philadelphia, University of Pennsylvania, Rare Book and Manuscript Library, AE25.E53.

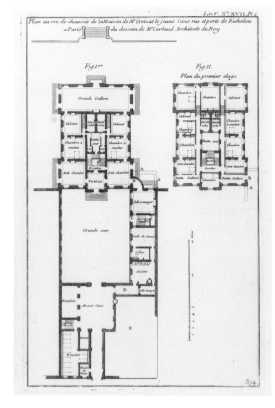

particularly proud, a flush toilet. (Blondel's model *hôtel*
also provided for two other toilet rooms in the truly
private zones.)

The second half of the semiprivate zone, to the
right of the *vestibule*, was reserved for a business suite.
This encompassed a waiting room, a small room, called
a *serre-papiers,* for the private storage of important
documents, and still another *salon*, this one designed
as a reception space in which the master of the house
could receive business associates. Aristocrats did not
work, so the proliferation of spaces designed to accom-
modate the needs of a high-level businessman indicates
that the home promoted by the *Encyclopédie* could well
have been intended for one of the newly wealthy non-
aristocratic families.

The *salon* leads directly into a walkway referred to
here as a *gallerie*, a space also found in the seventeenth
century's vastly more public architecture. Whereas in
the seventeenth century the gallery was intended as
the most public space of all, one in which the owner's
greatest treasures were on display to impress each and
every visitor, Blondel positioned his gallery squarely

between the public and the semipublic zones, because he saw it as fulfilling a variety of functions all across the public–private spectrum. The gallery was on the one hand a place where the businessman could, in Blondel's words, "clear his head" and "unwind" after stressful negotiations.[12] It was also designed with collectors in mind. Many of the financiers responsible for Paris's building boom had major art collections; such galleries allowed them either to enjoy their treasures in private or to display them to a public of their choice.

The best-known gallery of the early eighteenth century was undoubtedly found in the fabled mansion designed in 1704 by Sylvain Cartaud (1675–1758) for Pierre Crozat (1661–1740), noted financier and advisor to the Crown (fig. 19). It showcased 152 canvases by artists such as Rembrandt, Rubens, and Van Dyck, all displayed under a ceiling, painted by Charles de La Fosse (1636–1716), that depicted the birth of Minerva.[13] Crozat's *grande gallerie*, visible at the top of the plan of his *hôtel*'s ground floor, could be entered from either of the two bedroom suites adjacent to it. This allowed it to function as a private or a semiprivate space. But

it could also be entered directly from the garden, an access that made its public role possible. The gallery was the setting for monthly concerts that were represented in canvases by Nicolas Lancret. In one of Lancret's depictions, the red upholstery of the furniture on which Crozat's guests are seated is visible (fig. 20).

From the inventory drawn up after Crozat's death in 1740, we know that the gallery contained a suite of furniture, dating from about 1710, composed of "twelve armchairs, two sofas, two benches, four stools (*tabourets*), upholstered in red morocco leather."[14] Miraculously, half of that set still exists today: one of the sofas and six of the armchairs are in the Louvre, one of the stools belongs to the Getty Museum (fig. 21).[15]

The remaining zones in Blondel's layout are those in which French architecture's innovativeness is most apparent. These zones, on the lower left and right-hand sides of the plan, were both gender- and time-specific, designed to be used mostly at the beginning and the end of the day, by the master of the house (right-hand side) and the home's mistress (left-hand side). They were also the most intensely private zones in the home,

Figure 21
Stool (*tabouret*), French, ca. 1710–20. Gessoed and gilded walnut; modern leather upholstery, silk *galon*, brass-headed nails, 47 × 63.5 × 47.9 cm (18½ × 25 × 18⅞ in.). Los Angeles, J. Paul Getty Museum, 84.DA.970.

intended for the almost exclusive use of family members. Blondel said of rooms found here, "outsiders are rarely allowed there."[16] Each side contains a bedroom, as well as adjacent spaces (labeled *cabinet* on the plan) convenient for clothes storage and/or dressing.

Adjacent to the female zone (to the left of the *buffet*) is a final architectural ensemble, still another of modern architecture's innovations of which Blondel was proud: a four-room suite devoted to the pleasures of the bath. While a few seventeenth-century dwellings had included rooms reserved for bathing, prior to the eighteenth century, for the most part tubs were simply moved around as needed and filled with water heated in the kitchen and carried to the tub by servants. By the time Blondel was writing in the 1740s and 1750s, French architects considered a space specifically set aside for bathing to be essential; if at all possible, more than one room was strongly advised. The new experience was centered around the availability of running water, hot as well as cold, delivered to the tub through pipes and faucets.[17]

The *chambre des bains* is the centerpiece of Blondel's suite. His ideal bathing suite also includes tanks containing hot and cold water and a furnace to heat the water. Among the optional rooms for a bathing suite are a tiny space reserved for drying and warming the linen used after the bath, a room in which to take a nap after a very hot bath, and one in which servants could wait in case they were needed. The model bathing suite also features a space, known as a *cabinet de toilette*, dedicated to one of the signature moments in the day of the men and women of eighteenth-century Paris, the grooming ritual known as *la toilette*.[18] Finally, adjacent to the *cabinet de toilette* still another space houses a flush toilet. (The room is labeled *soupape* [valve] in reference to its flushing mechanism.)

Blondel's plan illustrates the ways devised by eighteenth-century architects for getting around the *enfilade* system in order to create for their clients "living" rooms to which access could be controlled. In order to regulate access between zones, eighteenth-century Parisian residences used a variety of circulatory devices known collectively as *dégagements* (removals or separations). The most visible *dégagements* were the small hallways and passageways visible, for example, in the bathing suite and in the two bedroom suites. In a bedroom suite, a well-positioned passageway made it possible, to cite but one example, for a servant to enter a bedroom through a door camouflaged in the wall next to the bed and thus to make the bed without passing through any private spaces. In the business suite, the *dégagement* next to the room where important papers were locked away is a tiny space that was intended to function as a sort of escape hatch, a private exit for the master of the house. There are also *petits escaliers*, small back staircases that would allow servants to circulate unobtrusively and their masters to get from floor to floor without calling attention to their movements.[19]

One of the most obvious ways in which the new French architecture set itself apart from its precursors was a simple question of size. In seventeenth-century residences, size was an essential sign of status: bigger was thus always considered better, and rooms were as large, and ceilings as high, as possible. The eighteenth century was, on the contrary, an age of downsizing. In a ceremonial suite, ceilings were usually twenty and often twenty-two feet high; rooms were designed on a scale that suited that uplift. In the new private zones, however, ceilings could be as low as nine feet and according to Blondel should be no higher than thirteen.[20]

The new smaller spaces were more intimate, cozier, and easier to heat. They were also easier to light, and the small salons thus had a particular appeal after dark, when, as several of the paintings in this volume prove, they sparkled from the reverberation of candlelight in well-positioned mirrors.[21] The craze for a smaller scale in interior space caught on so quickly that by the mid-eighteenth century the most widely circulated French periodical of the day, the *Mercure de France*, proclaimed that in France, "those of the highest rank live in the smallest rooms."[22] By then, the new craze for smallness had become evident even at that temple of the grand scale, Versailles, where Louis XV had the ceilings in many rooms built by Louis XIV lowered by a full three feet.[23]

At least one person took the concept of small scale to its logical limit. The most celebrated actress of the turn of the eighteenth century, Charlotte Desmares (1682–1753), commissioned François Debias-Aubry (d. 1773) to build a three-bedroom home for her on the rue de Verneuil in the Faubourg Saint-Germain (fig. 22). It is by far the smallest residence included in Blondel's compendium of great modern architecture and the only architect-designed home of the period with a size that now does not seem overwhelming. (Desmares's home still exists, but it was greatly enlarged in 1746 by its next owner.)

Nowhere was this question of scale more evident than in a room new to French homes in the

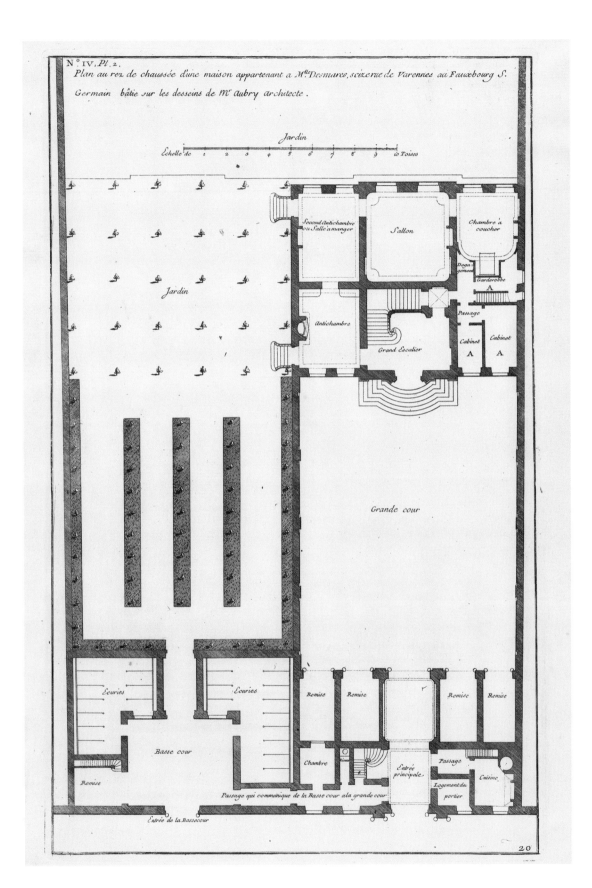

N.º IV. Pl. 2.

Plan au rez de chaussée d'une maison appartenant a M.ᵗᵗᵉ Desmares, scize rue de Varennes au Fauxbourg S.
Germain bâtie sur les desseins de M.ᵉ Aubry Architecte.

Jardin

Echelle de 1 2 3 4 5 6 7 8 9 10 Toises

Jardin

Second Antichambre
ou Salle à manger

Sallon

Chambre à
coucher

Dega-
gement

Garderobbe

A

Antichambre

Passage

Cabinet

Cabinet

Grand Escalier

A A

Grande cour

Ecuries

Ecuries

Remise

Remise

Remise

Remise

Basse cour

Chambre

Entrée
principale

Passage

Cuisine

Remise

Logement du
portier

Passage qui communique de la Basse cour a la grande cour

Entrée de la Bassecour

20

Figure 22

JACQUES-FRANÇOIS BLONDEL
(French, 1705–1774), *Plan
du rez-de-chaussée d'une
maison appartenant a Mlle.
Desmares* from *Architecture
française*, vol. 1 (Paris, 1752).
Engraving, H: 52 cm (20½ in.).
Los Angeles, Getty Research
Institute, Research Library,
87-B434-2.

Figure 23
JEAN-FRANÇOIS DE TROY
(French, 1679–1752), *Reading in a Salon*, ca. 1728. Oil on canvas, 74 × 93 cm (29⅛ × 36⅝ in). Private Collection. Photo: The Bridgeman Art Library.

seventeenth-century, the salon. At first, all French salons followed the Italianate model and featured the highest ceilings in the home: true salons were two stories high. In the homes of eighteenth-century Paris, these grand salons all but disappeared. People preferred instead what architects referred to as "pretty, small salons." One of the foremost creators of the new interior architecture, Charles-Étienne Briseux (1680–1754), pronounced that "a small space is much more agreeable when you're entertaining only a few guests."[24] The salon in which Jean-François de Troy portrayed a group of close friends—everything about their body language points to their easy intimacy—gathered together near a fireplace to enjoy a moment of companionate reading is just such a "pretty, small salon" (fig. 23).

Nowhere in the home did the implications of the shift from formality and ceremony to intimacy and comfort play out in greater complexity than in the "living" room that is now synonymous with privacy: the bedroom. The evolution that culminated in today's sense of the bedroom as a personal space designed to promote a good night's sleep began at the turn of the eighteenth century. Prior to this time, in all but the finest dwellings there were no rooms reserved for sleep. Beds were surrounded by curtains, which, when closed, offered protection from cold and drafts. Once the curtains were closed, the bed turned into a sort of little room within a room. The bed was not even assigned to a fixed spot; in the winter, for example, it was moved close to the fire for warmth. Châteaux and great *hôtels*

had spaces designated for sleep, known as *chambres de parade* (ceremonial or parade bedrooms).

The parade bedroom did contain a bed, and people did sleep there, but those concerns were secondary to its function as a ceremonial space. The master and mistress of the house observed the most significant occasions and received important visitors while positioned on the parade bed. The space around it was designed to convey a sense of the owner's dignity and rank. The bed was thus situated in an alcove and was usually surrounded by columns (fig. 24). The alcove was in turn marked off from the rest of the room by a balustrade. All this produced a theatrical effect, as though the person receiving visitors were on display for an audience.

Gradually over the first half of the eighteenth century, the ceremonial bedroom became obsolete. Its demise was among the most visible signs of the fact that Parisians, no matter how powerful, were becoming more concerned with privacy and comfort than with projecting a vision of self-importance. In its place, a new type of bedroom came into existence, the first truly modern sleep chamber.

All during the transitional period, many residences were faithful to both the old system and the new. In his idealized vision of a Parisian *hôtel*, for example, Blondel included a display bedroom, prominently situated near the far end of the ceremonial suite. (This is the room marked *chambre à coucher* in the upper far right corner of the plan.) He also included, however, two of the new-style bedrooms, also labeled *chambre à coucher*, one in each of the private suites. In the mid-century period represented by this distribution, the parade bedroom was purely for show and would hardly ever, if ever, have been used. In their memoirs, Parisians of the day made it clear that they no longer wanted anything to do with ceremonies previously considered de rigueur, such as the ritual of positioning the bride and groom on the display bed to receive visitors the day after their wedding. Charlotte Desmares, for example, had a display bedroom in her tiny home, but a very informal one—it had no balustrade, no columns. Small back stairs behind it led to her private bedroom suite on the floor above.

By this time, the day ended in Parisian homes in the most private zone, in what was known as a *chambre en niche* (niche bedroom), a space designed, in direct opposition to the display bedroom, to be private and intimate (fig. 25). The clearest sign of the room's new definition was the placement of the bed

inside a recessed nook or niche. The bed, also redesigned with the room's particular vocation in mind and named a niche bed, was placed sideways in the nook. This protected the person in it from drafts and therefore eliminated the need for curtains. (Here the singular is intentional, for niche beds belonged very definitely to the category of what are now called single beds and could be used only with great difficulty by two people.) Doors in the walls on either side of the bed opened onto a passageway behind it. By 1740, both Pierre Crozat and Charlotte Desmares were sleeping in niche beds.

The new private bedroom was less grand than the display bedroom, with far lower ceilings and often much smaller dimensions. Gone were all the trappings of ostentation such as the balustrade. Instead, niche bedrooms privileged convenience and the personal

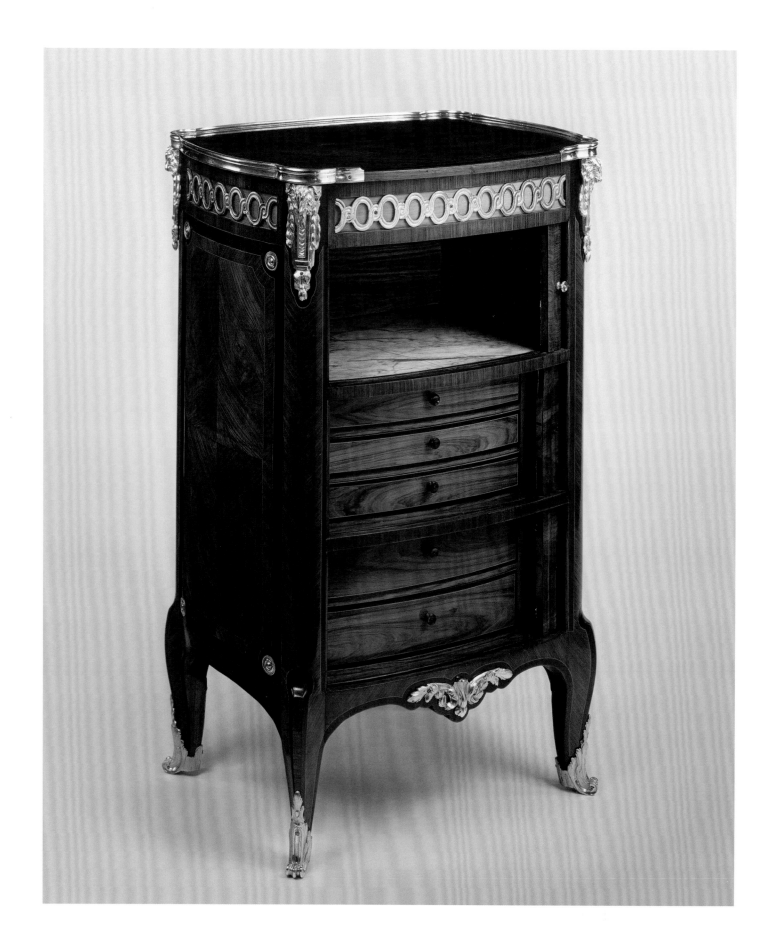

44

taste of their occupants. They always made room, for example, for the original piece of furniture created with drawer-based storage in mind, the *commode* (chest of drawers). (Homeowners often had installed next to their niche bedrooms large built-in *armoires*, closets in which clothes could be stored folded or hung, either from pegs or on the original coat hangers.) Niche bedrooms were also easily personalized.

The occasional tables to suit every need that were among the masterpieces of eighteenth-century furniture design would have been lost in the vastness of the parade bedroom but were ideally suited to its successor's proportions and style. Thus, for example, a kind of night table known as an *en cas* (or "just in case," because it was fitted out with a shelf specially designed to hold a midnight snack, rather than the usual cham-

ber pot) could be pulled up close by the bed of someone subject to hunger pangs during the night (fig. 26). Tiny writing tables were also positioned near the niche bed for the convenience of avid readers; a candlestick and a favorite book were thus ready at hand, as well as a shelf on which the book could be propped open for easy reading (fig. 27; full view fig. 47).[25] Most such tables were equipped with small drawers that could contain writing instruments, as well as a writing slide. If inspiration struck during the night, authors and all those who indulged in one of the century's favorite pastimes, letter writing, did not have to leave the cozy warmth of the sleeping niche. Particularly voracious readers had their niches lined with bookshelves.

It was also in the niche bedroom that the bed became a piece of furniture in its own right. Histori-

Figure 26
ROGER VANDERCRUSE
LACROIX (French, 1727–1799, master in 1755), *Cabinet*, ca. 1765. Oak and fir veneered with tulipwood, amaranth, and holly; gilt-bronze mounts; white marble interior shelf, 93.7 × 59.4 × 43.8 cm (36⅞ × 23⅜ × 17¼ in.). Los Angeles, J. Paul Getty Museum, Gift of J. Paul Getty, 70.DA.81.

Figure 27
Detail of fig. 47 (drawer and bookshelf).

cally, beds were valued for the (often very expensive) textiles that covered them; when people spoke of "a bed," they were referring to the bed hangings and bedcovers. Then, as soon as niche bedrooms began to appear in Parisian residences, the bed itself was reinvented. During the final decades of the seventeenth century and the early years of the eighteenth, many new models of beds appeared on the Parisian scene. Some faced out into the room; such beds, known as *lits d'ange* (angel beds) or *lits à la duchesse* (duchess beds), replaced the traditional four-poster style (fig. 28).[26] They had at the most only very short posts, or more often none at all, at the front end. They featured instead an immensely tall headboard that helped hold up the tester, which was attached to the wall rather than resting on posts. These models created a new look for the bed. Even so, the bed remained defined by the quality and the quantity of the textiles displayed on these vast surfaces.

That all changed with the sleeping niche. At first, very plain models with low headboards and bolsters at each end were used in the niche. Soon, however, niche beds began to be aligned with the latest trends in furniture design. In the process, the frame became ever more apparent, ever more an object of value in its own right. The new models developed for presentation sideways in the niche often received exotic names: the one shown here was known as a *lit à la turque* (Turkish bed) (fig. 29). Turkish beds were a big favorite with the Parisian clientele of the mid-eighteenth century; estate inventories prove that they were found in niche bedrooms all over the city. (A system of wheels made it possible to roll and pivot a Turkish bed, which made making the bed far easier.)

Figure 29
Jean-Baptiste Tilliard
(French, 1686–1766),
Bed (*lit à la turque*), ca. 1750–60.
Gessoed and gilded beech and
walnut; modern silk upholstery,
174 × 264.8 × 188 cm (68½ ×
104¼ × 74 in.) and *Wall Clock*
(*pendule*), ca. 1735–40. Case:
possibly after a design by
Juste-Auréle Meissonnier
(French, b. Italy, 1695–1710);
clock movement: Jean-Jacques
Fiéffé (French, ca. 1700–1770).
Gilt bronze; enameled metal;
wood carcass; glass, 133.4 × 67.3 ×
14.3 cm (52½ × 26½ × 5⅝ in.).
Los Angeles, J. Paul Getty
Museum, 86.DA.535 and 72.DB.89.

Figure 28
Hangings for a Bed (*lit à
la duchesse*), French,
ca. 1690–1715. Silk satin
and damask; cording;
velour; silk embroidery;
linen lining, overall
415.9 × 181.6 × 182.9 cm
(163¾ × 61½ × 72 in.).
Los Angeles, J. Paul Getty
Museum, 79.DD.3.

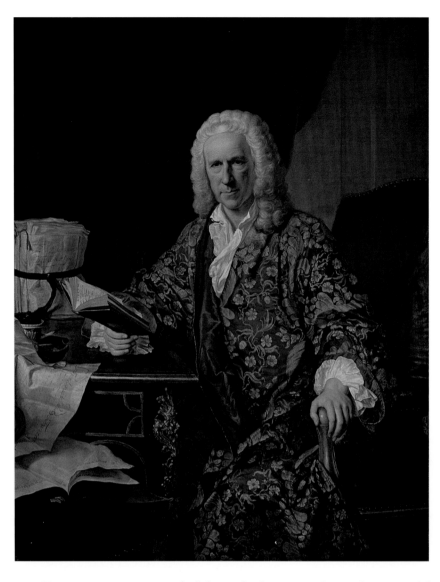

Figure 30
JACQUES-ANDRÉ-JOSEPH AVED (French, 1702–1766), *Portrait of Marc de Villiers, Secrétaire du roi*, 1747. Oil on canvas, 146.7 × 114.6 cm (57¾ × 45⅛ in.). Los Angeles, J. Paul Getty Museum, 79.PA.70.

Figure 31
Woman's Dress (robe volante; back view), French, ca. 1725–35. Silk. Paris, Les Arts Décoratifs, Musée des Arts décoratifs/ Musée de la Mode et du Textile, UF 59-31-1. Photo: Laurent Sully Jaulmes.

New garments were imagined, all designed to be worn in the privacy of new rooms such as the niche bedroom, and all designed with the inhabitants' comfort in mind. Both men and women spent many hours of the day in dressing gowns. Pierre Crozat's probate inventory shows that he kept his gown on a peg in the dressing room adjacent to his niche bedroom. In France in the early decades of the eighteenth century, by far the favorite style of gown was a loose-fitting, ample model based on a kimono-cut; such robes could easily be *matelassé* (padded for winter wear) (fig. 30). Dressing gowns could be immensely colorful affairs; they were often made of fabrics such as Indian cotton printed and hand-painted with bright floral scenes. When they removed their wigs in the evening, men put on matching caps to keep their heads warm.

Memoirs, correspondences, and other contemporary documents such as periodicals indicate how much French women of the early eighteenth century loved different kinds of loose-fitting garments for the ease of movement they allowed. In fact, for a time French women's daywear even mimicked the dressing gown look. Canvases by Jean-François de Troy and other painters of the day show off various incarnations of the style most commonly referred to today as the *robe volante* (flying dress), presumably because of the way in which the ample folds of fabric swirled around women's bodies when they walked (fig. 31). De Troy's *Reading in a Salon* portrays a winter scene in which the women, like the men, are depicted in street wear: the ladies wear flying gowns made from such heavy textiles as velvets and brocades (see fig. 23). Their tiny lace-trimmed caps complete the fashion statement. Around her shoulders, the lady on the far left shows off the accessory of the moment for winter 1729, a *mantille* (shawl). De Troy has depicted her from behind, which

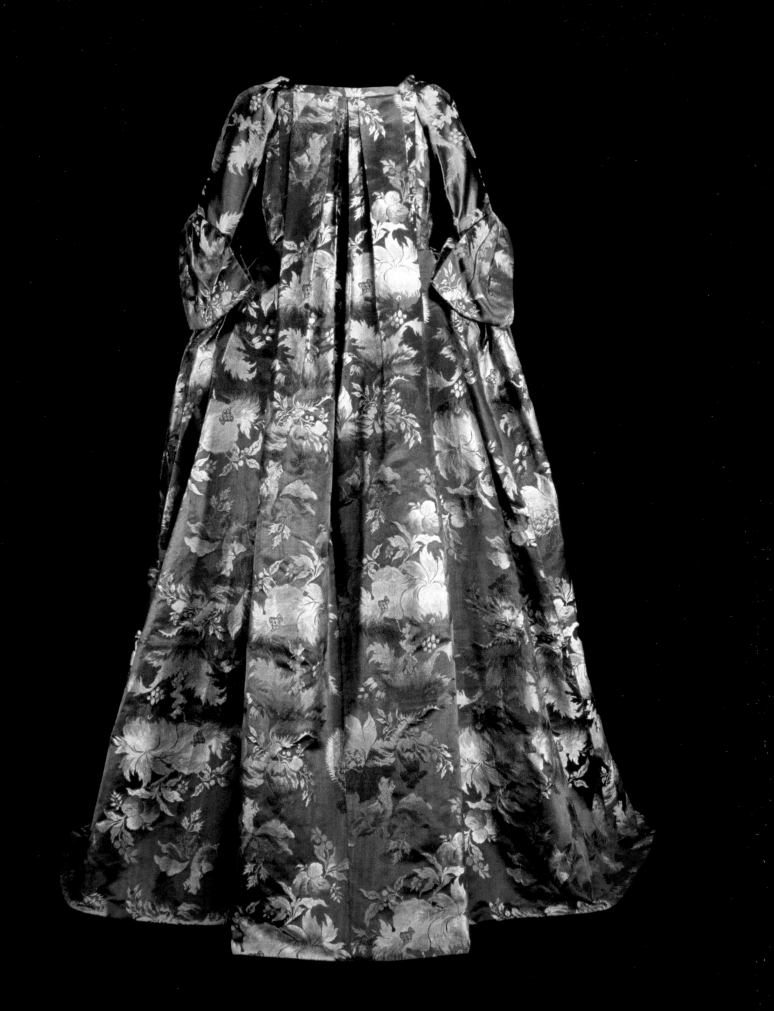

allows him to show that she also wears it in the pre-scribed way: with the two ends wrapped around and tied in the back.

While the ladies of Paris did take out into the street some fashions that their contemporaries con-demned as fit only for the bedroom, one new gar-ment was only worn in private, the peignoir (see figs. 32 and 46).²⁷ The peignoir was invented to protect ladies' outfits while they were combing their hair (*se peigner*). This was especially necessary in an age when women covered their curls with a fine, silvery powder. The peignoir was made of sheer muslin, generally lace-trimmed, and tied around the neck.

* * *

An architecture that was innovative in large part because it encouraged the creation of new rooms as well as new ways of moving about within the home; furniture designed for convenience; clothing intended to be worn inside the home and at certain times of the day—all of this illustrates the increased attention paid to facilitating everyday activities, from eating to sleeping, in the residences of eighteenth-century Paris. Architect Germain Boffrand (1667–1754), among the most influential promoters of the period's residential style, claimed that a new way of living daily life had come into existence in these new homes; he called it "this century's way of life."²⁸ His testimonial to the suc-cess of modern architecture was confirmed by numer-ous Parisians, individuals who recorded their daily lives in voluminous memoirs and correspondences. The tes-timony of one such individual proves how quickly and widely ideals first articulated in the century's opening decades spread through French society.

The involvement of Françoise de Graffigny (1695–1758) with the kind of life possible within the new pri-vate rooms began in 1738. She was then a widow, on her way from provincial Lunéville to the French capi-tal to make a life for herself after a profligate husband had squandered her dowry. She stopped off at Cirey, the château that Voltaire (1694–1778) and Émilie du Châtelet (1706–1749) were in the process of renovating according to the latest standards. At Cirey, Graffigny saw architecture, interior decoration, and furniture used in ways she had never before imagined, and she fell in love with everything she saw. She recorded her detailed impressions in a series of letters to the friends she'd left behind; these are among the earliest missives in what was destined to become one of the greatest correspondences of the century. From them, we learn

how perfectly the wealthy residents of Cirey had put into practice all the principles found in manuals such as Blondel's: from the bathing suite to the boudoir, they had all the accouterments of the new private life, all done in just the right style.

By 1751, Graffigny had found a new life as a writer in Paris. She was by no means wealthy, but she was managing to get by quite well. For months, the eigh-teenth century's equivalent of today's working woman described her experiences "visiting apartments for rent."²⁹ When she finally found the apartment of her dreams, she proceeded to renovate it to the highest standards of comfort within her budget. (It was com-mon practice to remodel rental property.) This time, her letters prove that, by mid-century, even a person of relatively modest means could live a quite respectable version of the new architectural life. Graffigny waxed lyrical about a series of tiny spaces, each devoted to a specific activity: a writing room, a dressing room "full of" storage space, a bedroom with an adjacent (*en suite*) toilet room. The description of her decorating dream realized in 1751 sounds as if she had brought François Boucher's 1746 canvas *The Milliner* (see fig. 32) to life in Paris on the edge of the Luxembourg gardens.

She was proud of her apartment's hardwood floors, and she considered its overdoors especially attractive. She took particular delight, however, in the bedroom. Over the years, drafty bedrooms, such as the guest room at Cirey, had been the bane of Graffigny's existence. She was thrilled that her new bed was tucked sideways into a cozy niche; she also loved her harmoni-ous decorating scheme, as well as the large-paned win-dows that flooded the room with light.

When the editors of the *Encyclopédie* featured Blondel's plan for the ideal *hôtel*, they sent a message to the "enlightened" world that the best French archi-tecture was based on new values: families now used their wealth to make their lives more private and more comfortable. This was the same vision conveyed by every significant eighteenth-century French architec-tural publication, by the greatest contemporary French genre painters, and it was also the vision that inspired the planning of what Françoise de Graffigny called her "fairy tale" come true. A layout that facilitated privacy, rooms dedicated to the activities that each homeowner considered most important—the fact that Graffigny used these criteria to evaluate the quality of her new apartment indicates that, by 1751, eighteenth-century French architects were succeeding in their goal of revising the standards for domestic architecture.

NOTES

I would like to thank the editors for their invitation to contribute to this volume and the other contributors for their comments on this chapter.

1. In the following pages, I do not attempt to include references to all relevant scholarship; this volume's editors requested that contributors keep footnotes to a minimum. For additional information on the subjects I discuss in this chapter and for a full bibliography, see DeJean 2009.

2. All these maps are reproduced in Pinon, Le Boudec, and Carré 2004. The volume is accompanied by a CD-ROM.

3. The most convincing account of the economics of John Law's system is provided by François Velde, *Government Equity and Money: John Law's System in 1720 France*, Federal Reserve Bank of Chicago Working Paper No. 2003-31. See www.chicagofed.org/webpages/publications/working_papers/2003/wp_31.cfm.

4. On the transformation of Parisian architecture, see Dennis 1986.

5. For more on the rituals of daily life in eighteenth-century Paris, see Charissa Bremer-David's chapter in this volume.

6. The quotation is from Courtonne 1725, p. 92. On architectural modernity, see Rykwert 1980.

7. For an account of the spike in publications related to architecture in the eighteenth-century, see Neuman 1980, in particular, p. 130 n. 12. The second half of the seventeenth century and the entire eighteenth century marked a golden age for French print culture in general. However, other areas (the novel, for example) did not see the same spectacular and continuous progression evident in publication related to architecture.

8. d'Aviler 1691, vol. 2, p. 275, and vol. 1, p. 180. The French term *appartement* is perhaps best translated as "suite"; it was used to designate a set of rooms devoted to a single purpose (a bathing suite, for instance) or reserved for a single individual (such as a master suite).

9. *Académie Royale d'Architecture 1671–1793* (1913), vol. 1, p. 124, and vol. 3, p. 93. See also, for example, Blondel 1752–56, vol. 1, p. 21.

10. On the social rhythms of the day, see Charissa Bremer-David's chapter in this volume.

11. Other eighteenth-century architects referred to the semiprivate zone as *appartements de société*, rather than *compagnie*. Blondel at times also used this alternative term.

12. Blondel 1737–38, vol. 2, pp. 159, 178.

13. On the works displayed in Crozat's gallery, see Wildenstein 1968.

14. See Pierre Crozat, "Inventaire," May 30, 1740. Archives nationales, Paris, ET/XXX/278.

15. On the Getty *tabouret* from the suite of furniture designed for Pierre Crozat, see Wilson, Bremer-David, and Weaver 2008, pp. 242–47, no. 24.

16. On a residence's most private zones, see note 9 above and Blondel 1752–56, vol. 1, p. 27.

17. Blondel gives his most complete description of the bathing suite in his *Traité d'architecture dans le goût moderne*; see Blondel 1737–38, vol. 1, pp. 72–74, and vol 2, pp. 129–35. I base my conclusions on the role of bathing in eighteenth-century Parisian homes on the evidence provided by memoirs and correspondences, as well as on that found in architectural treatises and the floor plans of Parisian homes. I realize that my account differs from that found in many works on the history of bathing that do not rely on this evidence. For a different view of the place of bathing in eighteenth-century life, see Kimberly Chrisman-Campbell's chapter in this volume.

18. For more on the toilette, see Kimberly Chrisman Campbell's chapter in this volume.

19. For a study of the ways in which Blondel planned for the movements of servants throughout the home, see Benhamou 1994. The floor plans of various Parisian homes illustrate how many kinds of *dégagements* were in use; they also show that many of them were intended for the convenience of the residents of these dwellings, something confirmed by memoirs and correspondences.

20. On the height of ceilings, see Blondel 1771–77, vol. 4, p. 384.

21. For more on the lighting of interior space in the eighteenth-century home, see Mimi Hellman's chapter in this volume.

22. *Mercure de France* (February 1755), p. 168.

23. The duc de Croÿ never failed to note examples of the new small scale. See Croÿ 1718–84, vol. 1, pp. 528–29.

24. Briseux 1743, vol. 1, p. 22.

25. For more on lighting of homes in the evening hours, see Mimi Hellman's chapter in this volume.

26. Bremer-David 1997, pp. 172–81.

27. For more on the peignoir and its uses, see Kimberly Chrisman-Campbell's chapter in this volume.

28. Boffrand 1745, p. 11.

29. Graffigny 1985–2010. Graffigny's letters describing Cirey are in volume 1 (p. 197, for instance); her letters about her new apartment are in volumes 11–12. See volume 11, p. 383, and volume 12, pp. 59–60, in particular. I thank one of the editors of her correspondence, English Showalter, for his help with these references.

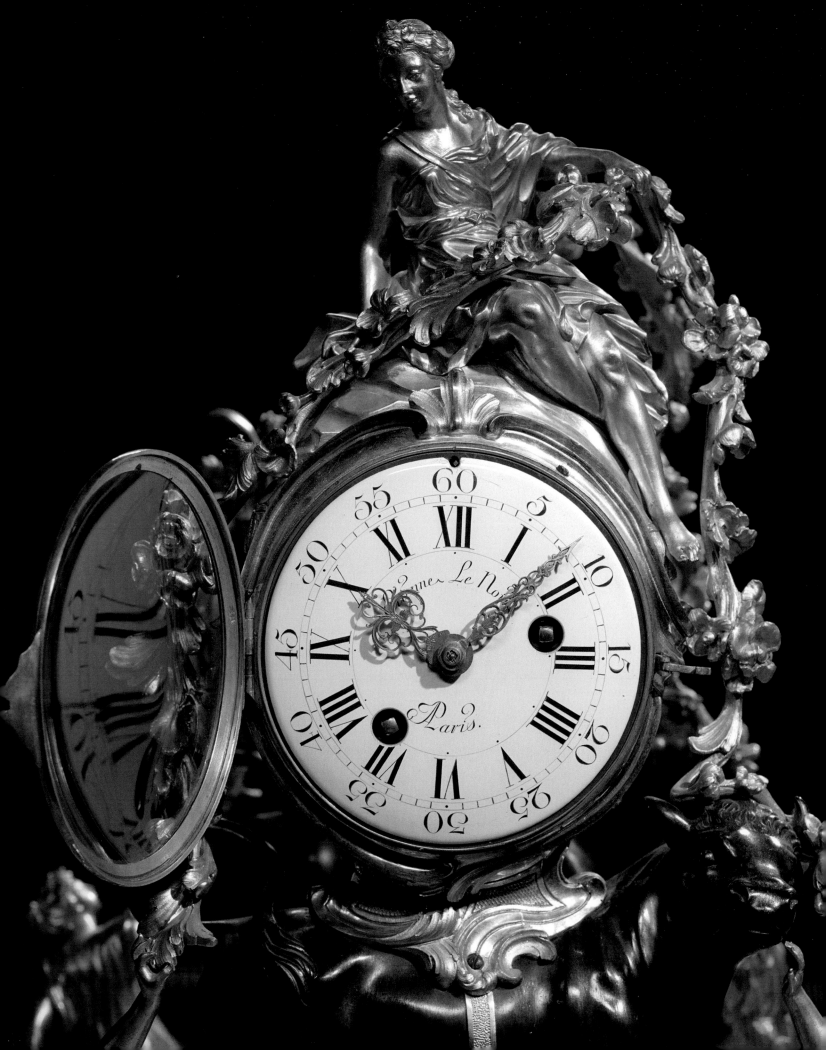

Dressing to Impress:

The Morning Toilette and the Fabrication of Femininity

Kimberly Chrisman-Campbell

The role of a pretty woman is much more serious than one might suppose: there is nothing more important than what happens each morning at her toilette, surrounded by her servants; a general of an army pays no less attention to placing his right flank or his reserves than she does to the placement of a patch, which can fail, but from which she hopes or anticipates success.

Montesquieu, *Lettres Persanes* (1721)[1]

La Toilette Defined and Refined

Over the course of the late seventeenth and early eighteenth centuries, the toilette evolved from an object (*petite toile*) to a set of objects (*service de toilette*) to a room to a ritual performance of taste and consumption, synonymous with the morning. Although ostensibly private, the eighteenth-century toilette was actually quite public. Louis XIV (1638–1715, reigned from 1643) and his mother, Anne of Austria (1601–1666), had instituted the custom of the *toilette* or *lever* (rising), during which courtiers would gather in the royal bedchamber while the king or queen dressed.[2] This royal ritual was imitated by women (and men) of the nobility and *haute bourgeoisie,* who, in the eighteenth century, transformed it from a formal ceremony of etiquette into a vital exercise in taste and sociability.

Although elite men and women alike held toilettes attended by friends, family members, servants, and tradesmen, it was the female toilette that became a recurring theme in French visual culture. The taste for toilette scenes spanned history painting, genre scenes, and portraits. Combining the ancient *vanitas* tradition with the ultramodern *tableau de mode,*[3] the highly

codified rituals of the toilette were reenacted over and over again in rococo art, not only by beautiful women but by children, monkeys, and even butterflies.[4] The popularity of toilette scenes in the first half of the eighteenth century cannot be explained by mere titillation; although they purported to show the natural, unadorned woman, in many cases her coiffure and makeup were already in place, and she was fully covered, if not fully dressed. Indeed, it was generally understood that women performed two toilettes, one truly private, followed by a longer, public toilette. According to Louis-Sébastien Mercier, "the second toilette is nothing but a game invented by coquetry," with every object and gesture caculated to entice a male audience. "If one braids long, flowing hair, it already has its plaits and it has received its perfumes…If one plunges an alabaster arm in scented water, one can add nothing to its luster and its whiteness."[5] Toilette scenes thus restaged an already theatrical event, filling it with stock props and characters.[6] They balanced art and artifice, revelation and concealment, offering a suggestion of secrecy and intimacy that was not borne out by either the image or the reality.

Paintings of toilettes (and cosmetically enhanced women) participated in an even more complex interplay of self-referential signs. In the eighteenth century, paint and makeup shared many of the same pigments and could be bought from the same merchants. As Caroline Palmer has demonstrated, "the mode of application was also very similar. Handbooks on cosmetics emphasized the need for thorough cleansing and smoothing of the skin before the laying down of a white lead base coat. This process is strongly reminiscent of the priming of an artist's canvas."[7] Finally, rouge and other colors were applied with small brushes resembling paintbrushes. Indeed, Scottish novelist Tobias Smollett (1721–1771) described "the manner in which the faces of the ladies are primed and painted" in France.[8] It is impossible to tell where the painter's brush ends and the makeup brush begins; the woman's true face is doubly obscured.

The passage of time is implicit in toilette scenes, whether or not they depict an actual clock. Not only was the toilette associated with a specific time of day, but it served as a reminder of the fleeting nature of beauty and the futility of attempting to mask the ravages of time. This is underscored by the presence of mirrors and burning candles—standard components of toilette sets as well as traditional *vanitas* emblems.[9] Time moved particularly swiftly in the life of the eighteenth-century woman. It was commonly believed that youth—and, by implication, beauty—ended at thirty. Images of aged coquettes at their toilettes were satirical variants on the subject. The toilette is framed as a place—a temporal place as much as a physical one—of transformation and desire. "The beauty of women in France renews itself every morning. Like a clock, one could say that their charms are wound: it's a flower that is reborn and dies in a day."[10]

Toilette scenes are also illustrative of the French moral ambivalence toward beauty and fashion. Although cosmetics were nothing new in the eighteenth century, Vincent Cochet singles out their "quasi-ritualized" use in this period, combined with a new understanding and appreciation of hygiene.[11] Furthermore, cosmetics were evolving from traditional home remedies to a bewildering variety of store-bought concoctions, including some priced within reach of the lower-class shop-girls and servants who increasingly aped aristocratic modes.[12] While cosmetics were to some extent considered inseparable from nobility, femininity, and Frenchness, they were also morally suspect, as demonstrated by the censorious captions often applied to the engravings of fairly innocuous toilette scenes, such as the verses on René Gaillard's engraving of François Boucher's *The Milliner* (fig. 32):

> The gods took pleasure in making you perfect,
> And these vain ornaments that you wrongfully borrow
> Only serve to hide genuine beauty;
> So give up your toilette forever, Philis,
> If you want to inspire the most lively ardour,
> To submit every heart to your loveable laws,
> As in the golden age without paint or finery,
> Show yourself in a state of simple nature.[13]

Above and beyond the recurring critiques of cosmetic artifice found in the *Mercure de France* and elsewhere, the many hours women spent at the toilette were of grave concern to moralists and philosophers.[14] This idle time was thought to breed further moral failings, including narcissism, lust, and gossip. In this context, Jean-Siméon Chardin's *The Morning Toilette* serves as a pointed rebuttal (fig. 33). The burning candle, the clock indicating five minutes to seven, and the missal lying on chair suggest that the mother and daughter are preparing to attend an early mass.[15] Rather than portraying a leisurely morning of pampering and gossip, Chardin aligns the toilette with the liturgical clock, with bourgeois virtue rather than aristocratic indolence.

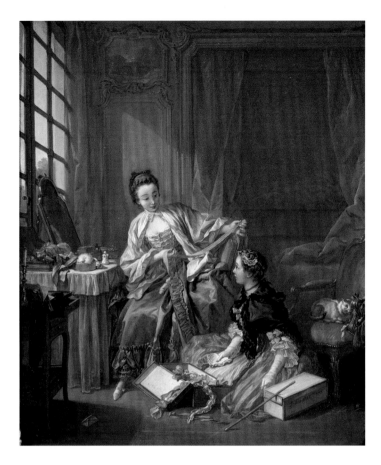

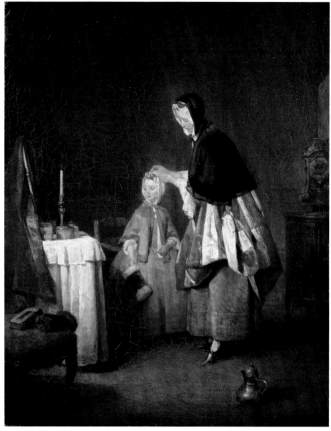

But it was precisely the bourgeois adoption of the toilette that incensed other critics. The comtesse de Genlis (1746–1830) remembered: "In the country and in Paris, women received visits from men at their toilette, which took a long time for hairdressing, because of the long hair and the curls. They got dressed, even changing their chemises and lacing their corsets in front of men."[16] Genlis found this custom "indecent"—not because it was immoral, but because it was a blatant, impertinent imitation of a rite properly conducted by queens and princesses.

At the same time, the French recognized that beauty was a form of power. "A charming woman uses more subtlety and politics in her dressing than there are in all the governments of Europe."[17] The prominent example of Madame de Pompadour (1721–1764), a commoner whose beauty allowed her into to the bed and confidence of King Louis XV (1710–1774, reigned from 1723), served as a cautionary—or inspirational—tale.[18] Thanks to the thriving cosmetics trade, beauty could be acquired by anyone. "In Paris, there is nothing easier than being beautiful; it is enough to have a head to give oneself a pretty face. Each woman keeps hers in a little

pot: age does not destroy it, because the pot is always refilled."[19] Cosmetics became synonymous with beauty itself, and beauty was a force to be reckoned with.

Display, Consumption, and the Toilette

Rather than an intimate, private moment, a woman's toilette was a performance before a large audience, who doubled as actors in the scene. "One went to women's toilettes as if to the theatre, and *petits-maîtres,* chambermaids, dogs, and *abbés* made up the decoration"[20] (see fig. 4). Thus, the accoutrements of the toilette combined luxury, novelty, and exoticism; to dress was to impress. Spending several hours in the act of dressing, attended by servants and lackeys, was a luxury in itself. Doing so surrounded by luxury goods like lace, porcelain, lacquer, silver, and tortoiseshell—all reflected in a large mirror, perhaps the most costly item of all—was the ultimate exercise in consumption and display.

The toilette table itself was the least of these luxuries. Often simply a wooden frame, it would be stored away when not in use, an operation sometimes facilitated by casters.[21] The table was unimportant because it was usually invisible, fully covered by a *petite toile* (little

Figure 32
FRANÇOIS BOUCHER (French, 1703–1770), *The Milliner*, 1746. Oil on canvas, 64 × 53 cm (25³/₁₆ × 20⁷/₈ in.). Stockholm, Nationalmuseum, NM 772. Photo: © Erik Cornelius – Hans Thorwid / Nationalmuseum, Stockholm.

Figure 33
JEAN-SIMÉON CHARDIN (French, 1699–1779), *The Morning Toilette*, ca. 1741. Oil on canvas, 49 × 39 cm (19⁵/₁₆ × 15³/₈ in.). Stockholm, Nationalmuseum, NM 782. Photo: © Erik Cornelius – Hans Thorwid / Nationalmuseum, Stockholm.

cloth). Originally of plain white linen, in the eighteenth century the humble *toile* began to be supplanted by less strictly utilitarian fabrics such as white taffeta and embroidered muslin. By mid-century, it was "entirely trimmed with lace."[22] As Anne Kraatz has pointed out, despite its persistent presence in the boudoir, lace had no erotic connotations in the eighteenth century; "it remained above all the symbol of class which it had always been."[23] All lace was handmade; a flounce large enough to cover a toilette table represented a significant financial investment (fig. 34). Paintings and inventories also record toilette tables swathed in richly colored velvet, taffeta, or satin, the *toile* often being fully lined and edged with metallic lace or fringe, although the top of the table generally remained white. Almost invariably, a short flounce bordered the top of the table, with a longer flounce or flounces falling to the floor. The word *toilette* also came to mean the rich, vibrantly colored textile that often hung on the back of the mirror.[24] These lavish textiles would disappear in the second half of the eighteenth century with the arrival of the purpose-built *table de toilette*, which concealed the toilette articles and mirror behind a rich, decorative facade of gilding and marquetry.

The mirror was the largest item in a toilette set (*service de toilette*) that could comprise more than two dozen pieces; a nineteen-piece French silver toilette set in the Detroit Institute of Arts includes a mirror weighing twenty-four and a half pounds (fig. 35).[25] At the time of her death in 1764, Madame de Pompadour owned a toilette set consisting of "two *quarrés*; two powder boxes; two others for patches; another *en pelo-ton*; another for roots, of rosewood; a mirror twenty inches high and eighteen wide, matching wood in its frame; two paste pots; two others for pomade; a little cup; a saucer of Sèvres porcelain; a goblet and two little bottles of Bohemian glass; a bell of silvered brass."[26] Toilette sets might also include miscellaneous items like tweezers, trays, knives, eyelash combs, funnels, chamber pots, eye baths, brushes, candlesticks, and candle snuffers. Men's toilette sets were also equipped with shaving bowls and implements.

Although most people had toilette sets made of painted or varnished wood, the elite chose more luxurious materials, like gold, silver, and vermeil.[27] Only five French-made eighteenth-century silver toilette sets have survived intact; many of them—and particularly their large mirrors—were patriotically melted down to help Louis XV finance the Seven Years' War, including one belonging to Madame de Pompadour.[28] It was during this time that lacquer and porcelain toilette sets came into fashion. A Sèvres porcelain toilette service in the Wallace Collection may have been commissioned by Pompadour, an enthusiastic collector of Sèvres (fig. 36).[29] The asymmetrical decoration and fanciful motifs of imported Japanese and Chinese lacquer appealed to the taste of the Louis XV period; due to its scarcity, it was as prestigious as it was fashionable. A team of Parisian craftsmen, the Martin brothers, specialized in lacquered wood objects in the Asian style, which were dubbed *vernis Martin*. Pompadour, who collected Japanese lacquer as well as Sèvres porcelain, owned a complete toilette set in *vernis Martin*.[30] Small items of imported or domestic lacquer could supplement toilette sets of precious metals, such as the lacquer box on the toilette table in Boucher's *Lady Fastening Her Garter* (fig. 37). Indeed, the dominant black and gold colors of Asian lacquer blended admirably with French-made gilt bronze.[31]

The basin (*jatte*) and ewer (*aiguière*) or water pitcher (*pot à eau*) were used to wash one's hands with scent-infused water after the toilette was finished.[32] At the outset of the eighteenth century, bathing was a rare luxury, even for the elite; clean water was scarce, and

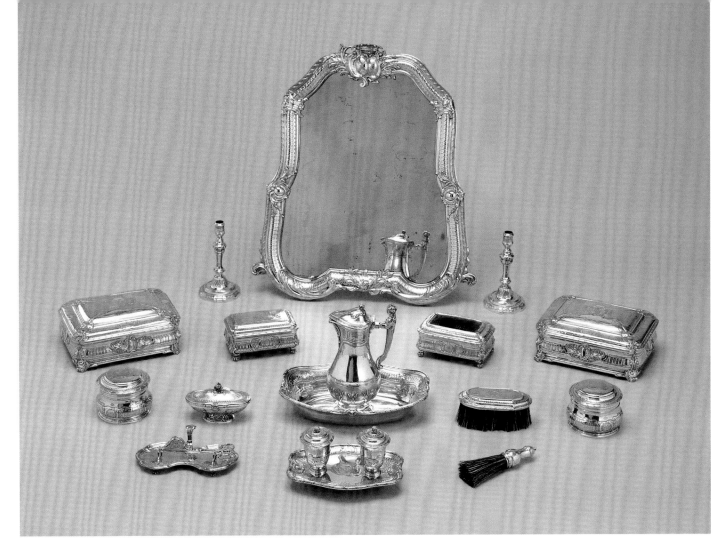

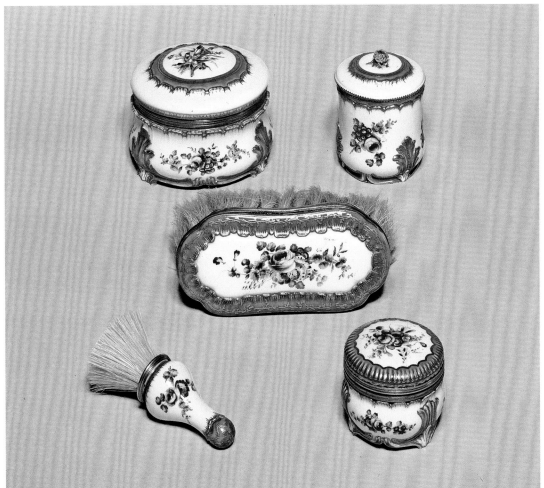

Figure 35
ANTOINE LeBRUN (French,
d. 1758, master in 1702) et al.,
*Toilette Service (service de
toilette)*, 1738–39. Silver;
modern mirror glass; boars' hair
bristles; silk velvet;
table mirror: 67.3 × 60.6 × 6.4 cm
(26½ × 23⅞ × 2½ in.). Detroit
Institute of Arts, Founders
Society Purchase, Elizabeth Parke
Firestone Collection of Early
French Silver Fund, 53.177–192.
Photo: courtesy of the Detroit
Institute of Arts.

Figure 36
Sèvres porcelain manufactory,
possibly painted by PHILIPPE
PARPETTE (French, active at
Sèvres 1755–57, 1773–86, 1789–
1806), *Toilette Service (service
de toilette)*, 1763. Soft-paste
porcelain, polychrome enamel
decoration, gilding; gold mounts;
brush bristles; wood; powder
box: 10.2 × 13.3 cm (4 × 5¼ in.).
London, Wallace Collection,
c458-65. Photo: © By kind
permission of the Trustees of the
Wallace Collection, London.

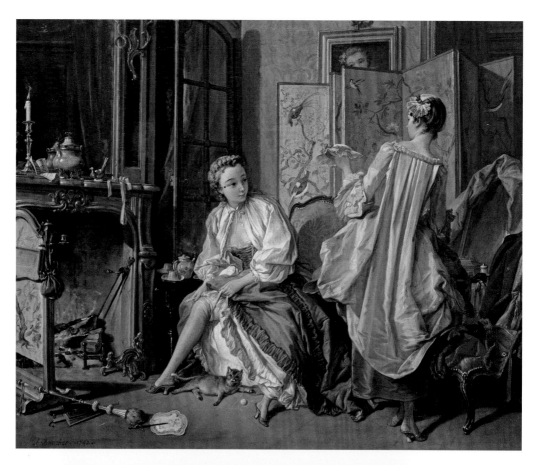

Figure 37
FRANÇOIS BOUCHER
(French, 1703–1770), *Lady Fastening Her Garter*, also known as *La Toilette*, 1742. Oil on canvas, 52.5 × 66.5 cm (20¹¹⁄₁₆ × 26³⁄₁₆ in.). Madrid, Museo Thyssen-Bornemisza, 58 (1967.4). Photo: © Museo Thyssen-Bornemisza, Madrid.

Figure 38
FRANÇOIS-HUBERT DROUAIS
(French, 1727–1775), *Family Portrait* (*Toilette*), 1756. Oil on canvas, 244 × 195 cm (96¹⁄₁₆ × 76¾ in.). Washington, D.C., National Gallery of Art, Samuel H. Kress Collection, 1946.7.4. Image: courtesy of the Board of Trustees, National Gallery of Art.

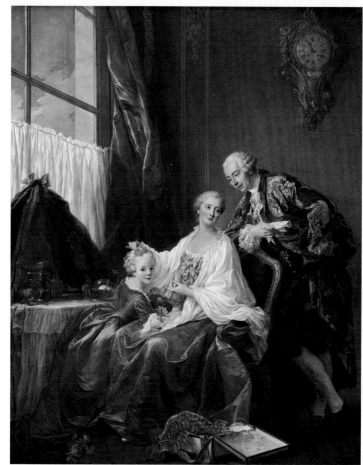

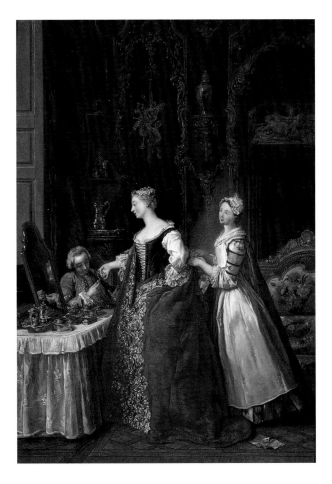

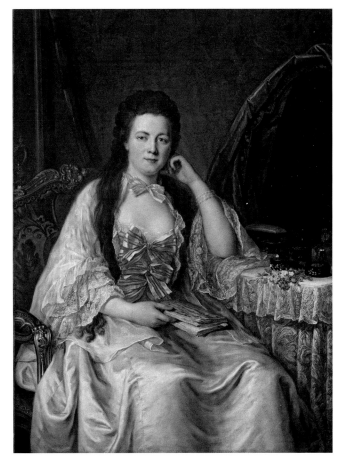

many doctors considered bathing—or even washing one's face with water—to be hazardous to the health.[33] People relied on perfume, as well as scented cosmetics and articles of dress, to mask body odors. The gold-mounted crystal ewers visible on the toilette tables in portraits by François-Hubert Drouais (fig. 38) and Jean-Marc Nattier (fig. 41), and the silver ewers and basins seen in the background of Jean-François de Troy's *A Lady Showing a Bracelet to Her Suitor* (fig. 39) and included in the Detroit toilette set testify to the perceived relationship between beauty and hygiene in the eighteenth century.[34]

Small boxes first appeared in toilette sets at the beginning of the eighteenth century. As the range of cosmetics and accessories expanded, toilette sets began to include more boxes of varied sizes and functions, designed to hold soap, sponges, combs, pins, jewelry, and other accessories as well as cosmetics. Pin boxes had lids covered in velvet pincushions, which were used for fastening clothing and attaching accessories and hair ornaments; they could double as jewelry boxes. Pin boxes are visible on the toilette tables in

Boucher's *The Milliner* and *Lady Fastening Her Garter;* they may be the same box (see figs. 32 and 37). Another appears in Guillaume Voiriot's *Femme à sa Toilette* (fig. 40); and there is an extant example in the Detroit toilette set. Root boxes (*boîtes à racine*) held aromatic plant roots and herbs used to freshen the breath and clean the teeth; the Detroit example is symbolically decorated with roots around its base.[35]

Women stored combs, brushes, and small accessories in square caskets called *quarrés* (Old French for "square"; now spelled *carré*). These multifunctional containers were available in various sizes; the Detroit set includes large and small pairs. A *quarré* graces the toilette table in Boucher's *The Milliner,* and, in Nattier's double portrait, Mademoiselle Marsollier holds a gilt-bronze–mounted tortoiseshell *quarré* filled with feathers, flowers, and other hair ornaments. A similarly shaped casket in the J. Paul Getty Museum is mounted in gilt bronze and elaborately veneered with precious materials like mother-of-pearl and horn (fig. 42a). The marquetry lid depicts the toilette of Venus, a witty reference to its function as a container for toilette articles (fig. 42b).

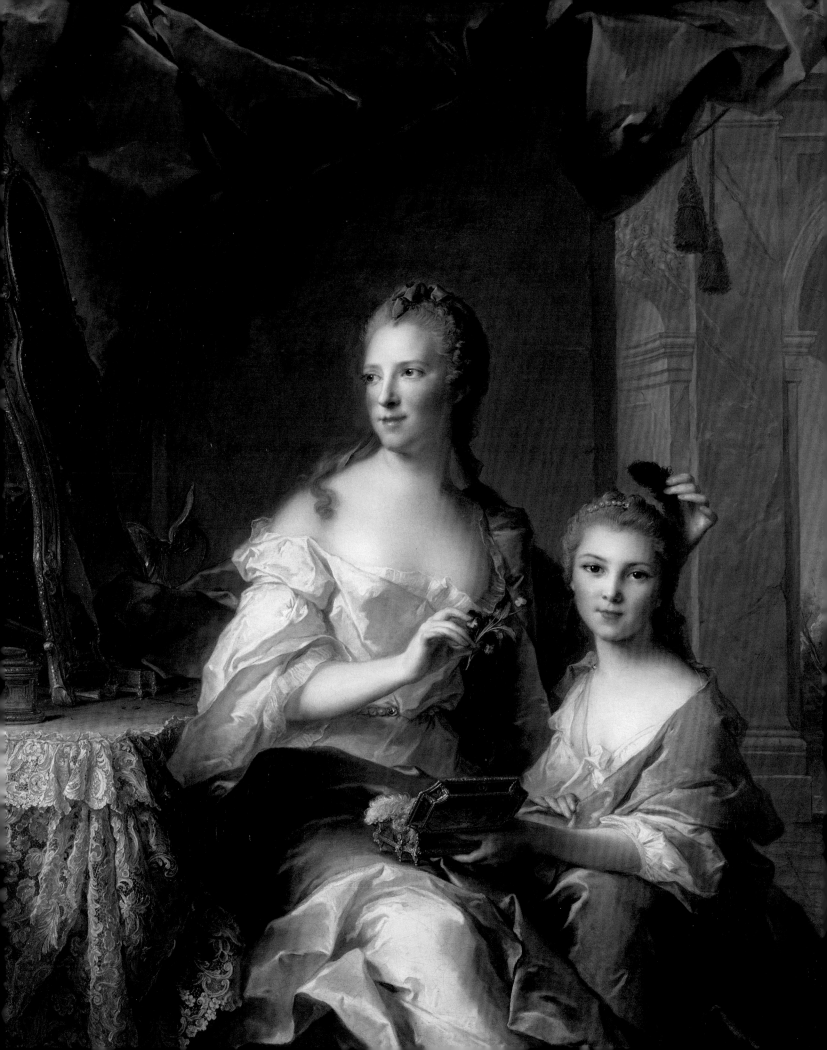

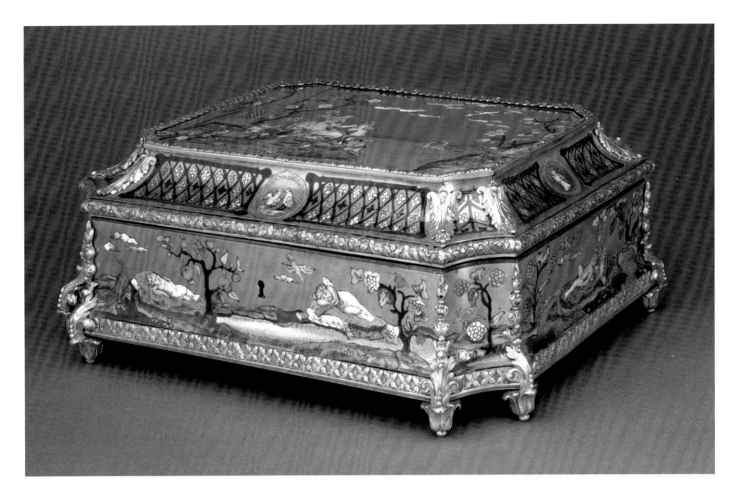

Figure 41
JEAN-MARC NATTIER
(French, 1685–1766),
*Portrait of Madame
Marsollier and Her
Daughter*, 1749. Oil on
canvas, 146.1 × 114.3 cm
(57½ × 45 in.). New York,
Metropolitan Museum
of Art, Bequest of Florence S.
Schuette, 45.172. Image: ©
The Metropolitan Museum
of Art / Art Resource, N.Y.

Figure 42a
Casket (carré de toilette),
French, ca. 1680–90. Wood
veneered with rosewood,
brass, mother-of-pearl,
pewter, copper, stained and
painted horn; gilt-bronze
mounts, 13 × 32.1 × 25.7
cm (5⅛ × 12⅝ × 10⅛ in.).
Los Angeles, J. Paul Getty
Museum, 88.DA.111.

Figure 42b
Detail of fig. 42a.

Figure 43
GILLES-EDMÉ PETIT (French,
1694–1760) after François
Boucher (French, 1703–1770),
*Le Matin: La Dame à sa
Toilette*, ca. 1734. Etching and
engraving, sheet: 31.4 × 21.5 cm
(12⅜ × 8 ½ in.). New York,
Metropolitan Museum of Art,
Harris Brisbane Dick Fund,
53.600.104. Image: © The
Metropolitan Museum of Art /
Art Resource, N.Y.

The first, messiest, and most time-consuming step in the process was having one's hair dressed, either by a talented maid or a professional hairdresser, who in the eighteenth century was almost always male. Coiffures had to be curled with hot irons, pomaded and powdered, and, finally, decorated with ribbons, feathers, and pompons—small ornaments named for Madame de Pompadour, who popularized them. Although the tedious first two steps are rarely depicted in toilette scenes, the final stage can be seen in canvases by Nattier, Drouais, Lancret, and Boucher, among others.

Pomade was a thick, scented cream, usually containing animal fat, or almond oil, and apples (*pommes*), from which the name derives.[38] Although some pomades served as face creams or cleansers, the principal function of pomade was to dress and scent the hair. Along with other types of cosmetics, pomades increased in number and variety over the course of the eighteenth century. As they became more essential to achieving the fashionable coiffure, new scents were introduced; by the 1740s, pomades perfumed with lemon, citron, and bergamot joined the traditional orange and jasmine. Traditionally sold in pots, from the 1750s pomade was also available in solid sticks, which permitted a more rapid and precise application, ideally suited to the more complex hairstyles then coming into vogue.[39] The Sèvres manufactory introduced "pots for sticks of pomade" to accommodate the new product.[40]

Perfumer's accounts indicate that pomade was almost always purchased together with hair powder, which had its own delicate scent. "Pomade made the application of powder possible.... Powder and pomade are therefore attached to each other by reciprocal necessities."[41] The fashion for hair powder originated as a tribute to the ageing Louis XIV.[42] Ironically, by imitating the gray hairs of old age, it masked one's true age, as did the wigs worn by men of all classes. This flattering quality may explain powder's lasting appeal. Like rouge, powder was "an artifice intended to be seen."[43] But it also served to camouflage the increasingly elaborate understructures used to create ever more complex edifices of hair, giving the head a smooth and uniform appearance.[44]

Powder, like pomade, was scented and sold by perfumers; small quantities would be mixed with inex-pensive, unscented starch before being applied to the hair.[45] Toilette sets usually include a pair of powder containers, suggesting the possibility of varying or mixing scents and shades. These containers had

Although the cosmetics themselves were relatively inexpensive compared to the decorative containers and applicators that formed part of the toilette set, they, too, functioned as status symbols; the very act of wearing makeup spoke volumes about one's social standing. "As the etymology of the word suggests, cosmetics were a sign of the wearer's proper place in the social cosmos and a sign of social distinction."[36] This was particularly true of rouge, although rouge was always worn as part of large and varied palette of cosmetics. By the later eighteenth century, cosmetics (as well as toilette accessories like brushes and mirrors) had become more affordable and more widely available, and wearing makeup was longer exclusive to the elite.

The heavy-handed application of paint, rouge, and powder continued to be confined to court circles, however, and it remained exclusive to France. Throughout the eighteenth century, foreigners commented on the quantity and garishness of makeup worn by French women. Lady Mary Wortley Montagu (1689–1762), visiting Paris in 1718, described them as being "so monstrously unnatural in their paint! their hair cut short, and curled round their faces, loaded with powder, that makes it look like white wool! and on their cheeks to their chins, unmercifully laid on, a shining red japan, that glistens in a most flaming manner, that they seem to have no resemblance to human faces."[37] The women, however, certainly resembled each other; their faces declared their Frenchness.

airtight seals to keep the contents dry and to prevent mites from infesting the powder. The lid of the Wallace Collection powder box (see fig. 36) is decorated with heads of wheat, of which starch was a by-product.[46] Powder containers had to be big enough to hold the large quantities of powder and starch needed to whiten the head, as well as a large powder puff (*houppe*). Powder puffs of swansdown begin to appear in perfumers' inventories at the beginning of the eighteenth century, the very moment when white hair powder began to play such a conspicuous part in male and female coiffures.[47] The *Encyclopédie* described the *houppe* as a little ball covered with feathers of eiderdown or the softest down of other birds, attached by the ends in a spherical arrangement.[48] Powder puffs equipped with small handles and resting in lidded powder boxes are prominently displayed on the toilette tables in Drouais's *Family Portrait (Toilette)* (see fig. 38), Boucher's *The Milliner* (see fig. 32) and *Le Matin* (fig. 43), and Jean-Michel Moreau le Jeune's *La Petite Toilette* (fig. 44). In the second half of the eighteenth century, the appearance of cheap powder puffs of wool, yarn, or cat hair testified to the widespread adoption of hair powder across French society.[49]

White linen peignoirs (from *peigner*, "to comb") protected ladies' clothes from powder, pomade, and other cosmetics. Toilette sets also included small, rectangular whisks (*vergettes*) used to dust excess powder from clothing.[50] A new accessory, the powder bellows (*soufflet en poire*), became common in toilette sets and scenes in the second half of the eighteenth century, replacing the powder puff. The bellows permitted a more regular and less wasteful application of powder than the powder puff, but it was less precise and necessitated the use of masks or long cones to protect the face.[51] White powder began to go out of fashion in the 1770s, but colored (and hair-colored) powders continued to be worn; in addition to scenting the hair, they absorbed oils.

Along with white hair, white skin was considered the feminine and aristocratic ideal. Women protected themselves from the sun with hats, veils, gloves, parasols, and masks and applied whitening creams and white face paint—*blanc*—to achieve the desired pallor. It was alleged that they even painted their veins blue to emphasize the whiteness of their skin.[52] Although *blanc* "was the most suspect cosmetic of all due to its noxious ingredients and ability to mask the wearer's true self," many women justified it as a means to cover blemishes or smallpox scars.[53]

From the late seventeenth century, small, shaped patches of black velvet or taffeta—called *mouches* (flies), because they were the size of a fly's wing—highlighted the whiteness of the skin and also communicated a range of flirtatious messages depending on where they were placed.[54] The seated figure in Boucher's *Lady Fastening Her Garter* wears one, and *Le Matin* depicts a woman applying patches. The caption to Gilles-Edmé Petit's engraving of the now-lost painting reads:

> These artificial spots
> Give more vivacity to the eyes and to the complexion,
> But by placing them badly, one risks
> Blighting beauty with them.[55]

By 1768, some men had adopted them as well, and "this fashion unknown to the ancients has become so esteemed, that most girls and ladies do not consider

Figure 44
PIETRO ANTONIO MARTINI (Italian, 1738–1797) after JEAN-MICHEL MOREAU LE JEUNE (French, 1741–1814), *La Petite Toilette*, 1781. Etching and engraving, plate: 40.9 × 31.8 cm (16⅛ × 12⁹⁄₁₆ in.). New York, Metropolitan Museum of Art, 33.6.28. Image: © The Metropolitan Museum of Art / Art Resource, N.Y.

themselves fully dressed without patches."[56] Many of the characteristic boxes used for storing patches survive, including those in the Detroit and Wallace Collection toilette sets.

Rouge restored color to faces painted white. "Good taste dictated that rouge should be very thick, that it should touch the lower eyelids. That, they said, gave fire to the eyes."[57] The taste for wearing rouge is difficult to comprehend today. Indeed, it perplexed contemporary observers as well. In 1763, Smollett noted the rouge "daubed on their faces, from the chin up to the eyes, without the least art or dexterity" and complained that "this horrible masque," as he called it, "destroys all distinction of features."[58] But conformity, not "distinction of features," was precisely the point of wearing rouge. It rendered all women identically unnatural and identified them as members of an exclusive sorority.

Rouge imitated the enticing glow of a blush. What this blush signified—modesty, good health, or sexual excitement—was open to interpretation. But this counterfeit flow of blood to the cheeks also evoked another kind of blood: nobility. In France, heavy rouge was reserved for the elite. "It is a mark of distinction which no bourgeoise dare assume."[59] The court led the fashion; foreign princesses adopted rouge when they married into the royal family. *L'Encyclopédie* disparaged the practice of wearing rouge but conceded: "For a long time, it has been one of the marks of rank or fortune among us."[60] Therefore, women who wore rouge did so as a badge of honor, laying it on thickly and taking no trouble to hide their artifice.

In January 1774, comte Axel Fersen (1755–1810) attended the toilette of one of these women, a comtesse. He recorded in his diary:

> After having powdered herself, she took a little silver knife, about a finger long, and carefully removed the powder, going over her face several times. Then one of her women, of whom she had three, brought a large box, which she opened; in it were six pots of rouge, and another box, small, which was full of a pommade that seemed to me black. The Comtesse took some rouge on her finger and daubed it on her cheek, it was the prettiest rouge that ever was; she increased it by taking more from all the six pots, two and two.[61]

Although available in powder and liquid form, it was the creamy *rouges en pot* that influenced the design of toilette sets. This rouge was sold in decorative containers worth far more than the product itself.

In addition to selling complete toilette sets, the Sèvres manufactory contracted with rouge and perfume merchants to produce containers for their wares. Merchants sold the same rouge at different price points depending on the packaging; customers could even supply their own jars.[62]

The discrepancy between rouge's prestige and its low price did not go unnoticed. In his satirical *Avis aux dames*, Charles-Nicolas Cochin remarked: "It is surprising that such distinction has been attached to a color so common and inexpensive that even the lowliest *grisettes* can make this expenditure as abundantly as a person of the highest birth."[63] Indeed, in the second half of the century, rouge was adopted by the middle and lower classes, though never with the same vehemence as the upper classes. By 1750, Cochin could make a distinction between the boldly rouged cheeks of the nobility and the more natural-looking rosy complexions of bourgeois women.

If rouge was a mark of nobility, it was also a prerogative of youth; the comtesse de Genlis gave up rouge on her thirtieth birthday in 1776, explaining: "Old women who always wore rouge were talked about, and criticized."[64] Many of the moral attacks on rouge were specifically directed at old or low-class women who wore rouge, rather than the practice of wearing rouge itself.[65]

The final step of the toilette, after the application of hair and makeup, was getting dressed—or rather, being dressed. In the Louis XV period, it was virtually impossible for a woman with any aspirations to fashionability to dress herself without the help of servants and a hairdresser. A complete ensemble consisted of many separate garments and ornaments that were pinned, tied, or basted into place by a servant and could be taken apart and rearranged according to individual flair or caprice. (Hence, the presence of pin boxes and pincushions in toilette sets). The large quantities of fabric in voluminous *robes volantes* and *robes à la française*, as well as the number of decorative accessories worn by women, made assistance with dressing necessary. If women fastening their garters are over-represented in French genre painting, it may be because that was one of the few acts of dressing a woman could perform by herself.

In addition to physical assistance, advice from friends was useful and encouraged. The eighteenth-century woman's outer attire was a complex assemblage of detachable parts, usually consisting of a gown, stomacher, and petticoat. Similarly, her jewelry was charac-

terized by its versatility: every piece was detachable and interchangeable, so a brooch might be worn alone, or dangling from a necklace, or nestled in a headdress (see fig. 64). Hats, caps, gloves, sleeve ruffles, fans, lappets, tippets, mantles, fichus, and pockets were not optional extras but essential components of fashionable dress. Because the cut of garments remained relatively stable over the course of the eighteenth century, it was these trimmings and accessories—provided by the milliner (*marchande de modes*)—that determined whether or not one was *à la mode*.[66] Before the complicated physical act of dressing came the collaborative, performative process of selecting garments, accessories, and trimmings from a wide array of choices, demonstrating one's good taste and personality while also showing off graceful hands, arms, and, occasionally, legs.[67]

Perhaps for lack of a linear narrative, toilette scenes and portraits often focus on the drama of this moment of decision, in which the female protagonist chooses an ornament from a chic cornucopia: a bandbox, *chiffonier*, or *quarré* bursting with fashionable luxuries. Nattier captures the care with which Madame Marsollier contemplates the effect of a feather for her daughter's hair or, alternatively, a sprig of yellow flowers. Boucher's and Lancret's maids present caps, as if waiting for a sign of approval. The woman in *The Milliner* considers a ribbon from an open bandbox teeming with them, to add to her already overflowing *chiffonier* and toilette table. A similar bandbox overflows in Drouais's *Family Portrait*. De Troy's protagonist in *A Lady Showing a Bracelet to Her Suitor* seems to be soliciting his opinion or flaunting her possession, which bears his portrait (a similar portrait-bracelet can be seen in Valade's portrait of Madame Faventines; see fig. 12). These images are studies in abundance: mountains of ribbons, flowers, and feathers; chairs and sofas piled with garments; powder puffs protruding from powder boxes; teapots pouring; and workbags trailing thread. They excite the sense of sight as well as that of touch.

Mimi Hellman has argued that among the eighteenth-century elite, "objects possessed many of the same surface qualities as the richly clothed bodies of their users."[68] Just as beauty and cosmetics are synonymous, the female body takes on the properties of the toilette table, and vice versa. Ribbons, flowers, feathers, combs, cosmetics, lace, pearls, powder, rouge, and patches migrate from the toilette table to the body and back in a seamless exchange. The linen and lace flounces of the skirted toilette table are reflected in deli-

cate white peignoirs, tied at the neck to reveal triangles of equally delicate white flesh, or in the exquisite sleeve ruffles (*engageantes*) worn by the subject of Voiriot's *Femme à sa Toilette*. The cats, dogs, parrots, and monkeys who are frequent witnesses to their mistresses' toilettes find their fur and feathers appropriated for sable-trimmed cloaks and powder puffs. In Drouais's *Family Portrait*, the textiles at the window are echoed in the mother's and daughter's garments; the triangular swathe of drapery framing the mirror repeats the silhouette of the mother's *peignoir*. The woman is reflected not just in the mirror (if, indeed, her reflection in the mirror is visible at all, which it seldom is in these images) but in the accoutrements of the toilette spread out before her.

The Toilette Portrait and the Fabrication of Femininity
Explicitly or implicitly, eighteenth-century toilette scenes referenced the famous toilettes of antiquity, Venus and Psyche. Portraits of women as Venus, in particular, allowed for "a bold display of the sitter's mostly naked charms" as well as making a "flattering allusion" to the sitter's likeness to the goddess of love.[69] Roses and pearls—emblems of Venus—were equally at home on the eighteenth-century toilette table.

Scenes from the lives of the gods were common currency in rococo art, with its sensual, light-hearted interpretations of classical mythology. Boucher painted the definitive eighteenth-century version of the toilette of Venus in 1751 for Madame de Pompadour's bathroom at Bellevue (fig. 45). Although not a portrait, the reference to Pompadour was obvious; Louis XV's mistress had played the title role in *La Toilette de Vénus, ou le Matin*, a ballet performed at Versailles in 1750, and her own morning toilette was famously the site of intellectual conversation and political intrigue. (Venus also wears Pompadour's namesake hair ornaments.) *La Toilette de Vénus* is a genre painting elevated to the status of history painting; like the contemporary toilette scenes discussed above, it exudes abundance, luxury, and exoticism and assembles a large cast of characters to assist at the toilette. Boucher has even positioned the curtain at right to cover the back of the mirror, in imitation of a toilette table.

Toilette portraits frequently depicted brides, as they offered an "opportunity to record the largesse of the husband in providing an expensive silver toilette service"—a traditional wedding gift from husband to wife—"while immortalizing the beauty of the young wife."[70] Louis-Michel Van Loo's portrait of Pompadour's

brother, the marquis de Marigny (1727–1781), and his eighteen-year-old bride includes a still life of her wedding gift from her husband, a silver toilette set (fig. 46). Alternatively, the toilette set might form part of a woman's trousseau. Louis XV's twin daughters, Elisabeth (1727–1759) and Henriette (1727–1752), received toilette sets of *vernis Martin* for their twelfth birthdays; Elisabeth married days later, so hers doubled as a wedding gift.[71] The Detroit toilette set—a superb example of French craftsmanship—was included in the French owner's trousseau when she married a Portuguese nobleman, the duc de Cadaval (1684–1749), and thus reflected her family's wealth and status rather than her husband's, though both families' coats of arms are engraved on all nineteen pieces.[72]

The toilette portrait itself was a potent status symbol, as demonstrated by Nattier's *Portrait of Madame Marsollier and Her Daughter*, exhibited at the Salon of 1750 (see fig. 41). Marsollier (d. 1756) was the wife of a successful Parisian textile merchant. As the daughter of a minor courtier, she was mortified by her husband's trade, and her portrait attempts to rehabilitate her image. Her choice of Nattier—and, by implication, her ability to afford him—"was in itself a statement about her position in the world."[73] Her insistence on a toilette portrait, an anomaly in the prolific portraitist's oeuvre, was also a statement; in portraiture, such iconography was associated with noble and courtly women.

The subject gave Marsollier the opportunity to show off her seminude charms and, more importantly, her possessions, including an impressive toilette set with a large mirror. As Donald Posner has pointed out, the mythological and allegorical portraits, or *portraits déguisés,* with which Nattier had made his name, provide "at most only minimal information about the sitter's actual position and circumstances in life. People more secure about their place in the world than Madame Marsollier did not, of course, need to call attention to what everyone knew quite well....She wanted to display evidence of her real-life distinction."[74] The luxury textiles in the portrait advertise her wealth while explicitly referencing its source.

Although portrayed at the toilette table, Marsollier and her daughter are fully dressed and coiffed, with the exception of the mother's few finishing touches to her daughter's coiffure. This is not in itself unusual; however, the sitters are dressed for a very specific occasion. While their white garments resemble shifts and peignoirs (and, in the case of the daughter, may indeed be just that), they are not actually *en déshabillé*, but rather draped in picturesque and sensual swathes of colorful satin drapery worn only to be immortalized on canvas. Such draperies are part of a long tradition of allegorical portraiture, including Nattier's, and contemporary observers would have recognized that the mother and daughter were wearing neither undergarments nor fashionable outer garments but a mishmash of classical, pastoral, and theatrical draperies. The architectural background is as much of a fantasy and a painterly conceit as the costumes. Combined with the highly realistic and specific toilette articles, their costumes suggest that the two women are primping to have their portrait painted in Nattier's characteristic style—a witty fusion of two popular genres of portraiture. Thus, the artist managed to combine his own preference for timeless, sensual allegory with Marsollier's desire for a showy toilette portrait in the courtly tradition.

It is significant that many toilette scenes and portraits depict mothers and daughters, including the canvases by Drouais and Chardin discussed previously.[75] Just as women in toilette scenes fabricate their own femininity, they gently instruct the next generation in the secrets (if they can be called that) of the toilette. The artist's use of coordinating attire—the matching capes, hoods, and muffs in Chardin; the asymmetrical drapery and bare nipples in Nattier; the uniformly unnatural hair and makeup in Nattier and Drouais—underlines the point. Any suspicion that the mother might be jealous of her daughter's youth and beauty, a common trope in French fiction and theater, is undermined by their very sameness; thanks to the improving and conforming effects of the toilette, one can hardly tell them apart. Indeed, it is the daughter, and not the large mirror, that perfectly reflects the mother's beauty and fashionability.

While depictions of men's toilettes were fairly common in the later seventeenth century, and numerous documentary sources testify to their continued existence in the eighteenth century, the few extant examples from the period of Louis XV are satirical or foreign.[76] This may be partly explained by the fact that men did not spend as much time at their toilettes as women did, whether because their clothing and hairstyles (or, properly, wigs) required less effort, or because they preferred to spend their mornings conducting business or else riding or hunting, in imitation of the king. It is also true that men of all classes went to barbers' and wigmakers' shops to have themselves shaved and powdered, a practice well documented in popular prints. In the 1770s, however, this practice

Figure 45
FRANÇOIS BOUCHER (French, 1703–1770), *Toilette de Vénus,* 1751. Oil on canvas, 108.3 × 85.1 cm (42⅝ × 33½ in.). New York, Metropolitan Museum of Art, Bequest of William K. Vanderbilt, 1920, 20.155.9. Image: © The Metropolitan Museum of Art / Art Resource, N.Y.

began to decline; by the time of the French Revolution, Nicolas-Edmé Restif de la Bretonne claimed he was "the only man in Paris" who still followed this custom.[77] In Moreau le Jeune's *La Petite Toilette* of 1781, a man is having his hair curled and powdered at home in the new fashion, surrounded by many of the actors and accoutrements familiar from female toilette scenes (see fig. 44).

Changing gender norms—and the anxiety surrounding them—were manifested in the increasing association of bodily adornment with effeminacy. The definition of *toilette* in *L'Encyclopédie* included those of men, "who in our time have become women."[78] It is true that in the eighteenth century, rouge, powder, paint, and patches were worn by both sexes, along with lace, fur, high heels, muffs, jewels, and embroidery. But that had been the case in the seventeenth century, as well. Instead of men themselves, this critique may have been directed at the women who exposed their male visitors to the secrets—and pleasures—of the toilette. As Smollett observed:

> A Frenchman in consequence of his mingling with the females from his infancy, not only becomes acquainted with all their customs and humours; but grows wonderfully alert in performing a thousand little offices, which are overlooked by other men, whose time hath been spent in making more valuable acquisitions. He enters, without ceremony, a lady's bed-chamber, while she is in bed, reaches her whatever she wants, airs her shift, and helps to put it on. He attends at her toilette, regulates the distribution of her patches, and advises where to lay on the paint. If he visits her when she is dressed, and perceives the least impropriety in her *coeffure* [sic], he insists upon adjusting it with his own hands: if he sees a curl, or even a single hair amiss, he produces his comb, his scissars, and pomatum, and sets it to rights with the dexterity of a professed *friseur*.[79]

Similarly, when Abigail Adams (1744–1818) encountered the U.S. naval hero John Paul Jones (1747–1792) living in Paris in 1784, she was disappointed to find him thoroughly Frenchified: "He...understands all the etiquette of a lady's toilette, as perfectly as he does the mast, sails and rigging of his ship.... He knows how often the ladies use the baths, what color best suits a lady's complexion, what cosmetics are most favorable to the skin."[80] These foreigners' accounts are not merely satirical or xenophobic; they are confirmed by French sources. Geneviève Randon de Malboissière (1746–1766), a

Parisienne, wrote of a suitor in 1764: "At 8:00 he is in my room, assisting at my toilette, powdering me, putting on my slippers, attaching my bracelets, fastening my necklace, putting on my rings."[81] According to the contemporary satirical publication *L'Espion chinois* (*The Chinese Spy*), "Frenchmen spend their life at ladies' toilettes or in back alleys."[82] Indeed, Louis-Antoine Caraccioli blamed men's preoccupation with their own toilettes on youths spent "in the midst of curlpapers and mirrors."[83] If the hours a woman spent at her toilette were morally suspect, the time a man spent there was doubly so. However, Morag Martin posits that satirical portrayals of the male toilette were intended to curb the excesses of the female toilette, rather than the male one. "The male version of the coquette provided a mirror in which women could recognize the absurdity of their behavior."[84] A realistic portrayal of a male toilette could only legitimize the female version, which was itself held responsible for the feminization of French men.

Moral critiques of female artifice and frivolity centered on the toilette—or, alternatively, the voyeuristic images of half-dressed women that proliferated in the later eighteenth century—overlook the important social (and, in some cases, political) ramifications of the toilette. Visual and documentary records, as well as the contents of toilette sets and, later, mechanical toilette tables, indicate that dressing was only one of a wide range of activities and rituals of sociability that a woman performed in quasiprivate in the morning.

Despite their intimations of gallantry, most toilette scenes from the first half of the eighteenth century reveal very little. The breasts bared over the tea table in Lancret's *Morning* are the exception, not the rule (see fig. 4). Madame Marsollier wears her provocative drapery in spite of the fact that she is being portrayed at her toilette, not because of it. In de Troy's *A Lady Showing a Bracelet to Her Suitor*, the voyeurism is directed at the male visitor, as the overdoor depicting a nymph gazing at her nude lover suggests.[85] That is not to say that there is not a seduction taking place, but it is one rooted in desire for the clothed body, not the nude one hidden (or just visible) beneath the sumptuous surface. Martin calls the toilette a "reversal of the strip show."[86] It is the performance of taste and decorum encoded in a woman's choice of fashions and graceful application of cosmetics—and in her elegant toilette equipment—that seduces her beholders.

Furthermore, these scenes are strewn with clues to the wide variety of activities that took place in the

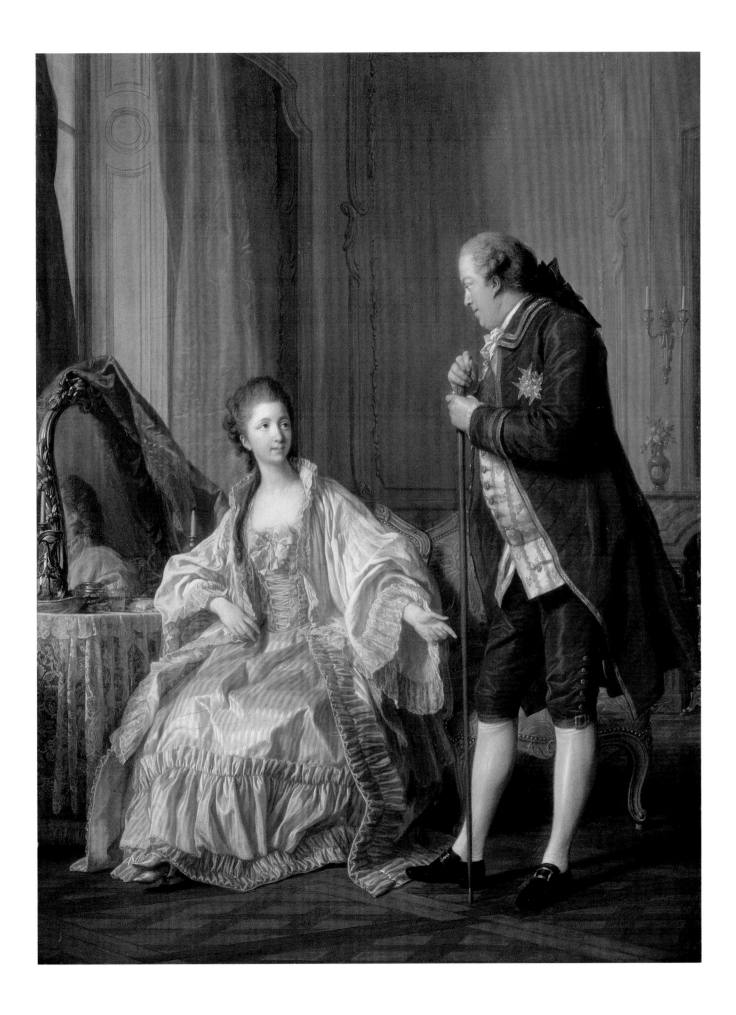

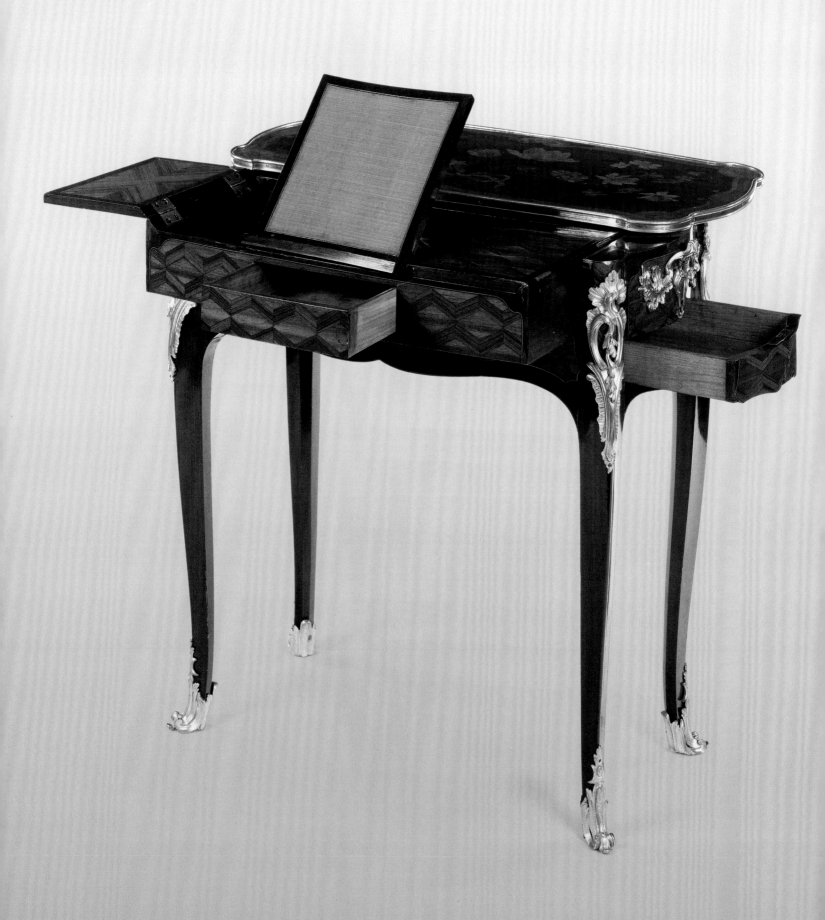

morning, and in women's lives in general in the eighteenth century. Tea tables set for two, open books, letters, missals, visitors, cloaks—all hint at interests, destinations, and activities beyond the immediate business of the toilette, even if those activities may take place within the same circumscribed physical and temporal space. The women in these scenes are not female Narcissi gazing at their own reflections for hours on end. On the contrary, they turn their backs on their mirrors to converse with husbands, *abbés*, and milliners, or to confront the viewer directly. In many cases, they are already fully dressed, coiffed, and made up and are simply applying the finishing touches: caps, garters, patches, hair ornaments. Voiriot's *Femme à sa Toilette* is a rare image of an eighteenth-century woman—even one at her toilette—with loose, unpowdered hair. Her body is turned away from the table and the mirror; her finger marks the page of her book.[87] She seems wholly uninterested in the beautiful and costly lacquer toilette set and lace flounces. The viewer has interrupted her reading, not her toilette.

The act of dressing (and hairdressing) was unusually complicated and collaborative in mid-eighteenth-century France. A lengthy toilette did not necessarily imply a self-indulgent waste of the morning hours. Rather, it was precisely because the fabrication of fashionable femininity took so much time that many elite women socialized and transacted business during the toilette. In common with many of her contemporaries, Geneviève Randon de Malboissière used the time to write letters, ending one of them with the explanation that: "[The hairdresser] is leaving, I am waiting for M. Huber [her German tutor]; I have to brush off my powder and put on a dress."[88] Her correspondence offers a picture of industry, not idleness. It was during their toilettes that women read books, wrote letters, breakfasted, shopped, entertained, and studied music or languages.

The widespread practice of receiving visitors at the toilette is bound up with the development of sociability in the eighteenth century. Tellingly, in 1702, the princess Palatine complained that toilette mirrors had become so high that you could no longer see what was going on in the room.[89] The toilette was "an occasion for defining the intellectual, social, and political universe of the protagonist through the exchange of information and ideas on a wide range of subjects, and the forging or reiteration of relationships involving various patterns of allegiance, obligation, and power."[90] Madame de Pompadour's is perhaps the ultimate example of the power toilette. From the late 1740s, Pompadour took advantage of the informal nature of the toilette to advance her political agenda while circumventing court etiquette. "Pompadour's toilette became celebrated for the amount of business that the marquise transacted at it."[91] Just as French women imitated the fashions she wore, they must have used Pompadour's toilette as a model for their own ambitious social goals.

In the second half of the eighteenth century, dedicated *cabinets de toilette* and specialized furnishings containing the toilette articles became increasingly common, eliminating the need for multifunctional tables, elaborate toilette sets, and lavish textiles.[92] The ingenious new *tables de toilette* incorporated built-in mirrors, cosmetics containers, and grooming implements that could be hidden away easily when not in use (fig. 47). Combined with low-backed swivel chairs (*chaises de toilette*) designed to facilitate the hairdressing process, these *coiffeuses* and *poudreuses* combined novelty with convenience.

But that is not all they offered. Along with pots of rouge and powder puffs, these tables concealed items wholly unrelated to dress and cosmetics, like writing and sewing implements. A *table de toilette* in the Metropolitan Museum of Art of about 1775 is equipped with a complete breakfast service for two (including egg cups, salt cellar, and cutlery), as well as cosmetics containers.[93] The multitasking character of the female toilette was inscribed in these new furnishings.

At the same time, however, the toilette became increasingly portable. Pocket-sized boxes equipped with small mirrors for applying rouge and tweezers and gum for attaching patches—the ancestors of the modern compact—allowed their owners to make their toilette any time of the day or night. "Many ladies refresh their beautiful rouged cheeks without ceremony, at their convenience, wherever they find themselves."[94] The toilette, an activity once synonymous with the morning hours, became an all-day affair; although it had never been truly private, it now put on a very public face.

Figure 47
JEAN-FRANÇOIS OEBEN (German, naturalized French, 1721–1763), *Mechanical Writing and Toilette Table* (*table mécanique de toilette*), ca. 1750. Oak veneered with kingwood, amaranth, bloodwood, holly, and various stained exotic woods; drawers of juniper; iron mechanism; silk; gilt-bronze mounts; 73 × 74 × 37.8 cm (26¾ × 29⅛ × 14⅞ in.). Los Angeles, J. Paul Getty Museum, Gift of J. Paul Getty, 70.DA.84.

NOTES

1. Montesquieu 1914, p. 172: "Le rôle d'une jolie femme est beaucoup plus grave qu'on ne pense: il n'y a rien de plus sérieux que ce qui se passe le matin à sa toilette, au milieu de ses domestiques: un général d'armée n'emploie pas plus d'attention à placer sa droite ou son corps de réserve qu'elle en met à poster une mouche, qui peut manquer, mais dont elle espère ou prévoit le succès." Unless otherwise indicated, all translations are by the author.

2. For a description of the *lever* of Louis XIV, see Saint-Simon 1856–58, vol. 13, pp. 88–89.

3. Loosely translated: fashion picture.

4. See, for example, Charles-Antoine Coypel's *Jeux d'Enfants* (1728), Christophe Huet's *Petite singerie* at the château de Chantilly (1735), and Charles-Germain de Saint-Aubin's engraving *La Toilette* from the series *Essais de papilloneries imaginaires* (1748).

5. Mercier 1782–88, vol. 6, pp. 148–49: "La seconde toilette n'est qu'un jeu inventé par la coquetterie. . . . Si l'on tresse des longs cheveux flottans, ils ont déjà leur pli et reçu leurs parfums. . . . Si l'on plonge un bras d'albâtre dans une eau odoriférante, on ne peut rien ajouter à son poli et à sa blancheur."

6. Cosmetics heightened the theatricality of the toilette, as they were also used onstage. See Cochet 1998, p. 111.

7. Palmer 2008, p. 200.

8. Smollett 1919, p. 56.

9. Walker 2008, p. 54. See also the chapter by Charissa Bremer-David in this volume.

10. Goudar 1765, vol. 2, p. 73: "La beauté des femmes en France se remonte tous les matins, comme une pendule, on dirait que leurs charmes sont à vis: c'est une fleur qui renaît et meurt dans un jour."

11. Cochet 1998, p. 103.

12. Martin 2009, pp. 19–21

13. "Les dieux ont pris plaisir à vous rendre parfaite, / Et ses vains ornemens qu'à tort vous empruntez, / Ne servent qu'à cacher de réelles beautés; / Quitez donc pour toujours, Philis, votre toilette, / Voulez-vous exciter les plus vives ardeurs, / A vos aimables loix soumettre tous les coeurs, / Ainsi qu'en l'âge d'or sans fard et sans parure, / Montrez-vous dans l'état de la simple nature." For further examples of verses on vanity and makeup, see Goodman-Soellner 1987, pp. 53–55.

14. See, for example, *Mercure de France*, October 1730, vol. 19, p. 224.

15. Ottawa–Washington–Berlin 2003, p. 200.

16. Genlis 1996, p. 105: "Les femmes recevaient à la campagne et à Paris des visites d'hommes à leur toilette, qui était longue pour la coiffure, à cause des longs cheveux et de la frisure. Elles s'habillaient, même changeaient de chemises et se laçaient devant des hommes. Cet usage, presque universel pour les femmes de la Cour, m'a toujours paru intolérable. Cette indécence venait d'une imitation d'air de grandeur, parce que les reines et les princesses du sang faisaient ainsi leur toilette en cérémonie."

17. *Petit Dictionnaire de la Cour et de la vie* (1788), quoted in London–Glasgow 2008, p. 81.

18. Festa 2004, pp. 35–36.

19. Goudar 1765, vol. 2, p. 104: "Il n'y a rien de plus aisé à Paris que d'avoir la beauté; il suffit d'avoir une tête pour se donner un joli visage. Chaque femme conserve le sien dans un petit pot: l'âge ne le détruit pas, parce que le pot se renouvelle toujours."

20. *Le papillotage* 1769, p. 110: "On courut à la toilette de femmes comme au théâtre, & des petits-maîtres, des filles de chambre, des chiens & un abbé en firent la décoration."

21. London–Glasgow 2008, pp. 82–83.

22. Diderot and Le Rond d'Alembert 1751–65, vol. 16, p. 382, s.v. "Toilette": ". . . garnie de dentelle toute autour."

23. Kraatz 1989, p. 80.

24. Diderot and Le Rond d'Alembert 1751–65, vol. 16, p. 382, s.v. "Toilette."

25. Albainy 1999, p. 18.

26. Cordey 1939, p. 164: ". . . deux quarrés; deux boestes à poudre; deux autres à mouches; une autre en peloton; une autre à racine, de bois de rose; un miroir de vingt pouces de haut sur dix-huit de large, dans sa bordure de pareil bois; deux pots à pâte; deux autres à pommade; une petitte [sic] tasse; une soucoupe de porcelaine de Sève [sic]; un gobelet et deux petits flacons de verre de Bohème; une sonnette de cuivre argenté."

27. Carlier 2004, p. 6. For an examination of a gold toilette set made for Queen Sophie Magdalene of Denmark in 1731–32, see Boesen and Lassen 1951.

28. Carlier 2004, p. 6.

29. See Savill 1988, vol. 2, pp. 719–27.

30. Cordey 1939, p. 63.

31. Watson 1963, p. 106.

32. The water pitcher was pot-bellied, while the ewer, which was heavier, was straight-sided and conical. Some royal toilet sets included both types of vessels; see Carlier 2004, p. 11. For a discussion of the wide variety of scented waters available in the eighteenth century, see Albainy 1999, p. 19.

33. For a discussion of eighteenth-century attitudes towards bathing, see Perrot 1984, pp. 19–31.

34. For a discussion of this relationship, see Cochet 1998, p. 103. A comparable crystal and gold ewer with a matching basin dating to 1727 or 1730 is in the Wallace Collection (no. IA27).

35. Carlier 2004, pp. 10–13; Albainy 1999, p. 19.

36. Hyde 2000, p. 458.

37. Montagu 1893, vol. 1, p. 396.

38. Albainy 1999, p. 19.

39. Lanoë 2008, pp. 72–73.

40. Savill 1988, vol. 2, p. 719: "…pots pour bâtons de pommade."

41. Lanoë 2008, pp. 72–73: "La pommade rend possible la fixation de la poudre.… Poudre et pommade sont donc rattachées l'une à l'autre par des nécessités réciproques qui les éloignent toujours davantage de leurs qualités originelles de parfums."

42. De Marly 1987, p. 117.

43. Lanoë 2008, p. 70: "…un artifice destiné à être vu."

44. Lanoë 2008, pp. 72–73.

45. Lanoë 2008, pp. 188–92.

46. Savill 1998, vol. 2, p. 721.

47. Lanoë 2008, p. 75.

48. Diderot and Le Rond d'Alembert 1751–65, vol. 8, p. 326, s.v. "Houppe."

49. Lanoë 2008, p. 76.

50. Carlier 2004, p. 13.

51. Lanoë 2008, pp. 76–77.

52. "An Essay on Fashions, Extracted from the Holland Spectator," *Gentleman's Magazine* (July 1736), p. 377.

53. Martin 2009, pp. 102, 123.

54. For a discussion of the languages of patches, see Guillemé-Brulon 1983, p. 38; and Cochet 1998, p. 112.

55. "Ces taches Artificielles / Donnent aux yeux, au Teint plus de vivacité; / Mais en les plaçant mal, on s'expose avec elles / A défigurer la beauté."

56. L. A. de Caraccioli, "Mouche," *Dictionnaire critique* (Lyon, 1768), quoted in Cochet 1998, p. 112. "Cette mode inconnue des anciens, s'est tellement accréditée, que la plupart des Demoiselles et des Dames se regardent comme n'étant pas habillées, lorsqu'elles n'ont pas de mouches."

57. Vaublanc 1857, p. 133: "Le bon ton voulait que le rouge fût très-épais, qu'il touchât les paupières inférieures des yeux. Cela, disait-on, donnait du feu aux yeux."

58. Smollett 1919, p. 56.

59. Smollett 1919, p. 56.

60. Diderot and Le Rond d'Alembert 1751–65, vol. 14, p. 402, s.v. "Rouge": "Il est depuis assez long-tems parmi nous une des marques du rang ou de la fortune."

61. Fersen 1909, p. 6.

62. Oberkirch 1789, p. 598; Martin 2009, pp. 17, 67.

63. Charles-Nicolas Cochin, *Avis aux dames* (1750) quoted in Hyde 2000, p. 458.

64. Genlis 1825, vol. 3, p. 70: "On parla des vieilles femmes qui mettoient toujours du rouge, et on les critiqua."

65. In some cases, it is difficult to tell what lies behind the critique. As Melissa Hyde (2006, pp. 95–96) has pointed out, "if there is anything at all to the hostile and exaggerated accounts of [Madame de] Pompadour's appearance around 1758, which describe the copiousness of her red and white face paint in fulsome detail, then perhaps her heavy-handed use of cosmetics can be taken as a mark of her recent promotion as *dame du palais* rather than as a futile attempt to conceal the ravages of time."

66. For a discussion of the milliner's role in eighteenth-century art and fashion, see Chrisman-Campbell 2002.

67. See Mimi Hellman's chapter in this volume.

68. Hellman 1999, p. 436.

69. Posner 1996, p. 136.

70. Gordon and Hensick 2002, p. 24.

71. Carlier 2004, p. 8.

72. Carlier 2004, p. 7; Albainy 1999, p. 18.

73. Posner 1996, p. 134.

74. Posner 1996, p. 134.

75. Another example is Alexandre Roslin's *Vor dem ersten Ball*, 1760, Rheinisches Landesmuseum, Bonn.

76. For a history of the male toilette, see Gerken 2007, 252–69.

77. Restif de la Bretonne 1789, part 9, p. 30: "Je suis le seul homme à Paris, qui aille encore me faire raser ou me raser moi-même dans la boutique d'un perruquier."

78. Diderot and Le Rond d'Alembert 1751–65, vol. 16, p. 382, s.v. "Toilette": "…qui de nos jours sont devenus femmes."

79. Smollett 1919, pp. 61–62.

80. Adams 1848, p. 208.

81. Goodman 2005, p. 18.

82. Goudar 1765, vol. 4, p. 163.

83. Caraccioli 1760, p. 238.

84. Martin 2009, p. 85.

85. Goodman-Soellner 1987, pp. 56–57.

86. Martin 2009, p. 76.

87. See Peter Björn Kerber's chapter in this volume.

88. Goodman 2005, p. 14.

89. Carlier 2004, p. 9.

90. Hellman 1999, p. 427.

91. London 2002, p. 80.

92. See Joan DeJean's chapter in this volume.

93. For a detailed discussion of this piece, see Hellman 1999, pp. 425–27.

94. Vaublanc 1857, p. 133: "Plusieurs dames renouvelaient, sans façon, à leur aise, leurs belles joues rouges partout où elles se trouvaient."

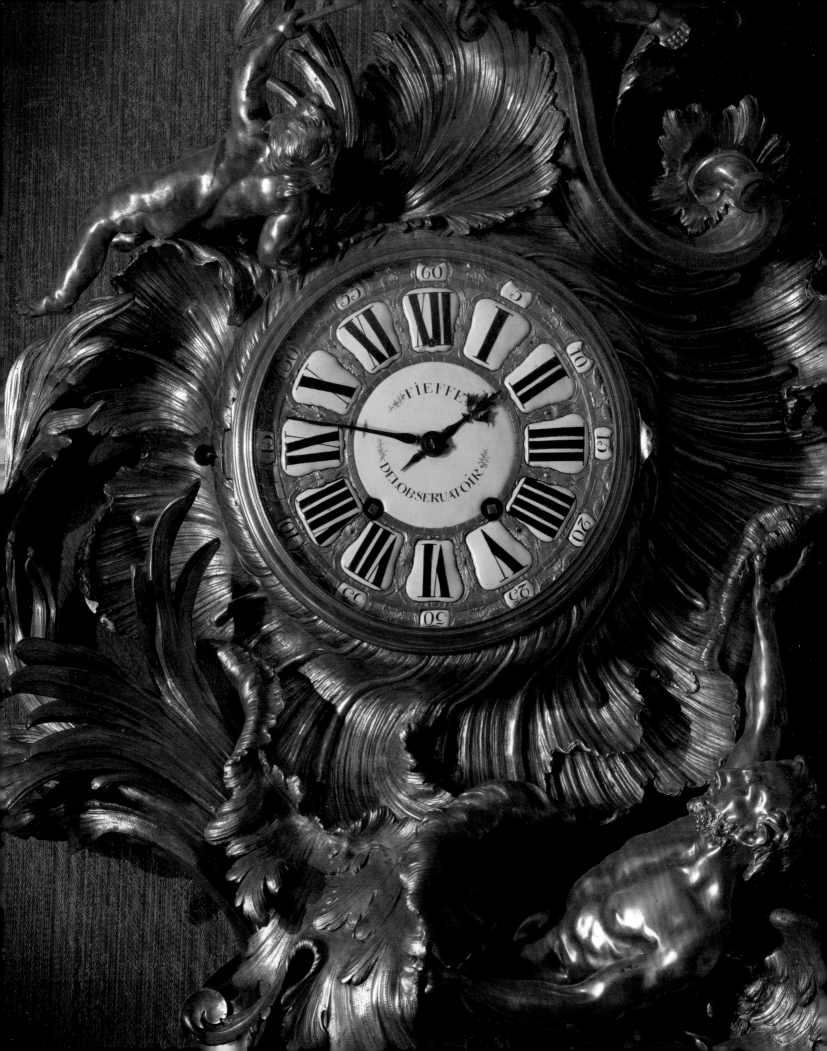

Perfectibility and Its Foreign Causes:

Reading for Self-Improvement in Eighteenth-Century Paris

Peter Björn Kerber

The morning's business has been attended to, correspondence has been answered, visitors have taken their leave, lunch has been served and consumed. In the early afternoon, a post-prandial calm settles over the household of the eighteenth-century Parisian *hôtel particulier*. The ensuing hours might very well be devoted to one of the favored pastimes of the city's educated elite, namely reading books.[1] This activity could take myriad forms, solitary or communal, for pleasure or for instruction. In order to gain and maintain social acceptance, it was equally important to read, to be known to read, and to be known as well-read.[2] For members of elite Parisian society such as Gabriel Bernard de Rieux (1687–1745), the numerous books surrounding him in his study were, simultaneously, tools of his profession and symbols of his erudition (fig. 48). Scuffed and dog-eared from heavy use, they were more than mere props, and households such as his usually owned substantial libraries.[3]

Immersion in the canonical works of ancient history, Greco-Roman mythology, and sacred scripture began at an early age, and some of the volumes filling the bookcases behind de Rieux would have been sumptuously bound luxury editions of the same texts a child might have recited in a reading lesson (fig. 49) or listened to during moments of maternal education (fig. 50).[4] These forms of reading for instruction and improvement can be contrasted with reading for entertainment, which privileged a rather different catalog of texts. The books one read aloud to a group of friends in the setting of a literary salon (see fig. 23)[5] were more likely to be by modern authors such as Molière (1622–1673) or La Fontaine (1621–1695) than by Virgil or Livy.

La Fontaine's *Fables choisies, mises en vers* of 1668–94 enjoyed immense popularity throughout the eighteenth century, but in the eyes of Jean-Jacques Rousseau (1712–1778), for example,

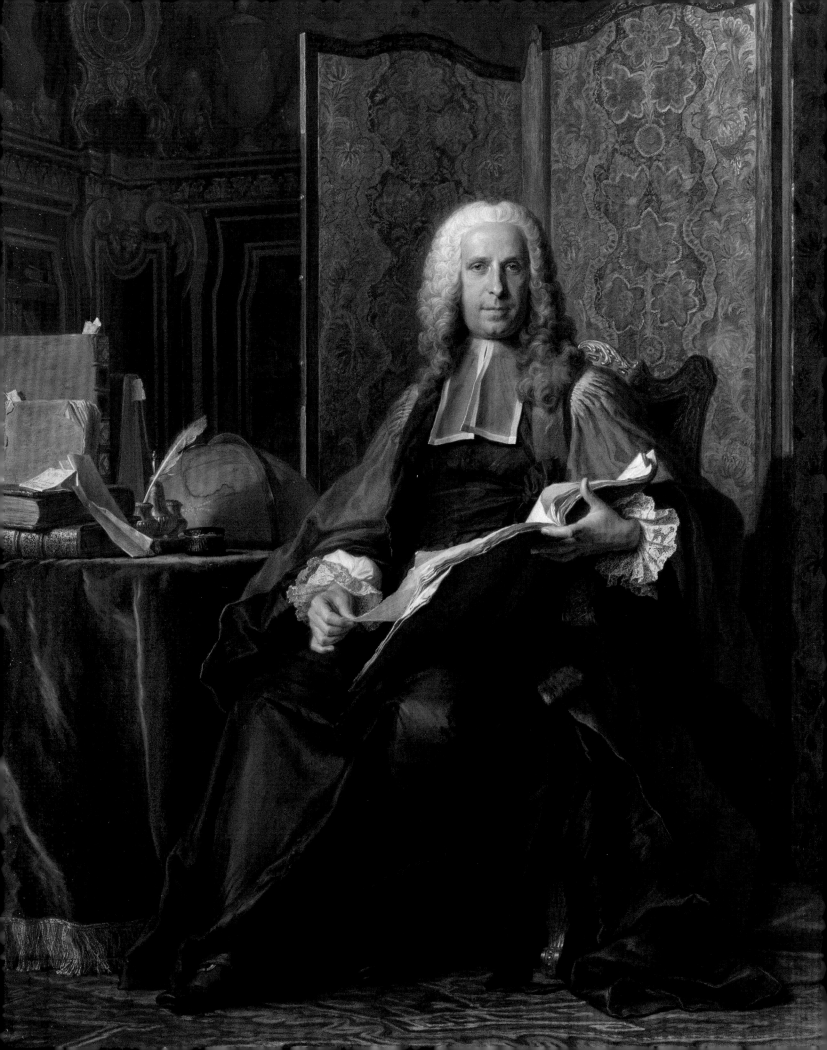

they were unfit for pedagogical purposes. While cloaked in a moralizing tone, the *Fables* were ultimately satires that sought to amuse and titillate, not to improve, their readers. La Fontaine took a darkly cynical view of human nature as beyond hope, and "the 'enchantment' of animals which can talk [had] become a means for a disenchanted poet to vent his spleen against mankind."[6] Equally unlikely to be used for educational purposes was the deluge of novels and pamphlets published in eighteenth-century Paris, some within and many outside the law.[7]

A highly desirable corollary of reading for instruction was the fact that the pleasure to be derived from works of art based on the canonical texts could be greatly increased by literary erudition, as might the prestige of owning and displaying such works if one was able to discuss the textual subtleties of the depicted narrative with a visitor one sought to impress.[8] Undergirding both the knowledge of the literary canon and the contemporary production (though not always the reception) of the works of art it spawned was a notion that might best be described by the term *perfectibility*, the conviction that eighteenth-century man was capable of traveling along a path toward greater virtuousness, that moral instruction through virtuous examples, by means textual and pictorial, could provide an effective and necessary method of self-improvement. To the young, books and works of art were mentors; to the adult, they were trusted friends whose company was sought for diversion, inspiration, and guidance.

The roots of mankind's quest for self-improvement can be traced back as far as—and considerably beyond—Christ's admonition in the Sermon on the Mount, "Be you therefore perfect" (Matthew 5:48), which simultaneously posited that mankind possessed both the capacity to achieve moral perfection and the duty to strive for it. One and three-quarter millennia on, Rousseau was still grappling with the causes and effects of the human capacity for improvement in his *Discours sur l'origine et les fondements de l'inégalité parmi les hommes*: "Perfectibility, the social virtues, and the other faculties that natural man had received as potential abilities could never develop of themselves, . . . they required the fortuitous concurrence of several foreign causes that might never have arisen, and without which he would have perpetually remained in his primitive condition."[9]

Ensuring that these "foreign causes" essential to perfecting mankind did indeed occur at the right moment was the purpose, possibly even the definition,

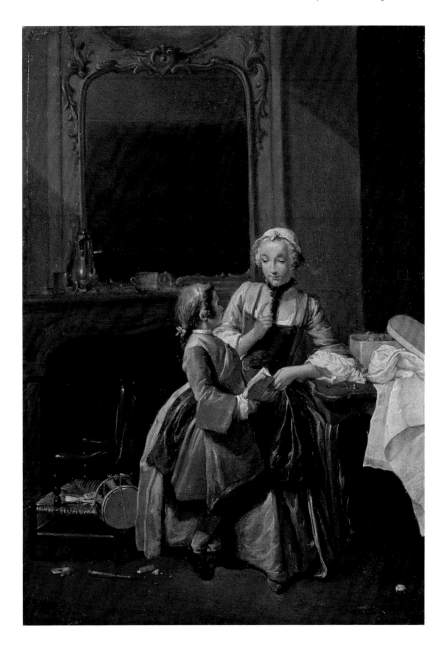

Figure 48
MAURICE-QUENTIN DE LA TOUR (French, 1704–1788), *Portrait of Gabriel Bernard de Rieux*, (detail) 1739–41. Pastel and gouache on paper mounted on canvas, 200.7 × 149.9 cm (79 × 59 in.), Los Angeles, J. Paul Getty Museum, 94.PC.39.

Figure 49
LOUIS AUBERT (1720–ca. 1798), *The Reading Lesson*, 1740. Oil on panel, 32.5 × 22.7 cm (12¹³⁄₁₆ × 8¹⁵⁄₁₆ in.). Amiens, Musée de Picardie, Gift of the Lavalard Brothers, M.P.Lav. 1894–160.

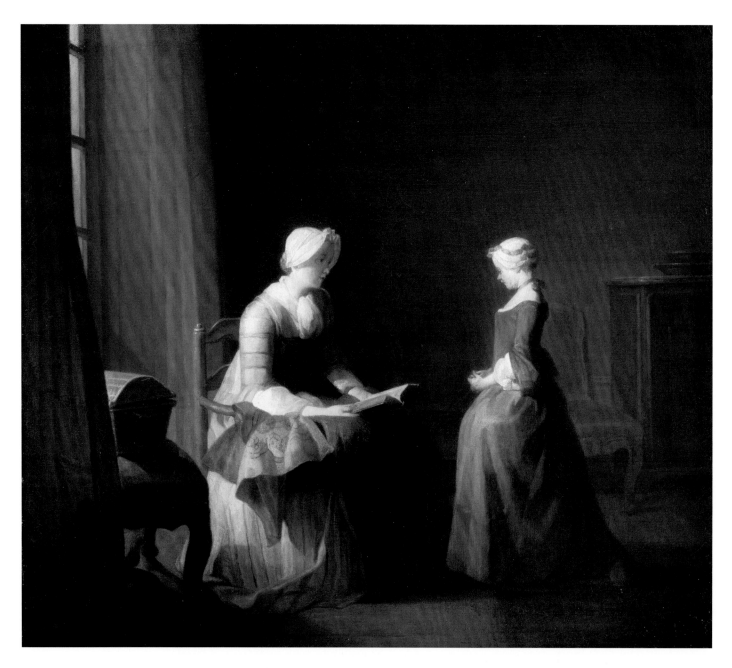

Figure 50
JEAN-SIMÉON CHARDIN
(French, 1699–1779), *The Good
Education*, ca. 1753. Oil on
canvas, 41.5 × 47.3 cm (16⁵/₁₆ ×
18⁵/₈ in.). Houston, Museum of
Fine Arts, Gift in memory of
George R. Brown by his wife
and children, 85.18.

of education. If the ideas put forward in this area by
eighteenth-century philosophes often echoed the
teachings of an institution they identified as one of
their principal foes, the Roman Catholic Church,
this is part of the context in which "the older model
of a unitary Enlightenment as a secularizing project"
has been duly reassessed by scholars such as Jona-
than Clark, who has pointed out that "a nineteenth-
century secular construct, 'the Enlightenment,' still
dominates research strategies to a far greater degree
than that undoubted eighteenth-century reality, the

Roman Catholic Church."[10] Similarly, Tim Blanning
has emphasized that "the eighteenth century has as
good a claim to be dubbed 'the age of religion' as 'the
age of reason.' Not only were the Churches flourish-
ing, but both public and private discourse were domi-
nated by religion."[11]

Christian thought had long maintained that the
most effective and enduring means of education was
to engage the emotions. In the present context, trac-
ing the extensive genealogy of this idea must remain
limited to a few examples that still resonated strongly

in eighteenth-century France—first and foremost Saint Augustine's dictum, "A certain orator has rightly said that 'an eloquent man must speak so as to teach, to delight, and to persuade.' Then he adds: 'To teach is a necessity, to delight is a beauty, to persuade is a triumph.'"[12]

Having been coined by Cicero (the orator left unnamed by Saint Augustine), the triad of instruction, delight, and persuasion was progressively recognized as being applicable not only in the field of rhetoric but also in literature, theater, and the visual arts. The third of these objectives, *flectere* in the Latin original, is inadequately rendered by the commonly used translation "to persuade"; its literal meaning, "to bend," is retained in the English adjective "flexible," while the figurative sense in which Cicero and Saint Augustine use the verb implies that the members of the audience are won over by the orator because he successfully engages their emotions—"to sway" is perhaps the closest approximation.

Since persuading a populace of the merits and necessity of virtuous behavior has always been an uphill battle, the repertoire of means that employed this technique toward the end of moral improvement was expanded to include the fine arts, thus ennobled by their enlistment in the service of social virtue. A direct analogy between the arts of rhetoric and painting as profitable means of instruction was drawn in the wake of the Council of Trent by Cardinal Gabriele Paleotti (1522–1597), archbishop of Bologna, in a treatise on sacred and profane imagery, the *Discorso intorno alle imagini sacre e profane* of 1582: "Three principal goals are customarily assigned to the art of rhetoric, namely to delight, to instruct, and to move, and there is no doubt that the same goals fall just as notably to painting."[13] In a note after this statement, Paleotti refers his readers to the following passage from Saint Thomas Aquinas's *Summa Theologica*:

> Since the Holy Ghost does not fail in anything that pertains to the profit of the Church, He provides also the members of the Church with speech; to the effect that a man not only speaks so as to be understood by different people, which pertains to the gift of tongues, but also speaks with effect, and this pertains to the grace of the word. This happens in three ways. First, in order to instruct the intellect, and this is the case when a man speaks so as to teach. Secondly, in order to move the emotions, so that a man willingly listens to the word of God. This is the case when a man speaks so as to delight his hearers, not indeed with a view to his own favor, but in order to draw them to listen to God's word. Thirdly, in order that men may love that which is signified by the word, and desire to fulfil it, and this is the case when a man so speaks as to sway his hearers.[14]

Further on in his treatise, Paleotti elaborates upon the parallel between writers and painters; on the former "it is imposed as a duty of their art that they should delight, instruct, and move. Similarly, it is the duty of the painter to employ the same means in his work, diligently developing a manner suited to giving delight to the viewer, instructing and moving him. And if all of these three means are important and necessary in order to satisfy those requirements, nonetheless it cannot be neglected that they do so with different degrees of excellence, as the great Father said when speaking of the duty of the orator: *Delectare est suavitatis, docere necessitatis, flectere victoriæ* [to delight is sweetness, to teach a necessity, to sway a victory]."[15] Paleotti thus credits the "great Father," i.e., Saint Augustine, with Cicero's dictum quoted above.

In eighteenth-century Paris, the terms of this discussion remained the same. Nicolas Boileau (1636–1711) offered sage advice to poets in *L'art poétique*, which first appeared in 1674 and went through ten editions (in Paris alone) between 1701 and 1772:

> You then that in this noble art would rise,
> Come and in lofty verse dispute the prize.
> Would you upon the stage acquire renown,
> And for your judges summon all the town?
> Would you your works forever should remain,
> And after ages past be sought again?
> In all you write observe with care and art
> To move the passions and incline the heart.
> If in a labored act, the pleasing rage
> Cannot our hopes and fears by turns engage,
> Nor in our mind a feeling pity raise,
> In vain with learned scenes you fill your plays;
> Your cold discourse can never move the mind
> Of a stern critic, naturally unkind,
> Who, justly tired with your pedantic flight,
> Or falls asleep or censures all you write.
> The secret is, attention first to gain,
> To move our minds and then to entertain.[16]

Winning over a reluctant audience by engaging the emotions was, as Paleotti had underscored, as promising a strategy for artists as for poets. Discussing mythological rather than religious subjects, Étienne-François La Font de Saint-Yenne (1688–1771)

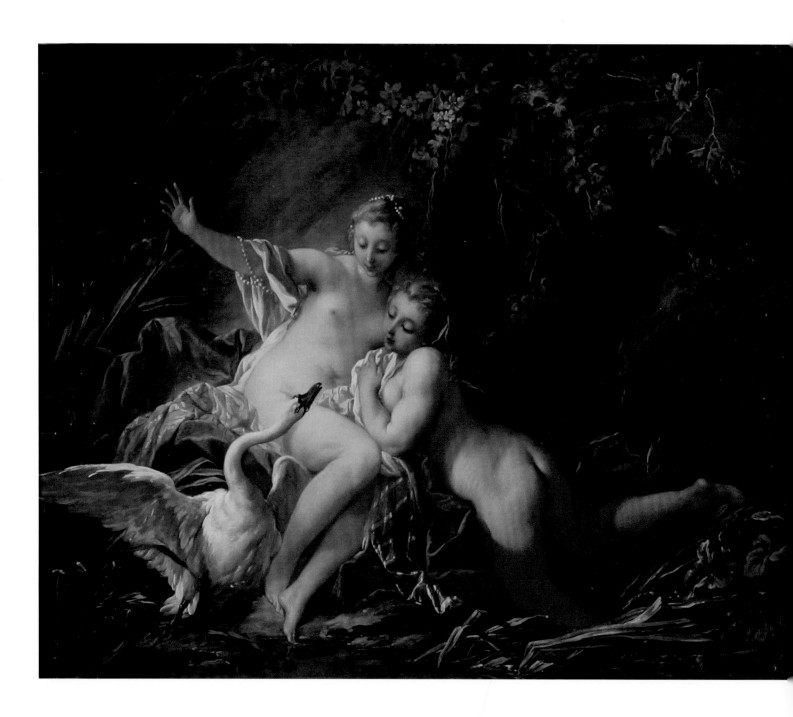

Figure 51
FRANÇOIS BOUCHER (French,
1703–1770), *Leda and the Swan*,
1742. Oil on canvas, 59.7 × 68.6 cm
(23½ × 27 in.). Beverly Hills,
California, Collection of Lynda
and Stewart Resnick, 1985-015.
Photo: courtesy of Lynda and
Stewart Resnick.

recommended history painting as an effective means of moral improvement. He reiterated many of Paleotti's ideas and again invoked the triad of instruction, delight, and persuasion: "If painting's noblest goal is to instruct us by speaking to the eyes through the charm of imitation, and through pleasure, that most dependable of all roads leading us to persuasion; if the purpose of such instruction is to rectify our dissolute inclinations, could there be a greater abuse of our talents in this beautiful art [than depicting obscene episodes]? Why not employ them in order to present examples appropriate for elevating our soul above the senses?"[17] Such criticism was directed at overtly erotic and immoral depictions in the vein of François Boucher's *Leda and the Swan* (fig. 51), which not only illustrates Jupiter's adulterous seduction of the young and beautiful Leda, wife of the Spartan king Tyndareus, but compounds the error by adding a second, equally voluptuous female nude entirely unwarranted by the textual sources.

La Font de Saint-Yenne's unabashed advocacy of the moral purity and educational value of history painting took place against the backdrop of an ongoing discussion about the relevance of the academic hierarchy of genres.[18] He came down firmly in favor of history painting as the noblest and most prestigious genre because "the history painter alone is the painter of the soul, the others paint only for the eye."[19] By showing "the great actions and the virtues of famous men," the canvas could become an *exemplum virtutis*: "If painting, other than offering the amusement of pleasure and illusion, is also to be a school of morals and a silent orator who disposes us to virtue and great deeds, should we not employ all of our intellect's activity in order to single out the most pathetic, the most striking, and the most suitable traits of history that will instill fire and movement in the soul, elevating it above the senses and recalling its original dignity through examples of humanity, generosity, greatness of courage, disregard of danger and even of life, a passionate zeal for the honour and welfare of one's homeland, and above all the defense of one's religion?"[20]

Invoking the customary classical precedents—the Horatian topos of *ut pictura poesis* (as is painting so is poetry)[21] and the aphorism of Simonides, attributed to him by Plutarch, that painting is mute poetry, poetry a speaking picture[22]—La Font de Saint-Yenne does not stray far from Paleotti's mandate that paintings (and painters) be "silent preachers" who bring "universal benefit to all."[23] However, in order for a canvas to effectively fulfill its function as a school of moral virtue, it

was imperative that the audience possessed a certain familiarity with the subject matter, a mythological literacy.[24] La Font de Saint-Yenne bemoaned—with a healthy dose of rhetorical exaggeration—the fact that since most people "read virtually nothing but pamphlets, little love stories, and dictionaries," it was necessary to place a cartouche with an inscription naming the subject on the frame underneath the painting, following the precedent set by engravings and tapestries, in order to prevent a composition from becoming "an inexplicable enigma."[25]

Writing almost three decades before La Font de Saint-Yenne, in 1726, Charles Rollin (1661–1741) had been equally adamant about the need for mythological literacy, but he was far less pessimistic about the prospect of achieving this goal through a proper education of the young: "There are other sorts of books, which are exposed to the view of the whole world, such as pictures, prints, tapestry and statues. These are so many riddles to those who are ignorant of fabulous history, from whence their explication is frequently to be taken. These matters are likewise frequently brought into discourse, and it is not, in my opinion, over agreeable to sit mute and seem stupid in company for want of being instructed, whilst young, in a matter so easy to be learned."[26]

The entry on "Fable," appearing in 1756 in the sixth volume of the *Encyclopédie* and written by Louis de Jaucourt (1704–1779), argued—La Font de Saint-Yenne's concerns notwithstanding—that works of art not only motivated the viewer to acquire an understanding of mythological subjects but were themselves capable of improving such comprehension: "This is why a knowledge, at least a superficial knowledge, of mythology is so widespread.... The engravings, the paintings, and the statues that decorate our cabinets, our galleries, our ceilings, and our gardens are nearly always drawn from mythology; furthermore, mythology is so widely employed in our writings, our novels, our pamphlets, and even in everyday discourse that it is impossible to remain quite ignorant of it without having to blush at this lack of education."[27]

The social importance of being able to participate in discussions requiring mythological literacy (in spite of two separate entries devoted to them in the *Encyclopédie*, the terms *fable* and *mythologie* were often used interchangeably in the eighteenth century[28]) was reiterated by Jaucourt in his entry on "Mythologie" in the tenth volume of the *Encyclopédie*, published in 1765: "All persons, even those displaying little interest in the

love of the sciences, are obliged to instruct themselves in mythology, since it occurs so frequently in our conversations that anyone ignorant of its rudiments must fear to appear deprived of the knowledge provided by a basic education."[29]

Familiarity with the canonical texts was therefore considered essential for the development of virtue, social acceptance, and taste, while the common ground prepared by this very knowledge in turn shaped the contemporary production of works of art. Jean Starobinski has aptly summarized this chicken-and-egg situation: "The result is a circle: It is necessary to know fables in order to understand works from ancient and contemporary culture; and, because one has learned about fables and the model remains alive, newly created works are also based on fables."[30]

Even though there was general agreement that classical literature formed an indispensable part of a well-rounded education, saturating the young mind with knowledge of the gods of antiquity "to the point where we find it hard to consider them imaginary"[31] could be fraught with moral risk, as Noël-Antoine Pluche (1688–1761) cautioned in 1739: "Childhood is thus passed among the gods. Upon leaving school, one meets them again on stage, where they speak a language that can be understood without effort and requires no master. All performances repeat their adventures: they are found in cantatas, in drinking songs, in the decorations of apartments, gardens, and public squares. Engravings, paintings, poems, music, light-hearted writings, learned dissertations, they all conspire to show us, in an honorable and touching disguise, actions punished by the laws, and absurdities diametrically opposed to common sense."[32]

The effects, Pluche warned, were dire: irreligion, idle puerility, an enfeebled character, and neglect of duty.[33] A dilemma presented itself—how to circumvent the moral hazards of licentious mythological narratives while instilling in children a profound knowledge of classical literature? One solution was to purge the sources of their most explicit passages. This method was both advocated and practiced by Antoine Banier (1673–1741) in his translation of Ovid's *Metamorphoses*, first published in 1732 and republished in a number of editions, often lavishly illustrated, in the course of the rest of the century. In his preface, Banier justified his revisions by emphasising Ovid's lack of decency in recounting the amorous passions of the gods.[34]

A very different approach was recommended by Rollin in his *Traité des études* of 1726. For him, the

debauchery on display in the ancient texts fulfilled an important function in that it demonstrated the moral superiority of Christianity over Greco-Roman civilization:

> What I have already observed concerning the origin of fables, which owe their birth to fiction, error and falsehood, to the alteration of historical facts and the corruption of man's heart, may occasion a demand, whether it is proper to instruct Christian children in all the foolish inventions, absurd and idle dreams, wherewith paganism has filled the books of antiquity. This study when undertook with all the precaution and wisdom, which religion demands and inspires, may be very useful to youth. First it teaches them what they owe to Jesus Christ, their Redeemer, who has delivered them from the power of darkness, to bring them into the admirable light of the Gospel. Before him what were even the wisest and best of men, those celebrated philosophers, those great politicians, those famous legislators of Greece, those grave senators of Rome, in a word, all the best disciplined nations of the world, and the most instructed. Fable informs us, they were blind worshippers of the devil, who bent their knees before gold, silver, and marble; who offered incense to statues, that were deaf and dumb; who acknowledged as Gods, animals, reptiles and plants; who were not ashamed to adore an adulterous Mars, prostituted Venus, and an incestuous Juno, a Jupiter polluted with all manner of crimes, and for that reason most fit to hold the first place among the Gods.[35]

A similar strategy of contrasting the moral turpitude of the ancient gods with the purity of the Christian faith in order to affirm the latter was pursued by the Jesuit François-Xavier Rigord (1690–1739) in his *Connoissance de la mythologie par demandes et par réponses* of 1739, written in a question-and-answer format strongly reminiscent of a catechism. To the question regarding the advantages to be drawn from a knowledge of mythology, Rigord responded: "It makes us understand the darkness into which all nations on Earth had plunged, and the degree of madness into which man is lead when he entrusts himself only his own knowledge."[36] To the student of mythology fortified by a Christian hermeneutics, even Ovid's *Metamorphoses* could be recommended as "one of the best sources"; at the same time, Rigord advised that the *Explication historique des fables* by Antoine Banier—the author who had also produced the successful translation of the *Metamorphoses* mentioned above—was a valid replacement for reading many of

the ancient texts themselves.[37] Banier's book, first published in 1711, was substantially revised and expanded for the definitive edition of 1738–40, which appeared under the title *La Mythologie et les fables expliquées par l'histoire*.[38] In an attempt to construct a thematic system for mythology, Banier employed the euhemerist method of interpreting the gods of antiquity as historical figures, usually kings of specific territorial jurisdictions in the eastern Mediterranean, and explained their actions as political events.[39]

Recapitulating the history of the house of Troy, Banier points out that Aeneas "is always represented [both by Homer and by Virgil] as a man fearing the Gods, who seemed to be taking particular care of him."[40] The topos of the pious Aeneas is employed by a number of authors of the period—even if the man considered to have been the founding father of the Roman nation had not yet had an opportunity to become a Catholic, he could at least be portrayed as exemplifying many of the virtues of a Christian. In a *Discours sur l'Enéide,* published as a preface to his prose translation of the *Aeneid*, Pierre-François Guyot Desfontaines (1685–1745) underscored that Aeneas was a "pious prince" but hedged his bets by describing the notion that he would have been more suited to founding a monastic order than an empire as a bad jest.[41]

One of the more problematic episodes in Virgil's story, which threatened to sully Aeneas's reputation, was his relationship with and abandonment of Dido, the queen of Carthage, who had offered the shipwrecked Trojan hero a new home and her hand in marriage. When her proposal was rejected and her impassioned pleas failed to persuade Aeneas to stay, she committed suicide. Rigord took pains to emphasize Aeneas's obedience and sense of duty: "His orders called the Trojan hero to Italy. He obeyed. Neither the advantages of an established Kingdom, nor love, nor Dido's tears could retain him." Any lingering doubts about Aeneas's treatment of Dido were dispelled by stressing that Virgil's account of the meeting between Dido and Aeneas was entirely fictitious and anachronistic, as Dido lived two centuries after Aeneas.[42] This anachronism was also pointed out by Banier.[43]

When Jean-Jacques Le Franc de Pompignan (1709–1784) wrote his *Didon*, a five-act tragedy first performed at the Comédie Française on June 21, 1734, he decided to alter (and, in his view, improve upon) Virgil's characterization of Aeneas.[44] In the preface to a substantially revised version of *Didon* published in 1746, Le Franc quotes from a letter he had received in

1740 from Desfontaines, while the latter was working on his translation of Virgil: "I confess that the miserable character of Aeneas truly disgusts me.... Aeneas is a weak man, and an insipid bigot."[45] In the first edition of *Didon*, Le Franc had lambasted Virgil for providing a bad role model for the formation of character; by 1746, he felt obliged to "retract this statement out of respect for Virgil, while still upholding it out of respect for the truth."[46]

At the center of Le Franc's criticism—and of his justification for recasting Aeneas—was, once again, the protagonist's conduct during his sojourn in Carthage: "In the Aeneid, Dido abandons herself too easily to her attraction to a foreigner, who is, when considered closely, nothing but a faithless lover, a feeble prince, a scrupulous bigot. In the character of my hero, I necessarily had to part company with Virgil. I even dared to impose limits upon Aeneas's excessive piety. I have made him speak out against the abuse of the oracles and the dangerous impression they often make upon the spirit of the people. I have wanted him to be religious without superstition, acting always in good faith, whether with the Trojans when he wants to stay in Carthage, or with Dido when he prepares to leave her; in a word, I have wanted him to be a prince and an *honnête homme*."[47]

This stratagem won the approval of Le Franc's contemporaries—the play was a triumph, remaining in the repertory for much of the eighteenth century,[48] while also becoming a literary success off the stage, with thirteen editions of the text appearing during Le Franc's lifetime. Desfontaines was far from alone when he expressed his wholehearted support of the improved Aeneas, praising Le Franc for making him "amorous and gallant, while leaving him his religion: but his love, subordinate to the noble ambition of founding the Roman Empire, goes as far as making him suspicious of the oracles of the gods. Aeneas, painted in such carefully chosen colors, has charmed the spectators, above all because they have seen him triumph over his passion and renounce the delights of Carthage the instant Achates asks him for his son, in the name of the Trojans, in order to embark on the conquest of Italy. This surprise is brought about with admirable skill. The great difficulty was effecting Aeneas's separation from the Queen, who had heaped favors on him, and his departure, without exposing him to the reproach of ingratitude: the author has easily overcome this difficulty by concocting a battle in which Aeneas kills his rival. Thus the hero's departure is not accompanied by

any odious circumstance. He is neither faithless nor ungrateful, as he was in the Aeneid."[49]

Thus Aeneas had been transformed into "a man corresponding to an eighteenth-century French Catholic definition of an *honnête homme*, one his audience can emulate."[50] He is a man in control of his passions, pious without being superstitious, a hero of ancient history reconciled with the ideals of Christianity. Contemporary painters, by contrast, were able to emphasize the positive sides of Aeneas's character—and show him as a model worthy of emulation—only by selecting certain episodes from the story, such as the flight from Troy, considered the epitome of filial piety: during the sack of Troy by the Greeks, Aeneas rescued his aged father Anchises from the burning city at night by carrying him on his back. He was accompanied by his wife Creusa, who was lost in the darkness during the flight, and his son, Ascanius. Perhaps not incidentally, the Parisian owner of Carle Vanloo's painting of this subject (fig. 52), Ange-Laurent de La Live de Jully (1725–1779),[51] had been admonished by his father in the latter's will "to do [your] duty towards others as is required by [your] rank, not merely for reasons of humanity, but from the dictates of religion and the love of God."[52] The erudite collector would have appreciated narrative details such as the young boy looking up into the night sky, a reference to Virgil's description of a meteor being interpreted as a sign that Jupiter had destined Ascanius for greatness.[53]

La Live de Jully also owned Chardin's *The Good Education* (see fig. 50), and taken together, these two canvases might be said to represent the trajectory of intergenerational assistance within the family structure, or the causes and effects of virtuous behaviour: parents who have raised and educated their children well may in turn depend on them in old age. The concept of the *honnête homme* comprised, in addition to a mastery of etiquette and manners,[54] both virtuousness and the possession of refined taste;[55] Rollin acknowledged that Virgil's text "is studied with the greatest attention by persons of rank: it is a perfect model, sufficient in itself for the formation of taste."[56]

The appropriation and integration of antiquity into the history of salvation had one of its foremost exponents in Jacques-Bénigne Bossuet (1627–1704). Stretching from Adam to Charlemagne, his *Discours sur l'histoire universelle* of 1681 interweaves biblical and pagan events, with the fall of Troy, for example, appearing between Moses' reception of the tablets of the law and Solomon's construction of the Temple in

Jerusalem.[57] Written, according to its subtitle, "in order to explain the development of the Faith and the transformations of Empires" to Louis, dauphin of France (1661–1711), eldest son of Louis XIV, multiple editions of the book, published over the course of the eighteenth century, played a central role in the education not only of the young members of elite society but also of the artists who would serve them when they grew up to be patrons of the arts. Mirroring the historical and literary canon taught to their future clients, young artists were raised on a diet of Tacitus, Livy, Homer, Virgil, and Ovid, supplemented by modern authors such as Rollin and Bossuet. As Bernard Lépicié (1698–1755), permanent secretary of the Académie Royale de Peinture et de Sculpture, explained in a description of the programme of studies in 1748: "I can think of no better way to begin these lessons than with a passage from Bossuet's *Histoire universelle*."[58] It was only the previous year that Charles-François-Paul Le Normant de Tournehem (1684–1751), the newly installed director of the Bâtiments du Roi, had approved the purchase of a range of books on mythology, history, and literature, since the Académie's library had hitherto consisted chiefly of volumes of engravings.[59] Among the newly acquired volumes were the complete works of Boileau, Banier's *La Mythologie et les fables expliquées par l'histoire,* as well as his translation of Ovid's *Metamorphoses*, and the *Histoire de l'Ancien et du Nouveau Testament, et des Juifs* by Augustin Calmet (1672–1757).[60]

When La Font de Saint-Yenne published, also in 1747, his analysis of the status quo of painting in France, he reinforced the view that a literary education was indispensable to painters, while employing a terminology that once again evoked the lineage from Cicero to Saint Augustine to Paleotti: "But where shall our young pupils find the heat and fire of those eloquent expressions, the source of those great ideas, of those striking or interesting features that characterize true history painting? Why, in the same sources that have always been drawn upon by our greatest poets. In the great writers of Antiquity: in the Iliad and Odyssey of Homer, so rich in sublime images; in the Aeneid, so rich in heroic actions, pathetic narratives and grand sentiments; in Horace's Ars Poetica, an inexhaustible treasure of good sense for arranging the composition of an epic or tragic painting, and in Despréaux [i.e., Boileau] his imitator; in Tasso, in Milton. These are the men who have unlocked the human heart and known how to read it, to render its troubles, its rages, its torments for us,

Figure 52
CARLE (CHARLES-ANDRÉ) VANLOO (French, 1705–1765), *Aeneas Carrying Anchises*, 1729. Oil on canvas, 110 × 105 cm (43⁵⁄₁₆ × 41⁵⁄₁₆ in.). Paris, Musée du Louvre, 6278. Photo: Réunion des Musées Nationaux /Art Resource, N.Y. (C. Jean).

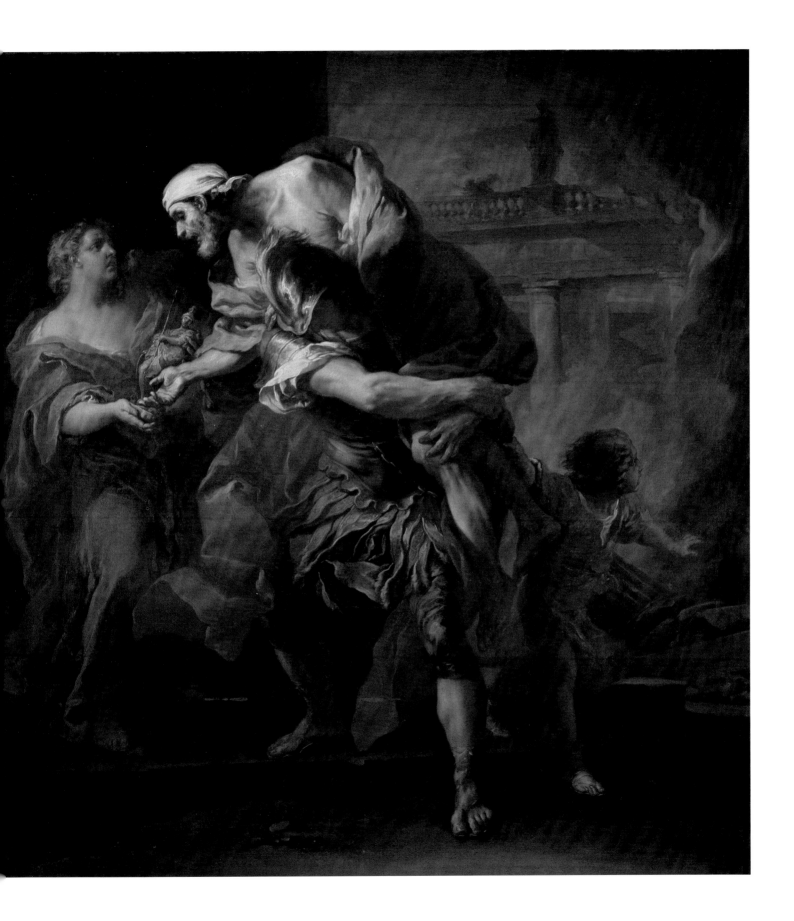

with an eloquence and truth which both teach us and fill us with pleasure."[61]

Similar advice was offered by Anne-Claude-Philippe de Tubières, comte de Caylus (1692–1765), who recommended that painters should choose subjects from ancient history or mythology, as these had a greater impact on the viewer than modern episodes.[62] Caylus seems to have considered the literary education offered to young painters still insufficient, since he took it upon himself to produce a guide to subjects suitable for history painting, complete with advice for the depiction of various mythological figures.[63]

The area of sacred scripture posed somewhat different challenges. While knowledge of the Bible was certainly aided by regular attendance at Sunday services, which usually included lengthy sermons expounding the verses of the day's Mass, reading the biblical text itself in the vernacular still carried the risk of ecclesiastical disapproval (depending on the translation).[64] The curriculum at the Académie therefore included a French renarration of the Bible by Calmet, the *Histoire de l'Ancien et du Nouveau Testament, et des Juifs,* published repeatedly in the eighteenth century.[65]

Having acquired a thorough knowledge of the literary canon, having commissioned works of art that not only enhanced the status of their owners but could also serve as a school of virtue,[66] most educated and wealthy eighteenth-century Parisians would still have been left to ponder the ultimate question about perfectibility: could self-improvement truly be achieved without assistance from above? The influence of the Jansenist doctrines of selective grace, divine predestination, and human depravity was already on the wane,[67] and the faithful had to accept personal responsibility for their actions while recognizing all the same that the human heart could do nothing without God. This precarious balance was reflected in a French paraphrase of the Lord's Prayer written by Le Franc. The invocation "Lord, my soul surrenders itself to your compassion: Have mercy on me for the offences I have committed against you" is offset by the acknowledgement that "Without you I am nothing but weakness, I draw my strength only from you."[68] In sum, according to an ode to Saint Augustine published by Le Franc in the same volume as his version of the Lord's Prayer, "absolute dependence is allied to liberty."[69] Rousseau might have been aghast, but for most of his French contemporaries, a combination of divine providence and the precepts of the Catholic faith still ranked first among the "foreign causes" of perfectibility.

NOTES

1. For a history of the production, distribution, and consumption of books in eighteenth-century France, see Martin and Chartier 1984.

2. On reading during the morning *toilette*, see Kimberly Chrisman-Campbell's chapter in this volume, and on reading by candlelight, see the chapter by Mimi Hellman.

3. On book ownership among the Parisian elite, see Chartier 1987, pp. 194–95.

4. On collective reading activities of parents with their children and among groups of adults, see Chartier 1987, pp. 231–33.

5. On the salon as the setting for reading as a social activity and furniture pieces designed for the avid reader, see Joan DeJean's chapter in this volume.

6. Slater 2000, p. 129.

7. See, among his many other studies on the subject, Darnton 1982 and Darnton 1995, as well as Weil 1986, esp. pp. 127–33, on the debate as to whether the novel was supportive or detrimental to virtue and moral values.

8. On visiting private collections in eighteenth-century Paris, see Guichard 2008, pp. 164–70. For an overview of cycles of mythological paintings commissioned for Parisian *hôtels particuliers* between 1719 and 1751, see Scott 1992, pp. 49, 58 n. 145.

9. Rousseau 1755, pp. 98–99: "La perfectibilité, les vertus sociales, & les autres facultés que l'homme naturel avoit reçues en puissance ne pouvoient jamais se développer d'elles-mêmes, … elles avoient besoin pour cela du concours fortuit de plusieurs causes étrangeres qui pouvoient ne jamais naître, & sans lesquelles il fût demeuré éternellement dans sa condition primitive." All quotations retain their original orthography and punctuation. Unless otherwise indicated, all translations are by the author.

10. Clark 2007, p. 63. See also Joutard 1991, pp. 195–97 (subsection authored by Dominique Julia).

11. Blanning 2007, p. 475.

12. Saint Augustine *De Doctrina Christiana* 4.12.27: "Dixit ergo quidam eloquens, et verum dixit, ita dicere debere eloquentem ut doceat, ut delectet, ut flectat. Deinde addidit: Docere necessitatis est, delectare suavitatis, flectere victoriæ." Augustine quotes two passages from Cicero *De Oratore* 21: "Est igitur eloquens qui ita dicet, ut probei, ut delectet, ut flectat" and "Probare, necessitatis est; delectare, suavitatis; flectere, victoriæ."

13. Paleotti 1582, p. 148: "…solendosi nell'arte oratoria assignare tre principali, che sono il dilettare, l'insegnare e il commovere, non è dubbio che i medesimi cadono ancor notabilmente nella pittura."

14. Saint Thomas Aquinas, *Summa Theologiæ*, II-II, q. 177, a. 1, ad 1: "Primo quidem, ad instruendum intellectum, quod fit dum aliquis sic loquitur quod doceat. Secundo, ad movendum affectum, ut scilicet libenter audiat verbum Dei, quod fit dum aliquis sic loquitur quod audi-

tores delectet. Quod non debet aliquis quaerere propter favorem suum, sed ut homines alliciantur ad audiendum verbum Dei. Tertio, ad hoc quod aliquis amet ea quae verbis significantur, et velit ea implere, quod fit dum aliquis sic loquitur quod auditorem flectat."

15. Paleotti 1582, pp. 215–16: "…per ufficio dell'arte è imposto che debbano dilettare, insegnare e movere. Parimente dunque ufficio del pittore sarà usare li stessi mezzi nella sua opera, faticandosi per formarla di maniera, che ella sia atta a dare diletto, ad insegnare e movere l'affetto di chi la guarderà. E se bene tutti questi tre mezzi sono importanti e necessarii per sodisfare a quello che si deve, niente-dimeno non si può negare che tra essi non siano i suoi gradi et alcuno più eccellente dell'altro, come disse quel gran Padre, parlando dell'ufficio dell'oratore: Delectare est suavitatis, docere necessitatis, flectere victoriæ."

16. Boileau 1735, pp. 273–74:
 Vous donc qui, d'un beau feu pour le théâtre épris,
 Venez en vers pompeux y disputer le prix,
 Voulez-vous sur la scène étaler des ouvrages
 Où tout Paris en foule apporte ses suffrages,
 Et qui, toujours plus beaux, plus ils sont regardés,
 Soient au bout de vingt ans encor redemandés?
 Que dans tous vos discours la passion émue
 Aille chercher le cœur, l'échauffe et le remue.
 Si, d'un beau mouvement l'agréable fureur
 Souvent ne nous remplit d'une douce terreur,
 Ou n'excite en notre âme une pitié charmante,
 En vain vous étalez une scène savante;
 Vos froids raisonnements ne feront qu'attiédir
 Un spectateur toujours paresseux d'applaudir,
 Et qui, des vains efforts de votre rhétorique
 Justement fatigué, s'endort ou vous critique.
 Le secret est d'abord de plaire et de toucher
 Inventez des ressorts qui puissent m'attacher.
 (translation: Cook 1892, pp. 185–86)
 Other Parisian editions of Boileau's works appeared in 1701, 1713, 1740, 1745, 1747, 1766, 1768, 1770, and 1772.

17. La Font de Saint-Yenne 1754, p. 71: "Si la fin la plus noble de la Peinture est de nous instruire en parlant aux yeux par le charme de l'imitation, & par le plaisir, la plus sure de toutes les routes pour nous mener à la persuasion, si l'objet de l'instruction est de corriger nos penchans vicieux, pouvons-nous faire un plus grand abus de nos talens dans ce bel art? Pourquoi ne les pas employer à nous offrir des exemples propres à élever notre ame au-dessus des sens?" On La Font de Saint-Yenne, see also the chapter by Charissa Bremer-David in this volume.

18. See Kluge 2009, pp. 155–59, 343–44; Henry 2001, pp. 463–66.

19. La Font de Saint-Yenne 1747, p. 8: "Le Peintre Historien est seul le Peintre de l'ame, les autres ne peignent que pour

les ïeux" (translation: Harrison, Wood, and Gaiger 2000, p. 556).

20. La Font de Saint-Yenne 1754, pp. 75–76: "Si la Peinture, outre l'amusement du plaisir & de l'illusion, doit être encore une école des mœurs, & un orateur muet qui nous persuade la vertu & les grandes actions, ne devons-nous pas employer toute l'activité de notre esprit à démêler dans l'histoire les traits les plus pathétiques, les plus frap-pans, & les plus susceptibles de ces expressions animées qui portent dans l'ame le feu & le mouvement, qui l'élevent au-dessus des sens & la rappellent à sa dignité primitive par des exemples d'humanité, de générosité, de grandeur de courage, de mépris des dangers & même de la vie, d'un zéle passionné pour l'honneur & le salut de sa patrie, & sur-tout de défense de sa religion?"

21. Horace *Ars poetica* 1.361.

22. Plutarch *De gloria Atheniensium* 3.347a.

23. Paleotti 1582, pp. 496–97: "Questo esempio pare a noi che debba movere molto i pittori dell'imagini sacre, che sono taciti predicatori del popolo, come più volte si è detto, ad affaticarsi con ogn'industria per conquistare più che potranno l'animo di ciascuno et apportare utilità univer-sale a tutti."

24. For examples of other types of literacy required of mem-bers of eighteenth-century Parisian elite society, see the chapters by Charissa Bremer-David (on temporal literacy) and Mimi Hellman (on decorative literacy) in this vol-ume.

25. La Font de Saint-Yenne 1754, pp. 109–10: "…dans ce tems où l'on ne lit presque plus (je parle du plus grand nombre) que des brochures, des historiettes galantes, & des Dic-tionnaires."

26. Rollin's treatise, best known as the *Traité des études*, was originally published under the title *De la manière d'enseigner d'étudier les belles-lettres, par rapport, à l'espirit et au coeur* (Paris: Estienne, 1726–28); quoted here from the standard edition of his works, Rollin 1819, pp. 455–56: "Il est d'autres espèces de livres exposés aux yeux de tout le monde: les tableaux, les estampes, les tapisseries, les statues. Ce sont autant d'énigmes pour ceux qui ignorent la fable, qui souvent en est l'explication et le dénouement. Il n'est pas rare que dans les entretiens on parle de ces matières. Ce n'est point, ce me semble, une chose agréable, que de demeurer muet et de paroître stupide dans une compagnie faute d'avoir été instruit, pendant la jeunesse, d'une chose qui coûte fort peu à apprendre" (translation: Rollin 1734, vol. 4, p. 170).

27. Diderot and Le Rond d'Alembert 1751–65, vol. 6, p. 344, s.v. "Fable" (Louis de Jaucourt): "Voilà pourquoi la con-noissance, du moins une connoissance superficielle de la fable, est si générale.…Les estampes, les peintures, les statues qui décorent nos cabinets, nos galeries, nos plafonds, nos jardins, sont presque toujours tirées de

la fable: enfin elle est d'un si grand usage dans tous nos écrits, nos romans, nos brochures, & même dans nos discours ordinaires, qu'il n'est pas possible de l'ignorer à un certain point, sans avoir à rougir de ce manque d'éducation."

28. See, for instance, Rigord 1739, p. 5: "La Fable est l'histoire Fabuleuse des Divinités du Paganisme. On lui donne aussi le nom de Mythologie, qui est formé de deux mots Grecs; sçavoir, Mythos & Logos, discours fabuleux."

29. Diderot and Le Rond d'Alembert 1751–65, vol. 10, p. 924, s.v. "Mythologie" (Louis de Jaucourt): "Les gens du monde, ceux mêmes qui se montrent les moins curieux de l'amour des Sciences, sont obligés de s'initier dans celle de la Mythologie, parce qu'elle est devenue d'un usage si fréquent dans nos conversations, que quiconque en ignore les élémens, doit craindre de passer pour être dépourvu des lumières les plus ordinaires à une éducation commune."

30. Starobinski 1977, p. 976: "Ainsi s'instaure un cercle: il faut connaître la fable pour comprendre les œuvres proposées par la culture ancienne et récente; et, parce que l'on a appris la fable, et que le modèle reste vivant, les œuvres nouvelles que l'on composera recourront à la fable."

31. Diderot and Le Rond d'Alembert 1751–65, vol. 10, p. 924, s.v. "Mythologie" (Louis de Jaucourt): "...au point que nous avons peine à les regarder comme des êtres imaginaires."

32. Pluche 1739, vol. 2, p. 387: "Ainsi l'enfance se passe parmi les dieux. Au sortir du collège, on les retrouve au théatre où ils parlent un langage qu'on entend sans efforts & sans maître. Tous les spectacles retentissent de leurs aventures: on les retrouve dans les cantates, dans les chansons de table, dans les décorations des appartemens, des jardins, & des places publiques. Gravures, peintures, poësies, musique, écrits enjoués, dissertations savantes, tout conspire à nous montrer sous des apparences honorables & touchantes des actions que les loix punissent, & des absurdités qui choquent de front le sens commun." On Pluche, see De Baere 2001.

33. Pluche 1739, vol. 2, p. 388: "On entretient donc à grand frais notre cœur dans l'irréligion, & notre raison dans un badinage éternel: d'où il ne peut résulter qu'une puérilité oisive qui affoiblit notre caractère, émousse tous nos talens, & qui en nous ôtant le goût de tous nos devoirs, en ruine toute la réalité."

34. Banier 1732, vol. 1, preface (unpaginated): "Ce qui m'a le plus coûté a été de rendre dans une langue chaste, un Poëte qui l'est peu. Les Métamorphoses, à les bien definir, ne sont que l'Histoire des passions des Dieux & des hommes, sur tout de leurs amours, & les effets de cette dernière passion y sont toûjours exposez avec trop de licence: les portraits que fait Ovide dans ces occasions sont trop vifs; la pudeur y est peu menagée, & c'est dans ces endroits-là seulement, qu'il ne donne que trop à penser."

35. Rollin 1819, p. 453: "Ce que j'ai dit jusqu'ici de l'origine des fables, qui doivent leur naissance à la fiction, à l'erreur, au mensonge, à l'altération des faits historiques, et à la corruption du cœur humain, peut donner lieu à une question, et faire demander s'il est fort à propos d'instruire des enfants chrétiens de toutes les folles inventions et des rêveries absurdes dont il a plu au paganisme de remplir les livres de l'antiquité. Cette étude, quand elle est faite avec les précautions et la sagesse que demande et qu'inspire la religion, peut être d'une grande utilité pour les jeunes gens. Premièrement, elle leur apprend ce qu'ils doivent à Jésus-Christ leur libérateur, qui les a arrachés de la puissance des ténèbres pour les faire passer à l'admirable lumière de l'Évangile. Avant lui, qu'étoient les hommes, même les plus sages et les plus réglés, ces célèbres philosophes, ces grands politiques, ces fameux législateurs de la Grèce, ces graves sénateurs de Rome, en un mot, toutes les nations du monde les mieux policées et les plus éclairées? La fable nous l'apprend. C'étaient des adorateurs aveugles du démon, qui fléchissoient le genou devant l'or, l'argent et le marbre; qui offroient de l'encens et des prières à des statues sourdes et muettes; qui reconnoissoient pour dieux des animaux, des reptiles, des plantes même; qui ne rougissoient pas d'adorer un Mars adultère, une Vénus prostituée, une Junon incestueuse, un Jupiter souillé de tous les crimes, et digne par cette raison de tenir le premier rang parmi les dieux" (translation: Rollin 1734, vol. 4, pp. 167–68).

36. Rigord 1739, p. 12: "Elle nous fait voir dans quelles ténèbres étoient plongées presque toutes les Nations de la terre, & jusqu'à quelle folie l'erreur conduit l'homme, quand il ne suit que ses propres lumières." Rigord had a late seventeenth-century forerunner in Thomassin 1681–82, a treatise that was republished several times in the eighteenth century.

37. Rigord 1739, p. 15.

38. Banier 1711; Banier 1738–40.

39. See Manuel 1959, pp. 105–7.

40. Banier 1738–40, vol. 3, p. 431: "[Enée] est toujours représenté comme un homme craignant les Dieux, qui paroissent prendre un soin particulier de lui."

41. Virgil 1743, vol. 2, p. xxxviii. On Charles-Nicolas Cochin's illustrations for this edition, see Michel 1987, pp. 204–7, cat. no. 32.

42. Rigord 1739, pp. 265–66: "Ses ordres appelloient le Heros Troyen en Italie. Il obéit. Ni les avantages d'un Royaume tout fondé, ni l'amour, ni les larmes de Didon, ne purent le retenir."

43. Banier 1738–40, vol. 3, pp. 493–94.

44. For a comparison of *Didon* with Virgil's text, see Robichez 1987, pp. 45–50.

45. Cited in Le Franc de Pompignan 1746, p. xiii: "Je vous avouë que le caractère miserable d'Enée me dégoûte bien.... Enée est un homme foible, & un dévot insipide."

46. Le Franc de Pompignan 1746, pp. iv–v: "J'écrivis en 1734 que Virgile étoit un mauvais modèle pour les caractères. L'expression est dure, & ne convenoit point à mon âge, ni à mon peu d'expérience. Je la rétracte aujourd'hui par respect pour Virgile, en pensant toujours de même par respect pour la vérité."

47. Le Franc de Pompignan 1746, p. iv: "Didon dans l'Eneïde se livre trop légerement à son goût pour un étranger, qui n'est, à le suivre de près, qu'un Amant sans foi, qu'un Prince foible, qu'un dévot scrupuleux. J'ai dû nécessairement abandonner Virgile dans le caractère de mon Héros. J'ai même osé donner des bornes à l'excessive piété d'Enée. Je l'ai fait parler contre l'abus des Oracles, & l'impression dangereuse qu'ils font souvent sur l'esprit des Peuples. J'ai voulu qu'il fût religieux sans superstition; qu'il agît toujours de bonne foi, soit avec les Troyens quand il veut demeurer à Carthage, soit avec Didon quand il se dispose à la quitter; en un mot, qu'il fût Prince & honnête homme."

48. See Braun 1972, p. 71.

49. Desfontaines 1735–43, vol. 1, pp. 51–52: "...amoureux & galant, en lui laissant de la religion: mais son amour subordonné à la noble ambition de fonder l'Empire Romain, va jusqu'à lui rendre suspects les Oracles des Dieux. Enée, peint de ses couleurs sagement assorties, a charmé les Spectateurs, surtout lorsqu'ils l'ont vû triompher de sa passion, & renoncer aux délices de Carthage, au moment qu'Acate lui demande son Fils au nom des Troyens, pour aller faire la conquête de l'Italie. Cette surprise a paru ménagée avec un art admirable. La grande difficulté étoit de séparer Enée de la Reine, qui l'avoit accablé de bienfaits, & de le faire partir, sans qu'on pût lui reprocher d'être ingrat: l'Auteur a surmonté habilement cette difficulté, en feignant une bataille où Enée tue son rival. Ainsi le départ de ce Héros n'est accompagné d'aucune odieuse circonstance. Ce n'est ni un infidele, ni un ingrat, comme dans l'Eneïde."

50. Braun 2005, p. 17.

51. For the painting's provenance, see Exhibition Object no. 101. On La Live de Jully's collection, see Bailey 2002, pp. 33–69.

52. Cited in Bailey 2002, pp. 40, 255 n. 21.

53. Virgil *Aeneid* 2.692–98.

54. On the connections between reading, manners, and social virtue, see Chartier 1987, pp. 91–101.

55. For a discussion concentrating on the latter aspect, see Baxter 2008, esp. pp. 275–76.

56. Rollin 1818, p. 273: "[Virgile] fait la plus grande occupation des classes: aussi est-ce un modèle parfait et qui peut suffire seul pour former le goût."

57. Bossuet 1732, pp. 17–22.

58. Cited in Courajod 1874, p. 33: "J'ai cru ne pouvoir mieux faire que de commencer mes leçons par un extrait de l'Histoire universelle de M. Bossuet."

59. Le Normant de Tournehem to Coypel, May 5, 1747, transcribed in Montaiglon 1875–92, vol. 6, p. 52. For the library's holdings prior to 1747, see the inventories transcribed in Müntz 1897, pp. 35–42.

60. "Catalogue des Livres donnés par le Roy à l'Académie royale de Peinture et de Sculpture," May 6, 1747, transcribed in Müntz 1897, pp. 42–43. The same titles appear in the "Mémoire des livres fournis pour l'Académie de peinture," October 26, 1747, transcribed in Locquin 1907.

61. La Font de Saint-Yenne 1747, pp. 9–10: "Mais où trouveront nos jeunes éleves la chaleur & le feu de ces éloquentes expressions, la source de ces grandes idées, de ces traits frapans ou intéressans, qui caractérisent le vrai Peintre d'Histoire? Ce sera dans les mêmes fonds où nos meilleurs Poëtes ont toûjours puisé. Chez les grands écrivains de l'antiquité: dans l'Iliade & l'Odissée d'Homere si fécond en images sublimes: dans l'Eneïde si riche en actions héroïques, en pathétiques narrations & en grands sentimens: dans l'art Poëtique d'Horace, thrésor inépuisable de bon sens pour la conduite d'un plan de Tableau épique ou tragique, dans celui de Despreaux son imitateur, chez le Tasse, chez Milton. Voilà les hommes qui ont ouvert le cœur humain; qui ont su y voir, & nous rendre ses troubles, ses fureurs, ses agitations avec une éloquence & une vérité qui nous instruisent, en nous comblant de plaisir" (translation: Harrison, Wood, and Gaiger 2000, pp. 556–57).

62. Anne-Claude-Philippe de Tubières, comte de Caylus: "Des causes de la petite manière de l'école française," Paris, Bibliothèque de l'Ecole Nationale Supérieure des Beaux-Arts, Ms. 522, pp. 43–49; cited in Kirchner 1991, p. 191.

63. Caylus 1757.

64. See Sauvy 1986, p. 28.

65. Cited in Courajod 1874, p. 33. The first five editions of Calmet's *Histoire de l'Ancien et du Nouveau Testament, et des Juifs* appeared in 1718 (Paris: Emery), 1720 (Paris: Emery), 1725 (Paris: Emery), 1737 (Paris: Martin), and 1742 (Paris: Martin).

66. See note 20 above.

67. See Kley 1975, pp. 6–36.

68. Le Franc de Pompignan 1771, p. 143: "Seigneur, à ta pitié mon ame s'abandonne: Fais grace aux attentas qu'envers toi j'ai commis"; p. 144: "Sans toi je ne suis que foiblesse, je n'ai de force qu'avec toi." For the different iterations of this book and its publishing history, see Braun 1972, pp. 127–28.

69. Le Franc de Pompignan 1771, p. 105: "la parfaite dépendance s'allie avec la liberté."

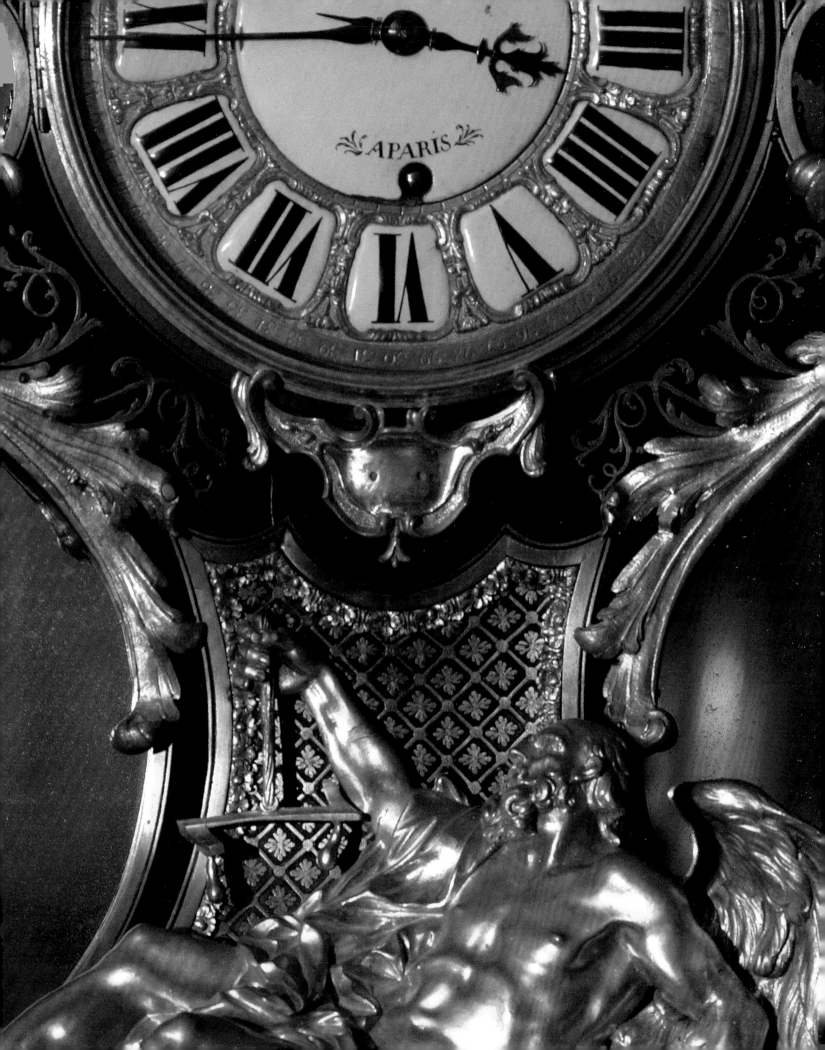

Enchanted Night:

Decoration, Sociability, and Visuality after Dark

V

Mimi Hellman

In the early twenty-first century, candlelight is widely associated with romance, sophistication, and nostalgia for an idealized past. Its warm, flattering glow is considered conducive to erotic intimacy; low light is *de rigueur* at formal parties and upscale restaurants; and a range of popular leisure activities and entertainments suggest a desire to experience the supposedly simpler conditions of preindustrial societies.[1] Even scholarship tends to waver between celebratory narratives of technological progress and affectionate documentation of candlelight's lost mystique. The English title of Wolfgang Schivelbusch's classic study, *Disenchanted Night: The Industrialization of Light in the Nineteenth Century* (1988), captures this equivocation by implying that gaslight and electricity abolished the allure of darkness.[2]

The romance of candlelight seems to be a central theme of pendant genre paintings by Jean-François de Troy (1679–1752), *Before the Ball* and *Return from the Ball* (figs. 53 and 54). Small groups of people, most enveloped in the flowing dominos worn for masquerade parties, gather in pools of light cast by a few candles and, in *Return from the Ball*, a glowing fireplace.[3] The palette is warm, the mood intimate and convivial. The limited illumination reduces bodies to animated fragments, touching only the most proximate surfaces of faces, hands, and garments, while leaving everything else in deep shadow. This pictorial device plays on the notion of concealment invoked by the theme of masquerade. Faces revealed by light appear paradoxically masklike, an effect heightened by the actual masks held just beneath the faces of several figures in *Before the Ball*. Darkness doubles the invisibility of bodies already swathed in garments designed to hide social distinctions expressed through dress. The figures look at one another, masks drawn aside, in shadowy domestic spaces, yet the juxtaposition of the two images invites viewers to imagine

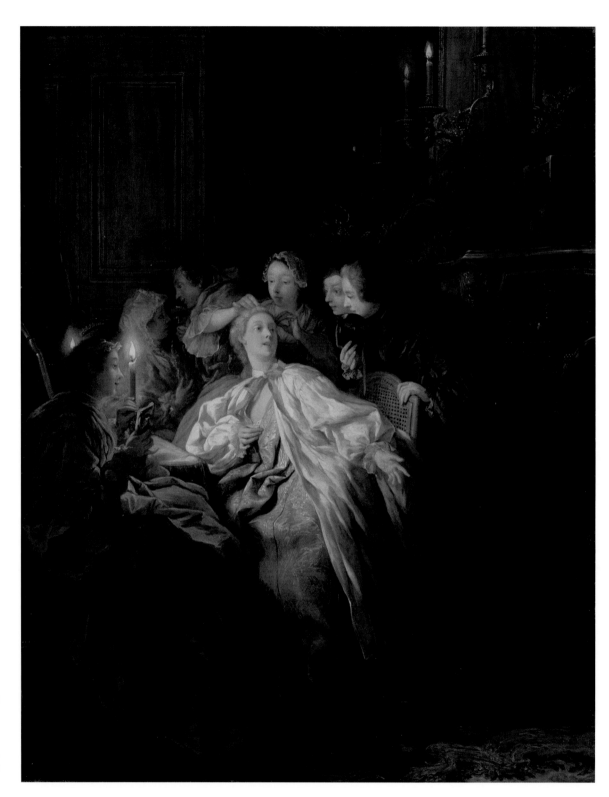

Figure 53
JEAN-FRANÇOIS DE TROY
(French, 1679–1752),
Before the Ball, 1735.
Oil on canvas, 82.2 ×
64.9 cm (32⅜ × 25⁹⁄₁₆ in.).
Los Angeles, J. Paul Getty
Museum, 84.PA.668.

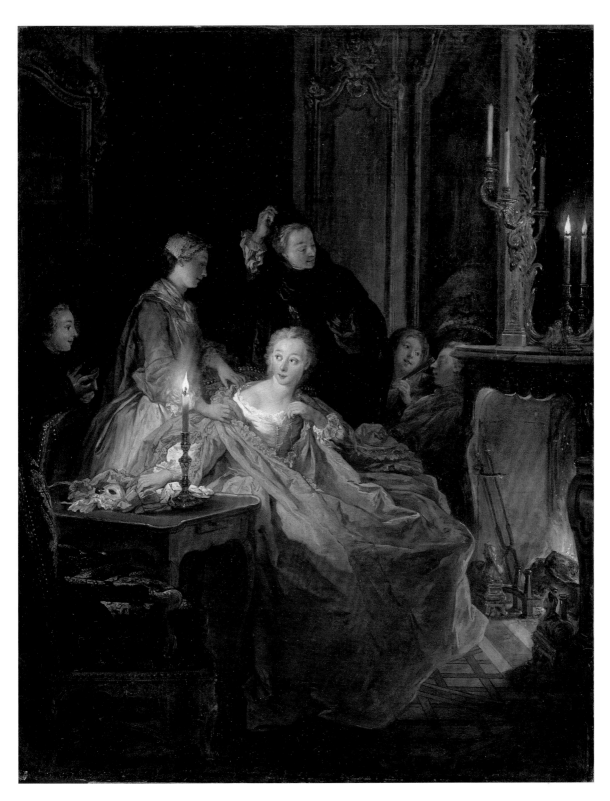

Figure 54
JEAN-FRANÇOIS DE TROY
(French, 1679–1752),
After the Ball, 1735.
Oil on canvas, 82 × 65 cm
(32⁵⁄₁₆ × 25⁹⁄₁₆ in.).
Private Collection. Photo:
courtesy of Konrad
Bernheimer, Munich.

a temporal and spatial interlude in which the same protagonists frolic anonymously—seen but unrecognized—in a brighter, more formal ballroom. In the playful manner of other pendant works by de Troy, the paintings encourage comparative association and imaginative extrapolation through visual and thematic patterns: animated preparation and sleepy aftermath, concealing and revealing, private disclosure and public disguise.[4]

But do these images fully capture the dynamics of sociability by candlelight in the eighteenth-century interior? It is tempting to accept what Roland Barthes would call the "reality effect" of genre pictures—their plenitude of apparently thorough, accurate detail—as evidence of historical environments and practices, and scholars of decorative art often rely on such works to explain the meanings of objects long separated from their original contexts.[5] But images are inventions, and we should use them to raise questions without assuming that they supply all the answers. This essay seeks to make candlelight strange, to complicate the associations with unproblematic elegance, romance, and simplicity that shape both modern discourses and—at least so it seems—eighteenth-century imagery. It explores the material conditions, social protocols, and visual effects of the evening interior in order to define a historically and culturally specific experience of candlelight and to suggest how decorative objects produced meaning even when they all but disappeared under dim lights. Elite sociability was very much about seeing and being seen, but the play of vision involved knowing how to manipulate, navigate, and make sense of both illumination and darkness. Like the thrill of the masquerade, the enchantment of candlelit interiors turned on a knowing engagement with the visible, the invisible, and the barely seen glints in between.

Visual Acuity and the Limits of Seeing

There was much to look at in the eighteenth-century French interior, and decoration was central to elite self-presentation and interaction. Wealthy individuals inhabited environments filled with finely crafted objects, from paintings and tapestries to veneered furniture and mounted porcelain, all of which were potentially legible to others as evidence of wealth, status, and taste.[6] The boutiques of luxury merchants (*marchands-merciers*) were also spaces where encounters with design shaped aesthetic preferences and social personas.[7] Moralists criticized elite consumption by associating it with feminine frivolity and a democratization of luxury that blurred important social distinctions. Yet the very vigor of their debates, not to mention the sheer quantity and variety of elegant objects in circulation, indicates that decoration was bound up with the construction of privilege. Even the most disdainful satires suggest a practice of what might be called decorative literacy, a mode of critical scrutiny that inferred character from objects. In his *Tableau de Paris*, Louis-Sébastien Mercier (1740–1814) wryly observed that, at public estate sales, "the confession of the deceased is clearly written in his cupboards...every man may tell himself, during his lifetime: these bronzes and pictures which have cost me so much, and which I hide from curious eyes, will serve as evidence, after my death, for judgment of my tastes."[8] In a world where the modern concept of a "true" inner self was not yet pervasive, appearances constituted identities and objects were avidly noticed.

The importance of display and discernment extended to the body itself. The well-appointed leisure of eighteenth-century elites is often characterized as comfortable and pleasurable, but it also demanded considerable self-awareness and visual acuity.[9] The central goal of cultivated sociability was to be aesthetically and socially gratifying to others. This meant suppressing the body's natural physicality and behaving with restrained yet seemingly natural grace. Elegant movement and speech were light, fluid, oblique, and attuned to the sensibilities of others. Refined individuals avoided abrupt movements, broad gestures, exaggerated facial expressions, and self-interested or pedantic conversation. Beyond these basic expectations, the specific terms of polite conduct depended upon a wide range of factors. Arriving at a social gathering, guests quickly assessed the location and nature of the occasion as well as the rank, gender, age, marital status, and character of its participants. Then, throughout the course of the event, they continued to monitor these variables and adjust their behavior to accommodate, for example, the respect due a widowed duchess or the confidences acceptable only among those of the same gender and rank.

Louis-Antoine Caraccioli (1719–1803) summarized these challenges in his 1759 treatise *Le véritable mentor, ou l'éducation de la noblesse*. Polite society, he explained, communicates by "the aid of signs, words, gestures, postures and looks," and successful interaction requires attentiveness and physical control. One must master a "science of discernment, which foresees in the blink of an eye the moment to advance or retreat,

to keep quiet or speak, to accept or refuse, to praise or censure." Every move conveys meaning: "Here it is the feet, gracefully gliding one before the other, which announce respect; there it is a nod of the head, which well managed denotes approbation. Here it is a look, cast without affectation, which expresses modesty; there it is an elegant walk which produces noble pride. One may judge these details infantile, yet it is these details that shape the balance of societies and what is known as living well."[10]

In other words, social conduct was self-reflexively visual: elites simultaneously watched one another and presented themselves as objects of delectation. Paradoxically, however, this strategic deployment of vision was supposed to be unobtrusive and apparently natural. Overt modes of looking such as squinting and staring distorted the pleasing body and implied social inferiority. In the 1723 edition of *Les Réflexions sur le ridicule*, Jean-Baptiste Morvan de Bellegarde (1648–1734) condemned the effusiveness of those he dubbed "praisers": "They no sooner enter a place or join a circle than they contemplate the situation with care; they praise the ceiling, the alcove, the bed, the armchair, the screen someone offers them, the little barking dog."[11] Such studious, enthusiastic looking was associated with provincials and parvenus, as opposed to the visual restraint of those accustomed to decorative abundance. Elite visuality was characterized not by a sustained, totalizing gaze but rather by mobile, fleeting, covert glances. Navigating the decorated interior was a matter of noticing and responding without actually appearing to see.

Certain aspects of interior design amplified the visibility of agreeable objects and bodies. Eighteenth-century living quarters were well lit compared with those of earlier periods. Newly built *hôtels,* especially those in the relatively undeveloped neighborhoods of western Paris, occupied lots large enough to distance living quarters from narrow, dark streets and allow large windows in both the side elevations and the longer, more articulated facades overlooking entrance courts and rear gardens. The most exclusive spaces were smaller and therefore easier to light, and the installation of white paneling and large mirrors in both formal and private apartments magnified natural and artificial illumination.[12]

Interiors were also equipped with an unprecedented quantity and variety of light fixtures in a wide range of media and designs, from elaborate objects of crystal or gilt bronze to modest ones of earthenware or imitation lacquer.[13] A typical scheme included large, fixed elements for ambient illumination and smaller, portable ones to focus light on specific areas and activities. Glass-enclosed lanterns were favored for drafty rooms such as vestibules and antechambers, while many formal spaces featured elaborate chandeliers (*lustres*). Multibranch wall lights (*bras*) projected from paneling, often flanking mirrors that increased their glow (see figs. 53 and 54). Movable light sources included candelabra (*girandoles*), candlesticks (*chandeliers*), stemless fixtures with candle sockets attached to saucer-shaped bases and handles for easy carrying (*bougeoirs*), and night lights that burned small candles or oil in protective, cuplike containers (*veilleuses*).

But even at their best, these design features could not provide bright, even, sustained illumination for all the rooms of a fashionable interior during all times of the day and night. Many hours of collective activity—including game playing, dining, musical performance, and even reading and handwork—unfolded by candlelight, within limited circles of flickering brightness surrounded by encroaching gloom. The visual acuity so essential for polite interaction was limited by both the protocols of looking and the variable, often dim lighting of social spaces. To better understand the complex interplay of vision and decoration, we must first consider, more specifically, what lighting the interior entailed.

Producing Candlelight

The production and consumption of candles turned on important material and linguistic distinctions.[14] *Chandelles* were made of tallow (rendered animal fat) and *bougies* were made of beeswax. Both involved labor-intensive artisanal techniques, some of which appear in an illustration of wax-candle making from the *Encyclopédie* (fig. 55). On the far right, a man repeatedly draws a spool of wick through a basin of melted wax, producing a thick rope to be cut into different lengths; the apparatus also appears below the vignette. The central figure pours melted wax over suspended wicks, while his colleague by the window rolls hardened candles on a table to impart an even shape and sheen. Candles, particularly tallow ones, were also manufactured using variously shaped molds, and some were painted different colors or even embellished with gold. In a 1762 treatise on wax-candle making, Henri-Louis Duhamel du Monceau (1700–1782) lists twenty different sizes for use in living quarters, plus others especially for lanterns and night lights.[15]

snuffing as often as every five minutes and lost at least half their fuel to guttering.[16]

Wax candles, by contrast, had a higher melting point and produced a brighter, steadier flame that lasted longer and needed less snuffing, but they were up to three times more expensive than those of tallow. Monceau lists a number of other potential limitations. Dirty wicks, or those of mixed composition or improper thickness, made candles gutter and smoke, while those coated with wax while damp produced sparks. Even the best candles guttered and required snuffing when placed in drafty rooms or carried from place to place, and trimming was necessary even in small, still rooms because insufficient air circulation resulted in unconsumed wick. Blowing candles out released a messy spray, and while high-quality wax could be removed from fabric with alcohol, inferior materials left greasy stains.[17]

Inventions promoted in popular publications suggest growing awareness of candlelight's limitations and a desire for alternatives. In 1761, for example, *L'Avantcoureur* announced a new type of fixture that burned olive oil, a medium that "is more beneficial for vision, gives light that does not flicker at all, produces no smoke, and costs little. These candlesticks have the advantage of never guttering and may be tilted and transported without risk of spilling anything."[18] In 1763, the same source recommended the use of lanterns with mirrored bases, which yield more light than crystal chandeliers, shelter candles from drafts, and do not drip wax on those below; in 1770, it advertised candles that last up to eleven hours and produce no smoke to damage gilding or upholstery.[19] A major development occurred in the 1780s, when several Frenchmen imitated and refined a new type of oil lamp designed by Swiss inventor François-Pierre Ami Argand (1750–1803). This device was widely praised for its white, brilliant, fuel-efficient light that neither wavered nor smoked, equaled that of at least ten candles, and was "infinitely more beautiful" than that of *bougies*.[20]

But most of these innovations remained curiosities; only the Argand lamp was widely adopted, and not until the very end of the century. During the reign of Louis XV (1710–1774, reigned from 1723), on the many occasions when social life unfolded during cloudy days or after dark, individuals pursued acts of elegantly appointed, visually agreeable interaction in only partially illuminated spaces, amid lighting conditions that were costly, messy, constantly changing, and often downright unpleasant. Perhaps they simply tolerated

Maintaining candlelight was no easy task. Tallow candles tended to smoke and smell due to residual proteins in the fat. They also had a low melting point and thus burned quickly and inconsistently, leaving both fuel and wick partly unconsumed. The charred wick then curled into the top of the candle, diminishing its brightness and causing molten tallow to spill down the sides. This tendency to gutter could be minimized by snuffing, which (contrary to widespread modern use of the term) did not mean extinguishing the flame but rather trimming the spent wick. Snuffing required patience and dexterity to avoid accidentally quenching the light, and by some estimates tallow candles required

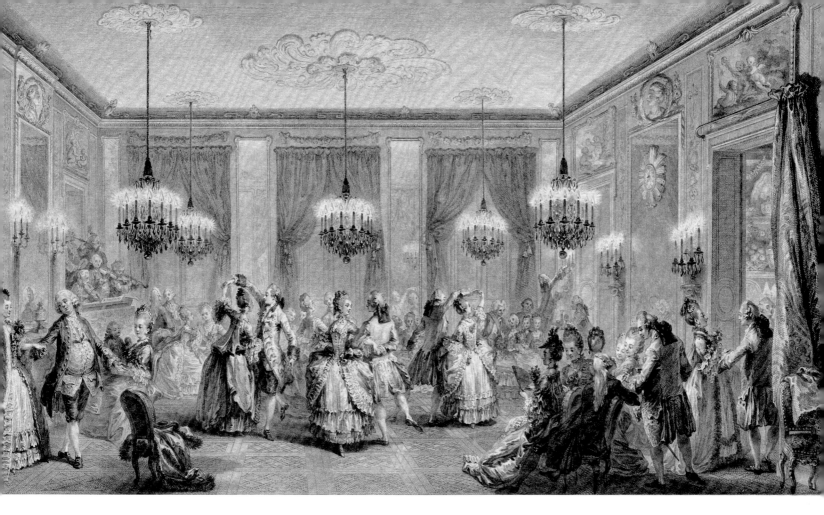

the inconvenience as a fact of life, but given their pre-occupation with artful appearances it is worth asking whether candlelight, despite its limitations—or perhaps even because of them—was a self-consciously manipulated effect that actually contributed to the interplay of vision, sociability, and decorative signification.

Performing Candlelight

The first thing to consider is that the quantity and type of lighting in a room helped to define social relationships along a spectrum of relative formality or intimacy. A print after Augustin de Saint-Aubin (1736–1807) entitled *Le Bal Paré* (fig. 56) correlates abundant illumination with festivity on a grand scale. The engraver leaves patches of unmarked paper to represent the haloes of candles from five chandeliers and four multibranch wall fixtures flanking large mirrors. Many chandeliers were costly and fragile, especially those of Bohemian or rock crystal, and owners incurred additional expense when they commissioned *marchands-merciers* to clean and repair them in a laborious process than sometimes entailed removal or even dismantling.[21] Lighting like that of Saint-Aubin's ball certainly would be recognized as a lavish gesture.

Ample illumination invited guests to admire decorative objects that might be less evident on other, more modestly lit occasions, and it also heightened the visibility of people themselves. Sarah Cohen has suggested that dance produced "a social connoisseurship of the body" in which spectators appreciated both the visual qualities of dancers and the abstract patterns their movements inscribed in space.[22] Even without this formalized aesthetic practice, blazing chandeliers turned everyone into a collective spectacle of corporeal virtuosity.

Other images suggest, conversely, that minimal lighting conveyed its own aura of privilege. In a print after Sigmund Freudeberg (1745–1801) entitled *La Soirée d'Hyver (The Winter Evening)* (fig. 57), a man and two women gather in the limited light of a glowing hearth, a three-branch wall light, and a shaded candlestick. In contrast to Saint-Aubin's busy, stagelike space, Freudeberg places his small group in a corner and uses illumination to suggest intimacy and intrigue. The man surreptitiously exchanges a note with one woman, while addressing the other with an expression and gesture of regard. The lighting helps to construct this moment of amorous duplicity: the fireplace and wall light draw attention to the man's contradictory

Figure 56
ANTOINE-JEAN DUCLOS (French, 1742–1795) after Augustin de Saint-Aubin (French, 1736–1807), *Le Bal Paré*, 1773. Engraving, image: 22.3 × 38.8 cm (8¾ × 15¼ in.). Williamstown, Massachusetts, Sterling and Francine Clark Art Institute, 1955.2361. Image: © Sterling and Francine Clark Art Institute, Williamstown, Massachusetts.

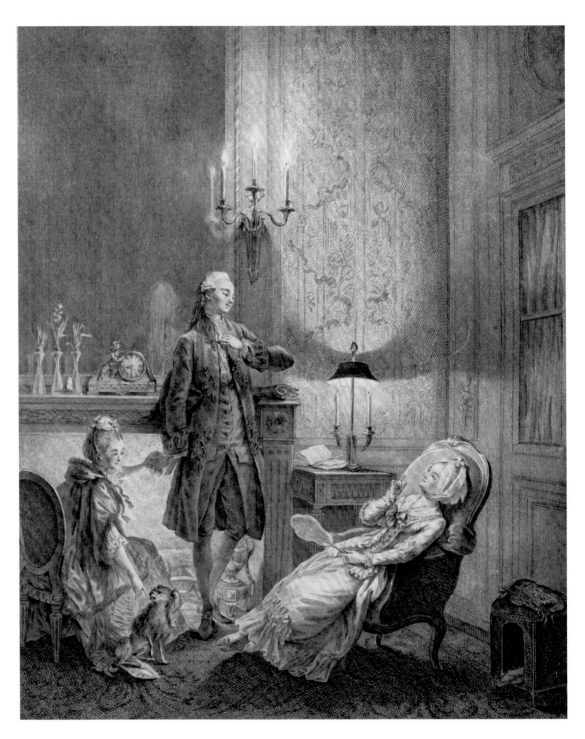

Figure 57
INGOUF THE YOUNGER
(French, 1742–1795) after
SIGMUND FREUDEBERG (Swiss,
1745–1801), *La Soirée d'Hyver*
(*The Winter Evening*) from
*Suite d'estampes pour servir
à l'histoire des moeurs et du
costume des françois dans le
dix-huitième siècle* (Paris, 1775).
Engraving, H (of book): 61 cm
(24 in.). Bibliothèque nationale
de France, DEV-1004-006199.

demonstrations of affection, while the shaded candle-stick spotlights the innocent party as she stretches receptively in an armchair. The scenario is, of course, fictional, but it is part of a series designed to exemplify fashionable luxury consumption and (like de Troy's pendants) invites a worldly audience to contemplate candlelight's capacity for revealing and concealing.[23] It

suggests how patterns of light and darkness can structure space, attracting or discouraging attention and thereby shaping the social workings of vision.

Candlelight, in other words, was bound up with power dynamics. By controlling light, hosts determined what visitors could see, and lighting patterns shaped guests' navigation of a room, beginning with their first

covert survey. More illumination did not necessarily mean greater social ease: a space brightly lit for formal entertaining was easier to assess at a glance than a dim one, but at the same time one's conduct was more susceptible to scrutiny. Intimate lighting presented its own complications. Pools of brightness directed vision and movement, but a new arrival might experience hesitation, if not disorientation, as her eyes adjusted and she charted a path through the shadows. If only for a moment, selective lighting positioned her outside a privileged social circle, and her ease of approach and integration was shaped in part by whether she was familiar, from prior encounters, with the setting or its occupants. Sociability by candlelight involved a psychological dimension, as light levels produced varying degrees of accessibility or exclusivity, uncertainty or recognition, objectification or inclusion.

Images of interiors rarely depict the maintenance of candlelight, but in actual social situations this could be a vehicle for self-presentation as well as a practical necessity. At regular intervals throughout the evening, masters and mistresses summoned servants to light or replace candles, snuff smoking wicks, and transport fixtures within or between rooms. Before the invention of friction matches in the early nineteenth century, illuminating a space meant bringing a lit candle from elsewhere—perhaps a faraway kitchen—or laboriously coaxing a spark from tinder using a flint and steel.[24] Candles were difficult to relight if their wicks were trapped in hardened fuel, and the remains of spent ones had to be pried from their sockets. In a large residence, dusk—or even the start of a gloomy day—must have generated a flurry of activity, and generously illuminating an interior must have taken some time. Not all instances of maintenance were undertaken in the presence of guests, but whether directly observed or implied through the luminary conditions they produced, repetitive cycles of domestic service contributed to the construction of identities. Well-managed lighting positioned elites not only as leisured people in control of domestic hierarchies but also as physically and aesthetically sensitive beings whose environments required constant, attentive regulation.

Moreover, the material and visual qualities of candles themselves could be legible social signs. Since expensive wax burned more brightly, evenly, and cleanly than cheaper tallow, the behavior of the flame—emphasized by the frequency of snuffing—could suggest the extent of one's expenditure, refinement, and hospitality. Monceau's treatise further suggests the aesthetic attractions of *bougies*. The best ones were "a clear white, a little bluish, and above all translucent."[25] Improperly melted wax had a reddish tint that marred this visual purity, and the rolling process (see fig. 55) was crucial for imparting "all the brilliance one could desire."[26] Candles stored in a warm place or kept for more than six to eight weeks became yellow and powdery but could be rubbed with a cloth to restore some sheen. Adulteration was a major problem: the presence of a tallow under-layer was betrayed by excessive guttering and a foul smell, and even lighting a wax candle with a tallow one—something that probably happened often when inferior candles were brought from antechambers or kitchens to light those in more privileged spaces—transmitted an unpleasant, lasting odor.[27] It is impossible to determine the degree to which consumers shared these specialized concerns, but given the ubiquity of candles they may well have registered in at least some situations. Here, again, the management of candlelight could signal privilege. By insisting on attractive *bougies*, demanding frequent snuffing, or expressing distress over guttering, smoke, or odor, elite consumers transformed the basic necessity for light into a performance of leisure, sensitivity, and refinement.

The preoccupation with light as an aesthetic effect was articulated even more pointedly through the design of fixtures. The account books of *marchand-mercier* Lazare Duvaux (1703–1758) document an extraordinary range of objects whose luxurious materials and elaborate forms far exceed functional requirements. A representative sample appears among the purchases of the comte d'Egmont on four occasions during the 1750s: a six-branch chandelier of Bohemian crystal and a pair of glass lanterns with gilt-bronze frames, all with tasseled silk cords (470 and 348 livres), two pairs of three-branch, gilt-bronze wall lights (680 livres), a pair of three-branch, gilt-bronze *girandoles* with Meissen porcelain swans (720 livres), and a pair of two-branch wall lights with lacquered blue and white flowers (72 livres).[28] Cost correlated with materials, scale, and formal complexity, and consumers would have been well equipped to assess the relative merits of various examples encountered on the social circuit.

The comte d'Egmont's *girandoles* with swans exemplify the fashionable practice of incorporating porcelain into gilt-bronze light fixtures. Often composed to order under the auspices of *marchands-merciers*, these ensembles featured brightly colored figurines, animals, birds, and flowers made at various manufactories, all united by mounts from which candle

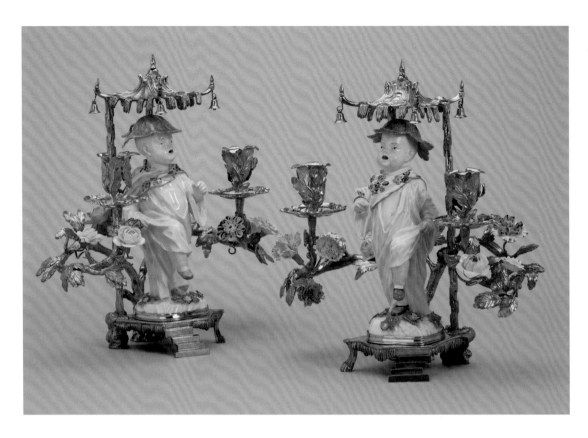

sockets sprouted like additional elegant blossoms.[29] In a typical composition that also signals the popularity of Chinese motifs (fig. 58), plump Meissen children wearing leaf caps, jaunty scarves, and loose robes dance beneath gilded canopies, flanked by candleholders shaped like foliage and punctuated with variously shaped and tinted flowers. In an artful combination of naturalism and artifice, illusionistically shaped leaves and flowers are rendered in hard, shiny materials. Lit candles—presumably white, shiny *bougies*—would extend the objects' visual appeal. Quivering flames would resonate with the pointed finials on the canopies, while the verticality and porcelainlike gleam of candles would echo the figures' upright poses, make their pale skin and garments glow, and emphasize their miniature scale and humorously gaping robes. The candelabra transform the functional operation of lighting into a clever source of entertainment, inviting viewers to engage playfully with exotic motifs mediated by European artistry and taste.[30]

The social resonance of these works also turned on the fact that they were highly impractical. Even equipped with the finest candles and carefully tended, their intricate surfaces could easily be damaged by soot and melted wax. Indeed, this prospect raises the question of how often such elaborate objects were actually used. Interestingly, Lazare Duvaux's accounts record

numerous instances of cleaning and repair of flower-embellished light fixtures.[31] But Duvaux sold far more ornate pieces than he serviced, and it seems likely that some owners rarely, if ever, subjected them to the vagaries of use. Ultimately, these responses expressed privileged indifference to quotidian concerns: either one enjoyed the means to acquire, damage, and restore an object whose design radically transcended—and, indeed, compromised—utility, or one possessed such an abundance of light sources that potentially functional fixtures could be left unused. In both cases, the object was meaningful because it was excessive, marking the owner's distance from the ordinary domestic constraints of lesser social beings.

Even if some items produced meaning through a refusal of function, candles were still an unavoidable necessity, and it is worth considering the specific physical conditions that shaped activities undertaken near open flames. Pursuits such as reading aloud and game playing required focused illumination, and the ambient glow of chandeliers and wall lights was supplemented by portable fixtures placed on small tables with often specialized functions (see figs. 53, 54, and 57).[32] A veneered writing and card table (fig. 59) might seem perfectly designed to facilitate visual and social ease. Unfolded for gaming, its surface is approximately three feet square with an undulating contour that flares

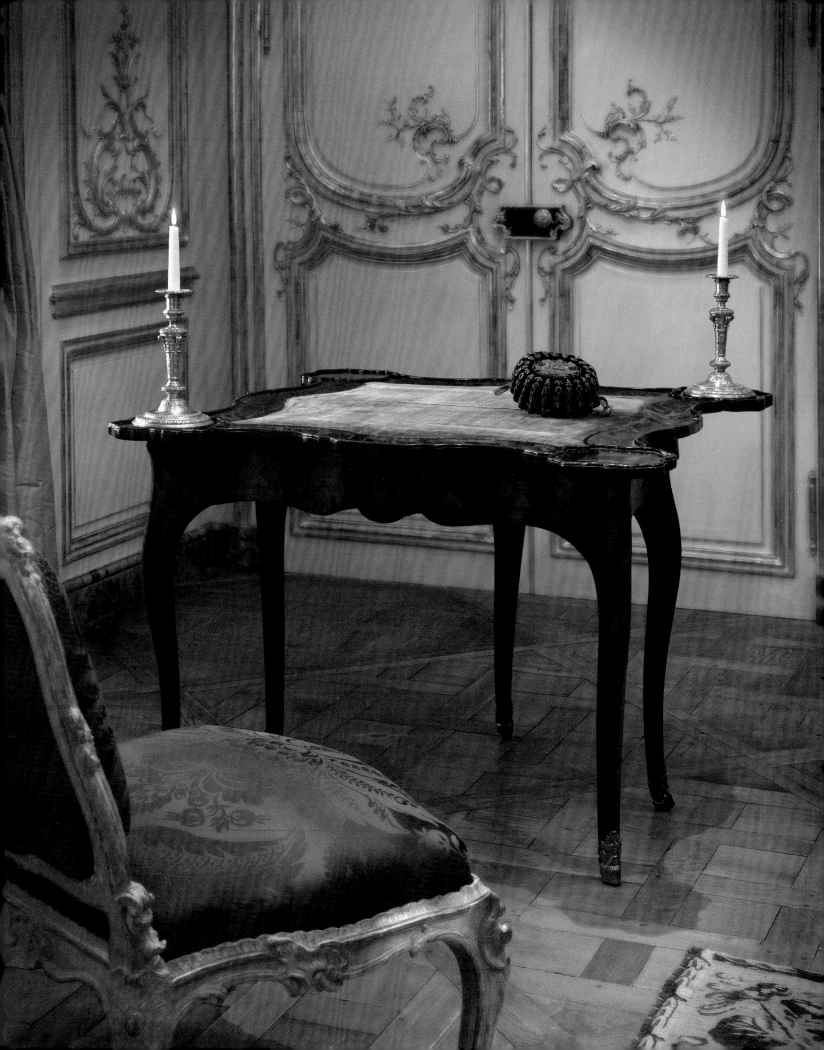

into corner projections intended to hold candlesticks. The small scale of such tables, together with women's voluminous skirts and the full sleeves worn by both genders, placed players very close together. A painting by Pierre-Louis Dumesnil (1698–1781) suggests this kind of proximity (fig. 60). In a dim salon, four women gather around a game table illuminated by just two candles and a pair of distant wall lights. With their high-backed armchairs pulled close to the small, bright tabletop, they enjoy what seems to be relaxed, convivial intimacy.

But considered more critically, both table and painting hint at the challenges of performing leisure by candlelight. Seated elbow to elbow, it would be quite easy to upset a candlestick or squint in the glare of a nearby flame, and any ill-calculated gestures or disagreeable facial expressions would be spotlit for all to see. In *Les Réflexions sur le ridicule*, Bellegarde warns against improper conduct at the game table: "It is necessary to moderate one's game, and to moderate oneself while playing. Those who play with passion, greed, and self-interest often forget themselves; they become impatient, they curse, they are bad-tempered when the game turns against them, and they disclose the baseness of their sentiments."[33] Candle flames would materialize such lapses, flaring in response to a loser's vigorous sigh of annoyance or turning a winner's triumphant smile into a grotesque grin. Conveniently lit

Figure 60
PIERRE-LOUIS DUMESNIL
(French, 1698–1781), *Interior with Card Players*, ca. 1752. Oil on canvas, 79 × 98 cm (31⅛ × 38⁹⁄₁₆ in.). New York, Metropolitan Museum of Art, Bequest of Harry G. Sperling, 1971, 1976.100.8. Image: © The Metropolitan Museum of Art / Art Resource, N.Y.

game tables did not simply facilitate entertainment, they also exposed behavioral lapses and challenged users to play with pleasingly self-conscious restraint.[34]

Another type of object that simultaneously valorized and disciplined social performance was the snuffer used to trim candle wicks. An example included in the toilette set discussed by Kimberly Chrisman-Campbell in chapter 3 (see fig. 35) characteristically features a small box attached to one blade, designed to catch the cut wick, and an elongated tip that supports the instrument on its tray and could be used to nudge a curling wick upright (fig. 61). This personal accessory arguably enhanced privacy and convenience by enabling the owner to tend candles herself rather than relying on servants, but its inclusion among grooming equipment also granted it a social role in a ritual that, as Chrisman-Campbell demonstrates, was central to the construction of elite personas. Like the candlelit game table, the snuffer encouraged pleasing conduct by posing performative hazards. Just over seven inches long, it essentially forced the hand into a graceful position. It also encouraged decorous movement by bringing the user's fingers close to the candle, where she might accidentally singe a drooping sleeve or return bits of previously clipped wick to the flame. Similarly, the small tray handle required a delicate grasp and careful balance, for

any charred material deposited there could easily scatter over the dressing table's elegant white drapery.[35]

The snuffer is only one example of a wide range of specialized instruments that facilitated individualized management of candlelight. Conical extinguishers offered an alternative to blowing candles out and sending molten drops flying. Candlesticks with adjustable arms or shades (see fig. 57) focused light for reading, letter writing, or sewing and spared users the indignities of squinting at a book or flushing in the heat of a flame.[36] And some fixtures could even be set to light or extinguish themselves automatically at a particular time, a curiosity that, even if used in the relative privacy of the bedroom, would have been irresistible as a conversation piece among friends.[37] Such inventions exemplify the material culture of what Norbert Elias has called "the civilizing process," the increasingly elaborate mediation of bodily experience by both artifacts and behavioral codes in early modern Europe.[38] Like polite conduct, with its suppression of overtly physical acts, the luminary apparatus transformed a basic need into a self-conscious demonstration of refined sensibilities. Candlelight was not only functional but also performative—a legible material and decorative code that was actively deployed to shape the meanings of social interaction.

Figure 61
ÉTIENNE POLLET (French, ca. 1685–1751, master 1715) and SÉBASTIEN IGONET (French, master 1725, still active in 1766), *Candle Snuffer and Tray*, 1738–39. Silver, candle snuffer: 3.5 × 18.4 × 6.2 cm (1⅜ × 7¼ × 2⁷⁄₁₆ in.) and tray: 5.4 × 22.2 × 12.4 cm (2⅛ × 8¾ × 4⅞ in.). Detroit Institute of Arts, Founders Society Purchase, Elizabeth Parke Firestone Collection of Early French Silver Fund, 53.188.1–2. Photo: courtesy of the Detroit Institute of the Arts.

The Aesthetics of the Glint

So far, this discussion has emphasized the appearance of objects and the ways in which they were noticed and appreciated. But given the expense, variability, and limited reach of candlelight, it is worth asking whether darkness itself also played a role in the performance of privilege. What could a dimly lit interior communicate to those moving through its shadows or looking out from armchairs or game tables set in pools of brightness? When the expressive qualities of artful objects were almost invisible, what happened to their social resonance?

First of all, consider the extensive use of gilding to mark the forms of an interior's most visually and spatially significant elements. In addition to fully gilded objects such as wall lights and firedogs, gold embellished numerous surfaces: wall panels; the frames of mirrors, paintings, and seat furniture; the mounts punctuating the corners and openings of cabinets, commodes, and desks; settings for clocks and porcelain. Most of these objects were positioned symmetrically along the major axes of a room, either against the wall or (in the case of desks and some seat furniture) in more centralized zones of social activity. Many of them were designed as matching pairs or sets, their repeated forms further emphasizing the regular visual and spatial rhythms of a room. By candlelight, the gilded portions of these objects, often highly plastic in shape, would capture irregular patterns of brightness and stand out against the more light-absorbing surfaces they surrounded. The major forms of both walls and furnishings would thus be limned with glints, outlined against the ambient dimness. In addition to signaling the pervasive material richness of an interior, this effect may also have facilitated social navigation: eye-catching gleams might help entering visitors to swiftly assess a room's layout and plan their transit with unobtrusive ease.

A corner cupboard (fig. 62), one of a pair, suggests how gold accents defined space. The marble top is deep enough to accommodate a fairly large candlestick or *girandole*, and illumination from above would impart a glow to the pale, polished *brèche d'Alep* and bring sparkle to the gilt-bronze mounts marking the upper corners, feet, apron, and doors. Catching the light on opposite sides of a dim room, the two matching cupboards would provide visual anchors that helped to define the space as a whole. Yet the objects would not fully disclose their attractions. Under low light, the extraordinary marquetry panels would be virtually invisible: viewers would miss the naturalis-

tic bouquets of lilies, roses, and other flowers, cleverly composed of various woods and different on each of the two pieces. These alluring features may have been available for appreciation on other occasions, if lighting and physical proximity allowed, but in the evening interior they would register only as ghostly presences.

A similarly selective definition of form also shaped the nocturnal resonance of the body itself. Certain elements of both male and female dress were especially expressive by candlelight, particularly those accentuating the head and hands. These were the body's most visible features, and elite individuals sought to deploy them artfully. According to the 1739 edition of *L'École du monde*, hands and eyes grant speech "a grace and liveliness that it would not have without this accompaniment, but it is necessary to use both, and especially the hand, with great discretion and sobriety, for excessive boldness of the eye descends easily into affront, and excessive movement of the hand turns the speaker into a comedian."[39] These aesthetically and socially charged forms captured light: cosmetics whitened women's and many men's faces, hair powder framed features with a pale glow, and white fabric and lace defined necklines and flowed from sleeves. Especially in close, spotlit circumstances, such as gatherings around dining or game tables, these physical attributes—whether pleasing or displeasing—would be unavoidably visible.

The overall effect of the highlighted body is suggested by Jean Valade's portraits of Monsieur and Madame Faventines (see figs. 11 and 12) and a portrait of the marquise d'Aiguirandes (fig. 63) by François-Hubert Drouais (1727–1775). The man's lace jabot and cuffs echo the gestural animation of his hands, while sparkling white accents define the women's upper bodies and tiers of lace (*engageantes*) turn their lower arms into almost disembodied forms. Fine lace was very expensive, with up to four meters required for a pair of *engageantes*, and it required careful cleaning and repair.[40] By candlelight, a cascade of beautiful ruffles would call attention to agreeably composed features and elegantly gesturing hands. Moreover, because physical cleanliness was judged by the whiteness of materials that marked boundaries between the body and its garments, the presence of pristine trimming at the neckline, bodice, and sleeves was a legible sign of refinement.[41] At the same time, however, certain items pointedly included in the portraits would be lost on those glancing at actual garments in dimly lit rooms. The luxurious silk lining

Figure 62
Carcass attributed to JEAN-PIERRE LATZ (French, ca. 1691–1754) and marquetry to the workshop of JEAN-FRANÇOIS OEBEN (German, naturalized French, 1721–1763), *One of a Pair of Corner Cupboards (encoignure)*, ca. 1750–55. Oak veneered with amaranth, stained sycamore, boxwood, and rosewood; gilt-bronze mounts; *brèche d'Alep* top, 97.2 × 85.7 × 58.7 cm (38¼ × 33¾ × 23⅛ in.). Los Angeles, J. Paul Getty Museum, 72.DA.39.1.

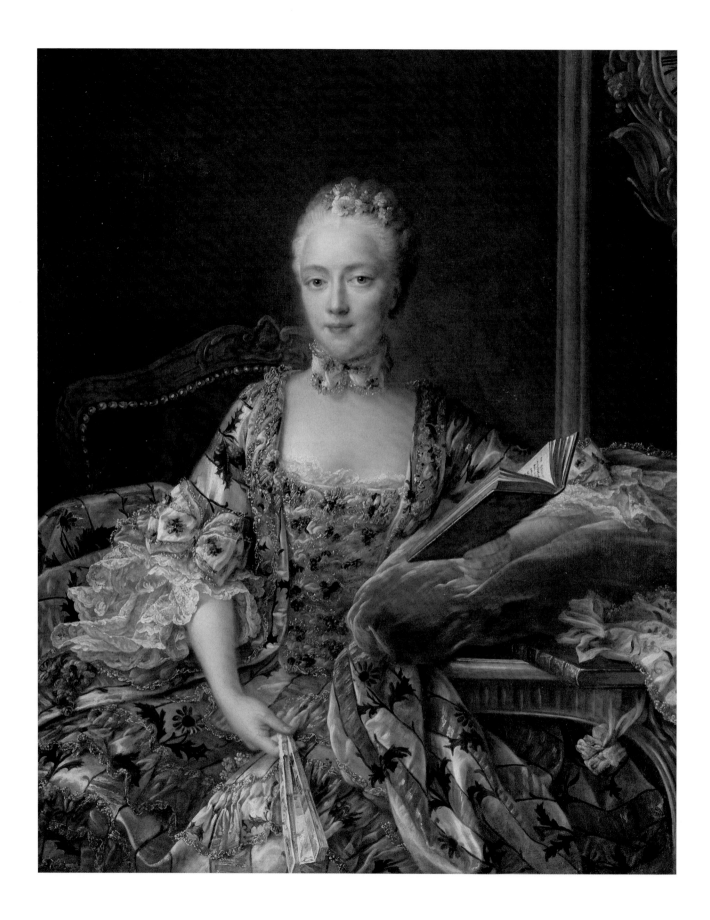

of Monsieur Faventines's waistcoat was certainly meant to be noticed, and Charissa Bremer-David has shown how the watch dangling from Madame Faventines's waist defined her as a fashionable yet prudent woman (see chapter 1). But in the evening interior, only the brightest, most evident features of elegant attire were available for assessment. The nuanced patterns of woven or embroidered silks, the differences between types of lace, miniature scenes painted on snuffboxes—these and many other potentially status-enhancing details eluded the decoratively literate gaze in spaces lit only by flickering flames.

Jewelry was another means of attracting light to expressive physical features. Intricately set clusters of precious gems or paste punctuated garments and hair, and jewelers developed the highly faceted brilliant cut to maximize their dazzle.[42] A bodice ornament and earrings of sapphires and topazes (fig. 64) demonstrates some typical design features. Intricately composed loops and drops, set with dozens of brilliant-cut gems, capture far more light than a simpler setting of less

faceted stones.[43] Probably part of a larger set that may have included a necklace and other items, the ensemble would accent a woman's upper body with flashes of yellow and blue. The bodice ornament (almost four inches high) would be centered beneath the low neckline of her dress, and with her hair drawn up according to midcentury style the large earrings (just over two inches high) would quiver prominently on either side of her face. The sparkle of jewelry heightened what one writer on manners calls "the sparkling fire" of the eyes, as well as "their keenness and the liveliness they lend to the speech they so perfectly accompany."[44] At the same time, these flattering objects might encourage the wearer's interlocutors to manage their visual conduct. Their eyes would tend to move almost involuntarily among the glittering, matching elements, traveling in a triangular formation around the upper body. This darting motion would keep the eyes from resting too long on any single element, including the face, which in turn complied with the shifting, oblique glances of decorous looking.

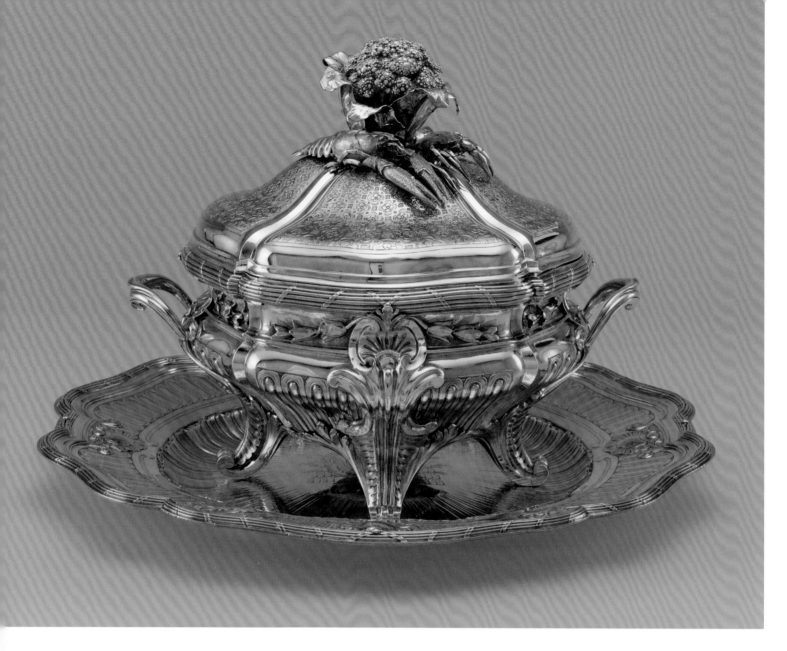

Figure 65a
THOMAS GERMAIN (French, 1673–1748), *One of a Pair of Lidded Tureens, Liners, and Stands*, ca. 1744–50. Silver, tureen: 30 × 34.9 × 28.2 cm (11³⁄₁₆ × 13¾ × 11⅛ in.); stand: 4.2 × 46.2 × 47.2 cm (1⅝ × 18³⁄₁₆ × 18⁹⁄₁₆ in.). Los Angeles, J. Paul Getty Museum, 82.DG.13.1–2.

Figure 65b
Detail of fig. 65a (crayfish on finial of lid).

In evening interiors, candlelight combined with social seeing to produce unstable conditions of visibility. Under inconstant, flickering light, agreeable objects and bodies were on display but not always legible. This raises interesting questions about the expressive workings of objects that, even more than those considered so far, seem to reward close scrutiny. A silver tureen (fig. 65a) by Thomas Germain (1673–1748), one of a pair, demonstrates the silversmith's art with almost encyclopedic scope. Registers of bold, architectonic ornament, set off by bands of shiny smoothness, are crowned by clusters of highly naturalistic vegetables and shellfish cast from life.[45] Germain's virtuosity was renowned throughout Europe and the tureen demands appreciation of his artistry, from the bold, liquid flare of the handles to the illusionism of stippled crayfish

claws and fleshy cauliflower leaves (fig. 65b). The still-life motif in particular seems like a rich premise for a range of responses. Since the Germain workshop employed the same life casts in different combinations for various pieces, some viewers may have been positioned to compare this configuration with other ensembles encountered elsewhere. The sea creatures may have inspired amateurs of natural history to share interesting information, like the fact that crayfish can regenerate lost limbs.[46] The sculpted ingredients may also have offered a pleasing culinary tease by informing—or perhaps misleading—diners about the contents of the tureen, or inspiring recognition of the same ingredients in other concoctions on the table.[47] And at least one item could have invited witty deployments of idiomatic expressions: according to the dictionary of

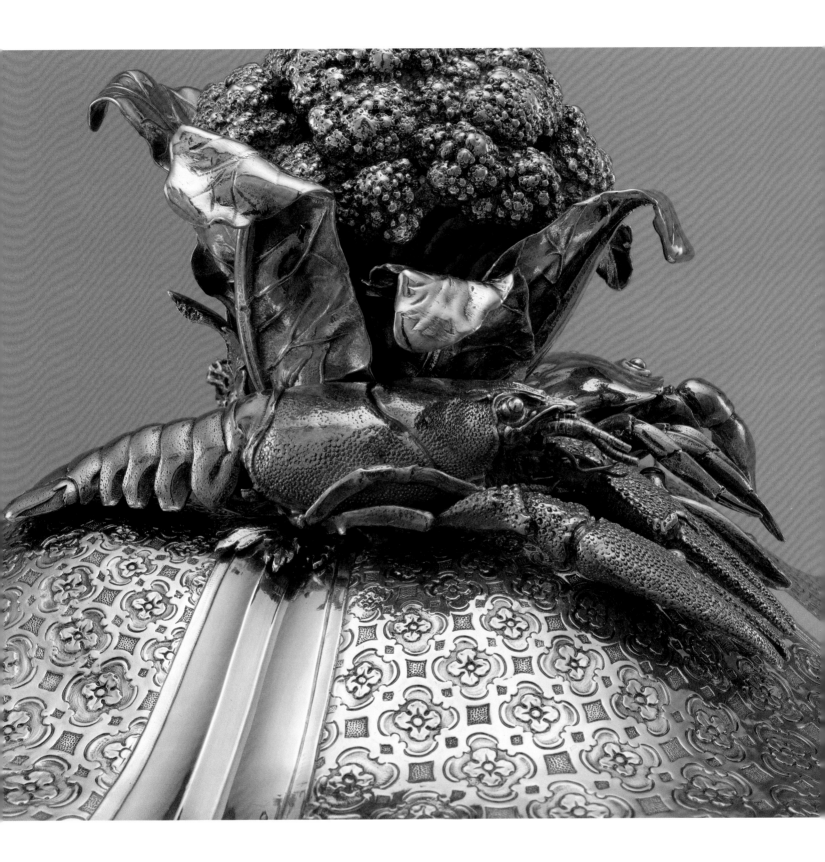

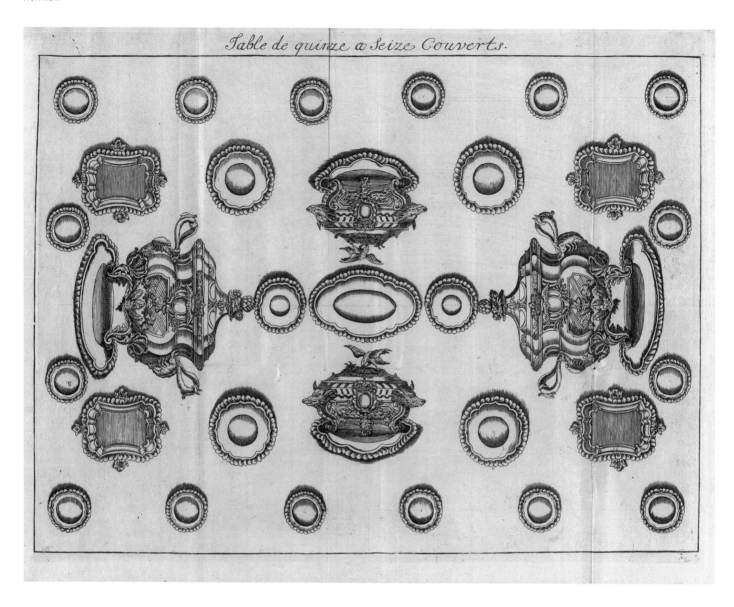

Table de quinze a Seize Couverts.

Figure 66
Anonymous, *Table de quinze a seize Couverts* (*table with fifteen to sixteen settings*), from Vincent La Chapelle, *Le Cuisinier moderne*, 2nd ed. (The Hague, 1742). Engraving, H (book): 20 cm (8⅞ in.). Cambridge, Massachusetts, Harvard University, Radcliffe Institute, The Schlesinger Library, 641.64 L13C.

the Académie française, someone suffering a reversal of fortune "goes backwards like a crayfish" and someone with a flushed face—probably a common occurrence at dinner parties—is "red as a crayfish."[48]

These visual triggers, however, would be difficult to see when lit by candles in the middle of a large banquet table. The pair of tureens probably belonged to a large set of silver used for formal dining in the manner known as *service à la française*. A plate from the 1742 edition of *Le Cuisinier moderne* by Vincent La Chapelle (1690/1703–1745) illustrates this approach to table setting (fig. 66): a central platter for roasted meat is symmetrically flanked by paired tureens for soups or stews and smaller dishes for various concoctions of meat, fish, eggs, and vegetables.[49] Seated around the periphery of this densely articulated visual field, diners would sample only a fraction of the offerings—whatever they could reach or request from servants—amid the protocol-laden distractions of polite eating and conversing. Codes of social seeing would discourage close scrutiny of the tureens, and the play of candlelight on silver would further inhibit examination by exaggerating highlights, deepening shadows, and suppressing detail. Although the objects would gleam with dazzling reflections, the subtly modeled and chased surfaces would disappear, leaving only a sense of generalized magnificence.

This limited visual access might seem to undercut the social resonance of Germain's tureens, as well as many other decorative features, such as marquetry

panels (see fig. 62) or details of dress (see fig. 63). But compromised visibility potentially generated its own modes of distinction and gratification. Within the constraints, only the most sharp-eyed, quick-witted, advantageously seated individuals would notice the visual triggers for agreeable conversation, and only some interlocutors would grasp their clever references. Most people would see just enough to realize that the environment harbored a plenitude of invisible charms and to imagine their host relishing personal access to them. Perhaps they, too, had gained special knowledge of certain objects on other occasions, such as daytime gatherings or conversations during the production of major commissions such as Germain's tureens. Or, conversely, they might recognize their exclusion from a privileged experience they could only hope to enjoy one day. In other words, decorative meaning was temporal and circumstantial: objects signified differently for variously positioned viewers under shifting conditions, and rarely spoke in the same way twice.

Rethinking Candlelight

If we return, in conclusion, to de Troy's masquerade pendants (see figs. 53 and 54), their glowing scenes of intimate conviviality no longer seem quite so simple. The material display and physical negotiation of light demonstrate artful living as much as the clothing and furniture. The candles neither gutter nor smoke. People in flowing garments gesture casually near open flames, hiding the self-conscious vigilance that lies beneath pleasing conduct. Lighting demonstrates not only the artist's pictorial virtuosity but also the exemplary social facility of these fashionable protagonists. Considered with historical understanding, the paintings also call into question modern conceptions of candlelight. The nostalgia that informs both popular and scholarly attitudes became possible only in the nineteenth century, when the development of gaslight and electricity diminished the functional necessity of candles and allowed them to be associated with the supposed romance of lost era. Rather than perpetuating industrial-age mythologies, we need to recognize the radical differences between past and present and critically reimagine the dynamics of social life under variable, unsteady, high-maintenance light. In elegant homes of the ancien régime, night was enchanted not because it was personal and simple, but because it was performative and complex.

Although the apparent realism of de Troy's paintings is a fiction that does not fully describe and explain the eighteenth-century experience of candlelight, the images do suggest what might be called the *artfulness effect* of the evening interior. If Barthes's "reality effect" mobilizes seemingly exhaustive detail to impart an illusion of truthful representation, the artfulness effect—more paradoxically—relies on a shifting array of barely glimpsed fragments to signal a plenitude of meaningful articulation that cannot actually be seen. In semiotic terms, the artfulness effect operates indexically: objects signify not as fully legible forms but rather as traces made visible through the vagaries of candlelight and social protocol. Or, to put it differently, while the reality effect claims to disclose everything, the artfulness effect insists that there is much more than meets the eye.

The interior after dark was a resonant yet unstable social space. Visual acuity mattered and design spoke in legible codes, but in candlelit rooms seeing, and therefore meaning, was constantly in flux and always incomplete. Decoration was an assortment of glimpsed provocations, and sociable visuality was the art of engaging them according to what was possible and desirable at a given moment. There is a fascinating psychology at work here that resembles the erotics of flirtation, often explored in eighteenth-century art and literature: an enjoyable oscillation between attention attracted and access denied that can extend indefinitely without ever resolving into conquest. These are provocative insights for art historians and curators, who dedicate themselves to demonstrating the agency of visual representation and the primacy of vision in culture. For scholars of decorative art in particular, arguments about the formal complexity and sophisticated reception of objects have become important means of resisting the stigma of "mere decoration." But a rich understanding of eighteenth-century life and luxury is only possible if we consider the social implications of invisible art, fleeting glances, and unfulfilled scopic desire—the enchantment of objects that signified even as they faded out of sight.

NOTES

I am grateful to my coauthors, especially Charissa Bremer-David and Peter Björn Kerber, for stimulating discussions, patient answers to numerous questions, and insightful comments on a draft of this essay. I also thank Ajay Sinha for ongoing conversation and experiments with candle snuffers.

1. A search of any online bookseller's stock yields numerous sources on home candle making; camping guides often include instructions for fire building without matches. Living history museums restage lighting technologies of the past, and the reality television series *History House*, in which participants attempt to live under historical domestic conditions, includes several programs with early modern settings. Even electric lighting can conjure historical effects with bulbs that glow softly or mimic the shape—and sometimes even the flicker—of candle flames.

2. This sense of loss is not conveyed by the original German title, *Lichtblicke: Zur Geschichte der künstlichen Helligkeit im 19. Jahrhundert*. A more direct translation, provided by Peter Björn Kerber, would be *Bright Spots: On the History of Artificial Illumination in the Nineteenth Century*.

3. Leribault 2002, pp. 69–71, 343–44. It is uncertain whether the pendants represent the same spaces and people.

4. Salzman 2007.

5. Barthes 1982. Barthes discusses how detailed description in nineteenth-century French fiction conveys an illusion of exhaustive truthfulness that discourages readers from questioning its artificiality and limitations.

6. The classic survey is Verlet 1967b; the most important recent study is Scott 1995. See also Whitehead 1993 and DeJean 2009.

7. Sargentson 1996; McClellan 1996. The best-known representation of a luxury merchant's boutique is Antoine Watteau's 1721 *L'Enseigne de Gersaint* (Berlin, Schloss Charlottenburg).

8. Mercier 1782–88, vol. 5, p. 342: "la confession du défunt se trouve visiblement écrite dans ses armoires…tout homme peut se dire de son vivant: ces bronzes, ces tableaux qui m'ont tant coûté et que je dérobe à l'oeil du curieux, seront témoins, après mon trépas, du jugement que l'on portera de mes goûts." All translations are by the author unless otherwise noted; French quotations retain original orthography and punctuation.

9. The following condenses an extended analysis in Hellman 1999.

10. Caraccioli 1759, pp. 136, 133–34, 113: "l'aide des signes, des paroles, des gestes, des postures et des regards;" "reglant l'extérieur"; "science de discernement, qui entrevoit d'un clin d'oeil, le moment de se présenter ou de se retirer, de se taire ou de parler, d'accepter ou de refuser, d'applaudir ou de censurer"; "Ici, c'est un pied, qui glissant l'un devant l'autre avec grace, annonce le respect; là, c'est un signe de tête, qui bien ordonné, dénote l'approbation. Ici, c'est un regard, qui tombant sans affectation, exprime la modestie; là, c'est une démarche élégante que produit une noble fierté. On jugera ces détails puériles, et cependant ce sont ces détails qui forment la symétrie des sociétés, ce qu'on appelle enfin le savoir-vivre."

11. Bellegarde 1723, p. 37: "Ils ne sont pas plûtôt entrez dans le lieu, où se tient le cercle, qu'ils en contemplent avec soin la situation; ils loüent le plat-fonds, l'alcove, le lit, le fauteuil, et l'écran qu'on leur presente, le petit chien qui aboïe."

12. DeJean 2009, pp. 45–66, 151–58. See also Dennis 1986 and Eleb-Vidal and Debarre-Blanchard 1989.

13. For the vocabulary and typology of fixtures, see Bourne and Brett 1991, pp. 44–125; d'Allemagne 1891, pp. 333–438; Arminjon and Blondel 1984, pp. 386–441; and entries for specific object types in Havard (n.d.). According to an extensive study of seventeenth- and eighteenth-century inventories, materials and design varied much more than quantity of fixtures in the residences of different socioeconomic groups: the average number of light sources was five per household; 63 percent had candlesticks but only 0.5 percent had chandeliers. See Pardailhé-Galabrun 1991, pp. 125–30.

14. The following account draws on Bowers 1998, pp. 9–29; Caspall 1987; and O'Dea 1958, pp. 1–26, 213–42. For eighteenth-century technical descriptions, see volume 3, s.v. "Chandelier" and "Cirier" of Diderot and Le Rond d'Alembert 1762–72 and Monceau 1762 and 1764.

15. Monceau 1762, p. 88. This treatise features the techniques of Trudon, supplier to the French court; the company is still in operation in Paris.

16. O'Dea 1958, pp. 3–5.

17. Monceau 1762, pp. 41–45, 70–75. Wicks only became completely self-consuming with the addition of fatty acids to candle fuel in the early nineteenth century; see O'Dea 1958, pp. 6–7.

18. *L'Avantcoureur* (October 1761), pp. 681–82: "est plus avantageuse pour la vue, fait une lumiere qui ne vacille point, ne fait point de fumée et coute peu. Ces chandeliers ont l'avantage de ne jamais couler, on les penche et on les transporte sans risque de rien répandre."

19. *L'Avantcoureur* (October 1763), p. 649; *L'Avantcoureur* (December 1770), p. 772.

20. *Journal de Paris* (1784) quoted in Schrøder 1969, p. 71: "infiniment plus belle que celle de la bougie même." In addition to Schrøder's detailed history, see O'Dea 1958, pp. 49–54; and Bowers 1998, pp. 25–33. The Argand lamp had an adjustable, cylindrical wick set in a metal sleeve

surmounted by a glass chimney. Inspired by the recent discovery that fire requires oxygen, it increased brightness by maximizing air flow around the flame.

21. See, for example, Courajod 1873, vol. 2, p. 16, no. 163; pp. 116–17, no. 1066; p. 142, no. 1260; and p. 158, no. 1420.

22. Cohen 1996, p. 457; Cohen 1994, pp. 164–65.

23. Regarding the series, see Heller-Greenman 2002, pp. 39–60. A verse beneath the image chides the woman in the armchair for failing to recognize her suitor's deception. I thank Bernardine Heller-Greenman for corresponding with me about Freudeberg.

24. See O'Dea 1958, pp. 214–15. The spark might be captured using a match coated with sulphur, or simply blown upon until it produced a flame.

25. Monceau 1762, p. 75: "d'un blanc clair, un peu bleuâtre, & sur-tout transparente."

26. Monceau 1762, pp. 51–52: "tout le brillant qu'on peut désirer." To further enhance whiteness, he also recommends bleaching candles in the sun (p. 70) and packaging them in off-white paper accented with blue bands (p. 69).

27. Monceau 1762, pp. 71–73.

28. Courajod 1873, vol. 2, p. 77, no. 740; p. 79, no. 762; p. 91, no. 879; and p. 327, no. 2847. To put these prices in context, it is worth noting that a skilled manual worker earned between 300 and 1,000 livres per year; the income of most noble households ranged from 40,000 to 100,000 livres per year and princely fortunes were much greater. See Sargentson 1996, p. xi.

29. For a detailed discussion, see Hellman 2010.

30. For the cultural politics of elite engagement with chinoiserie design, see Scott 2003. I thank Lynda and Steward Resnick for making photographs of the candelabra available for study.

31. To cite only two examples: Courajod 1873, vol. 2, p. 235, no. 2083 (replacement candle sockets and flowers for a pair of gilt-bronze wall lights); and p. 275, no. 2423 (restoration of a pair of *girandoles* with figures and flowers); each job cost 72 livres.

32. For examples of small, specialized tables, see Reyniès 1987, vol. 1, pp. 322–427; vol. 2, pp. 1022–27.

33. Bellegarde 1723, p. 164: "Il faut moderer son jeu, et se moderer soi-même en joüant. Ceux qui joüent par passion, par avidité, par interêt, s'oublient souvent, ils s'impatientent, ils jurent, ils sont emportez, quand le jeu tourne mal pour eux, et ils laissent entrevoir la bassesse de leurs sentimens."

34. Two films that evocatively capture gaming by candlelight are Stanley Kubrick's *Barry Lyndon* (1975) and Sofia Coppola's *Marie Antoinette* (2006).

35. In a 1745 satire on domestic service, Jonathan Swift notes that clipped wicks from candles on the dinner table might escape the snuffers and either fall into the food or soil the tablecloth; see Swift 2010, p. 205.

36. Lazare Duvaux sold a number of candle shades (*gardevues*), some attached to fixtures and others apparently freestanding, to be positioned as needed; see, for example, Courajod 1873, vol. 2, p. 51, no. 518 (adjustable candlestick with *gardevue* for embroidery frame, 21 livres); p. 366, no. 3154 (gilt bronze *gardevue* with Meissen figurines and flowers, 380 livres). For additional examples of snuffers, extinguishers, and *gardevues*, see Havard (n.d), vol. 1, cols. 1–5; vol. 2, cols. 624–26, 1068–69; vol. 3, cols. 991–98; see also d'Allemagne 1928, pp. 188–95.

37. *L'Avantcoureur* (February 1762), pp. 71–72, 119. The self-lighting fixture, "made with care and well decorated" (fait avec soin et fort ornée), was activated by a match attached to a manual pull cord or clock. The automatic extinguisher, available with or without a silver finish, was activated when the candle melted down to a predetermined point.

38. Elias 1978, vol. 1, pp. 53–205.

39. Le Noble 1739, vol. 1, p. 34: "une grace et une vie qu'il ne peut avoir sans cet accompagnement, mais il faut user les deux, et sur tout de la main, avec une grande discretion et sobrieté, car l'excès de la hardiesse de l'oeil dégenere aisément en affronterie, et l'excès du mouvement de l'autre, convertit le parleur en comédien."

40. Kraatz 1989, p. 77.

41. Vigarello 1988, pp. 58–77.

42. For surveys of design conventions, see Evans 1970, pp. 149–64; and Phillips 1996, pp. 54–63; on the brilliant cut by candlelight, see Pointon 2009, pp. 26–29, 48.

43. The silver setting and foil backing under the topazes enhance the stones' glitter. I thank Richard Edgcumbe for providing information about these pieces.

44. *Essai sur le caractère* 1776, p. 149: "le feu étincelant"; "leur *poignance* et la vie qu'ils donnent aux discours qu'ils accompagnent si à-propos" (emphasis in the original).

45. For the casts of food and creatures in Germain's workshop, inherited and reused by his son François-Thomas, see Sotheby's 2004, p. 40.

46. Diderot and Le Rond d'Alembert 1751–65, vol. 5, p. 355, s.v. "Ecrevisse."

47. Crayfish were used in soups, sauces, terrines, and poultry stuffings, among other preparations; see La Chapelle 1742, vol. 1, pp. 44–46, 102–4, 134–35, 143–45, 212–13.

48. *Dictionnaire de l'Académie française*, 4th ed., 1762: "Il va à reculons comme les écrevisses"; "Il est rouge comme une écrevisse."

49. A typical dinner offered at least two courses of savory dishes and one of sweets, each covering the table in this manner; see Wheaton 1983, pp. 138–40.

Critical Bibliography and Exhibition Object List

Compiled by Kira d'Alburquerque, Emily Beeny, and Grace Chuang

The following is a selected bibliography and guide to objects from the exhibition *Paris: Life & Luxury*, held at the J. Paul Getty Museum at the Getty Center, Los Angeles (April 26–August 7, 2011), and the Museum of Fine Arts, Houston (September 18–December 10, 2011). The aim of this resource is to provide:

- References to selected published sources, beginning with the most recent. The listing is not exhaustive but aims to call out the most substantive, relevant, and up-to-date sources on each category of object, each artist, and each individual work from the exhibition.
- Basic information on exhibited works, including media and dimensions, with dimensions provided in the format of height × width (× depth or × diameter, where relevant). Unless otherwise noted, measurements for paintings do not include frames, and three-dimensional objects are measured at their largest dimensions.
- Provenance, when known, for the period of the eighteenth century only, beginning with the earliest owner. A history of pre-Revolutionary ownership is provided whenever possible.
- A cross-referenced directory of related objects in the exhibition. Connections are made between exhibited objects, including works with shared iconography; furniture, clothing, and objets d'art represented in paintings or images on other objects; works owned by the same collectors; and objects exhibited at the same Salons.

This resource is divided into eight thematic sections:

- Furniture, keyboard instruments, and architectural fixtures
- Clocks, watches, and scientific instruments
- Bronze, gold and silver, snuffboxes and toilette boxes
- Porcelain, glass, and ivory
- Tapestries, decorative textiles, fashion, and sewing implements
- Sculpture
- Paintings and drawings
- Books and manuscripts

Each thematic section is further divided by object type and/or artist (listed alphabetically). Unless otherwise indicated, all artists are French and the object's place of origin is Paris.

Furniture, Keyboard Instruments, and Architectural Fixtures

FURNITURE

SELECTED GENERAL REFERENCES: Leeds–Los Angeles 2008–9; Wilson, Bremer-David, and Weaver 2008; Wilson and Hess 2001; Scott 1995; Pradère 1989; Kjellberg 1989; Pallot 1989.

MARTIN CARLIN
(French, b. Germany, ca. 1730–85, master 1766)
REFERENCE: Pradère 1989, pp. 342–61.

1

1. Music Stand (*pupitre*)
ca. 1770–75
Attributed to Martin Carlin
Oak veneered with tulipwood, amaranth (or purple heart), holly and fruitwood, and incised with colored mastics; gilt-bronze mounts
148.6 × 50.2 × 36.8 cm (58½ × 19¾ × 14½ in.)
Marks: stamped "JME" under oval shelf
Los Angeles, J. Paul Getty Museum, 55.DA.4
REFERENCES: Wilson and Hess 2001, p. 40, no. 72; Ramond 2000, vol. 2, pp. 178–79.

CHARLES CRESSENT
(1685–1768, master 1719)
REFERENCES: Pradère 2003; Pradère 1989, pp. 129–39.

2

2. Writing Table (*bureau plat*)
ca. 1720–25
Attributed to Charles Cressent
Veneered with satiné rouge and amaranth on oak and pine carcass; gilt-bronze mounts; modern leather top
76.5 × 202.2 × 89.5 cm (30⅛ × 79⅝ × 35¼ in.)
Los Angeles, J. Paul Getty Museum, Gift of J. Paul Getty, 67.DA.10
REFERENCES: Wilson, Bremer-David, and Weaver 2008, pp. 146–53, no. 13; Pradère 2003, pp. 113–19, 265, no. 43; Wilson and Hess 2001, p. 34, no. 58.
RELATED WORKS: Clock on bracket (no. 18 below) and pair of firedogs (no. 29 below); both designed by Cressent.

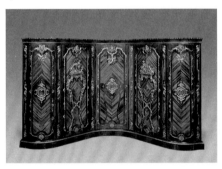

3

3. Pair of Corner Cupboards (*encoignures*)
ca. 1745
Attributed to Charles Cressent
Oak carcass veneered with tulipwood, kingwood, and amaranth; gilt-bronze mounts
191.8 × 332.7 × 39.4 cm (75½ × 131 × 15½ in.)
Los Angeles, J. Paul Getty Museum, 79.DA.2.1-.2
REFERENCES: Pradère 2003, pp. 96–98, 220–21, 226–27, 262, nos. 29–30; Wilson and Hess 2001, p. 19, no. 34.
RELATED WORKS: Clock on bracket (no. 18 below) and pair of firedogs (no. 29 below); both designed by Cressent.

JEAN-PIERRE LATZ
(ca. 1691–1754, *ébéniste privilégié du roi* before May 1741)
REFERENCES: Pradère 1989, pp. 153–61; Hawley 1979; Hawley 1970.

JEAN-FRANÇOIS OEBEN
(French, b. Germany, 1721–1763, *ébéniste du roi* 1754, master 1761)
REFERENCES: Stratmann-Döhler 2002; Pradère 1989, pp. 253–63.

4. Pair of Corner Cupboards (*encoignures*)
ca. 1750–55
Carcass and mounts attributed to Jean-Pierre Latz
Marquetry panels attributed to the workshop of Jean-François Oeben
Oak veneered with amaranth, stained sycamore, boxwood, and rosewood; gilt-bronze mounts; *brèche d'Alep* top
97.2 × 85.7 × 58.7 cm (38¼ × 33¾ × 23⅛ in.)
Los Angeles, J. Paul Getty Museum, 72.DA.39.1-.2
(see fig. 62, one of the pair)
REFERENCES: Wilson and Hess 2001, p. 21, no. 36; Hawley 1970, p. 254, no. 49.
RELATED WORKS: Planisphere clock (no. 19 below; see fig. 10); another work attributed to Latz.
 Mechanical writing and toilette table (no. 7 below; see fig. 47); another example of Oeben's work.

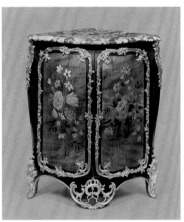

5

5. Pair of Corner Cupboards (*encoignures*)
ca. 1750–55
Carcass and mounts attributed to Jean-Pierre Latz
Marquetry panels attributed to the workshop of Jean-François Oeben
Oak veneered with amaranth, maple, stained maple, and walnut; gilt-bronze mounts; *brèche d'Alep* top
92.1 × 81.9 × 61 cm (36¼ × 32¼ × 24 in.)
Los Angeles, J. Paul Getty Museum, 72.DA.69.1-.2
REFERENCES: Wilson and Hess 2001, p. 21, no. 37; Hawley 1970, p. 255, no. 50.
RELATED WORKS: Planisphere clock (no. 19 below; see fig. 10); another work attributed to Latz.

 Mechanical writing and toilette table (no. 7 below; see fig. 47); another example of Oeben's work.

ÉTIENNE MEUNIER
(master 1732)
REFERENCE: Pallot 1989, p. 312.

6. Desk Chair (*fauteuil de cabinet*)
ca. 1735
Attributed to Étienne Meunier
Walnut with leather upholstery; silk velvet (linings); brass studs
89.9 × 71.1 × 64.1 cm (35⅜ × 28 × 25¼ in.)
Los Angeles, J. Paul Getty Museum, 71.DA.91
(see p. 9)
REFERENCE: Wilson and Hess 2001, p. 47, no. 88.

JEAN-FRANÇOIS OEBEN
(French, b. Germany, 1721–1763, *ébéniste du roi* 1754, master 1761)
REFERENCES: Stratmann-Döhler 2002; Pradère 1989, pp. 253–63.

7. Mechanical Reading, Writing, and Toilette Table (*table mécanique*)
ca. 1750
Jean-François Oeben
Oak veneered with kingwood, amaranth, bloodwood, holly, and various stained exotic woods; drawers of juniper; iron mechanism; silk; gilt-bronze mounts
73 × 74 × 37.8 cm (28¾ × 29⅛ × 14⅞ in.)
Marks: stamped "J.F.OEBEN" twice underneath table
Los Angeles, J. Paul Getty Museum, Gift of J. Paul Getty, 70.DA.84 (see fig. 47 and detail, fig. 27)
REFERENCES: Stratmann-Döhler 2002, pp. 98–99, 184, no. 135; Wilson and Hess 2001, p. 36, no. 63; Ramond 2000, vol. 3, pp. 15–19.
RELATED WORKS: Two pairs of corner cupboards (nos. 4 and 5 above) incorporating marquetry panels attributed to Oeben's workshop.

JEAN-BAPTISTE TILLIARD
(1686–1766)
REFERENCE: Pallot 1989, pp. 317–18.

8. Bed (*lit à la turque*)
ca. 1750–60
Jean-Baptiste Tilliard
Gessoed and gilded beech and walnut; modern silk upholstery
174 × 264.8 × 188 cm (68½ × 104¼ × 74 in.)
Los Angeles, J. Paul Getty Museum, 86.DA.535
[exhibited in Houston only]
(see fig. 29)
REFERENCES: Wilson and Hess 2001, p. 54, no. 103; Pallot 1989, p. 75; Stein 1994, pp. 29–44.

JEAN-BAPTISTE I TUART
(master 1741)
REFERENCE: Pradère 1989, p. 273.

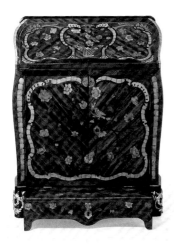

9

9. Secrétaire and Prayer Stool (*prie-Dieu secrétaire*)
ca. 1750
Jean-Baptiste I Tuart
Fir and oak, veneered with amaranth, bloodwood,
hornbeam; gilt-bronze mounts
90 × 69 × 43 cm (35^{7}/$_{16}$ × 27^{3}/$_{16}$ × 16^{15}/$_{16}$ in.)
Marks: stamped "I. Tuart" twice on the back
Paris, Les Arts Décoratifs, Musée des Arts décoratifs,
38659
REFERENCES: Kjellberg 1989, p. 850; Gonzáles-
Palacios 1966, pp. 148, 150.

ROGER VANDERCRUSE LACROIX
(1727–1799, master 1755)
REFERENCES: Roinet 2000; Pradère 1989, pp. 281–89.

10. Cabinet
ca. 1765
Roger Vandercruse Lacroix
Oak and fir veneered with tulipwood, amaranth, and
holly; gilt-bronze mounts; white marble interior shelf
93.7 × 59.4 × 43.8 cm (36^{7}/$_{8}$ × 23^{3}/$_{8}$ × 17^{1}/$_{4}$ in.)
Marks: stamped "RVLC" and "JME" inside the drawer
on top right-hand side
Los Angeles, J. Paul Getty Museum, Gift of J. Paul
Getty, 70.DA.81
(see fig. 26)
REFERENCE: Wilson and Hess 2001, p. 9, no. 14.

UNKNOWN MAKERS

11. Card and Writing Table (*table à quadrille brisé*)
ca. 1725
Oak and fir veneered with amaranth, bloodwood,
kingwood and wamara; mahogany; drawers of walnut
and oak; bronze mounts; silvered-bronze fittings; iron
fittings; modern silk velvet
Open: 74 × 101.3 × 101.6 cm (29^{1}/$_{8}$ × 39^{7}/$_{8}$ × 40 in.)
Closed: 76.8 × 101.3 × 51.4 cm (30^{1}/$_{4}$ × 39^{7}/$_{8}$ × 20^{1}/$_{4}$ in.)
Los Angeles, J. Paul Getty Museum, 75.DA.2
(see fig. 59)
REFERENCE: Wilson, Bremer-David, and Weaver
2008, pp. 162–69, no. 15.

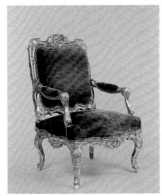

12

12. Armchair (*fauteuil à la reine*)
ca. 1735
Gilded walnut; modern upholstery; brass studs
104.8 × 64.1 × 57.8 cm (41^{1}/$_{4}$ × 25^{1}/$_{4}$ × 22^{3}/$_{4}$ in.)
Los Angeles, J. Paul Getty Museum, 75.DA.8.1
REFERENCES: Wilson, Bremer-David, and Weaver
2008, pp. 248–53, no. 25; Pallot 1989, p. 108.
RELATED WORK: François-Hubert Drouais, *Portrait
of the Marquise d'Aiguirandes*, 1759 (no. 86 below; see
fig. 63); the marquise is seated on a very similar chair.

KEYBOARD INSTRUMENTS

SELECTED GENERAL REFERENCES: Koster 1994;
Russell 1968.

JOANNES GOERMANS I
(French, b. The Netherlands, 1703–1777)

13. Harpsichord converted to a piano (*clavecin*)
1754
Joannes Goermans I
Wood, painted and lacquered; ivory; metal
Closed: 93.6 × 241.7 × 93.3 cm (36^{7}/$_{8}$ × 95^{3}/$_{16}$ × 36^{3}/$_{4}$ in.)
Marks: on name board in black letters on gold band
"Ioannes Goermans Me Fecit Parisis 1754"; inscription
painted around rose "Ioannes Goermans"
New York, Metropolitan Museum of Art, Gift of
Susan Dwight Bliss, 1944, 44.157.8a-e

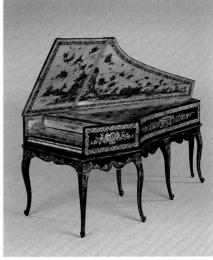

13

REFERENCES: Libin 1989, p. 26; Winternitz 1961,
pp. 29–31.
RELATED WORK: François-Hubert Drouais, *Portrait
of Madame Charles Simon Favart*, 1757 (no. 85 below);
Madame Favart is portrayed playing a harpsichord in
this painting.

ARCHITECTURAL FIXTURES

UNKNOWN MAKERS

14

14. Mantelpiece (*cheminée*)
ca. 1730–35
Brecciated marble (a variety of *sarrancolin
des Pyrénées*)
110.5 × 175.3 × 29.2 cm (43^{1}/$_{2}$ × 69 × 11^{1}/$_{2}$ in.)
Los Angeles, J. Paul Getty Museum, 85.DH.92
REFERENCE: Wilson and Hess 2001, p. 63, no. 123.

15

15. Mirror Frame (*trumeau*)
1751–53
Oak, gessoed, gilded and painted; modern mirror glass
329.6 × 141 cm (129¾ × 55½ in.)
Los Angeles, J. Paul Getty Museum, 97.DH.4.1
PROVENANCE: François-Charles Darnault, "A la Ville de Versailles," Paris, ca. 1751–53 (two paper trade labels of the *marchand-mercier* Darnault are pasted on the back).
REFERENCES: Wilson and Hess 2001, p. 59, no. 115; Moyer and Hanlon 1996, pp. 185–96; Sargentson 1996, p. 22.

Clocks, Watches, and Scientific Instruments

CLOCKS

SELECTED GENERAL REFERENCES: Augarde 1996a; Wilson et al. 1996; Hughes 1994; Verlet 1987, pp. 106–21, 184–185, 278–81; Tardy 1971–72.

ANDRÉ-CHARLES BOULLE
(1642–1732, master before 1666)
REFERENCES: Frankfurt 2009; Ronfort 1986.

PAUL GUDIN
(active until 1755, *marchand horloger privilégié suivant le cour* 1739)
REFERENCE: Augarde 1996a, pp. 330–31.

16. Mantel Clock (*pendule*)
ca. 1715–25
Case attributed to André-Charles Boulle
Clock movement by Paul Gudin
Oak veneered with tortoiseshell, blue-painted horn, brass, and ebony; enameled metal; gilt-bronze mounts; glass
101 × 46 × 28.6 cm (39¾ × 18⅛ × 11¼ in.)
Movement engraved "Gudin lejeune [AP]aris"; dial painted "GUDIN LE JEUNE [AP]ARIS"
Los Angeles, J. Paul Getty Museum, 72.DB.55
(see fig. 13 and p. 90)
REFERENCES: Wilson and Hess 2001, p. 68, no. 132; Wilson et al. 1996, pp. 20–27, no. IV; Ottomeyer and Pröschel 1986, vol. 2, pp. 475–79; New York 1983, p. 46, no. 38.
RELATED WORK: Jean-François de Troy, *Reading in a Salon*, ca. 1728 (no. 98 below; see fig. 23); a clock of similar form appears on the bookcase in the painting, but the position of Time has been changed, presumably by the painter.

CHANTILLY PORCELAIN MANUFACTORY
(active ca. 1725–ca. 1792)
REFERENCES: Le Duc 1998; Le Duc 1996.

CHARLES VOISIN
(1685–1761, master 1710)
REFERENCE: Augarde 1996a, p. 406.

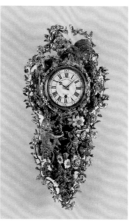

17

17. Wall Clock (*pendule à répétition*)
Chantilly and Paris, ca. 1740
Clock movement by Charles Voisin
Soft-paste porcelain, polychrome enamel decoration; gilt bronze; enameled metal; glass
74.9 × 35.6 × 11.1 cm (29½ × 14 × 4⅜ in.)
Movement engraved "C le Voisin [AP]aris."; dial painted "CHARLES VOISIN [AP]ARIS"
Los Angeles, J. Paul Getty Museum, 81.DB.81
[exhibited in Los Angeles only]
(see p. 10)

REFERENCES: Wilson and Hess 2001, p. 69, no. 134; Le Duc 1998, p. 39; Wilson et al. 1996, pp. 42–47, no. VI.
RELATED WORK: Chamber pot (no. 45 below); also made by the Chantilly manufactory.

CHARLES CRESSENT
(1685–1768, master 1719)
REFERENCES: Pradère 2003; Pradère 1989, pp. 129–39; Dell 1967.

JEAN-JOSEPH DE SAINT-GERMAIN
(1719–1791, master 1748)
REFERENCE: Augarde 1996b.

JEAN ROMILLY
(1714–1796, master 1752)
REFERENCE: Augarde 1996a, pp. 393–94.

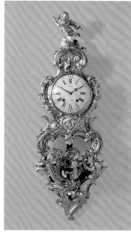

18

18. Clock on Bracket (*cartel sur une console*)
ca. 1758
Case attributed to Charles Cressent
Bracket by Jean-Joseph de Saint-Germain
Clock movement by Jean Romilly
Gilt bronze; enameled metal; glass
125.7 × 47 × 20.3 cm (49½ × 18½ × 8 in.)
Movement engraved and dial painted "ROMILLY A [AP]ARIS"; one spring inscribed and dated "Blakey 1758"
Los Angeles, J. Paul Getty Museum, 71.DB.115
REFERENCES: Pradère 2003, pp. 180–83, 297, no. 212; Wilson and Hess 2001, p. 71, no. 139; Augarde 1996b, pp. 66–67; Wilson et al. 1996, pp. 48–57 no. VII; Ottomeyer and Pröschel 1986, vol. 1, p. 79.
RELATED WORKS: Maurice-Quentin de La Tour, *Portrait of Gabriel Bernard de Rieux*, 1739–41 (no. 90 below; see fig. 48); a clock of the same design appears in the background of this painting.

Writing table (no. 2 above); pair of corner cupboards (no. 3 above); and pair of firedogs (no. 29 below); all attributed to Cressent.

JEAN-PIERRE LATZ

(ca. 1691–1754, *ébéniste privilégié du roi* before May 1741)

REFERENCES: Pradère 1989, pp. 153–61; Hawley 1979; Hawley 1970.

ALEXANDRE FORTIER

(ca. 1700–1770)

REFERENCE: Augarde 1996a, pp. 227–28.

19. Planisphere Clock (*pendule à planisphère*)
ca. 1745–49
Case attributed to Jean-Pierre Latz
Movement by Alexandre Fortier
Oak veneered with kingwood; silvered brass; gilt-bronze mounts; glass; and gilt paper
281.9 × 94 × 38.1 cm (111 × 37 × 15 in.)
Dial engraved "Inventé par A. FORTIER"
Los Angeles, J. Paul Getty Museum, 74.DB.2
(see fig. 10 and p. 32)
PROVENANCE: Louis-François de Bourbon (1717–1776), prince de Conti (sold, Paris, April 8–June 6, 1777, no. 2008).
REFERENCES: Wilson and Hess 2001, p. 70, no. 137; Wilson et al. 1996, pp. 92–101, no. XIII; Augarde 1996a, pp. 228–29.
RELATED WORKS: Carle Vanloo, *Aeneas Carrying Anchises*, 1729 (no. 101 below; see fig. 52); this painting was also in the collection of the prince de Conti.

Two pairs of corner cupboards (nos. 4 and 5 above); other works attributed to Latz.

JUSTE-AURÈLE MEISSONNIER

(French, b. Italy, 1695–1750, master 1724)

REFERENCE: Fuhring 1999.

JEAN-JACQUES FIÉFFÉ

(ca. 1700–1770, master 1725)

REFERENCE: Augarde 1996a, p. 314.

20. Wall Clock (*pendule*)
ca. 1735–40
Case possibly after a design by Juste-Aurèle Meissonier
Clock movement by Jean-Jacques Fiéffé
Gilt bronze; enameled metal; wood carcass; glass
133.4 × 67.3 × 14.3 cm (52½ × 26½ × 5⅝ in.)
Dial painted "FIEFFE DELOBSERVATOIR";
movement engraved "Fieffé [AP]aris"
Los Angeles, J. Paul Getty Museum, 72.DB.89
(see fig. 29 and p. 74)
REFERENCES: Leeds–Los Angeles 2008–9, pp. 72–73, no. 17; Augarde 1996a, pp. 314–15; Wilson et al. 1996, pp. 58–64, no. VIII; Ottomeyer and Pröschel 1986, vol. 1, p. 111.

ROBERT OSMOND

(ca. 1720–1789, master 1746)

REFERENCE: Verlet 1987, p. 426.

ÉTIENNE LE NOIR II

(1699–1778, master 1717) with

PIERRE-ÉTIENNE LE NOIR

(b. ca. 1725, master 1743)

REFERENCE: Augarde 1996a, p. 347.

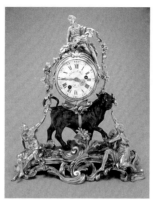

21

21. Mantel Clock (*pendule*)
ca. 1763
Case attributed to Robert Osmond
Movement by Étienne Le Noir II in partnership with his son Pierre-Étienne Le Noir
Patinated and gilt bronze; enameled metal; glass
54.3 × 45.1 × 23.2 cm (21⅜ × 17¾ × 9⅛ in.)
Dial painted "Etienne Le Noir [AP]aris"; movement engraved "Etienne le Noir [AP]aris No. 396," and springs inscribed "Masson 1763"
Los Angeles, J. Paul Getty Museum, 73.DB.85
PROVENANCE: possibly Louis-François-Armand de Vignerot du Plessis (1696–1788), duc de Richelieu, maréchal de France (sold, Paris, December 18, 1778, no. 692).
(see p. 52)
REFERENCES: Wilson and Hess 2001, p. 72, no. 140; Wilson et al. 1996, pp. 102–7, no. XIV.
RELATED WORK: Snuffbox (no. 41 below); this snuffbox was also in the collection of the duc de Richelieu.

WATCHES

SELECTED GENERAL REFERENCES: Cardinal 2000; Cardinal 1999; Cardinal 1984; Tardy 1971–72.

JEAN-BAPTISTE BAILLON III

(died 1772, master 1727)

REFERENCE: Augarde 1996a, pp. 272–73.

GÉDÉON DECOMBRAZ

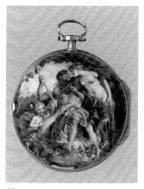

22

22. Watch (*montre*), with a miniature after *Hercules and Omphale*, 1724, a painting by François Lemoyne
ca. 1725–50
Case and movement by Jean-Baptiste Baillon III
Enamel decoration attributed to Gédéon Decombraz
Gold; enameled and gilt brass; glass
4.4 (diam.) × 2.3 (depth) cm (1¾ × ⅞ in.)
Case signed "DECOMBRAZ/PINXIT/geneue"
Paris, Musée du Louvre, Département des Objets d'art, OA 8338
REFERENCE: Cardinal 1984, pp. 119–20, no. 112, pl. VI.

23

23. Watch (*montre*)
ca. 1750–60
Case and movement by Jean-Baptiste Baillon III
Gold; silver; enameled and gilt brass.
4.7 (diam.) × 2.3 (depth) cm (1⅞ × ⅞ in.)
Movement signed "Baillon/AParis"
Paris, Musée du Louvre, Département des Objets d'art, OA 8355
REFERENCE: Cardinal 1984, p. 135, no. 139.

JACQUES-JÉRÔME GUDIN

(active 1750–1783, master 1762)

REFERENCE: Augarde 1996a, pp. 330–31.

CHARLES-SIMON BOCHER
(master 1751)
REFERENCE: Nocq 1968, vol. 1, p. 140.

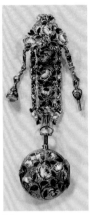

24

24. Châtelaine with watch (*montre*)
1750–51 (watch) and 1751–52 (châtelaine)
Watch by Jacques-Jérôme Gudin
Châtelaine by Charles-Simon Bocher
Gold; enameled and gilt brass; diamond; agate; glass
17.2 × 4.8 × 2.6 cm (6¹¹⁄₁₆ × 1⅞ × 1 in.)
Face and movement signed "GUDIN/A PARIS"
Paris, Musée du Louvre, Département des Objets
d'art, OA 8394
REFERENCE: Cardinal 1984, p. 131, no. 131, pl. VI.
RELATED WORK: Jean Valade, *Portrait of Madame
Faventines*, 1768 (no. 100b below; see fig. 12); the
sitter in Valade's portrait wears a similar watch and
châtelaine.

SCIENTIFIC INSTRUMENTS

SELECTED GENERAL REFERENCES: Pyenson and
Gauvin 2002; Clark, Golinski, and Schaffer 1999;
Ronfort 1989.

MICHEL-FERDINAND D'ALBERT D'AILLY, DUC DE CHAULNES
(1714–1769)

25. Compound Microscope and Case (*microscope
micrométrique et sa caisse*)
ca. 1751
Micrometric stage invented by Michel-Ferdinand
d'Albert d'Ailly, duc de Chaulnes
Gilt bronze; brass; glass and mirror glass;
enamel; wood; shagreen; gilt leather; silk velvet
and silver *galon*
Microscope: 48 × 28 × 20.5 cm (18⅞ × 11 × 8¹⁄₁₆ in.)
Case: 66 × 34.9 × 27 cm (26 × 13¾ × 10⅝ in.)
Los Angeles, J. Paul Getty Museum, 86.DH.694.1-.2
REFERENCES: Wilson and Hess 2001, pp. 75–76,
no. 147; Ronfort 1989, pp. 66–82.

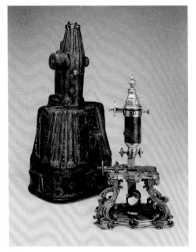

25

JEAN-ANTOINE NOLLET
(1700–1770)
REFERENCE: Pyenson and Gauvin 2002; Ronfort 1989,
pp. 51–53.

LOUIS BORDE
(active 1730–40)

NICOLAS BAILLIEUL
(active 1740s)

WORKSHOP OF GUILLAUME MARTIN
(d. 1749) and ÉTIENNE-SIMON MARTIN
(d. 1770)
REFERENCE: Ronfort 1989, p. 66

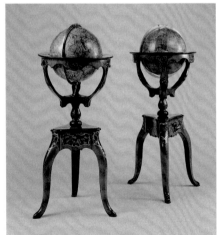

26

26. Terrestrial and Celestial Globes
(*globes terrestre et céleste*)
ca. 1728–30
Globes designed and assembled by Jean-Antoine
Nollet
Terrestrial map engraved by Louis Borde
Celestial map engraved by Nicolas Baillieul
Lacquer decoration attributed to the workshop of
Guillaume and Étienne-Simon Martin
Printed paper; papier-mâché; poplar, spruce, and
alder painted with *vernis Martin*; bronze; glass
109.2 × 44.5 × 31.8 cm (43 × 17½ × 12½ in.)
Los Angeles, J. Paul Getty Museum, 86.DH.705.1-.2
(see p. x)
REFERENCES: Pyenson and Gauvin 2002, p. 187;
Wilson and Hess 2001, p. 75, no. 146; Ronfort 1989,
pp. 51–66.
RELATED WORK: Maurice-Quentin de La Tour,
Portrait of Gabriel Bernard de Rieux, 1739–41 (no. 90
below; see fig. 48); a similar globe appears in La Tour's
portrait.

NICOLAS SPAYEMENT
(d. 1751)

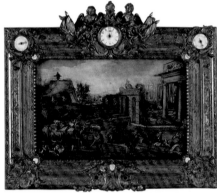

27

27. Mechanical Scene (*tableau mécanique*)
1739
Painting by Nicolas Spayement
Mechanism by Desmares (active in 1739)
Painted tin, enameled metal; gilt wood
With frame: 79 × 91.5 × 13 cm (31⅛ × 36 × 5⅛ in.)
Inscription on an enameled cartouche on the dial
"Fait par / Desmares / à Versailles / 1739"; inscription
in red on the painting "PIN.par.SPAYEMANT.1739"
and "F.PAR.DESMARES.A.VERSAILLE"
Paris, Les Arts Décoratifs, Musée des Arts décoratifs,
3131
PROVENANCE: in the cabinet of curiosities of Joseph
Bonnier de la Mosson (1702–1744); purchased in 1745
by the duc d'Estouville.
REFERENCES: Pointon 2009, pp. 204–5; Roland-
Michel 1975, pp. 214–15; Gelis 1924, pp. 254–72.
RELATED WORK: Jean-Marc Nattier, *Portrait of Joseph
Bonnier de la Mosson*, 1745 (no. 93 below); this is a
portrait of the first owner of this mechanical scene.

Bronze, Gold and Silver, Snuffboxes and Toilette Boxes

BRONZE

SELECTED GENERAL REFERENCES: Wilson, Bremer-David, and Weaver 2008; Verlet 1987; Ottomeyer and Pröschel 1986.

ANDRÉ-CHARLES BOULLE
(1642–1732, master before 1666)
REFERENCES: Frankfurt 2009; Ronfort 1986; Ronfort 1984.

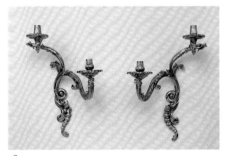

28

28. Pair of Wall Lights (*bras de lumière*)
ca. 1700–15
Attributed to André-Charles Boulle
Gilt bronze
55.2 × 37.5 × 17 cm (21¾ × 14¾ × 6¾ in.)
Los Angeles, J. Paul Getty Museum, 83.DF.195.1.-.2
REFERENCES: Wilson, Bremer-David, and Weaver 2008, pp. 300–309, no. 35; Ottomeyer and Pröschel 1986, vol. 1, pp. 62, 83; Ronfort 1986, p. 495, no. 2; Ronfort 1984, pp. 72–73.
RELATED WORKS: Jean-François de Troy, *Before the Ball*, 1735 (no. 99a below; see fig. 53); *After the Ball*, 1735 (no. 99b below; see fig. 54); and *Reading in a Salon*, ca. 1728 (no. 98 below; see fig. 23); similar wall lights appear in these and several other paintings by de Troy.

CHARLES CRESSENT
(1685–1768, master 1719)
REFERENCE: Pradère 2003; Pradère 1989, pp. 129–39.

29. Pair of Firedogs (*chenets*)
ca. 1735
Attributed to Charles Cressent
Gilt bronze
38.7 × 36.5 × 20.6 cm (15¼ × 14⅜ × 8⅛ in.)
Los Angeles, J. Paul Getty Museum, 73.DF.63.1-.2
REFERENCES: Leeds–Los Angeles 2008–9, pp. 58–59, no. 13; Pradère 2003, p. 307, no. 270; Wilson and Hess 2001, pp. 90–91, no. 182.
RELATED WORKS: Writing table (no. 2 above); pair of corner cupboards (no. 3 above); and clock on bracket (no. 18 above); examples of other works attributed to Cressent.

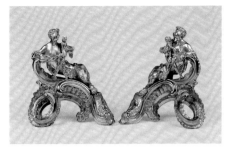

29

UNKNOWN MAKERS

30. Pair of Candlesticks (*flambeaux*)
ca. 1680–90
Gilt bronze
25.4 (height) × 14.6 (diam.) cm (10 × 5¾ in.)
Los Angeles, J. Paul Getty Museum, 72.DF.56.1-.2
(see fig. 59)
REFERENCES: Wilson, Bremer-David, and Weaver 2008, pp. 288–91, no. 32; Ottomeyer and Pröschel 1986, vol. 1, p. 58.

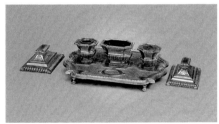

31

31. Inkstand and Paperweights (*encrier et presse-papiers*)
ca. 1715
Gilt bronze; walnut
Inkstand: 10.8 × 37.3 × 28.3 cm (4¼ × 14¹¹⁄₁₆ × 11⅛ in.)
Paperweight (each): 6.7 × 16.2 × 11.4 cm (2⅝ × 6⅜ × 4½ in.)
Los Angeles, J. Paul Getty Museum, 75.DF.6.1-.3
REFERENCE: Wilson, Bremer-David, and Weaver 2008, pp. 354–59, no. 43.

32. Inkstand (*encrier*)
Chinese, early 18th century (porcelain); French, ca. 1750 (lacquer and mounts)
Hard-paste porcelain; wood lacquered with *vernis Martin*; gilt-bronze mounts
20.3 × 35.6 × 26.7 cm (8 × 14 × 10½ in.)
Los Angeles, J. Paul Getty Museum, 76.DI.12
REFERENCES: Wilson and Hess 2001, p. 92 no. 186; Wilson 1999, pp. 85–87 no. 17.
RELATED WORK: Guillaume Voiriot, *[Pierre] Gilbert des Voisins*, 1761 (no. 102 below); a similar lacquered inkstand mounted with porcelain vessels appears on the desk in Voiriot's portrait.

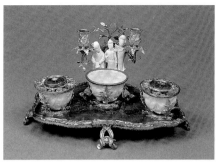

32

GOLD AND SILVER

SELECTED GENERAL REFERENCES: Mabille 1984; Hernmarck 1977; Dennis 1960; Brault and Bottineau 1959; Nocq 1968.

ROBERT-JOSEPH AUGUSTE
(1723–1805, master 1757, *orfèvre du roi* 1778)
REFERENCES: Mabille 1984, p. 16; Nocq 1968, vol. 1, pp. 32–33.

33

33. Plate (*assiette*)
1768–69
Robert-Joseph Auguste
Gilt silver
Diam.: 24 cm (9⁷⁄₁₆ in.)
Paris, Les Arts Décoratifs, Musée des Arts décoratifs, 30171
REFERENCE: Mabille 1984, pp. 16–17, no. 6.

ANTOINE-SÉBASTIEN DURAND
(master ca. 1740)
REFERENCES: Mabille 1984, p. 65; Nocq 1968, vol. 2, pp. 139–41.

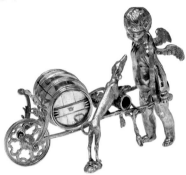

34

34. Mustard Pot (*moutardier*)
1753–55
Antoine-Sébastien Durand (master ca. 1740)
Parcel-gilt silver
15.1 × 22.5 × 9.5 cm (5¹⁵⁄₁₆ × 8⁷⁄₈ × 3¾ in.)
Paris, Les Arts Décoratifs, Musée des Arts décoratifs, 26884
REFERENCES: Portland 2002, pp. 54–55; Mabille 1984, p. 65, no. 93; Hernmarck 1977, vol. 1, p. 194, vol. 2, p. 176; Brault and Bottineau 1959, pp. 55, 68, 106, pl. XV.

SIMON GALLIEN
(died 1757, master 1714)
REFERENCE: Nocq 1968, vol. 2, pp. 208–9.

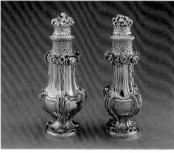

35

35. Pair of Sugar Castors (*sucriers à poudre*)
1743
Simon Gallien
Silver
26 (height) × 11.4 (diam.) cm (10¼ × 4½ in.)
Los Angeles, J. Paul Getty Museum, 84.DG.744.1–.2
REFERENCE: Wilson and Hess 2001, pp. 96–97, no. 195.

THOMAS GERMAIN
(1673–1748, *orfèvre du roi* 1723)
REFERENCES: Perrin 1993, pp. 34–45; Mabille 1984, p. 76.

36. Pair of Lidded Tureens, Liners, and Stands
(*terrine, doublure, avec couvercle sur un plateau*)
1744–50
Thomas Germain
Silver
Tureen: 28.4 × 34.9 × 28.3 cm (11³⁄₁₆ × 13¾ × 11⅛ in.)
Stand: 4.1 × 46.2 × 47.1 cm (1⅝ × 18³⁄₁₆ × 18⁹⁄₁₆ in.)
Los Angeles, J. Paul Getty Museum, 82.DG.13.1–.2
(see figs. 3 and 65a and 65b)
PROVENANCE: possibly Archbishop Dom Gaspar de Bragança (1716–1789), Braga, Portugal.
REFERENCES: Wilson and Hess 2001, p. 97, no. 196; Perrin 1993, pp. 96–98.

FRANÇOIS-THOMAS GERMAIN
(1726–1791, *orfèvre du roi* 1748–64)
REFERENCES: Perrin 1993; Nocq 1968, vol. 2, pp. 243–48.

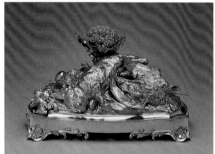

37

37. "La Machine d'Argent" or Centerpiece for a Table
(*surtout de table*)
1754
François-Thomas Germain
Silver
21 × 36.8 × 23.2 cm (8¼ × 14½ × 9⅛ in.)
Los Angeles, J. Paul Getty Museum, 2005.43
PROVENANCE: Christian Ludwig II, duke of Mecklenburg-Schwerin (1683–1756); by inheritance to his son Friedrich, duke of Mecklenburg-Schwerin (1717–1785); by inheritance to his nephew, Friedrich Franz I, duke of Mecklenburg-Schwerin (1756–1837).
REFERENCES: Leeds–Los Angeles 2008–9, pp. 160–61; Solodkoff 2006, pp. 93–103; Solodkoff 2000, pp. 122–35.
RELATED WORKS: Jean-Baptiste Oudry, *Still Life of Fish, Game, and a Spaniel ("Water")* and *Still Life with Rifle, Hare, and Bird ("Fire")*, 1719–20 (nos. 95b and 95c below); like these paintings, this sculpture is a still life with dead game. Oudry secured the commission of this silver centerpiece for Germain.

UNKNOWN MAKERS

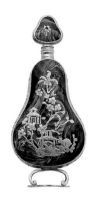

38

38. Perfume Bottle (*flacon à parfum*)
ca. 1700–50
Gold, jasper
10 × 7 × 2 cm (3¹⁵⁄₁₆ × 2¾ × ¹³⁄₁₆ in.)
Paris, Les Arts Décoratifs, Musée des Arts décoratifs, 57929

39

39. Set of Cutlery: Knife, Fork, Spoon, Marrow Spoon (*couvert de couteau, fourchette, cuiller, et cuiller à moelle*)
ca. 1740–50
Silver-gilt; blade of steel; leather case
Knife: 1.5 × 19.5 × 1.9 cm (⅝ × 7⅝ × ¾ in.); fork: 1.4 × 17 × 2.2 cm (⁹⁄₁₆ × 6¹¹⁄₁₆ × ⅞ in.); spoon: 1.9 × 18.2 × 3.9 cm (¾ × 7³⁄₁₆ × 1½ in.); marrow spoon: 0.9 × 15 × 2.3 cm (⅜ × 5⅞ × ¹⁵⁄₁₆ in.)
Stockholm, Nationalmuseum, Gift of Lennart Åberg, 1988, NMK53/1988, 54/1988, 55/1988, 56/1988

40. Bodice Ornament and Earrings
(*boucle de corsage et boucles d'oreille*)
ca. 1760
Topazes; sapphires; gold
Bodice: 9.6 × 8.2 × 1.6 cm (3¾ × 3¼ × ⅝ in.);
earring 1: 5.2 × 4.4 × 1.2 cm (2¹⁄₁₆ × 1¾ × ½ in.);
earring 2: 5.4 × 4.4 × 1 cm (2⅛ × 1¾ × ⅜ in.)
London, Victoria and Albert Museum, Given by
Dame Joan Evans, M.163.C-1975 and M.163.D-1975
(see fig. 64)
REFERENCE: Bury 1982, pp. 92, 96, no. 2.

SNUFFBOXES AND TOILETTE BOXES

SELECTED GENERAL REFERENCES: Hall 2008;
Grandjean 1981.

PIERRE-FRANÇOIS-MATHIS DE BEAULIEU
(active 1768–92, master 1769)

PIERRE-VICTOR-NICOLAS MAILLIÉE
(active 1748–85)

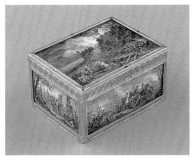

41

41. Snuffbox (*tabatière*) depicting the storming of the
British-held fortress of Saint-Philip at Mahon on the
island of Minorca in 1756 under the command of the
duc de Richelieu
1773–74
Box by Pierre-François-Mathis de Beaulieu
Miniatures by Pierre-Victor-Nicolas Mailliée
Gold; gouache on vellum; glass
6.5 × 7.3 × 5.6 cm (2⁹⁄₁₆ × 2⅞ × 2³⁄₁₆ in.)
San Marino, Calif., Huntington Library Art
Collections and Botanical Gardens, 2000.15
PROVENANCE: possibly made for Louis-François-
Armand Vignerot du Plessis (1696–1788), duc
de Richelieu, maréchal de France.
REFERENCE: Bennett and Sargentson 2008, pp. 393,
399, 420–23, no. 152.
RELATED WORK: mantel clock (no. 21 above); this
mantel clock was also in the collection of the duc
de Richelieu.

JEAN-FRANÇOIS BRETON
(active 1737–91, master 1737)

LOUIS LIOT
(active 1741–55)

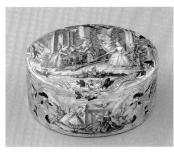

42

42. Snuffbox (*tabatière*) with scene after Nicolas
Lancret, *The Four Ages of Man: Childhood, 1730–35*
1754–55
Box by Jean-François Breton
Enamel decoration attributed to Louis Liot
Varicolored gold and enamel
3.8 × 7.3 × 8.3 cm (1 ½ × 2⅞ × 3 ¼ in.)
San Marino, Calif., Huntington Library Art
Collections and Botanical Gardens, 27.15 (see p. 115)
REFERENCE: Bennett and Sargentson 2008, pp. 399,
406–8, no. 146.

ÉTIENNE POLLET
(ca. 1685–1751, master 1715)

SÉBASTIEN IGONET
(master 1725, still active in 1766)

ANTOINE LEBRUN
(d. 1758, master 1702)

ALEXIS LOIR III
(d. 1775, master 1733)

JOSEPH LECLERC
(1706/7–1753, master 1737)

43. Toilette Service (*service de toilette*)
1738–39
Pair of large boxes, pair of small boxes, pair of round
powder boxes, and tray for candle snuffer by Étienne
Pollet, who directed the commission
Candle snuffer by Étienne Pollet and Sébastien Igonet
Root box by Sébastien Igonet
Ewer, basin, and table mirror by Antoine Lebrun
Pair of lidded cosmetic pots and stand by Joseph
Leclerc
Pair of candlesticks by Alexis Loir III
Whisk and clothes brush by an unknown maker

Silver; boar's hair bristles; modern velvet; modern
mirror glass
Table mirror: 67.3 × 60.6 × 6.4 cm (26½ × 23⅞ ×
2½ in.)
Detroit Institute of Arts, Founders Society Purchase,
Elizabeth Parke Firestone Collection of Early French
Silver Fund, 53.177-.192
(see figs. 35 and 61)
PROVENANCE: made for Henriette-Julie-Gabrielle de
Lorraine (1724–1761) on the occasion of her marriage
in 1739 to Jayme Perreira de Mello, third duke of
Cadaval (1684–1749).
REFERENCES: Carlier 2004; Albainy 1999.

UNKNOWN MAKERS

44. Casket (*carré de toilette*)
ca. 1680–90
Wood veneered with rosewood, brass, mother-of-
pearl, pewter, copper, stained and painted horn;
gilt-bronze mounts
13 × 32.1 × 25.7 cm (5⅛ × 12⅝ × 10⅛ in.)
Los Angeles, J. Paul Getty Museum, 88.DA.111
(see figs. 42a and 42b)
REFERENCE: Wilson, Bremer-David, and Weaver
2008, pp. 14–21, no. 2.
RELATED WORK: Jean-Marc Nattier, *Portrait of
Madame Marsollier and Her Daughter*, 1749 (no. 94
below; see fig. 41); the daughter holds an open casket
of the same form and similar decoration, while a
similar casket stands on the *toilette* table beside her.

Porcelain, Glass, and Ivory

PORCELAIN AND GLASS

SELECTED GENERAL REFERENCES: Roth and
Le Corbeiller 2000; Dawson 1994; Plinval de
Guillebon 1992.

CHANTILLY PORCELAIN MANUFACTORY
(active ca. 1725–ca. 1792)
REFERENCES: Le Duc 1998; Le Duc 1996.

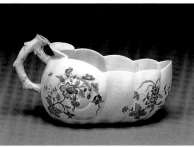

45

45. Chamber Pot (*bourdaloue*)
Chantilly, ca. 1740
Soft-paste porcelain, polychrome enamel decoration

9.8 × 19.7 × 11.7 cm (3⅞ × 7¾ × 4⅝ in.)
Los Angeles, J. Paul Getty Museum, 82.DE.9
REFERENCE: Wilson and Hess 2001, p. 105, no. 214.
RELATED WORK: Wall clock (no. 17 above); this clock
was made by the same manufactory.

DU PAQUIER PORCELAIN MANUFACTORY
(Austrian, active 1719–1744)
REFERENCE: Chilton et al. 2009.

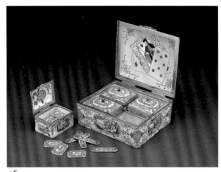

46

46. Box Set of Gaming Pieces
Vienna, ca. 1735–40
Hard-paste porcelain, polychrome enamel decoration,
gilding; gold and diamond mounts
7 × 16.8 × 15.1 cm (2¾ × 6⅝ × 5¾ in.)
Art Institute of Chicago, Eloise W. Martin Fund,
Richard T. Crane and Mrs. J. Ward Thorne endow-
ments, through prior gift of The Antiquarian Society,
1993.349, Gift of the Antiquarian Society, 1995.95.1–4
REFERENCE: Chilton et al. 2009, vol. 1, pp. 20–21;
vol. 2, pp. 632–36; vol. 3, pp. 1179, 1189, 1313, no. 383.

MENNECY PORCELAIN MANUFACTORY
(active 1735–73)
REFERENCE: Duchon 1988.

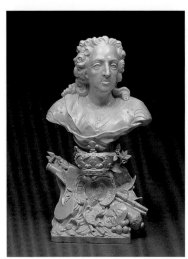

47

47. Bust of Louis XV
(?) Mennecy, ca. 1750–55
Soft-paste porcelain
43.2 × 24.3 × 14.4 cm (17 × 9⁹⁄₁₆ × 5¹¹⁄₁₆ in.)
Los Angeles, J. Paul Getty Museum, 84.DE.46
[exhibited in Los Angeles only]
REFERENCES: Wilson and Hess 2001, pp. 106–7,
no. 217; Roth and Le Corbeiller 2000, pp. 46, 48 nn. 5
and 16, 49; Le Duc 1996, pp. 194–97; Craven 1959,
pp. 135–42.

MENNECY PORCELAIN MANUFACTORY
(active 1735–73)
REFERENCE: Duchon 1988.

TOURNAI PORCELAIN MANUFACTORY
(Flemish, active 1750–1891)
REFERENCE: Lemaire 1999.

48

48. Allegorical Figure of Sculpture
(?) Mennecy or Tournai, ca. 1760
Soft-paste porcelain
14.9 × 7.3 × 5.2 cm (5⅞ × 2⅞ × 2¹⁄₁₆ in.)
Marks: incised underneath "Bernard"
Pasadena, Calif., MaryLou Boone, MLB 1991.069
REFERENCES: Dawson 2002, pp. 201, 203, 209 n. 19;
Claremont 1998, p. 90, no. 74.

SAINT-CLOUD PORCELAIN MANUFACTORY
(active by 1693–1766)
REFERENCES: New York 1999; Lahaussois 1997.

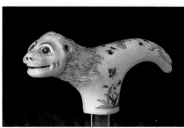

49

49. Cane Handle (*poignée de canne*)
Saint-Cloud, ca. 1735
Soft-paste porcelain, polychrome enamel decoration
5.7 × 12.8 × 3 cm (2¼ × 5⅛ × 1³⁄₁₆ in.)
Pasadena, Calif., MaryLou Boone, MLB 1989.058
REFERENCE: Claremont 1998, p. 76, no. 56.

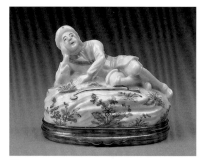

50

50. Box, possibly for snuff (*boîte*)
Saint-Cloud, ca. 1740
Soft-paste porcelain, polychrome enamel decoration;
silver mounts
6.5 × 7.2 × 5.2 cm (2⁹⁄₁₆ × 2⅞ × 2¹⁄₁₆ in.)
Pasadena, Calif., MaryLou Boone, MLB 1989.065
REFERENCE: Claremont 1998, p. 76, no. 55.

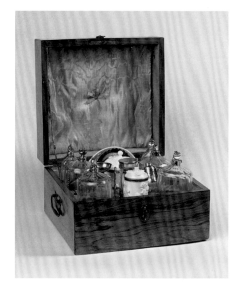

51

51. Traveling Equipage (*nécessaire de voyage*)
Saint-Cloud and (?) Paris, ca. 1750–51
Rosewood; silk; soft-paste porcelain; glass vessels;
silver mounts and implements
28.5 × 27.1 × 17.9 cm (11¼ × 10¹¹⁄₁₆ × 7¹⁄₁₆ in.)
Mark: incomplete silversmith's mark for Claude-
Nicolas Grébeude (d. 1751, master 1722)
London, Victoria and Albert Museum, given by
Miss H. L. Greenfield in accordance with the wishes
of the late Miss M. Bernardine Hall, c.575-1920
REFERENCE: Truman 2005; Truman 1980.

SÈVRES PORCELAIN MANUFACTORY

(active 1756–present)
REFERENCES: Sassoon 1991; Savill 1988; Paris 1977–78.

ÉTIENNE-MAURICE FALCONET

(1716-1791)
REFERENCES: Sèvres 2001–2; Levitine 1972.

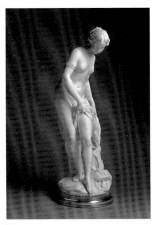

52

52. Bather (*Baigneuse*)
Sèvres, 1758–66
Designed by Étienne-Maurice Falconet
Soft-paste porcelain; gilt-bronze mount
55.9 × 13.5 × 14.5 cm (22 × 5⁵⁄₁₆ × 5¹¹⁄₁₆ in.)
Mark: incised near base rim "F"
New York, Metropolitan Museum of Art, Gift of
R. Thornton Wilson, in memory of Florence Ellsworth
Wilson, 1950, 50.211.138
REFERENCES: Sèvres 2001–2, pp. 94, 164–67; Levitine
1972, pp. 31–32.
RELATED WORK: Étienne-Maurice Falconet, *Bather
(Baigneuse)*, 1757 (no. 70 below); this Sèvres reduction
derives from the original marble by Falconet exhibited
at the Salon of 1757, no. 131.

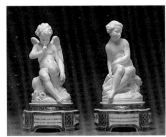

53

53. Pair of Figures and Pedestals: Cupid (*L'Amour
menaçant*) **and Psyche** (*Psyché*)
Sèvres, 1763
Designed by Étienne-Maurice Falconet
Pedestals gilded by Pierre-Nicolas Pierre (active
1759–76)
Figures: soft-paste biscuit porcelain; pedestals:
soft-paste porcelain, blue ground color, polychrome
enamel decoration, gilding

29.8 × 17.1 × 17.1 cm (11¾ × 6¾ × 6¾ in.)
Private collection
REFERENCES: Sèvres 2001–2, pp. 91–92, 160–61
(Cupid), 162 (Psyche); Savill 1988, vol. 2, pp. 823–34;
Levitine 1972, pp. 30–31.

VINCENNES PORCELAIN MANUFACTORY

(active ca. 1740–56)
REFERENCES: Sassoon 1991; Savill 1988; Paris 1977–78.

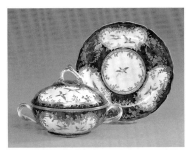

54

54. Lidded Bowl and Dish (*écuelle ronde
et plateau rond*)
Vincennes, ca. 1752–53
Soft-paste porcelain, *bleu lapis* ground color,
polychrome enamel decoration, gilding
Bowl: 14 × 22.2 × 16.7 cm (5½ × 8¾ × 6⅝ in.); stand:
4.13 (height) × 22.7 (diam.) cm (1⅝ × 8¹⁵⁄₁₆ in.)
Los Angeles, J. Paul Getty Museum, 89.DE.44.a-.b
(see p. viii)
REFERENCES: Wilson and Hess 2001, p. 108, no. 221;
Savill 1988, vol. 2, pp. 642–67.

IVORY

UNKNOWN MAKER

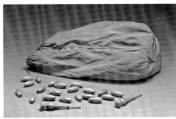

55

55. Cavagnole Game Bag and Pieces
ca. 1750
Green-stained ivory; watercolor on vellum; silk
Spindle (each): 2.2 × 12 × 2 cm (7/8 × 4¾ × ¹³⁄₁₆ in.)
Bead (each): 1.5 × 4 × 1.5 cm (⁹⁄₁₆ × 1⁹⁄₁₆ × ⁹⁄₁₆ in.)
Private collection
(see p. i)
REFERENCE: Belmas 2006, p. 400.

Tapestries, Decorative Textiles, Fashion, and Sewing Implements

TAPESTRIES AND DECORATIVE TEXTILES

BEAUVAIS TAPESTRY MANUFACTORY

(active 1664–present)
REFERENCES: Bremer-David 2007, pp. 406–19; Coural
and Gastinel-Coural 1992.

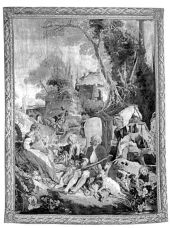

56a

56a. Tapestry: *Italian Village Scenes; The Hunter
and Girls with Grapes* (*Tapisserie: Les Fêtes Italiennes;
Le Chasseur et Les Filles aux Raisins*)
Beauvais, ca. 1738–53
After cartoons by François Boucher (1703–1770)
Wool and silk; modern linen support straps, dust
bands, and linings
279.3 × 220.3 cm (110 × 86¾ in.)
San Marino, Calif., Huntington Library Art
Collections and Botanical Gardens. The Arabella D.
Huntington Memorial Collection, 20.8

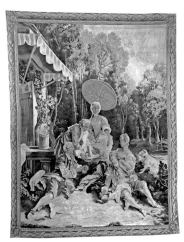

56b

56b. Tapestry: *Italian Village Scenes; The Collation*
(*Tapisserie: Les Fêtes Italiennes; La Collation*)
Beauvais, probably 1754
After cartoons by François Boucher (1703–1770)
Wool and silk; modern linen support straps, dust
bands, and linings
274.8 × 217.4 cm (108³⁄₁₆ × 85⁹⁄₁₆ in.)
San Marino, Calif., Huntington Library Art
Collections and Botanical Gardens. The Arabella D.
Huntington Memorial Collection, 20.5
PROVENANCE: *The Hunter and Girls with Grapes*,
probably from a set woven 1738–53; *The Collation*,
probably from a set woven April 6, 1754–September
28, 1754, for "M. Cochin" (probably Charles-Nicolas
Cochin *fils*).
REFERENCE: Bennett and Sargentson 2008, pp. 301–9,
no. 119.
RELATED WORKS: Jean-Baptiste Oudry (see nos. 95a–
95d below), co-director of the Beauvais manufactory,
commissioned the designs for *Italian Village Scenes*
from François Boucher (see nos. 77–80 below; figs. 32,
37, 45, and 51).

SAVONNERIE MANUFACTORY
(active 1627–present)
REFERENCES: Verlet 1982; Verlet 1967a; Jarry 1966.

57

57. Three-Panel Screen (*paravent*)
Chaillot, ca. 1714–40
Probably after cartoons by Jean-Baptiste Belin
de Fontenay (1653–1715) and Alexandre-François
Desportes (1661–1743)
Wool and linen; cotton twill gimp; wooden interior
frame; modern velvet lining
273.6 × 193.2 cm (107³⁄₄ × 76¹⁄₈ in.)
Los Angeles, J. Paul Getty Museum, 83.DD.260.2
PROVENANCE: (?) Garde Meuble de la Couronne,
first half of the eighteenth century.
REFERENCES: Wilson and Hess 2001, pp. 144–45,
no. 293; Bremer-David 1997, pp. 146–53, no. 15;
Standen 1985, vol. 2, pp. 655–56, no. 112; Verlet 1982,
pp. 301, 457–58 n. 82.

RELATED WORKS: Maurice-Quentin de La Tour,
Portrait of Gabriel Bernard de Rieux, 1739–41 (no. 90
below; see fig. 48); a different *paravent* appears behind
the sitter in this portrait.

UNKNOWN MAKER

58. Hangings for a Bed (*lit à la duchesse*)
ca. 1690–1715
Silk satin; cording; velour; silk embroidery; silk
damask panels; linen linings
415.9 × 181.6 × 182.9 cm (163³⁄₄ × 71¹⁄₂ × 72 in.)
Los Angeles, J. Paul Getty Museum, 79.DD.3
[exhibited in Los Angeles only]
(see fig. 28)
REFERENCES: Wilson and Hess 2001, p. 142, no. 289;
Bremer-David 1997, pp. 172–81, no. 18; Ratzki-Kraatz
1986, pp. 81–104.

FASHION

SELECTED GENERAL REFERENCES: Los Angeles 2010;
New York 2006; Jones 2004; Ribeiro 2002; Delpierre
1997; Roche 1994; Kyoto 1989; Los Angeles 1983.

UNKNOWN MAKERS

59. Man's At-Home Cap (*bonnet d'intérieur*)
ca. 1725–75
Silk with silk and metallic-thread embroidery
17.1 × 26.4 × 24.8 cm (6³⁄₄ × 10³⁄₈ × 9³⁄₄ in.)
Los Angeles County Museum of Art, Gift of
Mrs. Frederick Kingston, M.61.6
(see p. xiv)
REFERENCES: Los Angeles 2010, pp. 126–27;
Los Angeles 1983, pp. 91, 200, no. 316; Los Angeles
1974, no. 16.

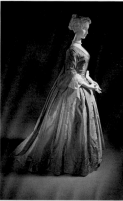

60

60a. Woman's Dress and Petticoat (*robe à la française*)
European, ca. 1725
Silk
Dress center back length: 153 cm (60¹⁄₄ in.)
Petticoat center back length: 95.9 cm (37³⁄₄ in.)
Los Angeles County Museum of Art, purchased with

funds provided by Suzanne A. Saperstein, Michael
and Ellen Michelson, with additional funding from
the Costume Council, the Edgerton Foundation,
Gail and Gerald Oppenheimer, Maureen H. Shapiro,
Grace Tsao, and Lenore and Richard Wayne,
M.2007.211.927 a-b

60b. Stomacher (*pièce d'estomac*)
French or Italian, ca. 1750
Silk with silk fly fringe, silk ribbon, and metallic
lace trim
Length: 41 cm (16¹⁄₈ in.)
Los Angeles County Museum of Art, Costume
Council Fund, M.80.27.2
[exhibited in Los Angeles only]
REFERENCE: Los Angeles 2010, pp. 74–75 (dress
and petticoat).

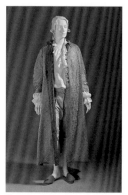

61

61. Man's At-Home Robe (*banyan*)
ca. 1760
Silk satin; silk lining
Center back length: 130.8 cm (51¹⁄₂ in.)
Los Angeles County Museum of Art, purchased with
funds provided by Suzanne A. Saperstein, Michael
and Ellen Michelson, with additional funding from
the Costume Council, the Edgerton Foundation, Gail
and Gerald Oppenheimer, Maureen H. Shapiro, Grace
Tsao, and Lenore and Richard Wayne, M.2007.211.949
RELATED WORKS: Jacques-André-Joseph Aved,
Portrait of Marc de Villiers, 1747 (no. 76 below; see
fig. 30); the sitter in this portrait wears a robe of
similar design.

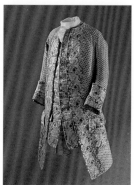

62

62. Man's Ensemble of Coat and Waistcoat
(*habit et gilet*)
ca. 1750
Silk and metallic-thread velvet; brass buttons
Coat center back length: 104.1 cm (41 in.)
Waistcoat center back length: 104.1 cm (41 in.)
Los Angeles County Museum of Art, Costume
Council Fund, M.57.35a-b
REFERENCE: Los Angeles 1983, p. 190, no. 230.

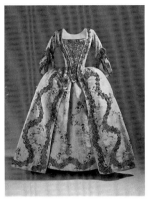

63

63a. Woman's Dress and Petticoat (*robe à la française*)
ca. 1760–65
French or English
Silk faille with metallic-thread, and metallic lace trim
Dress center back length: 158.8 cm (62½ in.)
Petticoat center back length: 97.8 cm (38½ in.)
Los Angeles County Museum of Art, Gift of
Mrs. Aldrich Peck, M.56.6a-b

63b. Stomacher (*pièce d'estomac*)
Probably English, ca. 1750
Silk with metallic-thread embroidery and
passementerie
Length: 39.4 cm (15½ in.)
Los Angeles County Museum of Art, purchased with
funds provided by Suzanne A. Saperstein, Michael
and Ellen Michelson, with additional funding from
the Costume Council, the Edgerton Foundation, Gail
and Gerald Oppenheimer, Maureen H. Shapiro, Grace
Tsao, and Lenore and Richard Wayne, M.2007.211.129
(see p. v)
REFERENCES: Los Angeles 2010, p. 191 (stomacher);
Los Angeles 1983, p. 171, no. 39 (dress and petticoat);
Holt 1960, p. 8 (dress and petticoat).
RELATED WORK: François-Hubert Drouais, *Portrait
of the Marquise d'Aiguirandes*, 1759 (no. 86 below;
see fig. 63); the marquise wears a gown of strikingly
similar design in this painting.

64. Gaming Purse (*bourse de jeu*)
Early 1700s
Velvet with silk and silver-thread embroidery
6.3 × 14 cm (2½ × 5½ in.)
Los Angeles, J. Paul Getty Museum, Gift of the
Kraemer Family, 97.DD.59
(see fig. 59 and back jacket)
REFERENCE: Wilson and Hess 2001, p. 142, no. 290.

65. Folding Fan (*éventail*)
ca. 1760s
Gouache, gold, gilt paint, silver foil on paper; mica;
ivory sticks with gold leaf, brass metallic button
and rivet
Guard length: 27.9 cm (11 in.)
Spread width: 71.4 cm (28⅛ in.)
Los Angeles County Museum of Art, Gift of Anita S.
Watson, M.83.189.69
(see p. vi)

SEWING IMPLEMENTS

UNKNOWN MAKERS

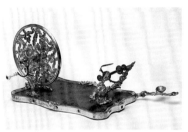

66

66. Skein-winder (*dévidoir*)
1740–50
Gilt bronze, wood, ivory, wool
23 × 43.5 × 25 cm (9¹/₁₆ × 17⅛ × 9¹³/₁₆ in.)
Paris, Les Arts Décoratifs, Musée des Arts
décoratifs, 14259
RELATED WORK: Étienne Jeaurat, *Family in an
Interior*, ca. 1750 (no. 88 below); a similar skein-
winder appears in Jeaurat's drawing.

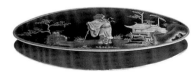

67

67. Shuttle (*navette*)
ca. 1750
Wood, lacquer
14 × 5 cm (5½ × 2 in.)
Paris, Les Arts Décoratifs, Musée des Arts
décoratifs, 29975

Sculpture

SELECTED GENERAL REFERENCES: Paris–New York–
Los Angeles 2009; Scherf 2001; Levey 1993; Lami
1910–11.

EDME BOUCHARDON
(1698–1762)
REFERENCES: Chaumont 1962, Roserot 1910.

68. Cupid (*L'Amour taillant son arc dans la massue
d'Hercule*)
Before 1757
Marble
73.9 (height) × 34.5 (diam. at base) cm (29⅛ ×
13⁹/₁₆ in.)
Inscription on the base:
"BOUCHARDON 1744"
Washington, D.C., National Gallery of Art, Samuel H.
Kress Collection, 1952.5.93
(see fig. 2)
PROVENANCE: possibly the marble in the collection of
fermier-général Étienne-Michel Bouret, mentioned as
being in his *hôtel particulier* in Paris from 1757 to 1762.
REFERENCES: Versailles–Munich–London 2002–3,
pp. 306–9, no. 135; National Gallery of Art 1994, p. 32;
Middeldorf 1976, pp. 102–4; Roserot 1910, p. 86.

JEAN-BAPTISTE DEFERNEX
(ca. 1729–1783)
REFERENCE: Réau 1931.

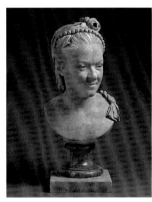

69

69. Portrait of Madame Favart (*born Marie-Justine-
Benoîte Duronceray*)
1757
Terra-cotta
50 × 25 × 23 cm (19¹¹/₁₆ × 9¹³/₁₆ × 9¹/₁₆ in.)
Signed on the neck in the back: "par J. B. Defernex
1757"
Paris, Musée du Louvre, Département des Sculptures,
RF 1518
(see p. iv)
PROVENANCE: exhibited at the Salon de l'Académie
de Saint-Luc, 1762, no. 144; Le Gendre sale, Paris,
December 3, 1770, no. 30.

REFERENCES: Gaborit et al. 1998, vol. 1, p. 328; Réau 1931, pp. 358–59, 364.
RELATED WORK: François-Hubert Drouais, *Portrait of Madame Charles-Simon Favart*, 1757 (no. 85 below); this bust represents the same sitter as in Drouais's painting.

ÉTIENNE-MAURICE FALCONET
(1716–1791)
REFERENCES: Sèvres 2001–2; Levitine 1972.

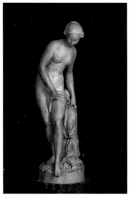

70

70. *Bather* (*Baigneuse*)
After 1757
Marble
80.5 × 25.7 × 29 cm (31¹¹/₁₆ × 10⅛ × 11⁷/₁₆ in.)
Paris, Musée du Louvre, Département des Sculptures, MR 1846
PROVENANCE: collection of Madame du Barry, Louveciennes (autograph copy of the original marble exhibited at the Salon of 1757, no. 131, from the collection of François Thiroux d'Épersenne, *avocat du Parlement* and *maître des requêtes*); revolutionary seizure, 1794.
REFERENCES: Sèvres 2001–2, pp. 92–94; Gaborit et al. 1998, vol. 1, p. 365; Levitine 1972, pp. 31–32.
RELATED WORK: Bather (*Baigneuse;* no. 52 above); reductions of this work were made by the Sèvres manufactory, 1758–66.

SIMON HURTRELLE
(1648–1724)
REFERENCE: Souchal 1977–93, vol. 2, pp. 150–61.

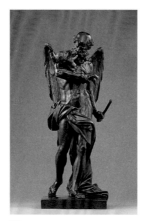

71

71. *Saturn Devouring One of His Children*
ca. 1700
Bronze
65.4 × 26.7 × 25.1 cm (25¾ × 10½ × 9⅞ in.)
Los Angeles, J. Paul Getty Museum, 85.SB.126
REFERENCES: Paris–New York–Los Angeles 2009, pp. 290, 292, 293, no. 79 B; Fusco 1997, p. 30.

UNKNOWN MAKERS

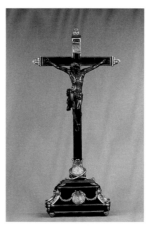

72

72. **Corpus and Cross**
Corpus: Flemish, 1680–1720
Cross: French, 1765–70
Boxwood figure on a cross of oak veneered with ebony and brass; gilt-bronze mounts
124.5 × 62.6 × 22 cm (49 × 24⅝ × 8⅝ in.)
Los Angeles, J. Paul Getty Museum, 82.SD.138.1-.2
REFERENCE: Fusco and Fogelman 1998, pp. 70–73, no. 23.

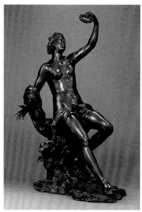

73

73. *Venus Marina*
After a model of ca. 1710
Bronze
64.8 × 54.9 × 29.5 cm (25½ × 21⅝ × 11⅝ in.)
Los Angeles, J. Paul Getty Museum, 74.SB.16
REFERENCE: Fusco and Fogelman 1998, p. 31.

Paintings and Drawings

SELECTED GENERAL REFERENCES: Portland–Tours 2008; Conisbee 2007; Ottawa–Washington–Berlin 2003; Bailey 2002; Versailles–Munich–London 2002–3; Gaehtgens et al. 2001; Ledbury 2001; Hanover–Toledo–Houston 1997–98; Stockholm–Paris 1993–94; Levey 1993; Paris–Philadelphia–Fort Worth 1992; Crow 1985; Bryson 1981; Conisbee 1981; Fried 1980.

LOUIS AUBERT
(1720–ca. 1798)
REFERENCE: Bénézit 1948–55, vol. 1, p. 281.

74. *The Reading Lesson*
1740
Oil on panel
32.5 × 22.7 cm (12¹³/₁₆ × 8¹⁵/₁₆ in.)
Signed at lower right: *L. Aubert f 1740*
Amiens, Musée de Picardie, Gift of the Lavalard Brothers, M.P.Lav. 1894-160
(see fig. 49)
REFERENCES: Pinette 2006, pp. 110–11; Columbia et al. 2000, pp. 80–81, no. 25; Roland-Michel 1994, pp. 248–49, 251.

JACQUES-ANDRÉ-JOSEPH AVED
(1702–1766)
REFERENCES: Lespes 2009; Wildenstein 1935; Wildenstein 1922.

75. *Portrait of Madame Antoine Crozat, marquise du Châtel* (*born Marguerite Legendre d'Armeny*)
1741

Oil on canvas
138.5 × 105 cm (54½ × 41⁵⁄₁₆ in.)
Signed at lower right: *Aved, 1741*
Montpellier, Musée Fabre, 839.2.1
(see fig. 1)
PROVENANCE: exhibited at the Salon of 1741, no. 86; Madame Crozat, 1741–42; collection of the marquis du Châtel (son of the sitter), from 1742.
REFERENCES: Canberra 2003, pp. 174–75, no. 13; Levey 1993, pp. 192–94; Musée Fabre 1988, pp. 108–9; Montpellier 1979, pp. 40–41, no. 12; Wildenstein 1922, vol. 1, pp. 52–55, 57–60, 117, vol. 2, p. 50, no. 29.
RELATED WORKS: Jean-Siméon Chardin, *The Morning Toilette*, 1741 (no. 81 below; see fig. 33) and Maurice-Quentin de La Tour, *Portrait of Gabriel Bernard de Rieux*, 1739–41 (no. 90 below; see fig. 48); these works were also exhibited at the Salon of 1741.

76. *Portrait of Marc de Villiers, Secrétaire du roi*
1747
Oil on canvas
146.7 × 114.6 cm (57¾ × 45⅛ in.)
Signed at lower right on armchair: *AVED 1747*
Los Angeles, J. Paul Getty Museum, 79.PA.70
(see fig. 30)
PROVENANCE: exhibited at the Salon of 1747, no. 62; Marc de Villiers du Terrage, 1747–62; Jacques Étienne de Villiers du Terrage, 1762–after 1786; Paul Étienne de Villiers du Terrage.
REFERENCES: Lespes 2009, p. 76; Shackelford and Holmes 1987, pp. 52–53, no. 10; Fredericksen 1980, p. 83, no. 46; Wildenstein 1935, pp. 167–69; Wildenstein 1922, vol. 1, p. 71, vol. 2, p. 139, no. 107.
RELATED WORK: Man's at-home robe, ca. 1760 (no. 61 above); the robe worn by Marc de Villiers in Aved's portrait is of similar design.

FRANÇOIS BOUCHER
(1703–1770)
REFERENCES: Lajer-Burcharth 2009; Hyde 2006; Hedley 2004; New York–Detroit–Paris 1986; Brunel 1986; Ananoff and Wildenstein 1976.

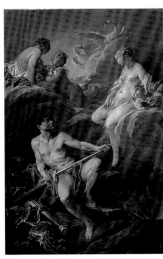

77

77. *Venus Ordering Arms from Vulcan*
1732
Oil on canvas
252 × 175 cm (99³⁄₁₆ × 68⅞ in.)
Signed: *f. Boucher 1732*
Paris, Musée du Louvre, Département des Peintures, 2709
PROVENANCE: François Derbais, by 1743; Claude-Henri Watelet, by 1786; sale of Watelet collection, June 12, 1786 (lot 11, with pendant, *Aurora and Cephalus*), bought by Charles Claude de Flahaut de la Billarderie, comte d'Angiviller for the Crown; the Louvre, from 1786.
REFERENCES: Lajer-Burcharth 2009, pp. 285–91; Hyde 2006, pp. 181–82; Paris–Philadelphia–Fort Worth 1992, pp. 380–89, no. 43; New York–Detroit–Paris 1986, pp. 133–36, no. 17; Brunel 1986, pp. 64, 69, 71; Crow 1986, pp. 12–13; Ananoff and Wildenstein 1976, vol. 1, pp. 217–18, no. 85.
RELATED WORK: Jean Restout, *Venus Ordering Arms from Vulcan*, 1717 (no. 97 below) portrays the same subject as Boucher's painting.

78. *Lady Fastening Her Garter,* also known as *La Toilette*
1742
Oil on canvas
52.5 × 66.5 cm (20¹¹⁄₁₆ × 26³⁄₁₆ in.)
Signed at lower left: *f. Boucher 1742*
Madrid, Museo Thyssen-Bornemisza, 58 (1967.4)
(see fig. 37)
PROVENANCE: Count Carl Gustaf Tessin, 1742–71; sale of the Tessin collection, February 4–16, 1771.
REFERENCES: Hedley 2004, pp. 70–71; Ottawa–Washington–Berlin 2003, pp. 222–23, 363, no. 52; Hanover–Toledo–Houston 1997–98, pp. 112–13, no. 12; New York–Detroit–Paris 1986, pp. 195–97, no. 38; Brunel 1986, pp. 116–17; Washington et al. 1979–81, pp. 138–39, no. 46; Ananoff and Wildenstein 1976, vol. 1, p. 324, no. 208.

79. *Leda and the Swan*
1742
Oil on canvas
59.7 × 74.9 cm (23½ × 29½ in.)
Signed at lower right: *F. BOUCHER*
Beverly Hills, Calif., Collection of Lynda and Stewart Resnick, 1985-015
(see fig. 51)
PROVENANCE: exhibited at the Salon of 1742, no. 21 bis; François-Michel Harenc de Presle, *secrétaire du roi*, by 1758.
REFERENCES: Paris–Philadelphia–Fort Worth 1992, pp. 396–401, no. 46; Grate 1994, pp. 57–58; New York–Detroit–Paris 1986, p. 200; Bailey 1985, pp. 102–5, no. 15; Ananoff and Wildenstein 1976, vol. 1, p. 336, no. 4 (incorrectly listed as a copy).
RELATED WORK: Jean-Marc Nattier, *Portrait of Constance-Gabrielle-Magdeleine Bonnier de la Mosson*, 1742 (no. 92 below), was also exhibited at the Salon of 1742.

80. *The Milliner*
1746
Oil on canvas
64 × 53 cm (25³⁄₁₆ × 20⅞ in.)
Signed at lower right, on bandbox: *f. Boucher 1746*
Stockholm, Nationalmuseum, NM 772
(see fig. 32)
PROVENANCE: commissioned for Crown Princess Louisa Ulrika of Sweden, 1745; delivered to Stockholm, 1747.
REFERENCES: Lajer-Burcharth 2009, pp. 291–93; Hedley 2004, pp. 72–74; Ottawa–Washington–Berlin 2003, pp. 226–29, 364, no. 54; Hanover–Toledo–Houston 1997–98, pp. 3, 114–16, no. 13; Grate 1994, pp. 65–66, no. 89; Stockholm–Paris 1993–94, pp. 396–97, 399, no. 610; New York–Detroit–Paris 1986, pp. 76, 224–29, no. 51; Ananoff and Wildenstein 1976, vol. 1, pp. 406–7, no. 297.
RELATED WORK: Nicolas Lancret, *Morning*, 1739 (no. 89a below; see fig. 4): Boucher's picture was originally commissioned as the first in a series depicting the four times of day, possibly inspired by Lancret's series. Boucher, however, never painted the other three scenes.

JEAN-SIMÉON CHARDIN
(1699–1779)
REFERENCES: Démoris 2005; Karlsruhe 1999; Paris 1999; Roland-Michel 1996; Démoris 1991; Johnson 1990; Conisbee 1986; Rosenberg 1983; Paris–Cleveland–Boston 1979; Snoep-Reitsma 1973.

81. *The Morning Toilette*
ca. 1741
Oil on canvas
49 × 39 cm (19⁵⁄₁₆ × 15⅜ in.)
Stockholm, Nationalmuseum, NM 782
(see fig. 33)
PROVENANCE: acquired by Count Carl Gustaf Tessin, ca. 1740–41; exhibited at the Salon of 1741, no. 71; sold by Tessin to King Frederick I of Sweden, 1749; acquired as a birthday present for Crown Princess Louisa Ulrika of Sweden.
REFERENCES: Michel 2007, pp. 276–77; Ottawa–Washington–Berlin 2003, pp. 200–201, 361, no. 41; Paris 1999, pp. 73, 88–89, 93, 253–54, no. 122; Roland-Michel 1996, pp. 44–47, 49, 121, 190, 213–14, 239, 240, 242, 244; Grate 1994, pp. 91–93, no. 107; Stockholm-Paris 1993–94, pp. 399, 401, no. 612; Johnson 1990, pp. 48, 62–64; Bryson 1981, pp. 117–20; Paris–Cleveland–Boston 1979, pp. 274–76, no. 88; Snoep-Reitsma 1973, pp. 190–91.
RELATED WORKS: Jacques-André-Joseph Aved, *Portrait of Madame Antoine Crozat, marquise du Châtel*, 1741 (no. 75 above; see fig. 1) and Maurice-Quentin de La Tour, *Portrait of Gabriel Bernard de Rieux* 1739–41 (no. 90 below; see fig. 48); these works were also exhibited at the Salon of 1741.

82. *The Good Education*
ca. 1753
Oil on canvas
41.5 × 47.3 cm (16⁵⁄₁₆ × 18⁵⁄₈ in.)
Houston, Museum of Fine Arts, Gift in memory of
George R. Brown by his wife and children, 85.18
(see fig. 50)
PROVENANCE: Ange-Laurent de La Live de Jully,
by 1753–70; exhibited at the Salon of 1753, no. 59;
Boileau sale of La Live de Jully collection, March 5
and May 2–14, 1770 (lot 97); possibly bought by
Count Gustave-Adolphe Sparre of Sweden.
REFERENCES: Démoris 2005, p. 459; Bailey 2002,
pp. 48, 50–51; Bowron and Morton 2000, pp. 108–10;
Hanover–Toledo–Houston 1997–98, pp. 132–34,
no. 20; Roland-Michel 1996, pp. 53, 68, 117, 190, 214,
216, 227; Fried 1980, pp. 15–16; Snoep-Reitsma 1973,
pp. 191–92.
RELATED WORKS: Carle Vanloo, *Aeneas Carrying
Anchises*, 1729 (no. 101 below; see fig. 52); both pictures
were commissioned by Ange-Laurent de La Live
de Jully.

Charles-Joseph Natoire, *Bacchanal*, ca. 1747 (no.
91 below); this painting was also in the collection of
Ange-Laurent de La Live de Jully.

NOËL-NICOLAS COYPEL
(1690–1734)
REFERENCES: Delaplanche 2004; Lomax 1982.

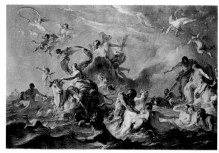
83

83. *The Abduction of Europa*
1727
Oil on canvas
127.6 x 194 cm (50¼ x 76⅜ in.)
Signed and dated (date effaced) at lower right
Philadelphia Museum of Art, acquired with the kind
assistance of John Cadwalader, Jr., through the gift
of Mr. and Mrs. Orville Bullitt (by exchange), the
Edith H. Bell Fund, and other Museum funds, 1978-
160-1
PROVENANCE: 1727, probably Charles-Jean-Baptiste
Fleuriau; by 1766, Augustin Blondel de Gagny;
December 10–24, 1776, sale of Blondel de Gagny col-
lection (lot 230), bought by Lenglier; December 10,
1778, sale at LeBrun's (lot 105); March 3, 1785, sale of
Le P*** collection (lot 56); March 20, 1787, sale of the
marquis de Chamgrand, de Proth, Saint-Maurice,
and Bouillac collections (lot 196), bought by Lebrun;
by 1788, Charles-Alexandre de Calonne; April 21–30,
1788, sale of the Calonne collection (lot 140).

REFERENCES: Delaplanche 2004, pp. 95–96 no. 35;
Bailey 2002, pp. 26 and 174; Levey 1993, pp. 52 and
54; Paris–Philadelphia–Fort Worth 1992, pp. 284–91
no. 30; Lomax 1982, pp. 35, 38, and 39.

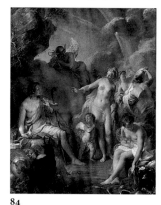
84

84. *The Judgment of Paris*
1728
Oil on canvas
101 × 82 cm (39¾ × 32⁵⁄₁₆ in.)
Signed at bottom center: *N. N. Coypel f. 1728*
Stockholm, Nationalmuseum, NM 793
PROVENANCE: acquired by Count Carl Gustaf Tessin
in Paris, 1729; Crown Princess Louisa Ulrika of
Sweden, by 1760 (inv. 60).
REFERENCES: Delaplanche 2004, pp. 63–65,
102–4, no. 45; Grate 1994, pp. 100–101, no. 113; Paris–
Philadelphia–Fort Worth 1992, pp. 292–97, no. 31;
Lomax 1982, pp. 39–40.

FRANÇOIS-HUBERT DROUAIS
(1727–1775)
REFERENCE: Gabillot 1906.

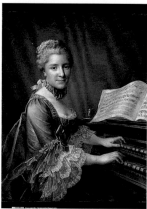
85

**85. *Portrait of Madame Charles-Simon Favart
(born Marie-Justine-Benoîte Duronceray)***
1757
Oil on canvas
80 × 64.8 cm (31½ × 25½ in.)
Signed on harpsichord: *Drouais le fils 1757*
New York, Metropolitan Museum of Art, Mr. and

Mrs. Isaac D. Fletcher Collection, Bequest of Isaac D.
Fletcher, 1917, 17.120.210
REFERENCES: Goodman 2000, pp. 113–15; Cavallo
1971, p. 28; Sterling 1955, pp. 146–47.
RELATED WORKS: Jean-Baptiste Defernex, *Portrait
of Madame Favart*, 1757 (no. 69 above; see p. v); this
sculpture represents the same sitter as in Drouais's
painting.

Harpsichord converted to a piano (no. 13 above);
Madame Favart plays a keyboard in Drouais's
painting.

86. *Portrait of the Marquise d'Aiguirandes*
1759
Oil on canvas
101 × 85.6 cm (39¾ × 33¹¹⁄₁₆ in.)
Signed at upper left: *Drouais fecit 1759*
Cleveland Museum of Art, Bequest of John L.
Severance, 1942.638
(see fig. 63)
PROVENANCE: possibly exhibited at the Salon of 1759,
no. 89; marquise d'Aiguirandes, ca. 1759; thence by
descent.
REFERENCES: Shackelford and Holmes 1987,
pp. 58–59, no. 13; Atlanta 1983, pp. 73, 88, no. 33;
Cleveland 1963, unpaginated, no. 51.
RELATED WORKS: Armchair (no. 12 above); the
marquise sits on a similar chair in Drouais's portrait.

Woman's dress (no. 63a above; see p. v); the
marquise d'Aiguirandes wears a strikingly similar
gown in Drouais's portrait.

PIERRE-LOUIS DUMESNIL
(1698–1781)
REFERENCE: Bénézit 1948–55, vol. 3, p. 398.

87. *Interior with Card Players*
ca. 1752
Oil on canvas
79 × 98 cm (31⅛ × 38⁹⁄₁₆ in.)
New York, Metropolitan Museum of Art, Bequest of
Harry G. Sperling, 1976.100.8
(see fig. 60)
REFERENCE: Atlanta 1983, pp. 108, 119, no. 55.

ÉTIENNE JEAURAT
(1699–1789)
REFERENCE: Turner 1996, vol. 17, pp. 465–66.

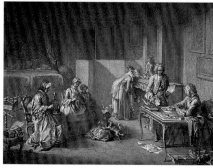
88

88. *Family in an Interior*
ca. 1750
Chalk and gouache on paper
48 × 64 cm (18⅞ × 25³⁄₁₆ in.)
Edinburgh, National Gallery of Scotland, D 5360
REFERENCES: Edinburgh 1999, pp. 100–101, no. 45;
Edinburgh 1994, pp. 8, 15, no. 16.
RELATED WORK: Skein-winder (no. 66 above); a
similar tool appears among madame's effects in
Jeaurat's drawing.

NICOLAS LANCRET
(1690–1743)
REFERENCES: Holmes 2006; New York–Fort Worth
1999; Wildenstein 1924.

89a. *The Four Times of Day: Morning*
1739
Oil on copper
28.6 × 36.5 cm (11¼ × 14⅜ in.)
London, National Gallery of Art, Bequeathed by
Sir Bernard Eckstein, 1948, NG5867
(see fig. 4)

89b. *The Four Times of Day: Midday*
1739–41
Oil on copper
28.9 × 36.8 cm (11⅜ × 14½ in.)
London, National Gallery of Art, Bequeathed by
Sir Bernard Eckstein, 1948, NG5868
(see fig. 5)

89c. *The Four Times of Day: Afternoon*
1739–41
Oil on copper
28.9 × 36.8 cm (11⅜ × 14½ in.)
London, National Gallery of Art, Bequeathed by
Sir Bernard Eckstein, 1948, NG5869
(see fig. 6)

89d. *The Four Times of Day: Evening*
1739–41
Oil on copper
28.9 × 36.8 cm (11⅜ × 14½ in.)
London, National Gallery of Art, Bequeathed by
Sir Bernard Eckstein, 1948, NG5870
(see fig. 7)
REFERENCES: New York–Fort Worth 1999, pp.
90–92, no. 16; Baker and Henry 1995, pp. 367–78, nos.
5867–870; Wildenstein 1924 pp. 73–74, nos. 34–37.
RELATED WORK: François Boucher, *The Milliner*, 1746
(no. 80 above; see fig. 32); this painting was originally
intended, like Lancret's *Morning*, as the first in a series
of genre scenes representing the four times of day.

MAURICE-QUENTIN DE LA TOUR
(1704–1788)
REFERENCES: Fumaroli 2005; Versailles 2004; Salmon
2004; Debrie and Salmon 2000; Debrie 1998.

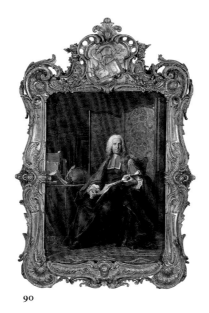

90

90. *Portrait of Gabriel Bernard de Rieux*
1739–41
Pastel and gouache on paper mounted on canvas
200.7 × 149.9 cm (79 × 59 in.); with frame: 317.5 ×
223.5 × 29.2 cm (125 × 88 × 11½ in.)
Los Angeles, J. Paul Getty Museum, 94.PC.39
[exhibited in Los Angeles only]
(see fig. 48 and pp. ii–iii)
PROVENANCE: exhibited at the Salon of 1741, no. 118;
Gabriel Bernard de Rieux, president of the second
Chamber of Inquests at the Parlement of Paris
(*président à la deuxième chambre des enquêtes du
Parlement de Paris*), ca. 1741–45; by inheritance to
Anne-Gabriel-Henri Bernard de Rieux, 1745; thence
by inheritance.
REFERENCES: Versailles 2004, pp. 121–22; Debrie
and Salmon 2000, pp. 111–16; Debrie 1998, pp. 23–24;
Wildenstein 1919.
RELATED WORKS: Three-panel screen (no. 57 above),
terrestrial globe (no. 26a above), and clock on bracket
(no. 18 above); a similar screen and a similar globe, as
well as a clock of similar design without its bracket,
appear in the background of La Tour's portrait.
Jean-Siméon Chardin, *The Morning Toilette*, ca.
1741 (no. 81 above; see fig. 33) and Jacques-Joseph
Aved, *Portrait of Madame Antoine Crozat, marquise du
Châtel*, 1741 (no. 75 above; see fig. 1); these works were
also exhibited at the Salon of 1741.

CHARLES-JOSEPH NATOIRE
(1700–1777)
REFERENCES: Caviglia-Brunel 2001; Duclaux 1991;
Troyes–Nîmes–Rome 1977.

91. *Bacchanal*
ca. 1749
Oil on canvas
81 × 101.2 cm (31⅞ × 39¹³⁄₁₆ in.)
Houston, Museum of Fine Arts, Museum
Purchase, 84.200

91

PROVENANCE: commissioned by Ange-Laurent
de La Live de Jully, ca. 1749; sale of La Live de Jully
collection, March 5, 1770 (lot 95); purchased by
Bourlat de Montredon; sale of Montredon collection,
March 16–April 1, 1778 (lot 16); purchased by a
M. Quesnot; sale of the collection of Mesnard de
Clesle, December 4, 1786 (lot 63); purchased by Paillet.
REFERENCES: Bailey 2002, pp. 38–39; Bowron and
Morton 2000, pp. 105–7; Paris–Philadelphia–Fort
Worth 1992, pp. 364–69, no. 41.
RELATED WORKS: Jean-Siméon Chardin, *The Good
Education*, ca. 1753 (no. 82 above; see fig. 50); this
painting was also commissioned by Ange-Laurent de
La Live de Jully.
 Carle Vanloo, *Aeneas Carrying Anchises*, 1729
(no. 101 below; see fig. 52); this painting was also in
the collection of Ange-Laurent de La Live de Jully.

JEAN-MARC NATTIER
(1685–1766)
REFERENCES: Versailles 1999; Renard 1999; Dimier
1928–30, vol. 2, pp. 93–133; Nolhac 1925.

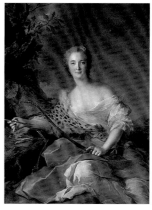

92

92. *Portrait of Constance-Gabrielle-Magdeleine
Bonnier de la Mosson*
1742
Oil on canvas
128.9 × 96.5 cm (50¾ × 38 in.)
Signed at lower left: *Nattier p.x. 1742*
Los Angeles, J. Paul Getty Museum, 77.PA.87
PROVENANCE: exhibited at the Salon of 1742, no. 64;
Baron Joseph Bonnier de La Mosson, from 1742.

REFERENCES: Versailles 1999, pp. 151–53, no. 35; Renard 1999, pp. 72, 177, 215; Fredericksen 1980, unpaginated, no. 45; Nolhac 1925, pp. 101–2, 190, 248.

RELATED WORKS: Jean-Marc Nattier, *Portrait of Baron Joseph Bonnier de la Mosson*, 1745 (no. 93 below); Constance Gabrielle Magdeleine was the wife of Baron Joseph Bonnier de la Mosson.

François Boucher, *Leda and the Swan*, 1742 (no. 79 above; see fig. 51) was also exhibited at the Salon of 1742.

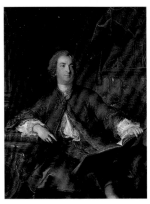

93

93. *Portrait of Baron Joseph Bonnier de la Mosson*
1745
Oil on canvas
137.9 × 105.4 cm (54⁵⁄₁₆ × 41½ in.)
Signed at center left on base of column: *Nattier pinx[i]t 1745*
Washington, D.C., National Gallery of Art, Samuel H. Kress Collection, 1961.9.30
PROVENANCE: exhibited at the Salon of 1746, no. 67.
REFERENCES: Conisbee 2009, pp. 336–41, no. 73; Versailles 1999, pp. 174–77, no. 42; Renard 1999, pp. 84–85, 177, 215, 236; Nolhac 1925, pp. 188–90, 248.
RELATED WORKS: Mechanical scene (*tableau méchanique;* no. 27 above); this object belonged to Baron Joseph Bonnier de la Mosson.

Jean-Marc Nattier, *Portrait of Constance-Gabrielle-Magdeleine Bonnier de la Mosson*, 1742 (no. 92 above); sitter was the wife of Baron Joseph Bonnier de la Mosson.

94. *Portrait of Madame Marsollier and Her Daughter*
1749
Oil on canvas
146.1 × 114.3 cm (57½ × 45 in.)
Signed at right on the pilaster: *Nattier pinxit. 1749*
New York, Metropolitan Museum of Art, Bequest of Florence S. Schuette, 1945, 45.172
(see fig. 41)
PROVENANCE: Madame Claude-Christophe Lorimier de Chamilly (daughter of the sitter), ca. 1749; thence by descent; exhibited at the Salon of 1750, no. 67.
REFERENCES: Bordes 2009, pp. 304, 307–9; Versailles 1999, pp. 203–6, no. 54; Renard 1999, pp. 177, 215; Posner 1996, pp. 131–41; Nolhac 1925, pp. 197–98, 261–62, 276.
RELATED WORK: Casket (no. 44 above; see figs. 42a and 42b); Madame Marsollier's daughter holds a casket of strikingly similar design in Nattier's painting.

JEAN-BAPTISTE OUDRY
(1686–1755)
REFERENCES: Los Angeles–Houston–Schwerin 2007; Fort Worth–Kansas City 1983; Fabré 1976, pp. 101–34; Locquin 1912.

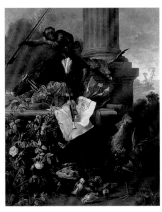

95a

95a. *Music-Making Animals ("Air")*
1719
Oil on canvas
144 × 118 cm (56¹¹⁄₁₆ × 46⁷⁄₁₆ in.)
Signed at lower left: *peint par J. B. Oudry 1719*
Stockholm, Nationalmuseum, NM872

95b. *Still Life of Fish, Game, and a Spaniel ("Water")*
1719
Oil on canvas
141 × 114 cm (55½ × 44⁷⁄₈ in.)
Signed at lower left: *peint par J. B. Oudry 1719*
Stockholm, Nationalmuseum, NM 868

95c. *Still Life with a Rifle, Hare, and Bird ("Fire")*
1720
Oil on canvas
144 × 116 cm (56¹¹⁄₁₆ × 45¹¹⁄₁₆ in.)
Signed at lower left: *J. B. Oudry 1720*
Stockholm, Nationalmuseum, NM 871

95d. *Still Life of Fruits and Vegetables ("Earth")*
1721
Oil on canvas
145 × 113 cm (57¹⁄₁₆ × 44½ in.)
Signed at bottom center: *J. B. Oudry 1721*
Stockholm, Nationalmuseum, NM 865
PROVENANCE: purchased by Count Carl Gustaf Tessin from Oudry for the Stockholm Palace, 1740.
REFERENCES: Grate 1994, pp. 220–25, nos. 199–202; Stockholm–Paris 1993–94, pp. 407–8, nos. 622–25; Fort Worth–Kansas City 1983, pp. 44–45; Fabré 1976, pp. 106–7, 111.
RELATED WORKS: These four paintings comprise an allegorical series of the elements and were purchased as a set from the artist by Count Carl Gustaf Tessin on behalf of the Swedish royal family.

"La Machine d'Argent" (centerpiece for a table; no. 37 above); like Oudry's *Fire* and *Water*, this sculpture in silver represents a still life with dead game; Oudry secured the commission of this centerpiece for Germain.

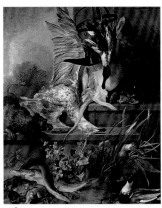

95b

95c

95d

JACQUES-ANDRÉ PORTAIL
(1695–1759)
REFERENCES: Salmon 1996; Lorme 1900.

96. *A Music Party*
1738
Red and black chalk on off-white paper
32.4 × 25.4 cm (12¾ × 10 in.)
Los Angeles, J. Paul Getty Museum, 88.GB.60
[exhibited in Los Angeles only]
(see p. ix)
REFERENCES: New York–Ottawa 1999, pp. 238–39,
no. 75; Salmon 1996, pp. 18, 53, no. 29; Goldner and
Hendrix 1992, pp. 164–65, no. 67.

JEAN RESTOUT
(1692–1768)
REFERENCES: Gouzi 2000; Rouen 1970.

97

97. *Venus Ordering Arms from Vulcan*
1717
Oil on canvas
103.2 × 138.1 cm (40⅝ × 54⅜ in.)
Signed at lower right: *Rêtout*
Beverly Hills, Calif., Collection of Lynda and Stewart
Resnick, 1999-079
REFERENCES: Gouzi 2000, pp. 18–19, 35, 196–98, 333,
no. 5; Laskin 1987, vol. 1, pp. 248–50; Rosenberg and
Schnapper 1983, pp. 44–45; Rouen 1970, pp. 19, 186.
RELATED WORKS: François Boucher, *Venus Ordering
Arms from Vulcan*, 1732 (no. 77 above) portrays the
same subject.

JEAN-FRANÇOIS DE TROY
(1679–1752)
REFERENCES: Baxter 2007; Ebeling 2007; Leribault
2002; Krause 1997; Bordeaux 1989.

98. *Reading in a Salon*
ca. 1728
Oil on canvas
74 × 93 cm (29⅛ × 36⅝ in.)
Signed on bottom of armchair at left: [D?]TROY./17[?]
Private collection
[exhibited in Los Angeles only]
(see fig. 23)
PROVENANCE: possibly Samuel Bernard, ca. 1728–44;
Frederick II of Prussia, Sanssouci Palace, Potsdam,
by 1768
REFERENCES: Ebeling 2007, pp. 72, 82; Ottawa–
Washington–Berlin 2003, pp. 168–69, 359, no. 25;
Leribault 2002, p. 322, no. 203; Faton 1982.
RELATED WORKS: Mantel clock (no. 16 above; see
fig. 13); this clock appears on the bookcase in de Troy's
painting, but the position of Time has been changed,
presumably by the painter, since no cases of the clock
are known with Time in this position.
 Pair of wall lights (no. 28 above); similar wall lights
appear in this and several other paintings by de Troy;
it is possible that he owned a pair.

99a. *Before the Ball*
1735
Oil on canvas
82.2 × 64.9 cm (32⅜ × 25⁹⁄₁₆ in.)
Signed lower right, in a figure on the carpet:
DETROY 1735
Los Angeles, J. Paul Getty Museum, 84.PA.668
(see fig. 53)

99b. *After the Ball*
1735
Oil on canvas
82 × 65 cm (32⁵⁄₁₆ × 25⁹⁄₁₆ in.)
Private collection
(see fig. 54)
PROVENANCE: Germain-Louis Chauvelin, marquis
de Grosbois, ca. 1735–49; exhibited at the Salon of
1737; Gersaint sale, March 26, 1749 (together as lot 48);
Salomon-Pierre Prousteau, by 1757–69; Remy sale of
Prousteau collection, June 5, 1769 (together as lot 46);
bought by Jacques Langlier.
REFERENCES: Baxter 2008, pp. 273–89; Baxter
2007, pp. 28, 42; Ottawa–Washington–Berlin 2003,
pp. 172–73, 359, no. 27 (*Before the Ball*); Leribault
2002, pp. 343–45, nos. 234, 235; Bordeaux 1989, pp. 143,
162–65, 167–68.
RELATED WORKS: These pictures were commissioned
as pendants by Germain-Louis Chauvelin, minister
of foreign affairs and keeper of the seals (*secrétaire
d'État aux Affaires étrangères* and *garde des Sceaux*) to
Louis XV; both works were also owned successively
by Salomon-Pierre Prousteau, captain of the civic
guard (*Capitaine des Gardes de la Ville*), and Jacques
Langlier; both were exhibited at the Salon of 1737 and
engraved by Jacques Beauvarlet in 1757.

Pair of wall lights (no. 28 above); similar wall lights
appear in these and several other paintings by de Troy;
it is possible that he owned a pair.

JEAN VALADE
(1710–1787)
REFERENCES: Jeffares 2003; Poitiers 1993.

100a. *Portrait of Pierre Faventines*
**100b. *Portrait of Madame Faventines* (*born Élisabeth
Astruc de Ganges*)**
1768
Pastel on paper
Each 107 × 88 cm (42⅛ × 34⅝ in.)
Each signed on the reverse in brown ink: *PEINT PAR /
I. VALADE / 1768*
Private collection
(see figs. 11 and 12)
REFERENCES: Jeffares 2003, pp. 225, 227–28;
Poitiers 1993, pp. 20, 21, 76, 81–82, no. 32 (*Portrait of
Pierre Faventines*) and no. 34 (*Portrait of Madame
Faventines*).
RELATED WORKS: These two paintings represent
a married couple and were almost certainly
commissioned as pendants.
 Watch and chatelaine (no. 24 above); Madame
Faventines wears a similar watch and chatelaine in
Valade's portrait.

CARLE (CHARLES-ANDRÉ) VANLOO
(1705–1765)
REFERENCES: Nice 2001; Nice–Clermont-Ferrand–
Nancy 1977; Colomer 1973.

101. *Aeneas Carrying Anchises*
1729
Oil on canvas
110 × 105 cm (43⁵⁄₁₆ × 41⁵⁄₁₆ in.)
Signed at lower right: *Charle Vanloo*
Paris, Musée du Louvre, Département des Peintures,
6278
(see fig. 52)
PROVENANCE: Ange-Laurent de La Live de Jully, by
1757; La Live de Jully collection sale, May 2–14, 1770
(lot 88); possibly Lebrun, brother-in-law of Vanloo;
Louis-Michel Vanloo, by 1771; estate sale of Louis-
Michel Vanloo, December 14, 1772 (lot 67); purchased
by Boileau for Louis-François de Bourbon, prince
de Conti; prince de Conti's sale, April 8–June 6, 1777
(lot 710); purchased by Remy for Louis XVI; palais
du Louvre.
REFERENCES: Bailey 2002, pp. 27, 54; Nice 2001, pp.
60, 71, 89, no. 29; Nice–Clermont-Ferrand–Nancy
1977, pp. 27–28, no. 7.
RELATED WORKS: Planisphere clock (no. 19 above; see
fig. 10); both objects were in the collection of Louis-
François de Bourbon, prince de Conti.
 Jean-Siméon Chardin, *The Good Education*, ca. 1753
(no. 82 above; see fig. 50) and Charles-Joseph Natoire,
Bacchanal, ca. 1749 (no. 91 above); these paintings
were also in the collection of Ange-Laurent de La Live
de Jully.

GUILLAUME VOIRIOT
(1713–1799)
REFERENCES: Voiriot 2004; Sørensen 1995.

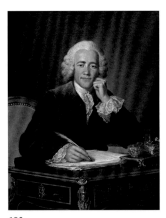

102

102. *Portrait of [Pierre] Gilbert des Voisins,*
Counselor of State
1761
Oil on canvas
101 × 80 cm (39¾ × 31½ in.)
Saint Petersburg, Florida, Museum of Fine Arts,
purchased with funds donated in honor of Michael
Milkovich, 2002.11
REFERENCES: Hoefer 1963–69, p. 506 (on sitter);
Michaud 1880, vol. 16, pp. 450–51 (on sitter).
RELATED WORK: Inkstand (no. 32 above); the sitter
in this portrait uses a similar lacquered inkstand
mounted with Chinese porcelain vessels.

Books and Manuscripts

103. Louis Bretez (d. 1738) and Michel-Étienne Turgot
(1690–1751), *Plan de Paris*
Paris, n.d. [1740]
Printed black in intaglio on paper bound in mottled
leather stamped in gold, marbled end-sheets
Leaf: 51.3 × 81 cm (20³⁄₁₆ × 31⅞ in.)
Los Angeles, Getty Research Institute, Research
Library, 83-B9225.c2

104. Georges Louis Leclerc, comte de Buffon
(1707–1788), *Histoire naturelle, générale et particulière*
(volume 1)
Paris, 1749
Printed black in relief and illustrated black in intaglio
on paper bound in brown leather stamped in gold,
marbled end-sheets
Leaf: H: 26 cm (10¼ in.)
Los Angeles, Getty Research Institute, Research
Library, 84-B8203

105. Jean de La Fontaine (1621–1695), *Fables choisies.*
Mises en vers (volume 1)
Paris, 1755
Printed black in relief and illustrated black in intaglio
on paper bound in red leather stamped in gold,
marbled end-sheets
Leaf: 30.5 × 22.5 cm (12 × 8⅞ in.)
Los Angeles, Getty Research Institute, Research
Library, 84-B18675
RELATED WORKS: Jean-Baptiste Oudry (nos. 95a–95d
above) also created 276 designs for the engraved
illustrations of this four-volume set of Fontaine's
fables.

106. L'Abbé Antoine Banier (1673–1741), translator,
Les Métamorphoses d'Ovide: En latin, traduites
en François, avec des remarques et des explications
historiques (volume 2)
Amsterdam, 1732
Printed black in relief and illustrated black in intaglio
on paper, bound in brown leather stamped in gold
Leaf: H: 57 cm (22⁷⁄₁₆ in.)
Los Angeles, Getty Research Institute, Research
Library, 84-B30696

107. Denis Diderot (1713–1784) and Jean Le Rond
d'Alembert (1717–1783), editors, *Encyclopédie, ou*
Dictionnaire raisonné des sciences, des arts et des
métiers par une société des gens de lettres (volume 1)
Paris, 1751
Printed and illustrated black in relief with frontispiece
black in intaglio on paper, bound in mottled brown
leather stamped in gold, marbled end-sheets
Frontispiece: 37.3 × 24 cm (14¹¹⁄₁₆ × 9⁷⁄₁₆ in.)
Los Angeles, Getty Research Institute, Research
Library, 84-B31186

108. Denis Diderot (1713–1784), Jean Le Rond
d'Alembert (1717–1783), and Robert Bénard (b. 1734),
editors, *Recueil de planches, sur les sciences, les arts*
libéraux, et les arts méchaniques, avec leur explication
(volume 1)
Paris, 1762
Printed black in relief and illustrated black in intaglio
on paper bound in mottled brown leather stamped in
gold, marbled end-sheets
Leaf: 34.8 × 22 (13¹¹⁄₁₆ × 8¹¹⁄₁₆ in.)
Los Angeles, Getty Research Institute, Research
Library, 84-B31322

109. Pierre Antoine, publisher (fl. 1730–40),
Dictionnaire universel françois et latin (volume 4)
Nancy, 1740
Printed and illustrated black in relief on paper bound
in mottled brown leather stamped in gold, marbled
end-sheets
Title page: 41 × 25.7 cm (16⅛ × 10⅛ in.)
Los Angeles, Getty Research Institute, Research
Library, 87-B4441

110. Jean Desmarets de Saint-Sorlin (1595–1676),
Jeux historiques des rois de France, reines renommées,
géographie et metamorphose

Paris, 1698
Printed black in intaglio on paper bound in black
leather stamped in gold; annotations in brown ink,
hand coloring of at least one illustration
Leaf: 8.7 × 5.5 cm (3⁷⁄₁₆ × 2³⁄₁₆ in.)
Los Angeles, Getty Research Institute, Research
Library, 88-B19378

111. Jean Philippe Rameau (1683–1764), *Fêtes d'Hébé,*
ou, Les Talents liriques: ballet (musical & vocal score)
Paris [1739?]
Printed black in relief on paper bound in brown
leather stamped in gold, marbled end-sheets
Leaf: 18 × 23.5 cm (7¹⁄₁₆ × 9¼ in.)
Los Angeles, Getty Research Institute, Research
Library, 89-B3740

112. Jean-Baptiste Poquelin, called Molière
(1622–1673), *Oeuvres de Molière, Nouvelle edition*
(6 volumes)
Paris, 1734
Printed black in relief and illustrated black in intaglio
on paper bound in brown leather stamped in gold,
marbled end-sheets
Leaf: 23 × 16.6 cm (9¹⁄₁₆ × 6⁹⁄₁₆ in.)
Los Angeles, Getty Research Institute, Research
Library, 2560-707
RELATED WORKS: François Boucher (nos. 77–80
above; figs. 32, 37, 45, and 51) also created the original
designs for the engraved illustrations of this six-
volume set.

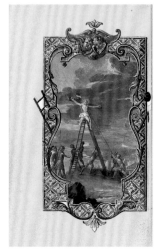

113

113. Jean Pierre Rousselet (dates unknown), *Prières*
de la Messe
ca. 1720–30
Tempera and gold leaf on paper bound between
pasteboard covered in dark blue morocco
Leaf: 11.9 × 7.1 cm (4¹¹⁄₁₆ × 2¹³⁄₁₆ in.)
Los Angeles, J. Paul Getty Museum, Ms. Ludwig v 8
83.MG.83
REFERENCES: Kren 2007, p. 111; Von Euw and Plotzek
1979, pp. 253–56.

Photographic Credits for Exhibition Object List

Nos. 13, 52, 85, 94: Image © The Metropolitan Museum of Art/Art Resource, N.Y.

Nos. 9, 22, 23, 24, 69, 70, 77: Réunion des Musées Nationaux / Art Resource, N.Y. (Photographers: Jean-Gilles Berizzi, nos. 22, 23, and 77; Rene-Gabriel Ojeda, no. 69; C. Jean, no. 70).

Nos. 27, 33, 34, 38, 66, 67: Les Arts Décoratifs, Musée des Arts decoratifs (Photographer: Jean Tholance).

Nos. 39, 84, 95a–d: ©Erik Cornelius – Hans Thorwid / National Museum, Stockholm.

Nos. 41, 42, 56a–b: Courtesy of the Huntington Library Art Collections and Botanical Gardens, San Marino, California.

No. 46: © The Art Institute of Chicago.

Nos. 48, 49, 50: Courtesy of MaryLou Boone.

No. 51: ©V&A Images / Victoria and Albert Museum, London.

Nos. 60a–b, 61, 62, 63a–b, 64: Digital image © 2009 Museum Associates, LACMA / Art Resource, N.Y.

No. 83: Courtesy of the Philadelphia Museum of Art.

No. 88: Courtesy of the National Gallery of Scotland.

Nos. 89a–d: Courtesy of the National Gallery of Art, London.

No. 91: Courtesy of the Museum of Fine Arts, Houston.

No. 93: Courtesy of the Board of Trustees, National Gallery of Art, Washington, D.C.

No. 97: Courtesy of Lynda and Stewart Resnick.

No. 102: Courtesy of the Museum of Fine Arts, Saint Petersburg, Florida.

References Cited

ACADÉMIE ROYALE D'ARCHITECTURE 1671–1793 (1913)
Procès verbaux de l'Académie royale d'Architecture: 1671–1793. 10 vols. Paris: Edouard Champion, 1913.

ADAMS 1848
Adams, Abigail. Letters of Mrs. Adams. Boston, 1848.

ALBAINY 1999
Albainy, Tracey. "Eighteenth-Century French Silver in the Elizabeth Parke Firestone Collection." Bulletin of the Detroit Institute of Arts 73, nos. 1–2 (1999): 8–29.

ANANOFF AND WILDENSTEIN 1976
Ananoff, Alexandre, with Daniel Wildenstein. François Boucher. 2 vols. Lausanne and Paris: Bibliothèque des arts, 1976.

ARMINJON AND BLONDEL 1984
Arminjon, Catherine, and Nicole Blondel. Principes d'analyse scientifique: Objets civils domestiques; Vocabulaire. Paris: Imprimerie nationale, 1984.

ATLANTA 1983
Zafran, Eric M. The Rococo Age: French Masterpieces of the Eighteenth Century. Exh. cat. Atlanta, High Museum of Art, 1983.

AUGARDE 1996a
Augarde, Jean-Dominique. Les Ouvriers du Temps: La Pendule à Paris de Louis XIV à Napoléon Ier. = Ornamental Clocks and Clockmakers in Eighteenth Century Paris. Geneva: Antiquorum Editions, 1996.

AUGARDE 1996b
Augarde, Jean-Dominique. "Jean-Joseph de Saint Germain Bronzier (1719–1791): Inédits sur sa Vie et son Œuvre." L'Estampille/L'Objet d'art 308 (December 1996): 62–82.

BAILEY 1985
Bailey, Colin B. The First Painters of the King: French Royal Taste from Louis XIV to the Revolution. New York: Stair Sainty Matthiesen Gallery, 1985.

BAILEY 2002
Bailey, Colin B. Patriotic Taste: Collecting Modern Art in Pre-Revolutionary Paris. New Haven: Yale University Press, 2002.

BAKER AND HENRY 1995
Baker, Christopher, and Tom Henry. The National Gallery: Complete Illustrated Catalogue. London: National Gallery, with Yale University Press, 1995.

BANIER 1711
Banier, Antoine. Explication historique des fables, où l'on découvre leur origine et leur conformité avec l'histoire ancienne. 2 vols. Paris: Breton, 1711.

BANIER 1738-40
Banier, Antoine. La Mythologie et les fables expliquées par l'histoire. 3 vols. Paris: Briasson, 1738–40.

BANIER 1732
Banier, Antoine. Les Métamorphoses d'Ovide, en latin, traduites en françois, avec des remarques, et des explications historiques. 2 vols. Amsterdam: Wetstein & Smith, 1732.

BARNET 1998
Barnet, Jo Ellen. Time's Pendulum: The Quest to Capture Time—From Sundials to Atomic Clocks. New York and London: Plenum Press, 1998.

BAROCCHI 1960–62
Barocchi, Paola, ed. Trattati d'arte del Cinquecento: Fra manierismo e controriforma. 3 vols. Bari: G. Laterza, 1960–62.

BARTHES 1982
Barthes, Roland. "The Reality Effect." In French Literary Theory Today, edited by Tzvetan Todorov, translated by R. Carter, pp. 11–17. Cambridge: Cambridge University Press, 1982.

BATTISTINI 2004
Battistini, Matilde. Astrology, Magic, and Alchemy in Art. Translated by Rosanna M. Giammanco Grongis. Los Angeles: J. Paul Getty Museum, 2004.

BAUDOIN 1664
Baudoin, J[ean]. Iconologie ou Explication Nouvelle de Plusieurs Images, Emblemes, et Autres Figures Hyerogliphiques des Vertus, des Vices, des Arts, des Sciences, des Causes Naturelles, des Humeurs Differentes, & des Passions Humaines... Tirée des Recherches & des Figures de Cesar Ripa. Part 2. Paris, 1644; repr. Dijon, 1999.

BAXTER 2007
Baxter, Denise Amy. "Fashions of Sociability in Jean-François de Troy's Tableaux de mode, 1725-1738: Defining a Fashionable Genre in Early Eighteenth-Century France." In Performing the "Everyday": The Culture of Genre in the Eighteenth Century, edited by Alden Cavanaugh, pp. 27–46. Newark: University of Delaware Press, 2007.

BAXTER 2008
Baxter, Denise Amy. "Parvenu or honnête homme: The Collecting Practices of Germain-Louis de Chauvelin." Journal of the History of Collections 20, no. 2 (2008): 273–89.

BELLEGARDE 1723
Bellegarde, Jean-Baptiste Morvan de. Les Réflexions sur le ridicule, et sur les moyens de l'éviter. In Oeuvres diverses de M. l'abbé de Bellegarde, vol. 1. Paris, 1723.

BELMAS 2006
Belmas, Elisabeth. Jouer autrefois: Essai sur le jeu dans la France moderne (XVIe–XVIIIe siècle). Paris: Champ Vallon, 2006.

BÉNÉZIT 1948–55
Bénézit, E[mmanuel]. Dictionnaire critique et documentaire des Peintres, Sculpteurs, Dessinateurs et Graveurs. 8 vols. Paris: Librairie Gründ, 1948–55.

BENHAMOU 1994
Benhamou, Reed. "Parallel Worlds: The Places of Masters and Servants in the Maisons de plaisance of Jacques-François Blondel." Journal of Design History 7, no. 1 (1994): 1–11.

BENNETT AND SARGENTSON 2008
Bennett, Shelley M., and Carolyn Sargentson. French Art of the Eighteenth Century at The Huntington. New Haven and London: Yale University Press, 2008.

BERG AND EGER 2003
Berg, Maxine, and Elizabeth Eger, eds. Luxury in the Eighteenth Century: Debates, Desires and Delectable Goods. Houndmills, Hampshire, UK, and New York: Palgrave Macmillan, 2003.

BLANNING 2007
Blanning, Tim. The Pursuit of Glory: Europe 1648–1815. London: Allen Lane, 2007.

BLONDEL 1737–38
Blondel, Jacques-François. Traité d'architecture dans le goût moderne: De la distribution des maisons de plaisance. 2 vols. Paris: C. A. Jombert, 1737–38.

BLONDEL 1752–56
Blondel, Jacques-François. Architecture française. 4 vols. Paris: C. A. Jombert, 1752–56.

BLONDEL 1771–77
Blondel, Jacques-François. Cours d'architecture. 6 vols. Paris: Desaint, 1771–77.

BOESEN AND LASSEN 1951
Boesen, Gudmund, and Erik Lassen. De Danske Dronningers Guildtoilette. Copenhagen: Berlingske Bogtrykkeri, 1951.

BOFFRAND 1745
Boffrand, Germain. Livre d'architecture. Paris: Guillaume Cavalier Père, 1745.

BOILEAU 1680
[Boileau, Jacques]. De l'abus des nuditez de gorge. Paris, 1680.

BOILEAU 1735
Boileau, Nicolas. L'art poétique. In Les œuvres de M. Boileau Despréaux avec des éclaircissements historiques, vol. 1. Paris: Alix, 1735.

BORDEAUX 1989
Bordeaux, Jean-Luc. "Jean-François de Troy—Still an Artistic Enigma: Some Observations on His Early Works." *Artibus et historiae* 20 (1989): 143–70.

BORDES 2009
Bordes, Philippe. "Interpreting Portraits: Images of Society or the Self." In *Dialogues in Art History, from Mesopotamian to Modern: Readings for a New Century*, edited by Elizabeth Cropper, pp. 305–15. Washington, D.C.: National Gallery of Art, 2009.

BOSSUET 1732
Bossuet, Jacques-Bénigne. *Discours sur l'histoire universelle*. Paris: David, 1732.

BOURNE AND BRETT 1991
Bourne, Jonathan, and Vanessa Brett. *Lighting in the Domestic Interior: Renaissance to Art Nouveau*. London: Sotheby's, 1991.

BOWERS 1998
Bowers, Brian. *Lengthening the Day: A History of Lighting Technology*. Oxford: Oxford University Press, 1998.

BOWRON AND MORTON 2000
Bowron, Edgar Peters, and Mary G. Morton. *Masterworks of European Painting in the Museum of Fine Arts, Houston*. Houston: Museum of Fine Arts, with Princeton University Press, 2000.

BRAULT AND BOTTINEAU 1959
Brault, Solange, and Yves Bottineau. *L'Orfèvrerie française du XVIIIe siècle*. Paris: Presses universitaires de France, 1959.

BRAUN 1972
Braun, Theodore. *Le Franc de Pompignan: Sa vie, ses œuvres, ses rapports avec Voltaire*. Paris: Lettres modernes, 1972.

BRAUN 2005
Braun, Theodore. "Voltaire, Metastasio, and Le Franc de Pompignan's *Didon*." In *The King's Crown: Essays on XVIIIth Century Culture and Literature Honoring Basil Guy*, edited by Francis Assaf, pp. 11–20. Louvain: Peeters, 2005.

BREMER-DAVID 1997
Bremer-David, Charissa. *French Tapestries and Textiles in the J. Paul Getty Museum*. Los Angeles: J. Paul Getty Museum, 1997.

BREMER-DAVID 2007
Bremer-David, Charissa. "Manufacture Royale de Tapisseries de Beauvais, 1644–1715." In New York 2007 (see below), pp. 406–19.

BRISEUX 1743
Briseux, Charles-Étienne. *L'Art de bâtir des maisons de campagne*. 2 vols. Paris: Prault, 1743.

BRUNEL 1986
Brunel, Georges. *Boucher*. New York: Vendome Press, 1986.

BRYSON 1981
Bryson, Norman. *Word and Image: French Painting of the Ancien Régime*. Cambridge: Cambridge University Press, 1981.

BURY 1982
Bury, Shirley. *Jewellery Gallery: Summary Catalogue*. London: Victoria and Albert Museum, 1982.

CANBERRA 2003
Hilaire, Michel, Jörg Zutter, and Olivier Zeder, eds. *French Paintings from the Musée Fabre, Montpellier*. Exh. cat. Canberra, National Gallery of Australia, 2003.

CARACCIOLI 1759
Caraccioli, Louis-Antoine. *Le Véritable mentor, ou l'éducation de la noblesse*. 2nd ed. Liège, 1759.

CARACCIOLI 1760
Caraccioli, L.-A. de. *La conversation avec soi-même*. Liège, 1760.

CARDINAL 1984
Cardinal, Catherine. *Catalogue des montres du Musée du Louvre*. Vol. 1, *La collection Olivier*. Paris: Réunion des musées nationaux, 1984.

CARDINAL 1999
Cardinal, Catherine. *Spendeurs de l'émail: Montres et horloges du XVIe au XXe siècle*. La Chaux-de-Fonds, Switzerland: Institut l'homme et le temps, 1999.

CARDINAL 2000
Cardinal, Catherine. *Les Montres et horloges de table du musée du Louvre*, vol. 2. Paris: Réunion des musées nationaux, 2000.

CARLIER 2004
Carlier, Yves. "Details of the Toilet Service of the duchesse de Cadaval." *Bulletin of the Detroit Institute of Arts* 78, nos. 1–2 (2004): 4–17.

CASPALL 1987
Caspall, John. *Making Fire and Light in the Home Pre-1820*. Woodbridge, Suffolk, UK: Antique Collectors' Club, 1987.

CAVALLO 1971
Cavallo, Adolph S., and Elizabeth Lawrence. "Sleuthing at the Seams." *Metropolitan Museum of Art Bulletin* 30 (August/September 1971): 28.

CAVIGLIA-BRUNEL 2001
Caviglia-Brunel, Susanna. "Charles-Joseph Natoire et les peintres italiens de son temps." *Gazette des Beaux-Arts* 138, no. 1590/91 (July-August 2001): 41–60.

CAYLUS 1757
Caylus, Anne-Claude-Philippe de Tubières, comte de. *Tableaux tirés de l'Iliade, de l'Odyssée d'Homère et de l'Eneide de Virgile avec des observations générales sur le costume*. Paris: Tilliard, 1757.

CHARTIER 1987
Chartier, Roger. *The Cultural Uses of Print in Early Modern France*. Translated by Lydia Cochrane. Princeton: Princeton University Press, 1987.

CHAUMONT 1962
Edme Bouchardon: Sculpteur du roi, 1698–1762. Exh. cat. Chaumont: Musée d'art et d'histoire, 1962.

CHILTON ET AL. 2009
Chilton, Meredith, and Claudia Lehner-Jobst, with contributions by Katharina Hantschmann, Johann Kraftner, Sebastian Kuhn, Johanna Lessmann, Samuel Wittwer, and Ghenete Zelleke. *Fired by Passion: Vienna Baroque Porcelain of Claudius Innocentius du Paquier*. 3 vols. Stuttgart: Arnoldsche Art Publishers, 2009.

CHRISMAN-CAMPBELL 2002
Chrisman-Campbell, Kimberly. "The Face of Fashion: Milliners in Eighteenth-Century Visual Culture." *British Journal for Eighteenth-Century Studies* (September 2002): 157–72.

CLAREMONT 1998
Boone, MaryLou. *Terre et Feu: Four Centuries of French Ceramics from the Boone Collection*. Exh. cat. Claremont, Calif., Scripps College, Clark Humanities Museum, 1998.

CLARK 2007
Clark, Jonathan. "The Re-Enchantment of the World? Religion and Monarchy in Eighteenth-Century Europe." In *Monarchy and Religion: The Transformation of Royal Culture in Eighteenth-Century Europe*, edited by Michael Schaich, pp. 41–75. Oxford: Oxford University Press, 2007.

CLARK, GOLINSKI, AND SCHAFFER 1999
Clark, William, Jan Golinski, and Simon Schaffer, eds. *The Sciences in Enlightened Europe*. Chicago: University of Chicago Press, 1999.

CLEVELAND 1963
Saisselin, Rémy G. *Style, Truth, and the Portrait*. Exh. cat. Cleveland Museum of Art, 1963.

COCHET 1998
Cochet, Vincent. "Le Fard au XVIIIe siècle: Image, maquillage, grimace." In *Annales du Centre Ledoux*. Vol. 2, *Imaginaire et création artistique à Paris sous l'ancien régime (XVIIe –XVIIIe siècles)*, edited by Daniel Rabreau, pp. 103–15. Paris: Fayard, 1998.

COHEN 1994
Cohen, Sarah. "*Un Bal Continuel*: Watteau's Cythera Paintings and Aristocratic Dancing in the 1710s." *Art History* 17 (June 1994): 160–81.

COHEN 1996
Cohen, Sarah R. "Body as 'Character' in Early Eighteenth-Century French Art and Performance." *Art Bulletin* 78 (September 1996): 454–66.

COLOMER 1973
Colomer, Claude. *La Famille et le milieu social du peintre Rigaud*. Paris: Association pour une meilleure connaissance du Roussillon, 1973.

COLUMBIA ET AL. 2000
Pinette, Matthieu. *From the Sun King to the Royal Twilight: Painting in Eighteenth-Century France from the Musée de Picardie, Amiens*. Exh. cat. Columbia [S.C.] Museum of Art; Pittsburgh, Frick Art and Historical Center; Omaha, Joslyn Art Museum; and Santa Barbara [Calif.] Museum of Art, 2000 (with the American Federation of Arts).

CONISBEE 1981
Conisbee, Philip. *Painting in Eighteenth-Century France*. Ithaca, N.Y.: Cornell University Press, with Phaidon, 1981.

CONISBEE 1986
Conisbee, Philip. *Chardin*. Oxford: Phaidon, 1986.

CONISBEE 2007
Conisbee, Philip, ed. *French Genre Painting in the Eighteenth Century*. Washington, D.C.: National Gallery of Art, with Yale University Press, 2007.

CONISBEE 2009
Conisbee, Philip, et al. *French Paintings of the Fifteenth through the Eighteenth Century.* Washington, D.C.: National Gallery of Art, 2009.

COOK 1892
Cook, Albert, ed. *The Art of Poetry: The Poetical Treatises of Horace, Vida, and Boileau.* Boston: Ginn & Company, 1892.

CORDEY 1939
Cordey, Jean. *Inventaire des biens de Madame de Pompadour: Rédigé après son décès.* Paris: Société des Bibliophiles François, 1939.

COURAJOD 1873
Courajod, Louis, ed., *Livre-journal de Lazare Duvaux, marchand-bijoutier ordinaire du roy.* 2 vols. Paris, 1873; repr. Paris, 1965.

COURAJOD 1874
Courajod, Louis. *Histoire de l'École des Beaux-Arts au XVIIIe siècle: L'École royale des élèves protégés.* Paris: Rouam, 1874.

COURAL AND GASTINEL-COURAL 1992
Coural, Jean, and Chantal Gastinel-Coural. *Beauvais: Manufacture nationale de tapisserie.* Paris: Centre national des arts plastiques, 1992.

COURTONNE 1725
Courtonne, Jean. *Traité de perspective pratique.* Paris, 1725.

CRAVEN 1959
Craven, Babette. "French Soft Paste Porcelain in the Collection of Mr. and Mrs. William Brown Meloney." *Connoisseur* 143 (May 1959): 135–42.

CROW 1985
Crow, Thomas E. *Painters and Public Life in Eighteenth-Century Paris.* New Haven: Yale University Press, 1985.

CROW 1986
Crow, Thomas. "La Critique des Lumières dans l'art du dix-huitième siècle." *Revue de l'Art* 73, no. 1 (1986): 9–16.

CROŸ 1718–84
Croÿ, Emmanuel, duc de. *Journal inédit: 1718–1784.* Edited by Vicomte de Grouchy and P. Cottin. 4 vols. Paris, 1906–7.

D'ALLEMAGNE 1891
d'Allemagne, Henry René. *Histoire du luminaire depuis l'époque romaine jusqu'au XIXe siècle.* Paris, 1891.

D'ALLEMAGNE 1928
d'Allemagne, Henry René. *Les Accessoires du costume et du mobilier depuis le treizième jusqu'au milieu du dix-neuvième siècle.* 2 vols. Paris, 1928; repr. New York, 1970.

DARNTON 1982
Darnton, Robert. *The Literary Underground of the Old Regime.* Cambridge: Harvard University Press, 1982.

DARNTON 1995
Darnton, Robert. *The Forbidden Best-Sellers of Prerevolutionary France.* New York: Norton, 1995.

D'AVILER 1691
d'Aviler, Augustin-Charles. *Cours d'architecture.* 2 vols. Paris: Nicolas Langlois, 1691.

DAWSON 1994
Dawson, Aileen. *French Porcelain: A Catalogue of the British Museum Collection.* London: British Museum Press, 1994.

DAWSON 2002
Dawson, Aileen. "The Development of Repertoire in Mennecy Porcelain Sculpture, circa 1738–65." *Metropolitan Museum Journal* 37 (2002): 199–211.

DE BAERE 2001
De Baere, Benoît. *Trois introductions à l'Abbé Pluche: Sa vie, son monde, ses livres.* Geneva: Droz, 2001.

DEBRIE 1998
Debrie, Christine. "Maurice Quentin de La Tour: Peintre de portraits au pastel et Peintre du Roi (1704–1788)." *Versalia, Revue de la Société des amis de Versailles* 1 (1998): 22–31.

DEBRIE AND SALMON 2000
Debrie, Christine, and Xavier Salmon. *Maurice-Quentin de La Tour: Prince des pastellistes.* Paris: Somogy Art Publishers, 2000.

DEJEAN 2005
DeJean, Joan. *The Essence of Style: How the French Invented High Fashion, Fine Food, Chic Cafés, Style, Sophistication, and Glamour.* New York: Free Press, 2005.

DEJEAN 2009
DeJean, Joan. *The Age of Comfort.* New York: Bloomsbury, 2009.

DELAPLANCHE 2004
Delaplanche, Jérôme. *Noël-Nicolas Coypel (1690–1734).* Paris: Arthéna, 2004.

DELL 1967
Dell, Theodore. "The Gilt-Bronze Cartel Clocks of Charles Cressent." *Burlington Magazine* 109, no. 769 (April 1967): 210–17.

DELPIERRE 1997
Delpierre, Madeleine. *Dress in France in the Eighteenth Century.* Translated by Caroline Beamish. New Haven and London: Yale University Press, 1997.

DE MARLY 1987
De Marly, Diana. *Louis XIV & Versailles.* New York: Holmes and Meier, 1987.

DÉMORIS 1991
Démoris, René. *Chardin: La Chair et l'objet.* Paris: A. Biro, 1991.

DÉMORIS 2005
Démoris, René. "Inside/Interiors: Chardin's Images of the Family (translated by Katie Scott)." *Art History* 28, no. 4 (September 2005): 442–67.

DENNIS 1960
Dennis, Faith. *Three Centuries of French Domestic Silver: Its Makers and Its Marks.* New York: Metropolitan Museum of Art, 1960.

DENNIS 1986
Dennis, Michael. *Court and Garden: From the French Hôtel to the City of Modern Architecture.* Cambridge: MIT Press, 1986.

DESFONTAINES 1735–43
Desfontaines, Pierre-François Guyot. *Observations sur les écrits modernes.* 33 vols. Paris: Chaubert, 1735–43.

DIDEROT AND LE ROND D'ALEMBERT 1751–65
Diderot, Denis, and Jean Le Rond d'Alembert, eds. *Encyclopédie, ou dictionnaire raisonné des sciences, des arts et des métiers.* 17 vols. Paris: Briasson et al., 1751–65.

DIDEROT AND LE ROND D'ALEMBERT 1762–72
Diderot, Denis, and Jean Le Rond d'Alembert, eds. *Recueil des planches sur les sciences, les arts libéraux et les arts méchaniques, avec leurs explications.* 11 vols. Paris: Briasson, 1762–72.

DIMIER 1928–30
Dimier, Louis. *Les Peintres français du XVIIIe siècle: Histoire des vies et catalogue des œuvres.* 2 vols. Paris: Les Éditions G. van Oest, 1928–30.

DOHRN-VAN ROSSUM 1996
Dohrn-van Rossum, Gerhard. *History of the Hour: Clocks and Modern Temporal Orders.* Translated by Thomas Dunlap. Chicago and London: University of Chicago Press, 1996.

DUCHON 1988
Duchon, Nicole. *La Manufacture de porcelaine de Mennecy Villeroy.* Le Mée-sur-Seine [Paris]: Éditions Amatteis, 1988.

DUCLAUX 1991
Duclaux, Lise. *Cahiers du dessin français: Charles Natoire.* Paris: Galerie de Bayser, 1991.

EBELING 2007
Ebeling, Jörg. "Upwardly Mobile: Genre Painting and the Conflict between Landed and Moneyed Interests." In Conisbee 2007 (see above), pp. 72–89.

EDINBURGH 1994
From Leonardo to Manet: Ten Years of Collecting Prints and Drawings. Exh. cat. Edinburgh, National Galleries of Scotland, 1994.

EDINBURGH 1999
Master Drawings from the National Gallery of Scotland: The Draughtsman's Art. Exh. cat. Edinburgh, National Galleries of Scotland, 1999.

ELEB-VIDAL AND DEBARRE-BLANCHARD 1989
Eleb-Vidal, Monique, and Anne Debarre-Blanchard. *Architectures de la vie privée: Maisons et mentalités XVIIe–XIXe siècles.* Brussels: Archives d'architecture moderne, 1989.

ELIAS 1978
Elias, Norbert. *The Civilizing Process: The Development of Manners; Changes in the Code of Conduct and Feeling in Early Modern Times.* Translated by Edmund Jephcott. New York: Urizen, 1978.

ESSAI SUR LE CARACTÈRE 1776
Essai sur le caractère et les moeurs des François comparés à ceux des Anglois. London, 1776.

EVANS 1970
Evans, Joan. *A History of Jewellery 1100–1870.* Boston: Boston Book and Art, 1970.

FABRÉ 1976
Fabré, Michel, and Fabrice Fabré. *La Vie silencieuse en France: La Nature morte au XVIIIe siècle.* Paris: Office du Livre, 1976.

FAIRCHILDS 1993
Fairchilds, Cissie. "The Production and Marketing of Populuxe Goods in Eighteenth-Century Paris." In *Consumption and the World of Goods,* edited by

John Brewer and Roy Porter, pp. 228–48. 3 vols. London and New York: Routledge, 1993.

FATON 1982
Faton, Louis. "Le Mystère du tableau de Jean-François de Troy." *L'Estampille* 150 (October 1982): 20–1.

FERSEN 1909
Fersen, Count Axel. *Diary and Correspondence of Count Axel Fersen, Grand-marshal of Sweden.* Translated by Katharine Prescott. Boston: Wormeley, 1909.

FESTA 2004
Festa, Lynn. "Cosmetic Differences: The Changing Faces of England and France." In *Studies in Eighteenth-Century Culture,* vol. 34, edited by Catherine Ingrassia and Jeffrey Ravel, pp. 25–54. Baltimore: Johns Hopkins University Press, 2004.

FORT WORTH–KANSAS CITY 1983
Opperman, Hal. *J-B Oudry 1686–1755.* Exh. cat. Fort Worth, Kimbell Art Museum, and Kansas City, Mo., Nelson-Atkins Museum of Art, 1983.

FRANKFURT 2009–10
André-Charles Boulle (1642–1732): Un nouveau style pour l'Europe. Exh. cat. Frankfurt, Museum für Angewandte Kunst (with Somogy), 2009–10.

FREDRICKSEN 1980
Fredericksen, Burton B. *Masterpieces of Painting in the J. Paul Getty Museum.* Malibu, Calif.: J. Paul Getty Museum, 1980.

FRIED 1980
Fried, Michael. *Absorption and Theatricality: Painting and Beholder in the Age of Diderot.* Berkeley: University of California Press, 1980.

FUHRING 1999
Fuhring, Peter. *Juste-Aurèle Meissonnier: Un génie du rococo, 1695–1750.* 2 vols. Turin: U. Allemandi, 1999.

FUMAROLI 2005
Fumaroli, Marc. *Maurice Quentin de La Tour et le Siècle de Louis XV.* Lille: Éditions du Quesne, 2005.

FURETIÈRE 1701
Furetière, Antoine. *Dictionnaire Universel, contenant généralement tour les mots.* 3 vols. La Haye and Rotterdam, 1701.

FUSCO 1997
Fusco, Peter. *Summary Catalogue of European Sculpture in the J. Paul Getty Museum.* Los Angeles: J. Paul Getty Museum, 1997.

FUSCO AND FOGELMAN 1998
Fusco, Peter, and Peggy Fogelman. *Masterpieces of the J. Paul Getty Museum: European Sculpture.* Los Angeles: J. Paul Getty Museum, 1998.

GABILLOT 1906
Gabillot, Claude. "Les trois Drouais: François-Hubert Drouais." *Gazette des Beaux-Arts* ser. 3, no. 35 (1906): 384–400, 456–74.

GABORIT ET AL. 1998
Gaborit, Jean-René, Geneviève Bresc-Bautier, Isabelle Leroy-Jay Lemaistre, and Guilhem Scherf. *Sculpture française II: Renaissance et temps modernes.* 2 vols. Paris: Réunion des musées nationaux, 1998.

GAEHTGENS ET AL. 2001
Gaehtgens, Thomas W., Christian Michel, Daniel Rabreau, and Martin Schieder. *L'Art et les normes sociales au XVIIIe siècle.* Paris: Centre allemand d'histoire de l'art, with Éditions de la Maison des sciences de l'homme, 2001.

Garland Series 1976
A Garland Series: The Renaissance and the Gods; A Comprehensive Collection of Renaissance Mythologies, Iconologies, & Iconographies, with a Selection of Works from The Enlightenment. Introduction by Stephen Orgel. New York and London: Garland, 1976.

GELIS 1924
Gelis, Édouard. "À propos d'un tableau mécanique du Musée des arts décoratifs." *Bulletin de la société de l'histoire de l'art français* (1924): 254–72.

GENLIS 1825
Genlis, Stéphanie Felicité Brulart de Sillery, comtesse de. *Mémoires inédits de Madame la Comtesse de Genlis.* London, 1825.

GENLIS 1996
Genlis, Stéphanie Felicité Brulart de Sillery, comtesse de. *De l'esprit des étiquettes de l'ancienne cour et des usages du monde de ce temps.* Paris: Mercure de France, 1996.

GERKEN 2007
Gerken, Rosemarie. *La Toilette: Die Inszenierung eines Raumes im 18. Jahrhundert in Frankreich.* Hildesheim: Olms Verlag, 2007.

GLENNIE AND THRIFT 2009
Glennie, Paul, and Nigel Thrift. *Shaping the Day: A History of Timekeeping in England and Wales 1300–1800.* Oxford: Oxford University Press, 2009.

GOLDNER AND HENDRIX 1992
Goldner, George R., and Hendrix, Lee. *European Drawings 2: Catalogue of the Collections.* Malibu, Calif.: J. Paul Getty Museum, 1992.

GONZÁLES-PALACIOS 1966
Gonzáles-Palacios, Alvar. *Gli ebanisti del Luigi XV.* Milan: Fratelli Fabbri Editori, 1966.

GOODMAN 2000
Goodman, Elise. *The Portraits of Madame de Pompadour: Celebrating the Femme Savante.* Berkeley and Los Angeles: University of California Press, 2000.

GOODMAN 2005
Goodman, Dena. "Letter Writing and the Emergence of Gendered Subjectivity in Eighteenth-Century France." *Journal of Women's History* (Summer 2005): 9–37.

GOODMAN-SOELLNER 1987
Goodman-Soellner, Elise. "Boucher's *Madame de Pompadour at her Toilette.*" *Simiolus: Netherlands Quarterly for the History of Art* 17, no. 1 (1987): 41–58.

GORDON AND HENSICK 2002
Gordon, Alden R., and Teri Hensick, "The Picture within the Picture: Boucher's 1750 Portrait of Madame de Pompadour Identified." *Apollo* (February 2002): 21–30.

GOUDAR 1765
Goudar, Ange. *L'Espion chinois: Ou, l'envoyé secret de la cour de Pékin.* 6 vols. Cologne, 1765.

GOUZI 2000
Gouzi, Christine. *Jean Restout (1692–1768): Peintre d'histoire à Paris.* Paris: Arthéna, 2000.

GRAFFIGNY 1985–2010
Graffigny, Françoise de. *Correspondance.* Edited by J. A. Dainard et al. 13 vols. Oxford: Voltaire Foundation, 1985–2010.

GRANDJEAN 1981
Grandjean, Serge. *Catalogue des tabatières, boîtes et étuis des XVIIIe et XIXe siècles du musée du Louvre.* Paris: Réunion des musées nationaux, 1981.

GRATE 1994
Grate, Pontus. *French Paintings II: Eighteenth Century.* Stockholm: Swedish National Art Museums, 1994.

GUICHARD 2008
Guichard, Charlotte. *Les Amateurs d'art à Paris au XVIIIe siècle.* Seyssel: Champ Vallon, 2008.

GUILLEMÉ-BRULON 1983
Guillemé-Brulon, D. "Les Objets de toilette en porcelaine de Sèvres au 18e siècle." *L'Estampille* (1983): 34–45.

HALL 2008
Hall, Michael. "Hand Made and Hand Held: Snuff Boxes in the Huntington Collection." In Bennett and Sargentson 2008 (see above), pp. 393–405.

HANOVER–TOLEDO–HOUSTON 1997–98
Rand, Richard, ed. *Intimate Encounters: Love and Domesticity in Eighteenth-Century France.* Exh. cat. Hanover, N.H., Dartmouth College, Hood Museum of Art; Toledo Museum of Art; and Houston, Museum of Fine Arts, 1997–98 (with Princeton University Press).

HARRISON, WOOD, AND GAIGER 2000
Harrison, Charles, Paul Wood, and Jason Gaiger, eds. *Art in Theory 1648–1815: An Anthology of Changing Ideas.* Malden, Mass.: Blackwell, 2000.

HAVARD N.D.
Havard, Henry. *Dictionnaire de l'ameublement et de la décoration depuis le XIIIe siècle jusqu'à nos jours.* 4 vols. Paris, n.d.

HAWLEY 1970
Hawley, Henry. "Jean-Pierre Latz, Cabinetmaker." *Bulletin of the Cleveland Museum of Art* 57, no. 7 (September/October 1970): 203–59.

HAWLEY 1979
Hawley, Henry. "A Reputation Revived, Jean-Pierre Latz, Cabinetmaker." *Connoisseur* 202, no. 813 (November 1979): 176–82.

HEDLEY 2004
Hedley, Jo. *François Boucher: Seductive Visions.* London: Wallace Collection, 2004.

HELLER-GREENMAN 2002
Heller-Greenman, Bernardine. "The Monument de Costume of Jean-Michel Moreau le Jeune in the Context of Rousseau and the Ancien Régime." PhD diss., Florida State University, 2002.

HELLMAN 1999
Hellman, Mimi. "Furniture, Sociability, and the Work of Leisure in Eighteenth-Century France."

Eighteenth-Century Studies (Summer 1999): 415–45.

HELLMAN 2010
Hellman, Mimi. "The Nature of Artifice: French Porcelain Flowers and the Rhetoric of the Garnish." In *The Cultural Aesthetics of Eighteenth-Century Porcelain*, edited by Alden Cavanaugh and Michael Yonan. Burlington, Vt., and Aldershot, Hampshire, UK: Ashgate, forthcoming 2010.

HENRY 2001
Henry, Christophe. "La Peinture en question: Genèse conflictuelle d'une fonction sociale de la peinture d'histoire en France au milieu du XVIIIe siècle." In Gaehtgens et al. 2001 (see above), pp. 459–76.

HERLAUT 1916
Herlaut, Commandant. "L'Éclairage des rues à Paris." *Mémoires de la Société de l'histoire de Paris et de l'Ile-de-France* 43 (1916): 129–265.

HERNMARCK 1977
Hernmarck, Carl. *The Art of the European Silversmith, 1430–1830*. London and New York: Sotheby Parke Bernet, 1977.

HOEFER 1963–69
Hoefer, Jean-Chrétien-Ferdinand. *Nouvelle biographie générale depuis les temps les plus reculés jusqu'à 1850–60*. Copenhagen: Rosenkilde and Bagger, 1963–69.

HOLMES 1985
Holmes, Mary Tavener. "Nicolas Lancret and Genre Themes of the Eighteenth Century." PhD diss., New York University, Institute of Fine Arts, 1985.

HOLMES 1991
Holmes, Mary Tavener. *Nicolas Lancret 1690–1743*. New York: Harry N. Abrams, 1991.

HOLMES 2006
Holmes, Mary Tavener. *Nicolas Lancret: Dance before a Fountain*. Los Angeles: J. Paul Getty Museum, 2006.

HOLT 1960
Holt, E. I. "Rococo Costumes and Fabrics in the Museum Collection." *Los Angeles County Museum, Bulletin of the Art Division* 12, no. 2 (1960): 3–14.

HUGHES 1994
Hughes, Peter. *French Eighteenth-Century Clocks and Barometers in the Wallace Collection*. London: Trustees of the Wallace Collection, 1994.

HUGHES 1996
Hughes, Peter. *The Wallace Collection Catalogue of Furniture*. 3 vols. London: Trustees of the Wallace Collection, 1996.

HURT 1971
Hurt, Jethro M., III. "An Eighteenth Century Bronze *Saturn* as a Figure of Time." *North Carolina Museum of Art Bulletin* 10, no. 3 (March 1971): 16–28.

HYDE 2000
Hyde, Melissa. "The 'Makeup' of the Marquise: Boucher's Portrait of Pompadour at Her Toilette." *Art Bulletin* (September 2000): 453–75.

HYDE 2006
Hyde, Melissa. *Making Up the Rococo: François Boucher and His Critics*. Los Angeles: Getty Research Institute, 2006.

JARRY 1966
Jarry, Madeleine. *The Carpets of the Manufacture de la Savonnerie*. Translated by C. Magdalino. Leigh-on-Sea, Essex, UK: F. Lewis, 1966.

JEFFARES 2003
Jeffares, Neil. "Jean Valade's Portraits of the Faventines Family." *British Journal for Eighteenth-Century Studies* 26, no. 2 (Autumn 2003): 217–50.

JOHNSON 1990
Johnson, Dorothy. "Picturing Pedagogy: Education and the Child in the Paintings of Chardin." *Eighteenth-Century Studies* 24 (Fall 1990): 47–68.

JONES 2004
Jones, Jennifer. *Sexing La Mode: Gender, Fashion and Commercial Culture in Old Regime France*. Oxford and New York: Berg, 2004.

JOUTARD 1991
Joutard, Philippe, ed. *Histoire de la France religieuse*. Vol. 3, *Du Roi Très Chrétien à la laïcité républicaine (XVIIIe–XIXe siècle)*. Paris: Seuil, 1991.

KARLSRUHE 1999
Jean Siméon Chardin, 1699–1779: Werk Herkunft, Wirkung. Exh. cat. Karlsruhe: Staatliche Kunsthalle, 1999.

KIRCHNER 1991
Kirchner, Thomas. *L'Expression des passions: Ausdruck als Darstellungsproblem in der französischen Kunst und Kunsttheorie des 17. und 18. Jahrhunderts*. Mainz: Zabern, 1991.

KJELLBERG 1989
Kjellberg, Pierre. *Le Mobilier français du XVIIIe siècle: Dictionnaire des ébénistes et des menuisiers*. Paris: Éditions de l'amateur, 1989.

KLEY 1975
Kley, Dale van. *The Jansenists and the Expulsion of the Jesuits from France 1757–1765*. New Haven: Yale University Press, 1975.

KLUGE 2009
Kluge, Dorit. *Kritik als Spiegel der Kunst: Die Kunstreflexionen des La Font de Saint-Yenne im Kontext der Entstehung der Kunstkritik im 18. Jahrhundert*. Weimar: VDG, 2009.

KOSTER 1994
Koster, John. *Keyboard Musical Instruments in the Museum of Fine Arts, Boston*. Boston: Museum of Fine Arts, 1994.

KRAATZ 1989
Kraatz, Anne. *Lace: History and Fashion*. Translated by Pat Earnshaw. New York: Rizzoli, 1989.

KRAUSE 1997
Krause, Katharina. "Genrebilder: Mode und Gesellschaft der Aristokraten bei Jean-François de Troy." In *Festschrift für Johannes Langner zum 65. Geburtstag am 1. Februar 1997*, edited by Klaus Gereon Beuckers and Annemarie Jaeggi, pp. 141–57. Münster: LIT Verlag, 1997.

KREN 2007
Kren, Thomas. *French Illuminated Manuscripts in the J. Paul Getty Museum*. Los Angeles: J. Paul Getty Museum, 2007.

KYOTO 1989
Revolution in Fashion: European Clothing, 1715–1815. Exh. cat. Kyoto, National Museum of Modern Art, 1989 (published by the Kyoto Costume Institute, with Abbeville).

LA CHAPELLE 1742
La Chapelle, Vincent. *Le Cuisinier moderne: Qui apprend à donner toutes sortes de repas, en gras & en maigre, d'une manière plus délicate qui ce qui en a été écrit jusqu'à présent*. 2nd ed. 5 vols. The Hague, 1742.

LA FONT DE SAINT-YENNE 1747
La Font de Saint-Yenne, Étienne-François. *Réflexions sur quelques causes de l'état présent de la peinture en France. Avec un examen des principaux ouvrages exposés au Louvre le mois d'août 1746*. The Hague: Neaulme, 1747.

LA FONT DE SAINT-YENNE 1754
La Font de Saint-Yenne, Étienne-François. *Sentimens sur quelques ouvrages de peinture, sculpture et gravure, écrits à un particulier en province*. Paris (?), 1754.

LAHAUSSOIS 1997
Lahaussois, Christine. *La Collection du Musée des Arts décoratifs: Porcelaines de Saint-Cloud*. Paris: Union centrale des arts décoratifs—Réunion des musées nationaux, 1997.

LAJER-BURCHARTH 2009
Lajer-Burcharth, Ewa. "Image Matters: The Case of Boucher." In *Dialogues in Art History from Mesopotamian to Modern*, pp. 277–303. Washington, D.C.: National Gallery of Art 2009 (with Yale University Press).

LAMI 1910–11
Lami, Stanislas. *Dictionnaire des sculpteurs de l'école française au dix-huitième siècle*. Paris: H. Champion, 1910–11; repr. Nendeln, Liechtenstein: Kraus, 1970.

LANDES 1983
Landes, David S. *Revolution in Time: Clocks and the Making of the Modern World*. Cambridge, Mass., and London: Belknap Press, 1983.

LANOË 2008
Lanoë, Catherine. *La Poudre et le fard: Une histoire des cosmétiques de la Renaissance aux Lumières*. Paris: Champ Vallon, 2008.

LASKIN 1987
Laskin, Myron. *European and American Painting, Sculpture, and Decorative Arts*. Ottawa: National Gallery of Canada, 1987.

LEDBURY 2001
Ledbury, Mark. "The Hierarchy of Genre in the Theory and Practice of Painting in Eighteenth-Century France." In *Théories et débats esthétiques au dix-huitième siècle: Éléments d'une enquête/Debates on Aesthetics in the Eighteenth Century: Questions of Theory and Practice*, edited by Élisabeth Décultot and Mark Ledbury, pp. 187–209. Paris: Honoré Champion, 2001.

LE DUC 1996
Le Duc, Geneviève. *Porcelaine tendre de Chantilly au XVIIIe siècle.* Paris: Hazan, 1996.

LE DUC 1998
Le Duc, Geneviève. "The Rocaille Style at Chantilly: A Different Aspect of French Porcelain c. 1750." *Apollo* (January 1998): 37–41.

LEEDS–LOS ANGELES 2008–9
Taking Shape: Finding Sculpture in the Decorative Arts. Exh. cat. Leeds, Henry Moore Institute, and Los Angeles, J. Paul Getty Museum, 2008–9.

LE FRANC DE POMPIGNAN 1746
Le Franc de Pompignan, Jean-Jacques. *Didon.* Paris: Chaubert, 1746.

LE FRANC DE POMPIGNAN 1771
Le Franc de Pompignan, Jean-Jacques. *Discours philosophiques, tirés des livres saints, avec des odes chrétiennes et philosophiques.* Paris: Saillant & Nyon, 1771.

LEMAIRE 1999
Lemaire, Jean. *La Porcelaine de Tournai: Histoire d'une manufacture (1750–1891).* Tournai: La Renaissance du Livre, 1999.

LE NOBLE 1739
Le Noble, Eustache. *L'École du monde, ou instruction d'un pere à un fils, touchant la manière dont il faut vivre dans le monde.* 4 vols. Paris, 1739.

LE PAPILLOTAGE 1769
Le papillotage, ouvrage comique et moral. Rotterdam, 1769.

LERIBAULT 2002
Leribault, Christophe. *Jean-Francois de Troy (1679–1752).* Paris: Arthéna, 2002.

LE ROUGE 1723
Le Rouge, George-Louis. *Les Curiositez de Paris, De Versailles, de Marly, de Vincennes, de S. Cloud, et des environs: avec les adresses pour trouver facilement tout ce qu'ils renferment d'agréable & d'utile: ouvrage enrichi d'un grand nombre de figures.* 2 vols. Paris, 1723.

LESPES 2009
Lespes, Michelle. "Jacques-André-Joseph Aved: Portraitiste des Lumières." *L'Estampille* 443 (February 2009): 70–79.

LEVEY 1993
Levey, Michael. *Painting and Sculpture in France, 1700–1789.* New Haven: Yale University Press, 1993.

LEVITINE 1972
Levitine, George. *The Sculpture of Falconet.* Greenwich: New York Graphic Society Ltd., 1972.

LIBIN 1989
Libin, Laurence. "Keyboard Instruments." *Metropolitan Museum of Art Bulletin* (Summer 1989): 1–56.

LOCQUIN 1907
Locquin, Jean. "La Bibliothèque de l'Académie royale de peinture et sculpture de Paris en 1747." *Chronique des Arts et de la Curiosité.* Supplement to *Gazette des Beaux-Arts* 36, no. 23 (November 1907): 340–41.

LOCQUIN 1912
Locquin, Jean. "Catalogue raisonné de l'oeuvre de Jean-Baptiste Oudry." *Archives de l'art français* 6 (1912): 1–209.

LOMAX 1982
Lomax, David. "Noël-Nicolas Coypel (1690–1734)." *Revue de l'art* 57 (1982): 29–48.

LONDON 2002
Jones, Colin. *Madame de Pompadour: Images of a Mistress.* Exh. cat. London, National Gallery, 2002.

LONDON–GLASGOW 2008
Dulau, Anne, ed. *Boucher & Chardin: Masters of Modern Manners.* Exh. cat. London, Wallace Collection, and Glasgow, Hunterian Art Gallery, 2008.

LORME 1900
Lorme, A. de. *L'Art à Brest au XVIIIe siècle, Jacques-André Portail, dessinateur du roy.* Brest, 1900.

LOS ANGELES 1974
Kahlenberg, Mary Hunt. *Fabric and Fashion: Twenty Years of Costume Council Gifts.* Exh. cat. Los Angeles County Museum of Art, 1974 (with Harry N. Abrams).

LOS ANGELES 1983
Maeder, Edward, et al. *An Elegant Art: Fashion and Fantasy in the Eighteenth Century.* Exh. cat. Los Angeles County Museum of Art, 1983.

LOS ANGELES 2010
Fashioning Fashion: European Dress in Detail, 1700–1915. Exh. cat. Los Angeles County Museum of Art, 2010.

LOS ANGELES–HOUSTON–SCHWERIN 2007
Morton, Mary, ed. *Oudry's Painted Menagerie: Portraits of Exotic Animals in Eighteenth-Century Europe.* Exh. cat. Los Angeles: J. Paul Getty Museum; Houston, Museum of Fine Arts, and Schwerin, Staatliches Museum, 2007.

MABILLE 1984
Mabille, Gérard. *Orfèvrerie française des XVIe XVIIe XVIIIe siècles: Catalogue raisonné des collections du Musée des Arts Décoratifs et du Musée Nissim de Camondo.* Paris: Flammarion, 1984.

MANDEVILLE 1714
Mandeville, Bernard. *The Fable of the Bees or Private Vices, Public Virtues.* 1714. 2nd ed. Edinburgh: J. Wood, 1772.

MANUEL 1959
Manuel, Frank. *The Eighteenth Century Confronts the Gods.* Cambridge: Harvard University Press, 1959.

MARTIN 2009
Martin, Morag. *Selling Beauty: Cosmetics, Commerce, and French Society, 1750–1830.* Baltimore: Johns Hopkins University Press, 2009.

MARTIN AND CHARTIER 1984
Martin, Henri-Jean, and Roger Chartier. *Histoire de l'édition française.* Vol. 2, *Le livre triomphant 1660–1830.* Paris: Promodis, 1984.

MASER 1971
Maser, Edward A., ed. *Cesare Ripa Baroque and Rococo Pictorial Imagery, The 1758–60 Hertel Edition of Ripa's "Iconologia."* New York: Dover Publications, Inc., 1971.

MCCLELLAN 1996
McClellan, Andrew. "Watteau's Dealer: Gersaint and the Marketing of Art in Eighteenth-Century Paris." *Art Bulletin* 78 (September 1996): 439–53.

MERCIER 1782
Mercier, Louis-Sébastien. *Paris in Miniature: Taken from The French Picture at full length entitled Tableau de Paris, Interspersed with Remarks and Anecdotes.* London, 1782.

MERCIER 1782–88
Mercier, Louis-Sébastien. *Tableau de Paris, Nouvelle Édition.* 12 vols. Amsterdam, 1782–88; repr. Geneva: Slatkine, 1979.

MICHAUD 1880
Michaud, M. *Biographie universelle ancienne et modern.* Paris: L. Vivès, 1880.

MICHEL 1987
Michel, Christian. *Charles-Nicolas Cochin et le livre illustré au XVIIIème siècle.* Geneva: Droz, 1987.

MICHEL 2007
Michel, Christian. "*Nature* and *Moeurs*: Thoughts on the Reception of Genre Painting in France." In Conisbee 2007 (see above), pp. 275–93.

MIDDELDORF 1976
Middeldorf, Ulrich. *Sculptures from the Samuel H. Kress Collection: European Schools, XIV–XIX Century.* London: Phaidon Press for the Samuel H. Kress Foundation, 1976.

MONCEAU 1762
Monceau, Henri-Louis Duhamel du. *Art du Cirier* [1762]. In *Descriptions des arts et métiers faites ou approuvées par MM de l'Académie des Sciences* (1761–81), vol. 15. Repr. Geneva, 1984.

MONCEAU 1764
Monceau, Henri-Louis Duhamel du. *Art du Chandelier* [1764]. In *Descriptions des arts et métiers faites ou approuvées par MM de l'Académie des Sciences* (1761–81), vol. 15. Repr. Geneva, 1984.

MONDON N.D.
Mondon le fils, Jean. *L'Oeuvre de Jean Mondon.* Paris, n.d.

MONTAGU 1893
Montagu, Lady Mary Wortley. *The Letters and Works of Lady Mary Wortley Montagu.* 2 vols. New York, 1893.

MONTAIGLON 1875–92
Montaiglon, Anatole de. *Procès-verbaux de l'Académie royale de peinture et de sculpture 1648–1793.* 10 vols. Paris: Baur, 1875–92.

MONTESQUIEU 1914
Montesquieu, Charles Louis de Secondat. *Lettres persanes.* New York: Oxford University Press, 1914.

MONTPELLIER 1979
Le Portrait à travers les collections du Musée Fabre: XVIIe, XVIIIe, XIXe siècles. Exh. cat. Montpellier, Musée Fabre, 1979.

MORLEY 1872
Morley, John. *The Works of Voltaire: A Contemporary Version.* 42 vols. 1872. Repr. New York: St. Hubert Guild, ca. 1901.

MOYER AND HANLON 1996
Moyer, Cynthia, and Gordon Hanlon. "Conservation of the Darnault Mirror: An Acrylic Emulsion Compensation System." *Journal of the American Institute for Conservation* 35, no. 3 (Autumn-Winter 1996): 185–96.

MÜNTZ 1897
Müntz, Eugène. "La Bibliothèque de l'ancienne Académie royale de peinture et de sculpture (1648–1793)." *Mémoires de la Société de l'Histoire de Paris et de l'Ile-de-France* 24 (1897): 33–50.

MUSÉE FABRE 1988
Chefs-d'oeuvre de la peinture (100 Masterpieces) de Jean Cousin à Degas. Montpellier: Musée Fabre, 1988.

NATIONAL GALLERY OF ART 1994
National Gallery of Art. Sculpture: An Illustrated Catalogue. Washington, D.C.: National Gallery of Art, 1994.

NEUMAN 1980
Neuman, Robert. "French Domestic Architecture in the Early Eighteenth Century: The Town Houses of Robert de Cotte." *Journal of the Society of Architectural Historians* 39, no. 2 (May 1980): 128–44.

NEVILL 1908
Nevill, Ralph. *French Prints of the Eighteenth Century.* London: Macmillan, 1908.

NEW YORK 1983
Edey, Winthrop. *French Clocks in North American Collections.* Exh. cat. New York, Frick Collection, 1983.

NEW YORK 1999
Rondot, Bertrand, ed. *Discovering the Secrets of Soft-Paste Porcelain at the Saint-Cloud Manufactory, ca. 1690–1766.* Exh. cat. New York, Bard College, Bard Graduate Center for Studies in the Decorative Arts, 1999 (with Yale University Press).

NEW YORK 2006
Koda, Harold, ed. *Dangerous Liaisons: Fashion and Furniture in the Eighteenth Century.* Exh. cat. New York, Metropolitan Museum of Art, 2006 (with Yale University Press).

NEW YORK 2007
Campbell, Thomas P., ed. *Tapestry in the Baroque: Threads of Splendor.* Exh. cat. New York, Metropolitan Museum of Art, 2007 (with Yale University Press).

NEW YORK–DETROIT–PARIS 1986
Laing, Alastair, et al. *François Boucher 1703–1770.* Exh. cat. New York, Metropolitan Museum of Art; Detroit Institute of Arts; and Paris, Galeries nationales du Grand Palais, 1986.

NEW YORK–FORT WORTH 1999
Holmes, Mary Tavener. *Nicolas Lancret 1690–1743.* Exh. cat. New York, Frick Collection, 1999 (with Harry N. Abrams).

NEW YORK–OTTAWA 1999
Wintermute, Alan. *Watteau and His World: French Drawings from 1700 to 1750.* Exh. cat. New York, Frick Collection, and Ottawa, National Gallery of Canada, 1999 (with the American Federation of the Arts).

NICE 2001
Debrabandère-Descamps, Béatrice. "Les Années de jeunesse de Carle Vanloo, de Nice à Paris (1705–1735)." In *Les Van Loo, fils d'Abraham,* pp. 57–82. Exh. cat. Nice, Musée des Beaux-Arts, 2001.

NICE–CLERMONT-FERRAND–NANCY 1977
Rosenberg, Pierre, and Marie Catherine Sahut. *Carle Vanloo, Premier peintre du roi (Nice 1705–Paris 1765).* Exh. cat. Nice, Musée Cheret; Clermont-Ferrand, Musée Bargoin; and Nancy, Musée des Beaux-Arts, 1977 (with Serg).

NOCQ 1968
Nocq, Henry. *Le Poinçon de Paris: Répertoire des maîtres-orfèvres de la juridiction de Paris depuis le Moyen-âge jusqu'à la fin du XVIIIe siècle.* 5 vols. Paris: L. Laget, 1968.

NOLHAC 1925
Nolhac, Pierre de. *Nattier: Peintre de la cour de Louis XV.* Paris: Henri Floury, 1925.

OBERKIRCH 1789
Oberkirch, Henriette-Louise de Waldner de Freundstein, baronne d'. *Mémoires de la baronne d'Oberkirch sur la cour de Louis XVI et la société française avant 1789.* Paris, 1789.

O'DEA 1958
O'Dea, William T. *The Social History of Lighting.* New York: Routledge, 1958.

OTTAWA–WASHINGTON–BERLIN 2003
Bailey, Colin B., ed., with Philip Conisbee and Thomas W. Gaehtgens. *The Age of Watteau, Chardin, and Fragonard: Masterpieces of French Genre Painting.* Exh. cat. Ottawa, National Gallery of Canada; Washington, D.C., National Gallery of Art; and Berlin, Staatliche Museen, Gemäldegalerie, 2003 (with Yale University Press).

OTTOMEYER AND PRÖSCHEL 1986
Ottomeyer, Hans, and Peter Pröschel. *Vergoldete Bronzen: Die Bronzearbeiten des Spätbarock und Klassizismus.* 2 vols. Munich: Klinkhardt & Biermann, 1986.

PALEOTTI 1582
Paleotti, Gabriele. "Discorso intorno alle imagini sacre e profane." In Barocchi 1960–62 (see above), vol. 2, pp. 117–509.

PALLOT 1989
Pallot, Bill G. B. *The Art of the Chair in Eighteenth-Century France.* Translated by Wilder-Luke Burnap. Paris: ACR-Gismondi, 1989.

PALMER 2008
Palmer, Caroline. "Brazen Cheek: Face-Painters in Late Eighteenth-Century England." *Oxford Art Journal* (June 2008): 195–213.

PANOFSKY 1972
Panofsky, Erwin. "Father Time." In *Studies in Iconology: Humanistic Themes in the Art of the Renaissance,* pp. 69–94. New York: Harper and Row, 1972.

PARDAILHÉ-GALABRUN 1991
Pardailhé-Galabrun, Annik. *The Birth of Intimacy: Privacy and Domestic Life in Early Modern Paris.* Translated by Jocelyn Phelps. Cambridge and Oxford: Polity Press in association with Basil Blackwell Limited, 1991.

PARIS 1974
Louis XV: Un Moment de perfection de l'art français. Exh. cat. Paris, Hôtel de la Monnaie, 1974.

PARIS 1976–77
Joseph Vernet 1714–1789. Exh. cat. Paris, Musée de la Marine, Palais de Chaillot, 1976–77.

PARIS 1977–78
Préaud, Tamara, and Antoinette Faÿ-Hallé. *Porcelaines de Vincennes: Les Origines de Sèvres.* Exh. cat. Paris, Grand Palais, 1977–78.

PARIS 1999
Rosenberg, Pierre, and Renaud Temperini. *Chardin.* Exh. cat. Paris, Musée du Louvre, 1999 (with Flammarion).

PARIS–CLEVELAND–BOSTON 1979
Rosenberg, Pierre. *Chardin 1699–1779.* Exh. cat. Cleveland Museum of Art, 1979 (with Indiana University Press).

PARIS–NEW YORK–LOS ANGELES 2009
Bresc-Bautier, Geneviève, and Guilhem Scherf, eds. *Cast in Bronze: French Sculpture from the Renaissance to the Revolution.* Exh. cat. Paris, Musée du Louvre; New York, Metropolitan Museum of Art; and Los Angeles, J. Paul Getty Museum, 2009 (with Somogy Art Publishers).

PARIS–PHILADELPHIA–FORT WORTH 1992
Bailey, Colin B. *The Loves of the Gods: Mythological Painting from Watteau to David.* Exh. cat. Paris, Galeries nationales du Grand Palais; Philadelphia Museum of Art; and Fort Worth, Kimbell Art Museum, 1992 (with Rizzoli).

PERRIN 1993
Perrin, Christiane. *Francois Germain orfèvre des rois.* Saint-Remy-en-l'Eau: Éditions Monelle Hayot, 1993.

PERROT 1984
Perrot, Philippe. *Le Travail des apparences: Le corps féminin, XVIIIᵉ–XIXᵉ siècle.* Paris: Seuil, 1984.

Petit Robert
Rey, A., and J. Rey-Debove, eds. *Le Petit Robert 1: Dictionnaire alphabétique et analogique de la langue française.* Paris: Le Robert, 1986.

PHILLIPS 1996
Phillips, Clare. *Jewelry from Antiquity to the Present.* London: Thames and Hudson, 1996.

PINETTE 2006
Pinette, Matthieu. *Peintures françaises des XVIIe et XVIIIe siècles des musées d'Amiens.* Amiens: Musée de Picardie, with Somogy Art Publishers, 2006.

PINON, LE BOUDEC, AND CARRÉ 2004
Pinon, Pierre, Bertrand Le Boudec, and Dominique Carré. *Les Plans de Paris: Histoire d'une capitale.* Paris: Bibliothèque nationale de France, 2004.

PLINVAL DE GUILLEBON 1992
Plinval de Guillebon, Régine de. *Musée du Louvre, département des Objets d'art: Catalogue des Porcelaines françaises I; Chantilly, Mennecy, Saint-Cloud, Boissette, Bordeaux, Limoges, Niderviller, Paris, Valenciennes.* Paris: Réunion des musées nationaux, 1992.

PLUCHE 1739
Pluche, Noël-Antoine. *Histoire du ciel considéré selon les idées des poètes, des philosophes et de Moïse.* 2 vols. Paris: Estienne, 1739.

POINTON 2009
Pointon, Marcia. *Brilliant Effects: A Cultural History of Gem Stones & Jewellery.* New Haven: Yale University Press, and London: Paul Mellon Centre for Studies in British Art, 2009.

POITIERS 1993
Trope, Marie-Hélène. *Jean Valade: Peintre ordinaire du Roi 1710–1787.* Exh. cat. with catalogue raisonné. Poitiers, Musées de la ville de Poitiers, 1993.

PORTLAND 2002
Nouvel-Kammerer, Odile, and Penelope Hunter-Stiebel. *Matière de rêves: Stuff of Dreams from the Paris Musée des Arts décoratifs.* Exh. cat. Portland Art Museum, 2002.

PORTLAND–TOURS 2008
Hunter-Stiebel, Penelope, and Philippe Le Leyzour, eds. *La Volupté du goût: French Painting in the Age of Madame de Pompadour.* Exh. cat. Portland Art Museum and Tours, Musée des Beaux Arts, 2008.

POSNER 1996
Posner, Donald. "The 'Duchesse de Velours' and Her Daughter: A Masterpiece by Nattier and Its Historical Context." *Metropolitan Museum Journal* 31 (1996): 131–41.

PRADÈRE 1989
Pradère, Alexandre. *French Furniture Makers: The Art of the Ébéniste from Louis XIV to the Revolution.* Translated by Perran Wood. Malibu, Calif.: J. Paul Getty Museum, 1989.

PRADÈRE 2003
Pradère, Alexandre. *Charles Cressent: Sculpteur, ébéniste du Régent.* Dijon: Éditions Faton, 2003.

PYENSON AND GAUVIN 2002
Pyenson, Lewis, and Jean-François Gauvin, eds. *L'Art d'enseigner la physique: Les appareils de démonstration de Jean-Antoine Nollet, 1700–1770.* Sillery, Quebec: Septentrion, 2002.

RALEIGH ET AL. 1994
Ishikawa, Chiyo, et al. *A Gift to America: Masterpieces of European Painting from the Samuel H. Kress Collection.* Raleigh, North Carolina Museum of Art; Houston, Museum of Fine Arts; Seattle Art Museum; and San Francisco, Fine Arts Museums, 1994 (with Harry N. Abrams).

RAMOND 2000
Ramond, Pierre. *Masterpieces of Marquetry.* Translated by Tim Levenson and Brian Considine. 3 vols. Los Angeles: J. Paul Getty Museum, 2000.

RATZKI-KRAATZ 1986
Ratzki-Kraatz, Anne. "A French *Lit de Parade* 'à la Duchesse' 1690–1715." *J. Paul Getty Museum Journal* 14 (1986): 81–104.

RÉAU 1931
Réau, Louis. "Jean-Baptiste Defernex, sculpteur du duc d'Orléans (1729–1783)." *Gazette des Beaux-Arts* (June 1931): 349–65.

RECHNIEWSKI 2007
Rechniewski, Elizabeth. "Private Lives and National Citizenship: The 'Moral' of Marmontel's Contes Moraux." *AUMLA: Journal of the Australasian Universities Modern Language Association* (May 2007): 25–40.

RENARD 1999
Renard, Philippe. *Jean-Marc Nattier (1685–1766): Un artiste parisien à la cour de Louis XV.* Saint-Remy-en-l'Eau: Éditions Monelle Hayot, 1999.

RESTIF DE LA BRETONNE 1789
Restif de la Bretonne, Nicolas-Edmé. *Les nuits de Paris, ou L'Observateur nocturne.* 14 parts in 7 vols. London, 1789.

REYNIÈS 1987
Reyniès, Nicole de. *Le Mobilier domestique. Vocabulaire typologique.* 2 vols. Paris: Imprimerie nationale, 1987.

RIBEIRO 1995
Ribeiro, Aileen. *The Art of Dress: Fashion in England and France 1750 to 1820.* New Haven and London: Yale University Press, 1995.

RIBEIRO 2002
Ribeiro, Aileen. *Dress in Eighteenth-Century Europe, 1715–1789.* New Haven and London: Yale University Press, 2002.

RIGORD 1739
Rigord, François-Xavier. *Connoissance de la mythologie par demandes et par réponses.* Paris: Simon, 1739.

ROBICHEZ 1987
Robichez, Guillaume. *J.-J. Lefranc de Pompignan: Un humaniste chrétien au siècle des Lumières.* Paris: Sedes, 1987.

ROCHE 1987
Roche, Daniel. *The People of Paris: An Essay in Popular Culture in the 18th Century.* Translated by Marie Evans in association with Gwynne Lewis. Berkeley and Los Angeles: University of California Press, 1987.

ROCHE 1994
Roche, Daniel. *The Culture of Clothing: Dress and Fashion in the "Ancien Régime."* Translated by Jean Birrel. Cambridge: Cambridge University Press, 1994.

ROINET 2000
Roinet, Clarisse. *Roger Vandercruse dit La Croix: 1727–1799.* Paris: Amateur, with Perrin & fils Antiquaires, 2000.

ROLAND-MICHEL 1975
Roland-Michel, Marianne. "Le Cabinet de Bonnier de la Mosson, et la participation de Lajoue à son décor." *Bulletin de la Société de l'histoire de l'art français* (1975): 214–21.

ROLAND-MICHEL 1996
Roland-Michel, Marianne. *Chardin.* Translated by Eithne McCarthy. New York: Harry N. Abrams, 1996.

ROLLIN 1734
Rollin, Charles. *The Method of Teaching and Studying the Belles Lettres.* 4 vols. London: Bettesworth and Hitch, 1734.

ROLLIN 1818
Rollin, Charles. "Traité des études." In *Œuvres complètes*, vol. 16. Paris: Ledoux et Tenré, 1818.

ROLLIN 1819
Rollin, Charles. "Traité des études." In *Œuvres complètes*, vol. 17. Paris: Ledoux et Tenré, 1819.

RONFORT 1984
Ronfort, Jean-Nérée. "Le Fondeur Jean-Mariette et la fin de l'atelier d'André-Charles Boulle." *L'Estampille* 173 (September 1984): 72–73.

RONFORT 1986
Ronfort, Jean-Nérée. "André-Charles Boulle: Die Bronzearbeiten und seine Werkstatt im Louvre." In Ottomeyer and Pröschel 1986 (see above), vol. 2, pp. 459–520.

RONFORT 1989
Ronfort, Jean-Nérée. "Science and Luxury: Two Acquisitions by the J. Paul Getty Museum." *J. Paul Getty Museum Journal* 17 (1989): 47–82.

ROSENBERG 1983
Rosenberg, Pierre. *L'opera completa di Chardin.* Milan: Rizzoli, 1983.

ROSENBERG AND SCHNAPPER 1983
Rosenberg, Pierre, and Antoine Schnapper. "Paintings by Restout on Mythological and Historical Themes: Acquisition by the National Gallery of Canada of *Venus Presenting Arms to Aeneas.*" *National Gallery of Canada Bulletin* 6 (1982–83): 42–55.

ROSEROT 1910
Roserot, Alphonse. *Edme Bouchardon.* Paris: Librairie centrale des Beaux-Arts, 1910.

ROTH AND LE CORBEILLER 2000
Roth, Linda H., and Clare Le Corbeiller. *French Eighteenth-Century Porcelain at the Wadsworth Atheneum: The J. Pierpont Morgan Collection.* Hartford: Wadsworth Atheneum, 2000.

ROUEN 1970
Rosenberg, Pierre, and Antoine Schnapper. *Jean Restout (1692–1768).* Exh. cat. Rouen, Musée des Beaux-Arts, 1970.

ROUSSEAU 1755
Rousseau, Jean-Jacques. *Discours sur l'origine et les fondements de l'inégalité parmi les hommes.* Amsterdam: Rey, 1755.

ROUX 1930
Roux, Marcel. *Inventaire du Fonds Français: Graveurs du Dix-Huitième Siècle.* 15 vols. Paris: Le Garrec, 1930.

RUSSELL 1968
Russell, Raymond. *Victoria and Albert Museum: Catalogue of Musical Instruments.* Vol. 1, *Keyboard Instruments.* London: Her Majesty's Stationery Office, 1968.

RYKWERT 1980
Rykwert, Joseph. *The First Moderns: The Architects of the Eighteenth-Century.* Cambridge: MIT Press, 1980.

SAINT-SIMON 1856–58
Saint-Simon, Louis de Rouvroy, duc de. *Mémoires complets et authentiques du duc de Saint-Simon sur le siècle de Louis XIV et la régence.* 20 vols. Paris, 1856–58.

SALMON 1996
Salmon, Xavier. *Jacques-André Portail 1695–1759/ Cahier du Dessin Français no. 10*. Paris: Galerie de Bayser, 1996.

SALMON 2004
Salmon, Xavier. "La Rançon de la gloire." *L'Objet d'Art* 395 (October 2004): 41–55.

SALZMAN 2007
Salzman, Mary. "Decoration and Enlightened Spectatorship." In *Furnishing the Eighteenth Century: What Furniture Can Tell Us about the European and American Past*, edited by Dena Goodman and Kathryn Norberg, pp. 155–65. New York and London: Routledge Taylor & Francis Group, 2007.

SARGENTSON 1996
Sargentson, Carolyn. *Merchants and Luxury Markets: The Marchands Merciers of Eighteenth-Century Paris*. London: Victoria and Albert Museum, and Malibu, Calif.: J. Paul Getty Museum, 1996.

SARRAZIN-CANI 1999
Sarrazin-Cani, Véronique. "Formes et usages du calendrier dans les almanachs parisiens au XVIIIe siècle." In *Construire le temps. Normes et usages chronologiques du Moyen Age à l'époque contemporaine, Études Réunies par Marie-Clothilde Hubert*, pp. 417–46. Paris: Champion, and Geneva: Droz, 2000.

SASSOON 1991
Sassoon, Adrian. *Vincennes and Sèvres Porcelain: Catalogue of the Collections*. Malibu, Calif.: J. Paul Getty Museum, 1991.

SAUGRAIN 1771
Saugrain, Claude-Marin. *Nouveau Voyage de France, géographique, historique et curieux*. Paris, 1771.

SAUVY 1986
Sauvy, Anne. "Lecture et diffusion de la Bible en France." In *Le Siècle des Lumières et la Bible*, edited by Yvon Belaval and Dominique Bourel, pp. 27–46. Paris: Beauchesne, 1986.

SAVILL 1988
Savill, Rosalind. *The Wallace Collection: Catalogue of the Sèvres Porcelain*. 3 vols. London: Trustees of the Wallace Collection, 1988.

SCHERF 2001
Scherf, Guilhem. "Collections et collectionneurs de sculptures modernes: Un nouveau champ d'étude." In Gaehtgens et al. 2001 (see above), pp. 147–64.

SCHIVELBUSCH 1988
Schivelbusch, Wolfgang. *Disenchanted Night: The Industrialization of Light in the Nineteenth Century*. Translated by Angela Davies. Berkeley, Los Angeles, and London: University of California Press, 1988 (published in German as: *Lichtblicke: Zur Geschichte der künstlichen Helligkeit im 19. Jahrhundert*).

SCHRØDER 1969
Schrøder, Michael. *The Argand Burner: Its Origin and Development in France and England, 1780–1800*. Translated by Hugh Shepherd. Odense: Odense University Press, 1969.

SCOTT 1992
Scott, Katie. "*D'un siècle à l'autre*. History, Mythology, and Decoration in Early Eighteenth-Century Paris." In Paris–Philadelphia–Fort Worth 1992 (see above), pp. 32–59.

SCOTT 1995
Scott, Katie. *The Rococo Interior: Decoration and Social Spaces in Early Eighteenth-Century Paris*. New Haven: Yale University Press, 1995.

SCOTT 2003
Scott, Katie. "Playing Games with Otherness: Watteau's Chinese Cabinet at the Château de La Muette." *Journal of the Warburg and Courtauld Institutes* 64 (2003): 189–247.

SÈVRES 2001–2
Falconet à Sèvres ou l'art de plaire (1757–1766). Exh. cat. Sèvres, Musée national de céramique, 2001–2 (with Réunion des musées nationaux).

SHACKELFORD AND HOLMES 1987
Shackelford, George T. M., and Mary Tavener Holmes. *A Magic Mirror: The Portrait in France 1700–1900*. Exh. cat. Houston, Museum of Fine Arts, 1987.

SHESGREEN [1982]
Shesgreen, Sean. *Hogarth and the Times-of-the-Day Tradition*. Ithaca and London: Cornell University Press, [1982].

SHOVLIN 2000
Shovlin, John. "The Cultural Politics of Luxury in Eighteenth-Century France." *French Historical Studies* 23, no. 4 (Fall 2000): 577–606.

SLATER 2000
Slater, Maya. *The Craft of La Fontaine*. London: Athlone, 2000.

SMOLLETT 1919
Smollett, Tobias. *Travels Through France and Italy*. London, 1919.

SNOEP-REITSMA 1973
Snoep-Reitsma, Ella. "Chardin and the Bourgeois Ideals of his Time." *Nederlands Kunsthistorisch Jaarboeck* 24 (1973): 147–243.

SOLODKOFF 2000
Solodkoff, Alexander von. "A Lost 'Machine d'Argent' of 1754 by François-Thomas Germain for the Duke of Mecklenburg." *Studies in the Decorative Arts* 7, no. 2 (Spring-Summer 2000): 122–35.

SOLODKOFF 2006
Solodkoff, Alexander von. "The Rediscovery of a 1754 'Machine d'Argent' by François-Thomas Germain." *Studies in the Decorative Arts* 13, no. 2 (Spring-Summer 2006): 93–103.

SØRENSEN 1995
Sørensen, Bent. "Carnets de voyage de deux artistes français au milieu du XVIIIe siècle, Barthélemy-Michel Hazon et Guillaume Voiriot." In *L'Oeil aux aguets ou l'artiste en voyage*, edited by François Moureau, pp. 3–12. Paris: Université de la Sorbonne, with Klincksieck, 1995.

SOTHEBY'S 2004
La Machine d'Argent by François-Thomas Germain. New York: Sotheby's, Inc., 2004.

SOUCHAL 1977–93
Souchal, François. *French Sculptors of the 17th and 18th Centuries: The Reign of Louis XIV; Illustrated Catalogue*. 4 vols. Oxford: Cassirer, and London: Faber, 1977–93.

STANDEN 1985
Standen, Edith. *European Post-Medieval Tapestries and Related Hangings in The Metropolitan Museum of Art*. 2 vols. New York: Metropolitan Museum of Art, 1985.

STAROBINSKI 1977
Starobinski, Jean. "Le Mythe au XVIIIe siècle." *Critique* 33, no. 366 (November 1977): 975–97.

STEIN 1994
Stein, Perrin. "Madame de Pompadour and the Harem Imagery at Bellevue." *Gazette des Beaux-Arts* 123 (January 1994): 29–44.

STERLING 1955
Sterling, Charles. *A Catalogue of French Paintings XV–XVIII Centuries*. New York, Metropolitan Museum of Art, with Harvard University Press, 1955.

STOCKHOLM–PARIS 1993–94
Grate, Pontus, and Pierre Lemoine. *Le Soleil et l'Étoile du Nord: La France et la Suède au XVIIIe siècle*. Exh. cat. Stockholm, Nationalmuseum, and Paris, Galeries nationales du Grand Palais, 1993–94.

STRATMANN-DÖHLER 2002
Stratmann-Döhler, Rosemarie. *Jean-François Oeben 1721–1763*. Paris: Amateur: Perrin & fils Antiquaires, 2002.

SWIFT 2010
Swift, Jonathan. "Directions to Servants." In *Jonathan Swift: The Essential Writings*, edited by Claude Rawson and Ian Higgins, pp. 194–231. New York: Norton, 2010.

TARDY 1971–72
Tardy, H. L. *Dictionnaire des horlogers français, documentation réunie par Tardy*. 2 vols. Paris: Tardy, 1971–72.

THOMASSIN 1681–82
Thomassin, Louis. *La Méthode d'étudier et d'enseigner chrétiennement et solidement les lettres humaines par rapport aux lettres divines et aux Ecritures*. 3 vols. Paris: Muguet, 1681–82.

TROYES–NÎMES–ROME 1977
Charles-Joseph Natoire (Nîmes 1700–Castel Gandolfo 1777) peintures, dessins, estampes et tapisseries des collections publiques françaises. Exh. cat. Troyes, Musée des Beaux-Arts; Nîmes, Musée des Beaux-Arts; and Rome, Villa Médicis, 1977.

TRUMAN 1980
Truman, Charles. "A St. Cloud Nécessaire de Voyage, circa 1750." *Connoisseur* 203, no. 818 (April 1980): 253–55.

TRUMAN 2005
Truman, Charles. "A Saint-Cloud Price List in the Victoria and Albert Museum." *French Porcelain Society Journal* 2 (2005): 24–32.

TURNER 1996
Turner, Jane, ed. *The Dictionary of Art*. 34 vols. London: Macmillan Publishers Ltd., and New York: Grove Dictionaries Inc., 1996.

VAUBLANC 1857
Vaublanc, comte de. *Mémoires de M. le comte de Vaublanc.* Paris, 1857.

VERLET 1967a
Verlet, Pierre. "Les Paravents de Savonnerie pendant la première moitié du XVIIIe siècle." *L'Information d'Histoire de l'Art* 12, no. 3 (May-June 1967): 106–18.

VERLET 1967b
Verlet, Pierre. *The Eighteenth Century in France: Society, Decoration, Furniture.* Rutland, Vt.: Charles E. Tuttle Company, 1967.

VERLET 1982
Verlet, Pierre. *The Savonnerie, Its History: The Waddesdon Collection.* London: National Trust, and Fribourg: Office du Livre, 1982.

VERLET 1987
Verlet, Pierre. *Les Bronzes dorés français du XVIIIe siècle.* Paris: Picart, 1987.

VERSAILLES 1999
Salmon, Xavier. *Jean-Marc Nattier 1685–1766.* Exh. cat. Versailles, Musée national des châteaux de Versailles et de Trianon, 1999.

VERSAILLES 2004
Salmon, Xavier. *Le Voleur d'âmes: Maurice Quentin de La Tour.* Exh. cat. Versailles, Musée national des châteaux de Versailles et de Trianon, 2004.

VERSAILLES–MUNICH–LONDON 2002–3
Salmon, Xavier, ed. *Madame de Pompadour et les arts.* Exh. cat. Versailles, Musée national des châteaux de Versailles et de Trianon; Munich, Kunsthalle der Hypo-Kulturstiftung; and London, National Gallery, 2002–3

VIGARELLO 1988
Vigarello, Georges. *Concepts of Cleanliness: Changing Attitudes in France since the Middle Ages.* Translated by Jean Birrell. Cambridge and New York: Cambridge University Press, 1988.

VIRGIL 1743
Virgil. *Les Œuvres de Virgile traduites en françois, le texte vis-à-vis la traduction, avec des remarques par M. l'abbé des Fontaines.* Translated by Pierre-François Guyot Desfontaines. 4 vols. Paris: Quillau, 1743.

VOIRIOT 2004
Voiriot, Catherine. "Guillaume Voiriot (1712–1799), portraitiste de l'Académie royale de Peinture et de Sculpture, avec un essai de catalogue." *Bulletin de la Société de l'histoire de l'art français* (2004): 111–57.

VON EUW AND PLOTZEK 1979
Von Euw, Anton, and Joachim M. Plotzek. *Die Handschriften der Sammlung Ludwig,* vol. 1. Cologne: Schnütgen-Museum, 1979.

WALKER 2008
Walker, Lesley H. *A Mother's Love: Crafting Feminine Virtue in Enlightenment France.* Lewisburg, Penn.: Bucknell University Press, 2008.

WASHINGTON ET AL. 1979–81
Rosenbaum, Allen. *Old Master Paintings from the Collection of Baron Thyssen-Bornemisza.* Exh. cat. Washington, International Exhibitions Foundation, 1979–81.

WATSON 1963
Watson, Francis J. B. "Beckford, Mme de Pompadour, the duc de Bouillon and the Taste for Japanese Lacquer in Eighteenth-Century France." *Gazette des Beaux-Arts* 61 (February 1963): 101–27.

WEIL 1986
Weil, Françoise. *L'interdiction du roman et la librairie 1728–1750.* Paris: Aux Amateurs de Livres, 1986.

WHEATON 1983
Wheaton, Barbara. *Savoring the Past: The French Kitchen and Table from 1300 to 1789.* Philadelphia: University of Pennsylvania Press, 1983.

WHITEHEAD 1993
Whitehead, John. *The French Interior in the Eighteenth Century.* New York: Laurence King, 1993.

WILDENSTEIN 1919
Wildenstein, Georges. "Un Chef-d'oeuvre inédit de La Tour: Le Portrait du Président de Rieux." *La renaissance de l'art français et des industries de luxe* 2, no. 3 (April 1919): 1–21.

WILDENSTEIN 1922
Wildenstein, Georges. *Le Peintre Aved, sa vie et son oeuvre 1702–1766.* Paris: Les Beaux-Arts, 1922.

WILDENSTEIN 1924
Wildenstein, Georges. *Lancret.* Paris: G. Servant, 1924.

WILDENSTEIN 1935
Wildenstein, Georges. "Premier Supplément à la biographie et au catalogue de J.-A.-J.-C. Aved." *Gazette des Beaux-Arts* 13 (1935): 159–72.

WILDENSTEIN 1968
Wildenstein, Georges. "Les Tableaux dans l'hôtel de Pierre Crozat." *Gazette des Beaux-Arts* 72 (1968): 5–10.

WILSON ET AL. 1996
Wilson, Gillian, David Harris Cohen, Jean Nerée Ronfort, Jean-Dominique Augarde, and Peter Friess. *European Clocks in the J. Paul Getty Museum.* Los Angeles: J. Paul Getty Museum, 1996.

WILSON 1999
Wilson, Gillian. *Mounted Oriental Porcelain in the J. Paul Getty Museum.* Los Angeles: J. Paul Getty Museum, 1999.

WILSON AND HESS 2001
Wilson, Gillian, and Catherine Hess. *Summary Catalogue of European Decorative Arts in the J. Paul Getty Museum.* Los Angeles: J. Paul Getty Museum, 2001.

WILSON, BREMER-DAVID, AND WEAVER 2008
Wilson, Gillian, with Charissa Bremer-David and Jeffrey Weaver. *French Furniture and Gilt Bronzes: Baroque and Régence.* Los Angeles: J. Paul Getty Museum, 2008.

WINTERNITZ 1961
Winternitz, Emanuel. *Keyboard Instruments in the Metropolitan Museum of Art.* New York: Metropolitan Museum of Art, 1961.

ZISKIN 1999
Ziskin, Rochelle. *The Place Vendôme: Architecture and Social Mobility in Eighteenth-Century Paris.* Cambridge: Cambridge University Press, 1999.

Index

CHARISSA BREMER-DAVID is curator of sculpture and decorative arts at the J. Paul Getty Museum. She has studied and written extensively on the Getty Museum's collection of European decorative arts and tapestries as well as on collections of other major arts institutions. In 2003, her research into the archives of the New York art dealer French & Company and the resulting publication earned the Robert C. Smith Award, presented by the Decorative Arts Society. She has collaborated on several exhibitions at the Getty Center, including the recent *Taking Shape: Finding Sculpture in the Decorative Arts* (2009) and *Oudry's Painted Menagerie* (2007).

KIMBERLY CHRISMAN-CAMPBELL is an art historian specializing in fashion and textiles. She has worked as a curator, consultant, and educator for museums and universities around the world and has also published and lectured extensively. Her areas of expertise include European dress and textiles and French and British painting and decorative arts of the seventeenth, eighteenth, and nineteenth centuries. She recently coauthored the exhibition catalogue *Fashioning Fashion: European Dress in Detail, 1700–1915* (Los Angeles County Museum of Art/Prestel, 2010).

JOAN DEJEAN has been trustee professor of French at the University of Pennsylvania since 1988. She is the author of nine books on French literature, history, and material culture of the seventeenth and eighteenth centuries, including most recently *The Age of Comfort: When Paris Discovered Casual and the Modern Home Began* (2009); *The Essence of Style: How the French Invented High Fashion, Fine Food, Chic Cafés, Style, Sophistication, and Glamour* (2005); and *Ancients Against Moderns: Culture Wars and the Making of a Fin de Siècle* (1997). She is currently working on a book about the rebirth of the city of Paris in the seventeenth century to be entitled, *The Invention of Paris: Making the City Modern*.

MIMI HELLMAN teaches art history at Skidmore College. Her work explores the roles of visual and material culture in the social formation of eighteenth-century French elites. She has published essays in *Eighteenth-Century Studies*, *SVEC* (*Studies on Voltaire and the Eighteenth Century*), and *Furnishing the Eighteenth Century: What Furniture Can Tell Us About the European and American Past*. She is currently writing a book on the architecture and interior design of the Hôtel de Soubise, an aristocratic residence in Paris.

PETER BJÖRN KERBER is assistant curator of paintings at the J. Paul Getty Museum.